Law and the Image

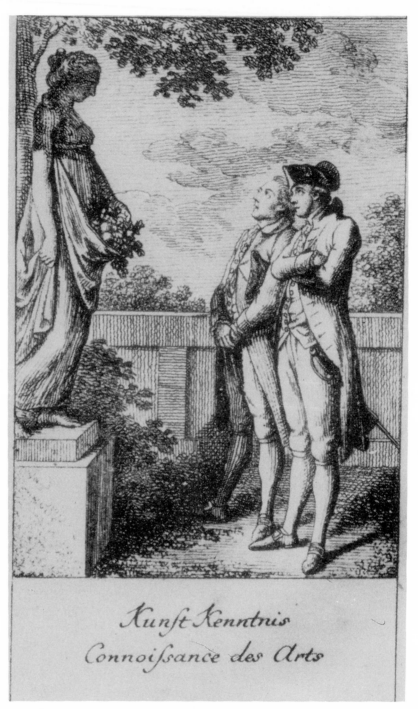

Daniel Chodowiecki, "Kunstkenntnis," from the Goettinger Taschen-Calendar, 1780 (July). Graphische Sammlung, Staatsgalerie Stuttgart.

LAW
AND THE
IMAGE

The Authority of Art
and the Aesthetics
of Law

EDITED BY
COSTAS DOUZINAS
AND
LYNDA NEAD

THE UNIVERSITY OF CHICAGO PRESS
CHICAGO AND LONDON

Costas Douzinas is professor and chair of the Department of
Law at Birkbeck College, University of London.

Lynda Nead is chair of the Department of Art History at
Birkbeck College, University of London.

The University of Chicago Press, Chicago 60637
The University of Chicago Press, Ltd., London
© 1999 by Costas Douzinas and Lynda Nead
Individual chapters copyright 1999 by the contributor(s).
All rights reserved. Published 1999
Printed in the United States of America

08 07 06 05 04 03 02 01 00 99 1 2 3 4 5

ISBN: 0-226-56953-5 (cloth)
ISBN: 0-226-56954-3 (paper)

Library of Congress Cataloging-in-Publication Data

Law and the image : the authority of art and the aesthetics of law /
edited by Costas Douzinas and Lynda Nead.
 p. cm.
 Includes bibliographical references and index.
 ISBN 0-226-56953-5 (alk. paper). — ISBN 0-226-56954-3
(pbk. : alk. paper)
 1. Law and aesthetics. 2. Law and art. I. Douzinas,
Costas, 1951– . II. Nead, Lynda.
K487.A3L395 1999
340′.11—dc21 98-50313
 CIP

CONTENTS

ILLUSTRATIONS

ACKNOWLEDGMENTS

This project started in the form of a conference entitled "The Art of Justice," which was held at the Tate Gallery, London, in February 1996. We wish to thank our colleagues Steven Connor and Peter Goodrich, who helped conceive and organize that event. Richard Humphreys and Andrew Brighton of the education department at the Tate Gallery made invaluable contributions to both the intellectual and administrative sides of the conference. This book could not have happened without the patience and editorial skills of Valerie Hoare, to whom we are grateful. We would also like to thank our copyeditor, Joel Score, for his meticulously precise editing.

Costas Douzinas
Lynda Nead

CONTRIBUTORS

GEORGES DIDI-HUBERMAN is professor at the Centre d'Histoire et Theorie de l'Art, in the Ecole des Hautes Etudes en Sciences Sociales. He is author of several books on the history and theory of art. His major works include *Devant l'image: Question posée aux fins d'une histoire de l'art* (1990) and *Fra Angelico: Dissemblance and Figuration* (1995).

COSTAS DOUZINAS is professor and chair of the Department of Law at Birkbeck College, University of London. He is author, with Ronnie Warrington, of *Postmodern Jurisprudence: The Law of Text in the Texts of Law* (1993), *Justice Miscarried: Ethics and Aesthetics in Law* (1994), and *The Logos of the Nomos* (1996) and coeditor of *Politics, Postmodernity, and Critical Legal Studies: The Legality of the Contingent* (1994).

HAL FOSTER is professor of modern art at Princeton University and coeditor of *October*. His most recent books are *The Return of the Real* (1996) and *Compulsive Beauty* (1993).

PETER GOODRICH is Corporation of London Professor of Law, University of London, Birkbeck College. He has written extensively on the semiotics and aesthetics of law and is author most recently of *Oedipus Lex: Psychoanalysis, History, Law* (1995). He is currently working on a history of women's courts and judgments of love.

PIYEL HALDAR is a lecturer in law at Birkbeck College, University of London. He has published widely in the areas of law of evidence, law and literature, and law and aesthetics and is currently writing a book on court buildings around the world.

MARTIN JAY is Sidney Hellman Ehrman Professor and chair of the history department at the University of California, Berkeley. Among his publications are *The Dialectical Imagination* (1973 and 1996), *Downcast Eyes* (1993), *Permanent Exiles* (1995), and *Cultural Semantics* (1998). He is currently writ-

ing a book on the discourse of experience in European and American thought.

MANDY MERCK teaches in the media studies and sexual dissidence programs at the University of Sussex. A former editor of *Screen* and senior producer of British television programs on homosexuality, she is author of *Perversions: Deviant Readings* (1993), coeditor of *Coming Out of Feminism?* (1998), and editor of *After Diana* (1998).

LYNDA NEAD is chair of the Department of Art History at Birkbeck College, University of London. She is author of *The Female Nude: Art, Obscenity, and Sexuality* (1993) and *Chila Kumari Burman: Beyond Two Cultures* (1995) and coeditor of *The Actuality of Walter Benjamin* (1998).

JONATHAN P. RIBNER is associate professor in the art history department at Boston University and a specialist in European painting and sculpture of the late eighteenth and nineteenth centuries. The author of *Broken Tablets: The Cult of the Law in French Art from David to Delacroix* (1993), he has published articles and book reviews in *The Art Bulletin, Zeitschrift für Kunstgeschichte, Art Journal, Nineteenth-Century French Studies,* and *The American Historical Review*. He is currently working on a book about Victorian art, literature, and society.

KATHERINE FISCHER TAYLOR is associate professor in the Department of Art History at the University of Chicago. She is author of *In the Theater of Criminal Justice: The Palais de Justice in Second Empire Paris* (1993) and other studies of the relationship between French judicial history and architecture.

Costas Douzinas and Lynda Nead

Law and Aesthetics

"It would be a dangerous undertaking for persons trained only to the law to constitute themselves as final judges of the worth of pictorial illustrations outside of the narrowest and most obvious limits. At the one end some works of genius would be sure to miss apprehension. Their very novelty would make them repulsive until the public had learned the new language in which their author spoke. It may be more than doubted for instance whether the etchings of Goya or the paintings of Manet would have been sure of protection when seen for the first time."[1] This striking statement about the relationship between law and art was made by Justice Oliver Wendell Holmes at the turn of the century in the context of a copyright law case. For Holmes, law and art were radically distinct and their separation would not allow people versed in the law to appreciate beauty or even the masterpieces of art. Lawyers live by the text and love the past, they hate novelty and misunderstand new languages. The law is able to appreciate new art only after it becomes a matter of convention, use, and habit, in other words, when art becomes like law. Great art, on the other hand, precisely because it breaks away from conventions and rules and expresses creative freedom and imagination, is the antithesis of law. The law of art is the opposite of the rule of law. Similar statements are not difficult to find in other judicial pronouncements dealing with the relationship between law and art or images.

The "aesthetic question" makes a pronounced appearance in planning law, in which "aesthetic" considerations "underlie all zoning in

1. *Bleistein v. Donaldson*, 188 U.S. 239, 251 (1903).

combination with other factors with which they are interwoven."[2] But this recognition of the importance of "aesthetics" seems to lead judges to extreme declamations on their importance. Speaking in a case involving an ordinance excluding the building of blocks of flats in a particular neighborhood, the court could not restrain its rhetoric. "Certain legislatures might consider that it was more important to cultivate a taste for jazz than for Beethoven, for posters than for Rembrandt, and for limericks than for Keats. The world would be at continual seesaw if aesthetic considerations were permitted to govern the use of [governmental] power."[3] But "aesthetic considerations are a matter of luxury and indulgence rather than of necessity and it is necessity alone which justifies the exercise of [governmental] power to take private property without compensation,"[4] thundered another court in a humble case involving local antibillboard regulations. These judicial statements express the most common justification of the attitude adopted by the law toward aesthetics. Taking or weakening property, the privileged domain of protection of the common law, must be justified by strict necessity and must follow general rules and a clear logic. The experience of art, by contrast, is radically subjective, with no common or universally valid standards for its appreciation; the government cannot indulge in such fanciful considerations in carrying out its functions. In Hegelian terms, law is the combination of reason and necessity; for law, art is the combination of sensuality and freedom.

These American judicial pronouncements are contemporary expressions of a long-standing but neglected ambivalence toward art and aesthetics. They express one way of looking at art, which emphasizes its formal qualities, its aesthetic affect, and its slightly frivolous status when compared with the practice of reason and the injunctions of social and political necessity expressed in law. They are part of a typically modern attitude introduced by Kant's critical philosophy and simplified by legal neo-Kantians. According to this approach, modernity releases three areas of inquiry and action—the cognitive, the practical, and the aesthetic—and the three faculties of knowledge, law, and taste are freed to develop their own specific, internal rationality, in separate institutions

2. *People v. Stover*, 12 N.Y.2d 462, 471, 191 N.E.2d 272, 277, appeal dismissed, 375 U.S. 42 (1963).

3. *City of Youngstown v. Kahn Building Co.*, 112 Ohio St. 654, 661–62, 148 N.E. 842, 844 (1925), quoted in J. Costonis, *Icons and Aliens* (Urbana: University of Illinois Press, 1989), 21.

4. *City of Passaic v. Paterson Bill Posting, Advertising & Sign Painting Co.*, 72 *New L.J.* 267, 268 (1905).

operated by distinct groups of experts.[5] Modern law is born in its separation from aesthetic considerations and the aspirations of literature and art, and a wall is built between the two sides. The relationship between art, literature, and law, between the aesthetic and the normative, is presented as one between pluralism and unity, surface openness and deep closure, figuration and emplotment. Art is assigned to imagination, creativity, and playfulness, law to control, discipline, and sobriety. There can be no greater contrast than that between the open texts and abstract paintings of the modernist tradition and the text of the Obscene Publications Act, the Official Secrets Act, or indeed any other statute. Statutes are based on the principle of textual parsimony; they are supposed to have a true meaning that technical expertise and the correct method will be able to discover.

The self in art—as painter or viewer—is free, desiring, corporeal, it has gender and history. The subject of law—as judge or litigant—is constrained, censored, and ethereal. The legal person is a collection of rights and duties, a point of condensation of capacities and obligations of a general or universal nature; the judge is at the service of the law of reason, which has no history, no past or future, but is omnipresent. The legal subject comes before the law genderless and without context, a persona or mask placed on the body. Justice must be blindfolded to avoid the temptation to see the face that comes to the law and put the unique characteristics of the concrete person before the abstract logic of the institution. Finally, in an institutional sense, law is presented as the solution to the conflict of values and the plurality of interpretations and is therefore functionally and politically differentiated from art and literature. In a mundane but revealing sense literature has treated law and lawyers with contempt, starting with the comedies of Aristophanes and continuing in modernist literature.

This apparent distance between the concerns of law and those of art and literature has been emphasized by the jurisprudence of modernity. Law, like philosophy and religion, indeed as heir to the latter, presents itself as a discourse about all other practices and discourses.[6] It has the power and the ability to translate and organize in its own grammar and vocabulary every language, dialect, and idiom. But this ability, seen as an integral part of its regulatory function, is predicated upon a cleansing

5. For a discussion of the Kantian faculties and their relevance to law and jurisprudence, see C. Douzinas and R. Warrington with S. McVeigh, *Postmodern Jurisprudence: The Law of Text in the Texts of Law* (London: Routledge, 1991), chaps. 1, 3.

6. For law's relationship to religion, see P. Goodrich, *Languages of Law* (London: Weidenfeld & Nicholson, 1990), chap. 4.

or purificatory operation. Law pretends that it can close itself off from other discourses and practices, attain a condition of total self-presence and purity, and keep outside its domain the nonlegal, the extraneous, the other—in particular the aesthetic, the beautiful, and the image. Jurisprudence creates an imaginary picture of law as ordered, systemic, closed, coherent, and hermeneutically stable, while art and literature are seen as anarchic, open, and free. Plato was right after all: poetry and art must be banned from the well-ordered polity.

We find a parallel history when we turn from law to art and literature. Art theory develops criteria of genre, of formal analysis of discourse and figure, that separate art from nonart and demarcate the aesthetic from the other faculties. A countermove seeks the meaning of art and the truth in literature in the environment of the work. The work of art expresses either the intention of the author or the conditions—economic, historical, psychological, ideological—of the age of its production. Both formalist, or internal, and external theories of art are preoccupied with the definition of art and the demarcation of its proper boundaries. They presuppose the ability to distinguish intrinsic from extrinsic, art from nonart, form from matter, pictures from words, aesthetic from practical questions. The intrinsic is a judgment of taste and beauty, the extrinsic opens to the empiricism of use and ends or the historicism of doctrine and the law. In its emphasis on such distinctions, the history of modern art theory parallels that of legal theory.

The judicial pronouncements encountered above reflect this philosophical climate. The programmatic separation of law and art can lead to deep suspicion and contempt of one side toward the other but also, although more rarely, to a feeling of inferiority and envy for the abilities exclusively attributed to the other. Following this logic the courts repeatedly invalidated zoning regulations that violated the constitutional protection of property rights "solely for aesthetics," until the Supreme Court, in *Berman v. Parker*, ruled that "the values [public welfare] represents are spiritual as well as physical, aesthetic as well as monetary. It is within the power of the legislature to determine that the community should be beautiful as well as healthy, spacious as well as clean, well-balanced as well as carefully patrolled."[7] This partial recognition of aesthetic considerations, motivated by a reorientation of attitudes toward property and by a new interest in the environment, crucially linked beauty, spaciousness, and balance to "spiritual" concerns. Both the earlier decisions condemning aesthetics as an indulgence and the later ones

7. 348 U.S. 26 (1954).

granting them partial admission as one aspect of the spiritual domain recall the arguments during the iconoclastic controversies, those great ecclesiastical and political battles over the material or spiritual character of art and images. Images affect the soul; icons are a material likeness of spiritual prototypes and bridge the gap between body and soul, matter and spirit, form and content. In a more modern terminology, images and icons are the support of our imaginary identifications; their importance and effects are too great for the law to stay uninterested in them. Despite the musings of judges and planners to the contrary, the law has always had an aesthetic policy, an attitude of policing images and licensing pleasures, which at times became an extreme but unrepresentative dismissal of their importance and use. Indeed, in modernity, law has become a literature that represses its literariness and an aesthetic practice that denies its art.

The common concerns of and mutual influences between law and art are acknowledged today only in discussions of art policies under fascism and soviet communism. "In Germany, the USSR and Italy, increasingly intense battles for the control of art and culture were an integral part of the establishment of power and prefigure the real war which started in Spain and then spread throughout Europe. . . . These battles for art—or cultural revolutions—were part of the process of purging or cleansing through which each threatened nation could be healed and made whole. . . . Art is a weapon that could be used to this end."[8] In this version, power, particularly pathological, authoritarian power, and the law are interested in art only as a tool for their evil purposes. But this is a perverted, degenerate, and transient way of dealing with art and has only been used by evil regimes with immoral laws.[9] A similar argument is often invoked against various types of "limited" censorship imposed on the arts by liberal legal systems. They are illiberal and oppressive, they stifle imagination and creativity and must be resisted as the worst excesses of power. Uses of art by power and of artistic censorship are presented as exceptional in the double sense of the word; they are rare and they represent exceptional emergency law. And yet, while it is true that tyrannical regimes have often tried either to use art or to ban certain images or punish their "degenerate" makers their main

8. David Elliott, "The Battle for Art," in *Art and Power: Europe under the Dictators 1930–45*, exh. cat. (London: Hayward Gallery, 1995), 33.

9. This was the overall point of the "Art and Power" exhibition at the Hayward Gallery, London. The use of art for political ends was presented as an interval in the enlightened Western attitude, which keeps out of the aesthetic realm leaving it to its practitioners.

distinction from liberal governments is in the blatant character of their attempts and their often ridiculous overreaching. A more careful examination of the history of the image shows that despite, or rather because of, the caution and indeed hostility of certain philosophical schools and religions, a strong internal link connects political power, law, and the image, in complex and historically evolving ways.

Law and Art

If we turn to the legal regulation of art, we find that the law has followed closely religious and philosophical anxieties about the power of images. In the Greek tradition, Plato excludes art and artists, poetry and poets from the realm of reason and good government and inaugurates the ancient quarrel between art and poetry on the one hand and philosophy and truth on the other. This "ancient quarrel" is well known and has been repeatedly commented upon.[10] What has been discussed less is the relationship between the aesthetic and the legal. Law has mimed philosophy in its reservations if not downright hostility to art and images. Plato again stated in the *Laws* that "when a poet or a painter represents men with contrasting characters he is often obliged to contradict himself, and he does not know which of the opposing speeches contains the truth. But for the legislator, this is impossible: he must not let his laws say two different things on the same subject."[11] Indeed the supreme achievement of the mythological Egyptian legislator was to realize that certain movements, tunes, and artistic representations were harmful to the young and to legislate a list of good and acceptable styles and forms. "Painters and everyone else who represents movements of the body of any kind were restricted" to those forms to such a degree that, according to Plato, paintings and reliefs produced ten thousand years earlier were identical to those created at his time.[12] From a contemporary liberal perspective, the Egyptian legislator may be presented as the first censor; but he was also first in realizing that the function and the truth of art are to be found in its use. Whatever the form or medium adopted, art has important social effects, which can and must be manipulated.

The Greek legislator often followed similar imperatives. The laws of Thebes commanded artists to idealize their themes and severely punished digression toward ugliness. Artists like Pauson and other "dirt-

10. Plato, *The Republic* (Penguin ed.), bk. 10, 421–39; for commentary, see Stanley Rosen, *The Quarrel between Poetry and Philosophy* (London: Routledge, 1988), chaps. 1–3.

11. Plato, *The Laws* (Penguin ed.), bk. 4, 180.

12. Ibid., bk. 2, 91.

painters," who enjoyed portraying ugly human beings, were condemned to poverty, a threat which, if applied today, would have stopped much contemporary art. The eighteenth-century art critic Gotthold Lessing commends the Greeks for legislating against caricature and insists that artists should make their copies more beautiful than the original. Art is too important for building the national character and its potential for harm is too great to be left unregulated. "The plastic arts in particular—aside from the inevitable influence they exert on the character of the nation—have an effect that demands close supervision by the law. If beautiful men created beautiful statues, these statues in turn affected the men and thus the state owed thanks to beautiful statues for beautiful men."[13] Images have important effects on people and nations and as a result the legislator cannot remain indifferent. "Pleasure is not indispensable," Lessing concludes. "What kind and what degree of pleasure shall be permitted may justly depend on the law-giver." It is the law's business to promote positive and deter negative effects, by developing a strategy for policing images.

Controversies about images permeate Western law. Their public and overtly political expression in the iconoclastic disputes reveals not only a deep-seated fear but also an ambiguity as to the use of art and of images more generally. This ambiguity is vividly captured in a famous aphorism by the Renaissance jurist Alciatus: *Imago veritas falsa*, the image is a false truth. The history of law's attitude toward images follows this tortuous dialectic, the deeply paradoxical combination of truth and falsity, of blindness and insight. The claim that image is truth implicates the theme of resemblance, similarity, or mimesis, a key metaphysical concept of Western philosophy. Wars over idols and icons, over representational, naturalistic, and abstract or conceptual art, have as their stake the order of representation of every particular society and epoch. But image is also false. Here the stake is not so much the relationship between the real and its mirror, but the effects or affect of the image on the senses and the soul. Images are sensual and fleshy; they address the labile elements of the self, they speak to the emotions, and they organize the unconscious. They have the power to short-circuit reason and enter the soul without the interpolation or intervention of language or interpretation. According to Pierre Legendre, images help bind the biological, unconscious, and social parts of the person.[14] By combining

13. Gotthold Lessing, *Laocoön: An Essay on the Limits of Painting and Poetry*, trans. E. A. McCormick (1766; Baltimore: Johns Hopkins University Press, 1984), 14.

14. Pierre Legendre, *Dieu au miroir: Etude sur l'institution des images* (Paris: Fayard, 1994); Legendre, "Introduction to the Theory of the Image," *Law and Critique* 8, no. 1 (1997).

truth and illusion in an ocular dialectic, they attach the subject to the logic of institutions.

After the Reformation and the fusion of secular and ecclesiastical jurisdictions, iconophobic ideas became the explicit foundation upon which the common law was established. The force of the common law is based on the celebration of spiritual community, social unity, and political sovereignty and the complementary exclusion of materiality and sensuality, of enemies without and within—the Romanists and the French, the Egyptians and the Jews, itinerants, idolaters, and witches. This strategy of inclusion and excommunication is organized around an order of acceptable and forbidden images, of icons and idols, of spiritual likenesses and false figures that, Medusa-like, can both fascinate and petrify.[15] In the same way that churches once excluded icons, the law was now encouraged to banish figures and imagery. The image had come to be seen as too worldly, too sensual and potentially corrupt, too contingent and transient, and so was replaced with the word. The further linkage of imagistic language with rhetoric led to the subordination of rhetoric to logic and the elevation of logic as the sole method of science and of law. The fear of images, displaced into judicial hermeneutics, becomes the fear of plural meanings and interpretations, of diverse, local, and informal jurisdictions, of different logics and particular reasons.[16] The aim of secular jurisdiction came to be to cleanse the mind from impure thoughts and the text of law from "painted words."

But at the same time, the law did not forget the utility and effectiveness of carefully policed images. Every iconophilic text is deeply worried about the possibility of confusion between original and copy, and every iconoclastic diatribe uses the most vivid imagery to combat the evil of images. The law loves and fears images, it both prohibits them and organizes its own operation in a spectacular and visual manner. The Reformation and the ascendancy of print turned the legal ritual from total to restricted theater, replacing trial by ordeal with trial by argument and persuasion. Law adopts a predominantly textual form, but its insistence on oral as against written procedure indicates its unceasing hostility toward anything that might detract from immediate communication or lead to semantic uncertainty. The fear of idols is evident in

15. For an extensive exploration of this argument, see P. Goodrich, *Oedipus Lex: Psychoanalysis, History, Law* (Berkeley: University of California Press, 1995).

16. C. Douzinas, P. Goodrich, and Y. Hachamovitz, "The Legality of the Contingent," in C. Douzinas, P. Goodrich, and Y. Hachamovitz, eds., *Politics, Postmodernity, Critical Legal Studies* (London: Routledge, 1995), 1–31.

the renunciation of rhetoric and imagery in legal doctrine and theory; in the claim that reason alone, without the contamination of eloquence, passion, or casuistry, can deliver justice; and, finally, in the denunciation of those figures of seduction and corruption—women, jesters, children—who do not think like the common man.

But despite this internalization of iconoclasm to the text, the law continues to struggle with images and its deep ambivalence toward images remains intact. The power of spiritual, edifying icons is celebrated in every courtroom: in the wigs, robes, and other theatrical paraphernalia of legal performance and in the images of justice that adorn our public buildings. The law arranges, distributes, and polices its own image through icons of authority and sovereignty, tradition and fidelity. In practical terms, law regulates and polices art. It imposes on art and artists the same principles and regulations as apply to other domains of commodity production and labor relations. It regulates the art market, enforces contracts, defines the duties of artistic expertise and imposes general restrictions on artistic expression under the laws of public order, libel, obscenity, blasphemy, copyright, and the like.

This collection challenges the claim that a radical separation exists between law and art and the historically complacent view that only dictatorial regimes develop a policy on images. On the contrary, law has always had a visual policy and understood the importance of the governance of images for the maintenance of the social bond. Law's force depends partly on the inscription on the soul of a regime of images. Religion and law have a long history of policing images, coupled with an economy of permitted images or icons, an iconomy, and a criminology of dangerous fallen and graven images, an idolatry. This peculiar and shifting combination of iconoclasm and iconophilia, this iconomachia or complex legal administration of aesthetics, received its most complete formulation after the Reformation but is still a central part of the operations of law. This strategic intervention in the field of vision and iconicity is organized around the regulation of the relationships between object, image, and text. The central aesthetic question of representation or mimesis is intensely influenced by legal considerations, and law's answers determine the regime of icons and idols in each period. If the relationship between words and images, text and icons, is political,[17] the law has been called upon to arbitrate and to impose temporary solutions to the ancient quarrel.

17. See, among others, W. J. T. Mitchell, *Iconology: Image, Text, Ideology* (Chicago: University of Chicago Press, 1986).

Ars Juris

Law's art has been recently explored from a literary perspective. The school of jurisprudence variously described as "law and literature" or "literary jurisprudence" has revived the classical tradition for which successful law was perceived as a felicitous language and instruction into the legal arcana involved an introduction to the power of beautiful speech. The earliest customs and laws of Greece took the form of legends, myths, and tales, the earliest judge was a histor. The first legal form was the narrative, and the great lawgivers—Solon, Lycurgus, Plato himself—were successful narrators. This close link between literary form and law continued in the classical period. Legal practice was the mainstay of rhetors and orators; a lawyer would be chosen as much for his ability to move an audience as for his mastery of the law. Demosthenes and Cicero were instructed in forensic rhetoric and the felicitous uses of speech and oratorical skill as well as in legal technique and procedure.

In a more general sense, throughout history law has been the performative language par excellence, a language whose success is measured by its consequences, its ability to act on the world. A language that carries the rudiments of order and transmits the commands of the law must act on the emotions and persuade the intellect; it can only be a beautiful language and, despite protestations to the contrary, legal practice and education consciously or unconsciously have always understood this. The link between performance of law and love for the text is pervasive in practice. But the greatest impediment to its full recognition has been what we may call the resistance of genre, the belief in the Platonic injunction against poetry and rhetoric and in the Kantian separation between the normative and the aesthetic.

Legal discourse in modernity has become, according to conventional jurisprudence, a literature that represses its literary quality, a rhetoric that forgets its textual organization and aesthetic arrangement. A key task of the school of law and literature is to examine the historical conditions and philosophical presuppositions of this repression, as well as the aesthetic qualities of the legal text. If the law works through the creation and projection of ordered worlds, attention to style, detail, and form will help one understand law's hidden vision and develop alternative worlds and visions that derive their legitimacy from repressed texts, histories, and traditions. Treating the law as literature brings to the surface and highlights the type of life and the form of soul that the institution constructs and tries to capture. But literary jurisprudence has concentrated on the linguistic and literary aspects of the law. In that, it has

followed the Protestant tradition of *sola scriptura* and the excessive logo-
nomocentrism of modernity.[18] If literary jurisprudence is to succeed in
its attempt to wake the jurisprudential enterprise from its positivistic
slumber and make jurisprudence again the prudence or phronesis of the
law, both law's consciousness and conscience, it must be supplemented
with a legal iconology. The aims of literary jurisprudence and of legal
iconology are not dissimilar; but while the former closes the eyes to
open the ear to the *ars legis* the latter insists that law's art captures the
soul by addressing the totality of the senses.

The relationship between law and art can be analytically distin-
guished into two components: law's art, the ways in which political and
legal systems have shaped, used, and regulated images and art, and art's
law, the representation of law, justice, and other legal themes in art.
The pioneering work of Ernst Kantorowicz, particularly *The King's Two
Bodies*,[19] opened this vast area of interdisciplinary study and has influ-
enced its main texts: Louis Marin's *Portrait of the King*,[20] Legendre's
Dieu au mirroir and the whole of his extraordinary body of psychoana-
lytically inspired legal history, and Peter Goodrich's *Oedipus Lex*. These
important contributions created the field of what could be called politi-
cal iconology by emphasizing the political uses of art and imagery. On
the reverse side, Cesare Ripa's *Iconologia*, published in 1593, proposes
a number of legal images, including justice and injustice.[21] More re-
cently a detailed art historical account of the iconography of justice has
been carried out in Robert Jacob's *Images de la Justice*.[22]

This collection is the first attempt to develop a specifically legal ico-
nology, to draw on the critical procedures of law, art history, and cul-
tural studies in order to consolidate a new interdisciplinary field of visual
culture and law. The focus is on the diverse interfaces between law and
the artistic image. The essays explore the ways in which art and law are
intertwined—the history of their relationship, the ways in which the
domain of the visual is made subject to the force of law, and the complex
relations between law, the image, and identity—while addressing ques-
tions of distinction and the maintenance of boundaries. As we have al-
ready noted, law as a system of rules and as the science of justice has
defined itself in modernity against aesthetic considerations. Art, too,

18. Douzinas and Warrington, *Postmodern Jurisprudence*, chap. 1.
19. Ernst Kantorowicz, *The King's Two Bodies: A Study in Medieval Political Theology*
(Princeton: Princeton University Press, 1957).
20. Louis Marin, *Portrait of the King*, trans. Martha M. Houle (1981; Minneapolis:
University of Minneapolis Press, 1988).
21. Cesare Ripa, *Iconologia*, ed. Piero Buscaroli (Milan: Tea, 1992).
22. Robert Jacob, *Images de la Justice: Essai sur l'iconographie judiciaire du Moyen Age
à l'âge classique* (Paris: Léopard d'Or, 1994).

has defined itself as an autonomous realm for the judgment of beauty and the training of the eye. Legal and aesthetic judgment may be said to control the borders of their separate domains. Judgment is at the heart of the relationship between art and law; indeed, the question of representation is itself a question of the adjudication of regimes of images.

The collection begins by addressing the ways in which art imagines and depicts law and, conversely, law's fascination with the image. The essays in the first section, "Vision and Law," move toward the formulation of a legal iconology. For Martin Jay, the blindfolded figure of justice not only functions as an emblem of impartiality but is also a guarantee of the resistance of law to the seduction of images. The blindfold allegorizes the expulsion of the visual from legal discourse in the newly formed public sphere of sixteenth-century Europe. Within this discourse, the image is perceived as dazzling, dissembling, overwhelming, whereas language is based on reason, which must be the foundation of law. But alongside this distrust of the visual there is also a critical investment in the image, according to which sight ensures freedom. If freedom is also the recognition of the existence of the unique, the peculiar, and the deviant, then the blindfolding of justice may be seen to eliminate attention to particularity and reduce justice to the law of norms and cases. Like so many allegorical figures the figure of justice is female, and Jay considers the specific implications of the thwarting of the female gaze. In the final instance, he calls for a creative tension between a seeing and a blindfolded justice, for an image of the law that attends to both particularity and abstract prescription—a form of two-faced deity symbolizing a free justice.

In the second essay Costas Douzinas considers the theological and psychological powers of the image and inaugurates a legal iconology. Following the icon from ancient Greece to the courtrooms of modern Europe, he uncovers the traces of ancient psychic investments in the power of the image. For Douzinas, images give visible form to invisible powers; they make present what is beyond presentation. The danger and the power of the image lies in its direct and unmediated address to the viewer; the cult image may represent the absent god or king and may move the viewer to tears and joy. The image stages the aura of imperial power and of divine presence; it both exposes and masks the absence at the heart of the subject and reconciles humanity to limitation. Douzinas argues that the blindness and insight represented by the aniconic and iconophilic traditions complement one another as two necessary moments in the creation of subjectivity. In modernity, the unrepresentable *Deus* whose imagoes reached all corners of the empire has been

replaced by sublime law, which, although invisible, can be known through its proliferating images. Going beyond Jay's call for a compromise seeing and unseeing justice, Douzinas argues that a full recognition of the aesthetic dimension of law opens the institution to the morality of otherness and the senses.

The essays in part 2, "The Law of Images," move on to consider the historically evolving relationship between law and the image and the close involvement of legal concerns and concepts in the creation and evolution of artistic genres. Taking up Douzinas's account of the Roman cult image, Georges Didi-Huberman formulates an institutional history of the portrait through an examination of the legal, aesthetic, and ethical differences between Pliny's and Vasari's histories of art. For Pliny, the origins of the image lie in the Roman imago: facial masks that inscribe ancestral features onto matter and, through resemblance, legitimize genealogical transmission, ritually supporting the claims of individuals to the status of citizen. The imago is an imprint, to be judged either just or unjust, legal or illegal; according to Didi-Huberman, it is governed by the law of resemblance and is beyond exchange. This juridical and anthropological conjunction of matter and ritual is contrasted with Vasari's academic ideals of portraiture and genre painting, which emphasize artistry, intellect, and style. For Vasari, the portrait is a work of art that must be judged accomplished or lacking in accomplishment, beautiful or ugly; the image is thus governed by the rules of connoisseurship and enters into the world of commodification.

Peter Goodrich considers one instance of the legal and aesthetic power of the portrait described by Didi-Huberman, analyzing the Tudor group portrait *Edward VI and the Pope*, which depicts a dying monarch, Henry VIII, passing power to Edward VI and his council. Goodrich focuses on the blank spaces in the painting—pages, bills, frames— which he regards as emblems of the Reformation's hostility to images. For him, these passages are signs asserting the inability of images to represent power and the primacy of the written word as the transmitter of the truth of a new, literal form of the law. But Goodrich sees a radical potential in these blank spaces and proposes an alternative reading in which justice is not known or judged in advance, but addressed in its singularity.

Part 3, "The Art and Architecture of Justice," examines the architectural and aesthetic organization of legal spaces, such as courtrooms. Piyel Haldar traces the elimination of the rhetorical category of the ornament in English common law and its reemergence in the architectural style of court buildings, where it serves to designate the special status of the courtroom. Haldar takes as his case study the Supreme Court of

Israel at Jerusalem, reading the organization of its internal and external spaces as a symbolic dialogue between identification and exclusion. Architectural ornament represents the affects of the law, the traces of its former rhetorical techniques. The visual spectacle of the edifice, argues Haldar, reconciles the individual to the force of the law.

The examination of spectacular rituals is continued in Katherine Fischer Taylor's study of the 1849 Festival of Justice, held in Paris to commemorate the aesthetics and politics of post-Revolutionary France. In a detailed historical reading of costumes, routes, and architectural space, Fischer Taylor argues that the festival staged a visual definition of modern justice as professional and autonomous and freed from associations with the absolute monarchy of the ancien régime. The design of the festival observed the needs of historical exigency; it adopted a feminized splendor with conventional signs of patriarchal power. By drawing judiciously on the attractions of artistry and ornament, it signified a new moderate, noncoercive force.

Jonathan Ribner examines how national identities in the nineteenth century were constructed around the representation of legal systems. He notes the English scorn for French justice and its claim to heritage and tradition. At the same time, however, there was a distrust of the legal profession that created difficulties for artists commissioned to celebrate the law. Drawing on examples from France and England, Ribner identifies a parallel between the discrediting of the law and a decline in the prestige of allegory. The forlorn allegorical painting in the lawyer's office in Dickens's *Bleak House* symbolizes this double fall from favor.

"Obscenity and Art," the fourth and final section of the book, turns to the crimes of art. It juxtaposes legal cases on obscenity with contemporary abject art and conceptions of legal and aesthetic connoisseurship. Lynda Nead examines the nature of the judgment involved in connoisseurship and the assumptions made about the integrity of the connoisseur. In the eighteenth and nineteenth centuries, obscene artifacts from Pompeii and sexually explicit literary texts constituted the extreme test for the connoisseur. The judgment of these cases created the boundaries between art and nonart, between the world of the mind and that of the body. This essay looks at the tensions within the category of the pure aesthetic gaze and the corruption of pure form when the corporeality of the viewer is invoked by the image. The transition from the particular appeal of vision to the implication of the other senses marks the moment of theorization of the corporeality of the viewing subject, of the troubled bodies on which artistic judgment might be said to hinge.

The move from contemplation to motivation, from the still image to active behavior, is also the subject of the essay by Mandy Merck.

Examining an attempted private prosecution of a play, *The Romans in Britain*, in England in 1980, Merck considers the way in which representations of homosexuality are caught up in the issue of the actuality of the represented act, rather than simply the obscenity or nonobscenity of the representation. The case reveals the confusion in liberal jurisprudence between material objects and signs, between sex and its simulation. Drawing on Judith Butler's account of speech acts, Merck calls for a more complex understanding within culture and the law of the relationship between representation and sexuality and of the interface between image and behavior.

The blurring of signs and behavior and the power of obscenity to disturb the category of art are also the subject of the essay by Hal Foster. Looking at instances of abject art in the 1990s, Foster considers the nature of obscenity's challenge to the individual and society, to art and law. According to psychoanalytic theory, vision—the gaze—fixes the subject in a double position in which s/he is both viewer and image. The subject may manipulate the gaze, but it is powerful and malevolent and may resist such taming. Within this account, art and aesthetic contemplation serve to placate and relax the viewer. Contemporary abject art, Foster argues, refuses this role of pacifying the gaze; it disrupts bodily and social ordering, dissolving categories such as inside and outside, the maternal body and paternal law. Through abjection, art undoes the law. But it is a compromised project that can easily become simply the drive to indistinction and an aestheticization of transgression. It still holds a truth, however, for abject art is the art of a broken social contract and a testimony against contemporary political power.

The contributors to this volume come from a variety of intellectual traditions and disciplines and draw on a range of different approaches to the interface of art and law. This in itself suggests the creative possibilities of exploring the relationship of aesthetics and legal history and theory. Authors have used history to examine theoretical issues and philosophy to understand history. This volume broaches many intellectual debates and raises as many questions as it provides answers; but this is in the nature of the project, which is to open up a field of study for further scholarship and to initiate international debate.

PART I

VISION AND LAW

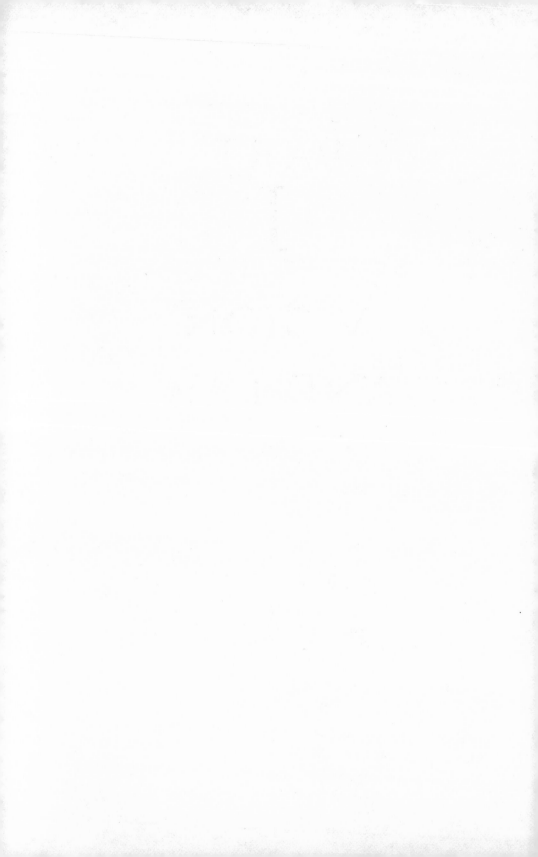

MUST JUSTICE BE BLIND?

THE CHALLENGE OF IMAGES TO THE LAW

Martin Jay

llegorical images of Justice, historians of iconography tell us, did not always cover the eyes of the goddess Justitia.[1] In its earliest Roman incarnations, preserved on the coins of Tiberius's reign, the woman with the sword in one hand, representing the power of the state, and the scales in the other, derived from the weighing of souls in the Egyptian Book of the Dead, was depicted as clear-sightedly considering the merits of the cases before her (fig. 1.1).[2] Medieval images of justice based on figures of Christ, Saint Michael, or secular rulers likewise provided them with the ability to make their judgments on the basis of visual evidence (fig. 1.2).

But suddenly at the end of the fifteenth century, a blindfold began to be placed over the goddess's eyes, producing what has rightly been called "the most enigmatic of the attributes of Justice."[3] Perhaps the earliest image showing the change is a 1494 wood engraving of a Fool covering the eyes of Justice, illustrating Sebastian Brant's *Narrenschiff* ("Ship of Fools"), which was rapidly reproduced in translations

This essay first appeared in *Filozofski vestnik* 17, no. 2 (1996): 65–81. © Filozofski inštitut ZRC SAZU; reprinted with permission.

1. O. E. von Möller, "Die Augenbinde der *Justitia*," *Zeitschrift für christliche Kunst* 18 (1905): 107–22, 141–52; Otto R. Kissel, *Die Justitia: Reflexionen über ein Symbol und seine Darstellung in der bildenden Kunst* (Munich: Beck, 1984); Dennis E. Curtis and Judith Resnik, "Images of Justice," *Yale Law Journal* 96, no. 8 (1987); Christian-Nils Robert, *La justice, vertu, courtisane et bourreau* (Geneva: Georg, 1993); Robert Jacob, *Images de la justice: Essai sur l'iconographie judiciaire du Moyen Age à l'âge classique* (Paris: Léopard d'Or, 1994).

2. Herman Bianchi, "The Scales of Justice as Represented in Engravings, Emblems, Reliefs and Sculptures in Early Modern Europe," in G. Lamoine, ed., *Images et répresentation de la justice du XVIe au XIXe siècle* (Toulouse: University of Toulouse-Le Mirail, 1983), 8.

3. Robert, *Justice, vertu*, 13.

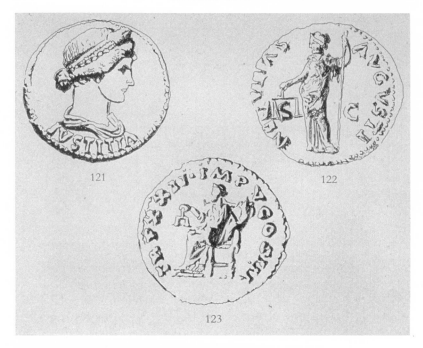

Figure 1.1: Roman coins dedicated to Justice and Impartiality. Justitia's sword is not yet in place in these images, which show her with a staff instead. *Upper left*, Dupondius of Tiberius, 22–23 A.D.; *upper right*, dupondius of Vespasian, 77–78 A.D.; *lower*, aureus of Marcus Aurelius, 168 A.D. Bibliothèque Nationale, Paris.

throughout Europe (fig. 1.3). Initially, as this engraving suggests, the blindfold implies that Justice has been robbed of her ability to get things straight, wield her sword effectively, or see what is balanced on her scales. Other medieval and Renaissance allegories of occluded vision, such as those of Death, Ambition, Cupidity, Ignorance, or Anger, were, in fact, uniformly negative. The figure of the nude child Cupid, as Erwin Panofsky pointed out many years ago, was depicted blindfolded not merely because love clouds judgment, but also because "he was on the wrong side of the moral world."[4]

By 1530, however, this image seems to have lost its satirical implication and the blindfold was transformed into a positive emblem of impartiality and equality before the law. Perhaps because of traditions transmitted by Plutarch and Diodore of Sicily from ancient Egypt that had

4. Erwin Panofsky, *Studies in Iconology: Humanist Themes in the Art of the Renaissance* (New York: Harper and Row, 1967), 109.

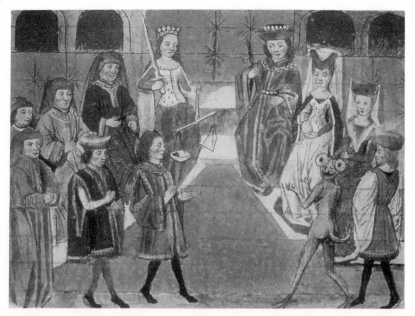

Figure 1.2: "The Eruption of Justice in Imaginary Causes: The Trial of Satan
and the Queen Ratio," from *The Book of the King Modus and of the Queen Ratio,*
fifteenth century. Library of the Arsenal, ms. 3080, fol. 103, xv. Bibliothèque
Nationale, Paris.

depicted judges as blind or handless, the blindfold, like the scales, came
to imply neutrality rather than helplessness. According to the French
scholar Robert Jacob, the explanation may also have something to do
with the reversal of fortunes experienced by the symbol of the Syna-
gogue in medieval Christian iconography.[5] Traditionally shown as
blindfolded—as well as with a broken lance—to symbolize her resis-
tance to the illumination of divine light, the Synagogue was nega-
tively contrasted with the open-eyed Church, as in the famous early–
fourteenth-century statue on the south gate of Strasbourg Cathedral
(fig. 1.4).

What had been a sign of inferiority was, however, dramatically re-
versed when the iconophobic Reformation took seriously the Hebrew
interdiction of images, the second of the commandments Moses
brought down from Mount Sinai. Now it was once again a virtue to
resist what Augustine had famously called the "lust of the eyes." A blind-
folded justice could thus avoid the seductions of images and achieve
the dispassionate distance necessary to render verdicts impartially, an

5. Jacob, *Justice, vertu,* 234 f.

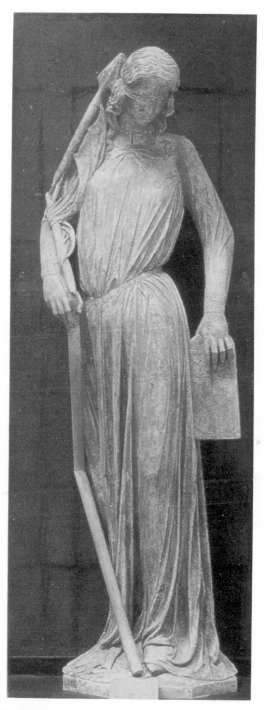

Figure 1.4: *The Synagogue*, sculpture on Strasbourg Cathedral, thirteenth century. Musée de Strasbourg.

argument advanced as early as the jurist Andrea Alciati's influential compendium of emblems, the *Emblemata* of 1531.[6] According to Christian-Nils Robert, this impartiality was required by the new urban, secular, bourgeois culture of the early modern period, which left behind the personalism of private, feudal justice. It was not by chance that many statues and fountains of blindfolded Justitia were placed in town squares in northern Europe next to newly erected civic buildings, in which a nascent public sphere was in the process of emerging.[7] Even in Catholic countries like France, where churches remained flooded with images, secular edifices began to grow more austere.

The law was now to be presented entirely in language and justice dispensed only through language rather than appearing in images, which might overwhelm through dazzlement. Along with the iconoclastic removal of artwork from courtrooms and illustrations from law books, at least in countries influenced by Reformation iconophobia, came the frequent robing of judges in sober black and white and the replacement of colorful seals by simple signatures on legal documents.[8] No longer would signs from heaven, like those informing medieval ordeals, be sufficient; now discussion and persuasion, men giving testimony about what they knew or had witnessed and then arguing about what rule might have been violated, would be required in most instances. That law was codified and preserved in written language that made frequent use of visual metaphors has been interpreted by some as reflecting the modern privileging of sight,[9] but the nonhieroglyphic script of Western languages meant that visual revelations of the truth, illuminations of divine will, were no longer relevant to the decision-making process. Along with the invisible "hidden God" of the Jansenists, who increasingly left the world to its own devices, went a justice that applied general rules and norms rather than looked for indications of divine dispensation. As with the later prohibition of laws referring to specific people with proper names, famously banned in the United States Constitution as "bills of attainder," so too the interdiction on images was designed to thwart favoritism or personal vengeance. With

6. Andreas Alciatus, *Emblemata cum Commentariis* (New York: Garland, 1976).

7. Robert, *Images de la justice*, 37 f.

8. Bernard J. Hibbitts, "Making Sense of Metaphors: Visuality, Aurality, and the Reconfiguration of American Legal Discourse," *Cardozo Law Review* 16, no. 2 (December 1994), 255–56. Hibbitts interprets these changes in terms of the ascendancy of an abstract, Cartesian visuality over the more concrete variant that reigned in the Middle Ages.

9. Ibid., 241. Hibbitts, however, acknowledges that in the early modern period, when most people were still illiterate, texts were meant mainly to be read aloud rather than silently (256).

the blindfolding of Justitia, we are well along the road to the modern cult of the abstract norm in juridical positivism.

If that road is paved with the prohibition of concrete images, we have to ask, however, whether building it had hidden costs that we may still be paying. It is precisely this question that will occupy us in what follows. One place to begin is with Max Horkheimer and Theodor Adorno's celebrated accusation, in the *Dialectic of Enlightenment*, that the modern notion of justice was still beholden to a mythic assumption: the fetish of equivalence, the desire for perfect commensurability, the domination of the exchange principle.

> For mythic and enlightened justice, guilt and atonement, happiness and unhappiness were sides of an equation. Justice is subsumed in law. . . . The blindfold over *Justitia*'s eyes does not only mean there should be no assault on justice, but that justice does not originate in freedom.[10]

Unexpectedly, in light of the Frankfurt School's often-remarked embrace of the Jewish taboo on idolatrous images as a mark of resistance to prematurely positive utopian thought, Horkheimer and Adorno here register a protest against the banishment of images. They cryptically associate preservation of the ability to see with freedom, a freedom that is threatened when justice is reduced to law. What, it has to be asked, is this freedom which the blindfolding of Justitia denies? How does the reduction of justice to law threaten its very existence?

One explanation, suggested by the famous argument in favor of the Greek regulation of images developed by Gotthold Lessing in *Laocoön*, his classical treatise on aesthetics, has drawn the critical attention of W. J. T. Mitchell in his influential study of images, texts, and ideologies, *Iconology*.[11] According to Lessing, images should be kept under legal control because of their capacity to depict monsters, indecorous amalgams of the human and the divine or the bestial that are a scandal to the alleged order of nature. Mitchell interprets Lessing's iconophobia as symptomatic of an anxiety over proper sex roles and adulterous fantasies, but it might just as plausibly indicate a fear of boundary transgression in general, especially with regard to the boundaries that define and circumscribe our bodies. Lessing's visual monsters are an affront to the law because they depart from the assumption that all the particulars of the world can be subsumed under the bounded categories we use to

10. Max Horkheimer and Theodor W. Adorno, *Dialectic of Enlightenment*, trans. John Cumming (New York: Continuum, 1972), 16–17.

11. W. J. T. Mitchell, *Iconology: Image, Text, Ideology* (Chicago: University of Chicago Press, 1986), 108 f.

order it. The image of a hybridized creature, at once man and beast, divine and human, male and female, confounds our reliance on conceptual subsumption by refusing to exemplify a general rule.

The freedom of which Horkheimer and Adorno speak is thus the ability of the particular, the unique, the incommensurable, the improper to escape from the dominating power of the exchange principle that is manifested in universalizing concepts and in the reduction of justice to the law of equivalents. To produce this reduction, the eye, by far the most discriminating of the sense organs in its ability to register minute differences, must be closed. Justitia's vision is veiled to maintain the fiction that each judgment brought before her is a "case" of something more general, equivalent to other like cases and subsumable under a general principle. That principle, applied without regard for circumstantial uniqueness, is understood to hover somewhere above specific cases, recalling the origin of the word *justice* in the Latin *iubeo* ("to command"). This is a version of justice, as Vassilis Lambropoulos has recently pointed out, that can be understood as "the right command, the command that rightfully deserves obedience. What is right is what is decreed as straight, the line of the ruler and the regime directing from above, the regal control, the reign of the supreme direction. . . . 'Justice' comes from above, from the realm of certainty."[12] It is thus unlike the Greek notion of *dike*, which in certain of its acceptations involved a dynamic, polemical balance between contraries, an agonistic ethos based on proportion and analogy that could not be subsumed under a single nomos or law.[13]

Achieving this effect of regal control required not merely a blindfold, but a blindfold placed over the eyes of a specifically female deity. Granted, as Christian-Nils Robert has argued, Justitia may be a somewhat androgynous figure, at least to the extent that she wields a powerful symbol of coercive authority, a sword fit for swift decapitations.[14] Traditional religious iconography had, in fact, permitted women the use of the sword only infrequently, the most notable instance being Judith, the slayer of Holofernes, in the Hebrew Bible. The stern and vaguely menacing statues of Justitia in front of the palaces of justice in early modern Europe were certainly a far cry from the maternal images

12. Vassilis Lambropoulos, "The Rule of Justice," *Thesis Eleven*, no. 40 (1995): 18.

13. See the entry on "Dike" in F. E. Peters, *Greek Philosophical Terms: A Historical Lexicon* (New York: New York University Press, 1967). For more sustained discussions, see Eric Havelock, *The Greek Concept of Justice: From Its Shadow in Homer to Its Substance in Plato* (Cambridge, Mass.: Harvard University Press, 1978); Michael Gagarin, *Early Greek Law* (Berkeley: University of California Press, 1986).

14. Robert, *Justice, vertu*, 65 f.

of the forgiving, mediating Madonna that populated so many medieval churches. Nor were they reminiscent of so many sainted, suffering female martyrs, whose assigned role was that of passive victim bearing witness to her faith. One might indeed detect a greater symmetry between the blindfolded criminal condemned to die and the image of blindfolded executioner.[15] As a result, Justitia may plausibly be interpreted as a symbol of the very temporal power, firmly in male hands, that sought to displace the spiritual power that had accrued to the cult of Mary in the late Middle Ages. The source of this allegory, after all, was in neoclassical images with martial overtones, not religious ones.

And yet it must be acknowledged that blindfolded Justitia, with all of her warlike attributes, was primarily a female figure, as had been the Egyptian Maat (goddess not only of justice but of truth and order) and the Greek Dike, a daughter of Zeus. Male images of divine justice, such as that of God at the Last Judgment or that of Saint Michael, had not been prevented from exercising the power of vision. Solomon, famously, could see how the two contesting women felt about dividing the child each claimed as her own. What was the implication of preventing a female judge from seeing? What power might still lurk beneath her blindfold, which, after all, does not permanently rob the goddess of her sight?

What that power may be is suggested by the traditional reading of an image from a slightly later era, Jan Vermeer's *Woman Holding a Balance* of 1664 (fig. 1.5). Depicted in front of a picture of the Last Judgment, thought to be by Cornelisz Enhelbreecht, the woman, with delicate scales in her hands, appears to be looking soberly and carefully at the pearls in each tray, as if contemplating their individual value. Whether she is actually doing so is a question to which I will return. But whatever the target of her gaze, there is no trace of judgmental harshness or vindictiveness in her visage; indeed these seem to be traits Vermeer was incapable of depicting. As with the souls being judged in the scene behind her, each pearl, that precious object mirroring the world around it, so often at the symbolic center of Vermeer's blissfully serene paintings, seems to merit careful, deliberate scrutiny. The setting, moreover, is a typical Vermeer interior, a private, intimate, humble realm, far from the public space of the early modern statues of Justitia.

The goddess's gender as mediated by this comparison with Vermeer's painting is relevant here if we recall the contrast between male and female variants of moral reasoning posited by feminists like Carol Gilligan and Seyla Benhabib against moral theorists like Lawrence

15. For a comparison, see ibid., 92.

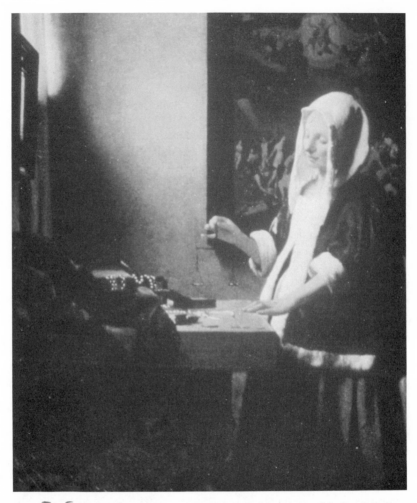

Figure 1.5: Jan Vermeer, *Woman Holding a Balance*, 1664. National Gallery of Art (Widener Collection), Washington, D.C.

Kohlberg and John Rawls.[16] Whereas male judgment tends to be abstractly universalist, decontextualized, and formalistic, its female counterpart, they tell us, is more frequently sensitive to particular detail, narrative uniqueness, and specific context. Instead of acknowledging only an imagined "generalized other," it focuses on the actual "concrete other" before it. The blindfolding of Justitia is thus not a thwarting of

16. Carol Gilligan, *In a Different Voice: Psychological Theory and Women's Development* (Cambridge, Mass.: Harvard University Press, 1982); Seyla Benhabib, *Situating the Self: Gender, Community and Postmodernism in Contemporary Theory* (New York: Routledge, 1992).

the gaze per se, but of the specifically female gaze, or at least of those qualities that have been associated with it in our culture.[17] It is, thus, ultimately in the service of the disembodiment, disembeddedness, and decontextualization that a legalistic justice based on the reductive equivalence of the exchange principle requires.

The victory of what has recently been dubbed "algorithmic justice"[18] because it involves following binding rules normally decreed from above is, to be sure, substantially modified in a legal system such as the Anglo-American, in which concrete precedent is often as important as statute as the basis for judgment. Kant's well-known contrast between reflective and determinant judgments, the former applied to aesthetic issues, the latter to cognitive and moral ones, might be invoked to justify the paradigmatic value of prior specific examples over abstract rules. But the law of precedent still presupposes at least analogical commensurability from case to case. Even reflective judgments, after all, draw on the presumption of a *sensus communis*, a shared sentiment that goes beyond idiosyncratic taste. If not by subsumption, then by analogy, what is different is somehow compelled to become similar. In addition, the common law of precedent can be said to collapse the temporal difference between past and present in its search for a replicable standard of measurement.

Although images can themselves be the object of such judgments, their initial, brute impact on the beholder's sense of sight may well precede any evaluation, reflective or determinant, of their meaning. Even Kant's a priori categories do not, after all, include a necessary mechanism of cultural, symbolic commensuration. If Horkheimer and Adorno are right, mute visuality retains traces of a mode of interaction between humans and the world that is prior to conceptual subsumption or the rule of common sense, a mode they call mimetic. This is not the

17. Hibbitts cites certain feminist scholars who claim that the power of the gaze is inherently male, whereas women's culture is more aural, and uses their arguments to buttress his claim that at least the American legal order until only recently was both ocularcentric and phallocentric ("Making Sense of Metaphors," 267). I would qualify this generalization to the extent that a female gaze is not a contradiction in terms; it is in fact precisely its occlusion that may be complicitous with the type of visual regime that Hibbitts shows dominated American legal theory. That is, without essentializing gender differences, there may be a link between realizing the abstracting potential in vision and patriarchal domination, which functions by repressing the more concretizing alternative latent in the "female gaze" denied Justitia.

18. Alan Wolfe, "Algorithmic Justice," in Drucilla Cornell, Michel Rosenfeld, and David Gray Carlson, eds., *Deconstruction and the Possibility of Justice* (New York: Routledge, 1992). Wolfe criticizes it for having a lack of appreciation for "the rule-making, rule-applying, rule-interpreting capacities of human beings and an emphasis instead on the rule-following character" (366).

place to launch a full-fledged analysis of the vexed concept of mimesis in their work, an analysis I have tentatively attempted elsewhere.[19] Suffice it to say that they understand mimesis to involve a nondominating relationship between subjects and objects, in which the world is not "subjected" to categorical determination or even intersubjective consensus. Mimesis entails a relatively passive affinity between perceiver and perceived rather than hierarchical control by one over the other. Affinity, it should immediately be noted, does not mean identity or equivalence, as a certain, irreducible difference between subject and object is maintained. Insofar as images and their referents, representations and originals, perceptions and objects may be similar but not ontologically identical, they resist the full power of the exchange principle. Thus the image need not be of an unnatural monster to do its work of resistance; it need merely evoke the primal power of mimetic affinity, which acknowledges differences even as it seeks similarities, against the counterpower of conceptual subsumption, which seeks to suppress the remainder left behind in the act of subsuming.

What ultimately distinguishes mimetic from conceptual behavior, according to this argument, is the absence of violence in the former, the symbolic violence, that is, of categorical subsumption, which finds an echo in the potential for literal force heard in the phrase "to enforce the law." Justitia, it should be remembered, is never depicted without her unsheathed sword.[20] As Jacques Derrida has recently pointed out in his meditation on Walter Benjamin's famous essay "Critique of Violence," there may well be a moment of originary violence or brute force in the foundation of even the most legitimate of laws: "Applicability, 'enforceability,' is not an exterior or secondary possibility that may or may not be added as a supplement to law," he writes. "It is the force essentially implied in the very concept of justice as law."[21] Here we detect an echo of the argument from Horkheimer and Adorno's *Dialectic of Enlightenment*: that algorithmic justice, justice reduced to a law of equivalence based on the subsumption of individual cases under a general rule, involves violence and restricts freedom. A different justice that

19. Martin Jay, "Mimesis and Mimetology: Adorno and Lacoue-Labarthe," in *Cultural Semantics: Keywords of Our Time* (Amherst: University of Massachusetts Press, 1998).

20. This raises the question of the status of images or representations of violence (or threatened violence, as in the case of the brandished sword). If they are understood as more mimetic than conceptual, does this mean that the violence in them is modified or even canceled? Or can images participate in another kind of violence beyond that of subsumption? For a consideration of this theme, see Paul Crowther, "Violence in Painting," in *Critical Aesthetics and Postmodernism* (Oxford: Oxford University Press, 1993).

21. Jacques Derrida, "Force of Law: The 'Mystical Foundation of Authority,'" in Cornell, Rosenfeld, and Carlson, *Deconstruction and the Possibility of Justice*, 5.

would evade the binding force of the algorithm would follow the logic of the gratuitous gift, bestowed without an expectation of reciprocity, rather than that of the debt paid to settle a score, the primitive act of vengeance that Nietzsche famously saw at the root of modern notions of exchange.[22] It would be incalculable, impossible to capture in definitions, irreducibly aporetic, perhaps even dangerously mad. Always either a memory of what may have been or a hope for a future that can perhaps be but never actually is, it haunts the project of justice in the present, a justice based on blinding itself to the absolute alterity of each of its alleged cases, a justice reduced to nothing but positive, formal, abstract law. This imagined justice is the basis not only of religious notions of divine justice but of every defense of a revolutionary "political justice" that claims the right to suspend the prevailing laws of a system it deems unjust.[23]

But both dialectical and deconstructionist modes of thinking, as we know, resist simple binary oppositions, and so this overly abstract dichotomy must itself be shaken. Allegedly nonviolent gratuitous justice based on respect for particularity and the benign mimesis of nature cannot be entirely separated from the putatively sinister, coercive force of law as command from above. In "Critique of Violence," Benjamin had in fact juxtaposed a divine violence, which destroys laws and transgresses boundaries, to a mythical one that makes and conserves them.[24] Although he cryptically described the former as "lethal without spilling blood,"[25] the troubling implication was that a justice beyond the law of formal equivalence, the life-affirming justice of absolute qualitative singularity based on the logic of the gift, was not itself beyond coercion. For without any rules or criteria, what was to prevent a soi-disant divine justice from descending into nothing more than the principle "might makes right." As Derrida himself uneasily concludes, "in one form or another, the undecidable is on each side, and is the violent condition of knowledge or action."[26]

22. Friedrich Nietzsche, *The Birth of Tragedy and the Genealogy of Morals*, trans. Francis Golfing (Garden City, N.Y.: Doubleday, 1956).

23. For a classic account of the dilemmas of political justice, see Otto Kirchheimer, *Political Justice: The Use of Legal Procedure for Political Ends* (Princeton: Princeton University Press, 1961). For a more recent discussion, which considers Kirchheimer's position with relation to Carl Schmitt, see William E. Scheuerman, *Between the Norm and the Exception: The Frankfurt School and the Rule of Law* (Cambridge, Mass.: MIT Press, 1994).

24. Walter Benjamin, "Critique of Violence," in *Reflections: Essays, Aphorisms, Autobiographical Writings*, ed. Peter Demetz (New York: Harcourt, Brace, Jovanovich, 1978), 297.

25. Ibid., 297.

26. Derrida, "Force of Law," 56. At the end of his piece, Derrida acknowledges the frightening potential for Benjamin's attraction to divine violence, an annihilating, expia-

Similarly, Horkheimer and Adorno were never willing to pit mimetic affinity against conceptual reflection as if they were simple opposites, one the locus of freedom, the other of repression. Discussing the residue of mimetic behavior that can be found in the work of art in his *Aesthetic Theory*, Adorno wrote,

> The desideratum of visuality seeks to preserve the mimetic moment of art. What this view does not realize is that mimesis only goes on living through its antithesis, which is rational control by art works over all that is heterogeneous to them. If this is ignored, visuality becomes a fetish.[27]

In art, he argued, it was important to avoid the either/or of sensuality versus spirituality, which simply repeats the alienation characteristic of modern life. Instead, the paradoxical mixture of the two must be preserved, for what lurks behind the false synthesis called aesthetic vision is a rigid polarity between spirit and sensuality, which is inadequate. At the center of the aesthetic of vision is the false, thinglike notion that in the aesthetic artifact tensions have been synthesized into a state of rest, whereas in fact those tensions are essential to the work.[28]

If we return to our point of departure, the blindfolding of Justitia, we can now understand that it was perhaps not entirely without reason that vision was denied even to a female gaze in the name of impartiality and the banishment of monsters. Like the other "fools" in medieval tales, who often speak a higher truth, the fool who blindfolds the goddess on Sebastian Brant's ship may have known what he was doing. For like the false synthesis of the aesthetic artifact, a practice of judgment based solely on the power of an immediate visual apprehension of irreducible singularity risks succumbing to the illusory potential that always accompanies sensual perception, however acute.

There is another powerful justification for the allegorical image of the blindfold. Because her eyes are covered, Justitia must walk cautiously into the future, not rushing headlong to judgment.[29] Vermeer's open-eyed woman with a scale can be shown without a blindfold be-

tory violence, to become a perverted justification for the Holocaust. For differing opinions of how successful Derrida himself has been in thwarting this potential, see Dominick LaCapra, "Violence, Justice, and the Force of Law," *Cardozo Law Review* 11, nos. 5–6 (1990): 1065; Drucilla Cornell, *The Philosophy of the Limit* (New York: Routledge, 1992), chap. 6; and Gillian Rose, *Judaism and Modernity: Philosophical Essays* (Oxford: Blackwell, 1993), chap. 7.

27. Theodor W. Adorno, *Aesthetic Theory*, trans. C. Lenhardt, ed. Gretel Adorno and Rolf Tiedemann (London: Routledge Kegan Paul, 1984), 141.

28. Ibid., 143.

29. This metaphor of blindfolded Justice walking cautiously is taken from M. Petitjean, "Un homme de loi semurois: L'avocat P. Lemulier," *Annales de Bourgogne* 57:245, cited in Robert, *Justice, vertu*, 130.

cause her judgment is allegorically linked to that of the Last Judgment in the canvas depicted behind her. But a secular judgment that is anything but the last, a justice of mere mortals, cannot pretend to possess so clear a vision of whose soul merits salvation and whose does not. It must acknowledge that imperfect general laws and the concrete judgments of those who apply them somehow always fall short of an absolute and final justice, and yet that both are necessary means in the endless struggle to realize that unrealizable goal.

Such judgment must furthermore acknowledge that even the most comprehensive notion of justice contains within it a pluralism of distinct logics, which may sometimes be in conflict.[30] Procedural notions of justice within an established order, those that subordinate it to positive law, are likely to be in tension with compensatory, distributive, restitutive, and retributive alternatives that may well point beyond that order. A justice that remembers and tries to redress the wrongs of the past and one that hopes to create a truly just society in the future can easily be at odds with formal procedures in the present, as any observer of the heated debate over affirmative action in the United States can well attest. Rather than a single overarching criterion, there may be several that cannot be perfectly reconciled, but this does not mean that it is better to throw out general considerations altogether and judge decisionistically.

Unexpectedly, this point is suggested in visual terms by the Vermeer painting discussed earlier as an example of a benign woman's gaze at concrete particulars. Recent microscopic analysis has revealed that the highlights on the scales are not painted with the pigments Vermeer used elsewhere in the canvas to depict either pearls or gold. What shines is apparently only the light reflecting off the trays, which are empty.[31] Rather than being directed at individual cases, the woman's contemplative gaze, we now appreciate, falls on the apparatus itself, as if she were weighing its merits as an impartial mechanism of fairness.

A justice that tries to see only concrete, contingent, incommensurable particularity and to judge without any abstract prescriptive criteria whatsoever—such as that defended by Jean-François Lyotard in *Just Gaming*[32]—may paradoxically be as blind as one that pretends to be entirely algorithmic. What is needed, as Adorno points out in the case

30. On this issue, see Michel Rosenfeld, "Restitution, Retribution, Political Justice and the Rule of Law," *Constellations* 2, no. 3 (January 1996): 309–32.

31. Arthur J. Wheelock Jr. and Ben Broos, *Johannes Vermeer* (New Haven: Yale University Press, 1996), 141–42.

32. Jean-François Lyotard and Jean-Loup Thébaud, *Just Gaming*, trans. Wlad Godzich (Minneapolis: University of Minnesota Press, 1985).

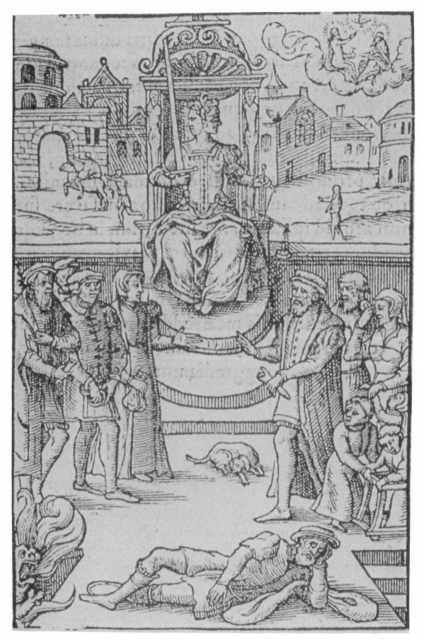

Figure 1.6: Justice with two faces, one veiled, the other with eyes open, frontispiece of J. de Damhoudere, *Praxis rerum civilium* . . . (Anvers, 1567). Bibliothèque Nationale, Paris.

of aesthetic judgment, is a creative tension between the two, a justice that can temper the rigor of conceptual subsumption, or several such subsumptions, with a sensitivity to individual particularity. The unresolvable paradox of the relationship between law and justice, as the Slovenian philosopher Jelica Šumić-Riha has recently argued, may, in fact, require a certain measure of blindness. "We know," she writes,

> that law as such is not and cannot be just. However, if we accept that and behave according to this knowledge, we will have lost not only justice, but also law. Law is namely conceived as an instance that appeals to justice which means that a law that does not refer to justice is simply not a law. It is therefore in some way necessary to blind ourselves to this knowledge. In Derrida's terms: even if justice cannot be reduced to rule-governed activity we must respect rules. We must respect them because in the very undecidability of justice on the one hand and the groundlessness of law on the other lies the danger that the right to do justice can be usurped by bad legislators.[33]

Perhaps it is best, therefore, to imagine the goddess Justitia neither as fully sighted nor as blindfolded, but rather as she was depicted in the mid–sixteenth century, at the threshold of the modern world, in the frontispiece to J. de Damhoudere's *Praxis rerum civilium:* as a goddess with not one face, but two. The first has eyes that are wide open, able to discern difference, alterity, and nonidentity, looking in the direction of the hand that wields her sword, while the second, facing the hand holding the calculating scales of rule-governed impartiality, has eyes that are veiled (fig. 1.6). For only the image of a two-faced deity, a hybrid, monstrous creature that we can in fact see, an allegory that resists subsumption under a general concept, only such an image can do, as it were, justice to the negative, even perhaps aporetic, dialectic that entangles law and justice itself.

33. Jelica Šumić-Riha, "Fictions of Justice," *Filozofski Vestnik* 2 (1994): 80.

PROSOPON AND ANTIPROSOPON

PROLEGOMENA FOR A LEGAL ICONOLOGY

Costas Douzinas

I n 626 A.D., the emperor Heraclius left Constantinople, the capi-
tal of the Byzantium, for a military campaign against the Per-
sians. During his absence, the Slav nation of the Atars attacked
and besieged the city. The patriarch Sergios, who had been entrusted
by Heraclius with the city's safety, appealed to the Virgin as protector
of the city and general of its armies.

> On all the gates of the city, whence the monstrous brood of darkness
> came, the venerable patriarch had painted, like a sun that drives away the
> darkness with its rays, images of the holy figures of the Virgin with the
> Lord her son on her arm, and cried with a terrible voice to the masses
> of the barbarians and their demons. "You wage war against these very
> images . . . but a woman, the Mother of god, will at one stroke crush
> your temerity and assume command, for she is truly the mother of him
> who drowned Pharaoh and his whole army in the Red Sea.[1]

And when, through the intercession of Mary, her son had given victory
to the faithful, the patriarch rushed again to the city walls and held up
to the enemies "*to phrikton eidos tes graphes tes agraphou* [the terrifying
form of the unpainted icon] . . . showing the enemy its *antiprosopon*
[nonface, or opposite of the face, *prosopon*]."[2] But the miraculous icons

1. Theodore Synkellos, "Sermon on the Siege of Constantinople in 626," in *Acta
Universitatis de Attila Jozsef nominatae*, Acta antiqua et archaeologica 19, Opuscula byz. 3
(Ferenc Makk ed., Szeged, 1975), 74–96 (Greek text), 80.
2. George the Pisidian, *Bellum Avaricum*, in Agostino Pertusi, *Giorgio di Pisidia Poemi*,
vol. 1, *Pengerici Epici* (Studie Patristica et byzantina 7, Ettal 1960), 176 ff. Pisidian's poem
to the Virgin has been anthologized in Hans Belting, *Likeness and Presence*, trans. Edmund
Jephcott (Chicago: University of Chicago Press, 1994), appendix, 497.

did not just save the city from the siege. Heraclius had taken with him in the campaign against the Persians the "divine and venerable figure of the nonpainted image [*morphen tes graphes tes agraphou*]. The Logos, which forms and creates all, appears in the icon as a form without painting [*morphosin aneu graphes*]." And when the emperor rose to address his army before the battle, he "took the awesome image [*phrikton apeikonisma*] of the figure painted by God in his hand and spoke briefly. This one (not I) is the universal emperor and lord and general of our armies."[3]

Such uses of icons are not unprecedented. Cult images existed throughout the Greco-Roman period. They often became symbols of social identity and a community's ideal and were given protective roles and responsibilities for the security and prosperity of the city. The Trojan *palladium* was such a heavenly image. It was kept hidden in its cella and, as it guaranteed the safety of the city, it had to be stolen before the Greeks could take Troy. Many Greek cities fought to acquire it; after its capture, according to legend, it was taken to Rome and later to Constantinople, where Constantine, who established the Christian empire, hid it under the famous column bearing his statue. The *palladia* were kept hidden and punished those who dared to see them. Such icons were often called *diipeteis*, "sent (literally, thrown) by Zeus." Cicero describes the miraculous image of Ceres in similar terms. It was *non humana manu factum, sed de caelo lapsam.*[4] A few centuries later the protective qualities of the miraculous image had been transferred fully to the *acheiropoietoi* ("not painted by the human hand") icons of Christ and his mother, the veronicas or holy shrouds so vividly presented by the seventh-century chroniclers.[5]

The supernatural powers of cult icons are simply an extension and exaggeration of the peculiar qualities of all images. Images give visual form to invisible powers and make present what is absent and cannot be represented. Regis Debray has argued that the birth of the image is linked with death.[6] Death turns the mind from the visible to the invisible, from the temporary to the eternal, from the material to the spiritual. Archaic images adorn graves and mausoleums; they are an attempt to defy the trauma of loss and soothe the sadness of mourning. By painting the image of the departed, in death masks, on mummies, in funereal sites, or as Roman imagoes, a double or replica is created and death is

3. George the Pisidian, *Expeditio Persica*, in Pertusi, *Giorgio di Pisidia Poemi*, 84 ff.; Belting, *Likeness and Presence*, 497.

4. Belting, *Likeness and Presence*, 55.

5. Robin Cormack, *Painting the Soul* (London: Reaktion, 1997), passim.

6. Regis Debray, *Vie et mort de l'image* (Paris, Gallimard, 1992), 26.

defied. The first ritual images of the Greeks were called *eidola*. The original Greek meaning of *eidolon* is the double, the replica of an object.[7] Archaic eidola refer to dream images, to apparitions and visitations sent by the gods and to the phantoms or ghosts of the dead. The simulacrum of the dead who visits the living as a ghostly double is called the *psyche*.[8] In the famous opening scene of the *Iliad*, the psyche of Patroclos visits Achilles and pleads with him to rejoin the battle against the Trojans. At the end of their conversation, "Achilles held out his arms to clasp the spirit but in vain. It vanished like a wisp of smoke and went gibbering underground." Achilles "leapt in amazement. He beat his hands together and in his desolation cried: 'Ah then, it is true that something of us does survive even in the Hall of Hades.'"[9] In the economy of the eidolon, the image is the double of its object, at times almost identical with it. It shares not only its shape, color, and form but also its voice, life, and soul, all its ontological qualities except for its material existence. It can be seen but cannot be touched. The phantasm or idol brings back to vision and imagination the invisible, it brings the absent to temporary presence.

These attitudes toward images indicate a permanent theme in the theory of the icon that crosses the ontological divide, inaugurated by Plato, between representation and its object. Images speak directly to the senses and affect the psyche, they address the labile elements of the self and avoid the calming intervention of *logos*, language, and reason. This extraordinary power of the image is an established theme in classical religion and culture well before Christianity. Genesis records that Jacob's cattle had produced striped and spotted offspring when exposed to colored rods during conception.[10] The church father Theodore the Studite, in his early defense of images, repeats and humanizes the claim: a woman who saw a black man during her pregnancy delivered a black child.[11] If these stories sound unbelievable, a more consistent line links imagery and dreams with strong emotion and erotic or sexual arousal. Artemidorus claims in his *Interpretation of Dreams* that it made no difference if one saw "Artemis [Diana] herself . . . or her statue" in a dream,

7. Jean-Pierre Vernant, "The Birth of Images," in Froma Zeitlin, ed., *Mortals and Immortals: Collected Essays* (Princeton: Princeton University Press, 1991), 165–85.

8. John Brenner, *The Early Greek Concept of Soul* (Princeton: Princeton Univerity Press, 1983), 78–79; Vernant, "Psyche: Simulacrum of the Body or Image of the Divine," in *Mortals and Immortals*, 186–92.

9. *The Iliad*, trans. E. V. Rieu (Harmondsworth: Penguin, 1950), bk. 23, p. 72 ff.

10. Genesis 30:37–41.

11. Theodore of Studion, quoted in Karl Morrison, *I Am You* (Princeton: Princeton University Press, 1988), 282.

because statues had the same effect "as if Gods were appearing in the flesh."[12] Pagan households, according to Gregory of Nyssa and Clement of Alexandria, had pictures of Aphrodite in erotic embrace and other lewd subjects on their bedroom walls, which were used to invigorate their users' erotic appetites and embraces.[13]

The great eighteenth-century art critic Lessing takes up these themes and links them with the classical beliefs. For Lessing, images create illusions because their vividness and presence give them strange powers. These may be used both to create beautiful men and nations and to defy nature. Modern artists, Lessing believes, do not consider the depiction of beauty as their main aim, and a type of art has developed that consists in the "wanton boasting of mere skills, not ennobled by the intrinsic worth of their subject."[14] At that point, Lessing digresses from the beautiful men and beautiful statues of Greece to the moderns for whom "the susceptible imagination of the mother seems to express itself only in monsters" and explains the detour by citing a recurrent mythical theme. Mothers of a number of heroes, including Alexander the Great, Scipio, and Augustus, dreamt during their pregnancies that they had intercourse with a serpent. Lessing explains that serpents were emblems of divinity and were commonly presented in statues and images of Bacchus, Apollo, Hermes, and Hercules. These pious and honorable women would have been "feasting their eyes upon God during the day" and as a result the adulterous fancy of the snake would visit them in their dreams.

The third century rhetor Quintilian writes that "what the Greeks call *phantasiai*, we call *visiones*, imaginative visions through which the images of absent things are represented in the soul in such a way that we seem to discern them with our eyes and to have them present before us."[15] Quintilian provides the link between archaic idols and faculty psychology and alerts us to an original attitude toward the imaginary, both images and imagination, that differs radically from Platonic mimesis. During the Byzantine iconoclasm, the iconoclasts mobilized earlier antipagan arguments against the followers of holy icons. In response, the iconophiles adopted implicitly the pagan position, affirming the affective power of images but changing their intent. While pagan illustra-

12. Artemidorus of Daldis, *Das Traumbuch*, ed. K. Brackertz (Munich, 1979), 163–64; quoted in Belting, *Likeness and Presence*, 37.

13. Clement of Alexandria, *Exhortation to the Greeks* (London: Loeb, 1963), 136–38.

14. Gotthold Lessing, *Laocoön: An Essay on the Limits of Painting and Poetry*, trans. E. A. McCormick (1766; Baltimore: Johns Hopkins University Press, 1984), 13 ff.

15. Quintilian, *Institutio Oratoria*, trans. H. Butler (London: Heinmann, 1922), 6.2.29.

tions, private and public, were meant to arouse passions and erotic de-
sire, the iconophile Christians believed a more pious love could be
created through the contemplation of holy icons.

From the archaic Greek eidola to the *visiones* of Quintillian to the
dream visitations of Artemidorus and Lessing to the cult icons of the
Church and virtual reality of the moderns, a persistent link can be traced
between desire and the image. Improper and holy images, snakes and
serpents as well as pious and saintly icons, imprint themselves on suscep-
tible imaginations and lead people either to sin, adultery, and unnatural
couplings or to holy life and spiritual and political salvation. This essay
explores the role of law in this articulation of imagery with desire.

An Excursus on the Theology of the Icon

In Plato's theory of mimesis, the psyche is no longer the ghostly double
of the dead but a living part of the person, while the fascinating and
bewitching aspects of the eidolon are now attributed to all images. The
image becomes an idol in the modern sense. It deludes and passes for
what it is not. The image is the copy of a prototype; it resembles the
form and shape of its model and is therefore false. In the *Timaeus*, Plato
defines the image as other from its model: "For an image, since the
reality, after which it is modeled does not belong to it, and it exists ever
as the fleeting shadow of some other, must be inferred to be another."[16]
The image has no reality other than its likeness to what it is not, the real
thing whose nature it feigns. A purely visible or sensible phenomenon, it
feigns the substance of its model and has a radically different ontological
status. In the dialectic of same and other, the eidolon shares the onto-
logical status of the model, working on the axis of absence and presence,
while the icon or image is ontologically different from its representatum
and therefore false, untrue, and fictive.

The great aniconic traditions in the West—the Jewish, Muslim, and
Christian iconoclasts—base their prohibition of images on philosophi-
cal arguments around these two forms of the dialectic of the same and
the different. It is no coincidence that the Bible places two key laws
about imagery at the center of the law. According to Genesis 1:26–27,
man is made in the image and likeness of God; he is the *Imago Dei*. But
Exodus places at the beginning of the Law the Second Commandment,
which proscribes graven images. The prohibition often has been inter-
preted only in relation to divine images, but its import is much more
general; man is banned from making "graven images, or any likeness

16. Plato, *Timaeus*, trans. H. D. P. Lee (Penguin ed., 1971), 52c.

of anything that is in heaven above, or that is in the earth beneath, or that is in the water under the earth." According to Maimonides, "the first intention of the law as a whole is to put an end to idolatry,"[17] a sentiment echoed by one of the early Christian apologists, Tertullian, who saw idolatry as the "principal crime of the human race, the highest guilt charged upon the world."[18] David Hoffman, a nineteenth-century rabbi, writes that "what was written on those tablets was exclusively the proscription of idolatry," and a contemporary commentator adds that to follow the Torah is simple: "It suffices to proscribe idolatry."[19] God speaks through the law and addresses the ear, he is visible only through the written word. Any image of divinity in the shape of a human body is condemned therefore as pagan idolatry.

Despite differences of nuance and detail, the prohibition of idolatry is justified on two grounds: First, worshiping images of gods turns these images into fetishes. The god is replaced by the material object because the idol takes on the qualities of the entity represented. Fetishism entails forgetting that an icon represents an invisible object or power and turns it instead into an autonomous object of veneration. The principal problem is not so much the impossibility of representation of invisible and supernatural powers but the wrongful worshiping of human artifacts, which is presented as a sexual sin. The main image used by the prophets to condemn idolatry shows God as a jealous husband whose wife, Israel, is not allowed to have adulterous relations with others. Idolatry is sometimes denounced as whoredom, at others as harlotry or nymphomania.[20] Idols are worshiped for their sexual temptations and, according to the prophets, "Israelites indulged in idolatry in order to allow themselves to perform forbidden sexual relations."[21] In a more abstract vein, idolatrous fetishism eliminates the ontological abyss between the original and the copy. The idol offers an inappropriate simulacrum of divinity, which attracts undeserved and sinful veneration.

17. Maimonides, quoted in Moshe Halbertal and Avisai Margalit, *Idolatry* (Cambridge, Mass.: Harvard University Press, 1992), 127.

18. Tertullian, "De Idolatria," in *The Anti-Nicene Fathers III*, trans. Rev. S. Thelwall (Ann Arbor: University of Michigan Press, 1976), 61–77 at 62; cf. "every crime appertaineth to idolatry," Erasmus, *A playne and godly exposition or declaration of the common Crede* (Robert Redman for W. Marshall, 1534), *STC* 10504, sig. T iiiv.

19. Jean Halpérin and Georges Lévitte, eds., *Idoles: Données et débats* (Paris: Denoël, 1985), 11–12.

20. Halbertal and Margalit, *Idolatry*, 13–25.

21. Ibid., 23. The link between idolatry and sexual immorality remains a common topos during the Reformation controversies, see *infra*, 53, 65, and Peter Goodrich, *Oedipus Lex: Psychoanalysis, History, Law* (Berkeley: University of California Press, 1995), chaps. 4, 6. Reformation iconoclasm has received a magisterial treatment in Margaret Aston, *England's Iconoclasts: Laws against Images* (Oxford: Clarendon Press, 1988).

But the iconic representation of divinity is also prohibited for cognitive or, in modern terms, aesthetic reasons. The fear now is directed at the representational practice. God has no image—a position that became the basis of Judaism in the theology of Maimonides, although without clear biblical authority—and any material depiction of the divine immaterial essence is wrong. Yet the Jewish tradition appreciates the urge to have visual witness of God. Philo of Alexandria repeatedly states that Moses burned with desire to receive "visible signs" of God. "So insatiably he desires to behold [God that] he will never cease from urging his desire," and though he "is aware that he desires a matter which is difficult of attainment, or rather which is wholly unattainable, he still strives on."[22] Moses could resist the sinful consequences of this insatiable desire, but for ordinary people the veneration of idols was inevitable. Idolatry is the theologically and philosophically misconceived expression of divine *eros*.

The paradoxical relation between these two foundational laws about images, in Genesis and Exodus, became the basis of theological and philosophical arguments during the Byzantine and later iconoclastic controversies, after which the insatiable desire of Moses was finally fulfilled. In the typological interpretation of Christianity, the conflict is resolved through the greatest of paradoxes, the incarnation of the Son of God. Saint Paul had argued that Christ was the image of the invisible God (Col. 1:15), and the early theologians dealt with the question of his image as a christological matter not immediately related to the question of iconic representation.[23] That Christ is the natural image of God was accepted by both iconoclasts and iconophiles. The incarnate Christ, the "word made flesh," partakes fully and perfectly of both divine and human nature. But while the iconoclasts claimed that this double nature of Christ cannot be circumscribed in icons and material representations, the victorious iconophiles retorted that "the new order" inaugurated by the incarnation meant that Christ's human form could be depicted. God, by violating his own commandment against graven images or by fulfilling his promise in Genesis, provided an image of himself in Christ and legitimized the production and display of representations and icons of his Son and the saints.

22. Philo, *On the Posterity of Cain (Works,* 1:289), quoted in Moshe Barasch, *Icon: Studies in the History of an Idea* (New York: New York University Press, 1992), 66. Barasch's *Icon* is an indispensable contribution to the theology of the icon and has influenced strongly what follows.

23. Origen's early gloss on Saint Paul is instructive: "The image of God is the firstborn of all creation, the very Logos and truth, and, further, the very Wisdom Himself, being the 'image of his goodness.' " *Contra Celsum* VI, 63, p. 378.

But the theology and philosophy of these types of images is fundamentally different. The theory of the aniconic natural image belongs to theology, the theory of the icon to economy. Theology deals with the reality of God, his eternal and invisible essence, while economy is a historicized theology that, through the doctrine of incarnation, deals with the dispensation of God in relation to all creation, to humanity, and to the Church.[24] For theology, there can be no resemblance between God and man. Christ is the natural image and Logos of God, the *Imago Dei*; he is cosubstantial with his Father. This essential likeness is one aspect of the love and grace that unites Father and Son. "Christ the image of God" and "Christ the Son of God" refer to the same essential relationship, which cannot be seen or portrayed but upon which all other relations and images are modeled. Economy, on the other hand, argues that the incarnation introduced the divine into history by presenting the image of God in human flesh. Economy cannot be separated from the bodily image of Christ: "He who refuses the icon refuses the economy of salvation."[25] We are presented therefore with two orders of resemblance. The absolute and unrepresentable likeness between Father and Son founds the relative or formal likeness between Christ and his icons. But this formal relationship is not one of representation.

The icon does not present Christ but tends toward him. It puts into plastic form the relationship between human and divine Logos. It does not resemble but imitates; it does not aim to persuade through verisimilitude but through the orientation of the mind from the limited formal likeness of iconic representation to the absolute likeness of divine affinity, which turns the soul from the material to the spiritual. The divine essence remains invisible while its limited imitation puts the transcendent into circulation and attaches the world of secular visibility to the unrepresentable essence of the Logos. The "chain of images" that penetrates every corner of the Byzantine Empire after the end of the iconoclastic controversies is a highly regulated and hierarchical order, a pyramid of symbolic and iconic links at the apex of which stands the

24. Jaroslav Pelikan, *Imago Dei* (New Haven: Yale University Press, 1990), 98; Marie-José Mondzain, *Image, icône, économie* (Paris: Seuil, 1996), 33–90.

25. Mondzain, *Image, icône, économie*, 79. The radical chasm between the natural image and the icon organizes the key distinction of the iconoclastic controversies between *latreia* ("worship") addressed to God and the *douleia* or *proskynesis* ("veneration" or "respect") appropriate to icons. The dividing line is necessarily blurred, and the terms were used with gusto by both sides in Byzantium and the Reformation. This chapter does not discuss the Reformation debates but, as Margaret Aston, the greatest contemporary Reformation historian, accurately puts it, the Byzantine theological arguments "became the key to all subsequent discussions of imagery" (Aston, *England's Iconoclasts*, 47, 47–61 passim).

ineffable, infinite, and invisible *Imago Dei*. Iconophilic doctrine, thus, does not attack the aniconic principle of the Second Commandment and of the other great monotheistic religions. It stages the transcendent by metonymically indicating spiritual and absolute likeness through the limited resemblance of iconic representation. This concern to retain divine invisibility is present in the negative theology of the Orthodox and Catholic churches. The *apophantic* theologians insisted time and again that divinity cannot be circumscribed by the human spirit or artifacts because it is radically transcendent of all secular existence. The role of the theologian is to express what God is not and cannot be, to formulate the principle of total otherness in relation to earthly existence. The first and greatest exponent of negative theology, Dionysius the Areopagite, says that any perfections we perceive and know are of this world and "there is no speaking of [the Supreme Cause], nor name or knowledge of it. Darkness and light, error and truth—it is none of these. It is beyond assertion and denial."[26] God can only be known "through unknowing." Yet despite his mysticism of total transcendence, Dionysius defends icons. A contemporary commentator finds it "strange" that his work has been claimed as authority by both iconoclasts and iconophiles.[27]

Dionysius bases his defense of holy icons on a dialectical reworking of the great paradox we encountered earlier in the debate between essential theology and historical economy, using the Neoplatonic theme of divine light. This light "can enlighten us only by being upliftingly concealed in a variety of sacred veils which the Providence of the Father adapts to our nature as human beings."[28] The veils or symbols allow us to perceive the divine revelation and provoke the mind to move toward the absolute they hide. Revelation works "by proceeding naturally through sacred images in which like presents like, while also using formations which are dissimilar and even entirely inadequate and ridiculous."[29] "I doubt that anyone," Dionysius adds, opening the way for the modern sublime, "would refuse to acknowledge that incongruities are more suitable for lifting our minds up into the domain of the spiritual than similarities are."[30] Holy icons are such dissimilar similarities, which

26. Pseudo-Dionysius, "On Mystical Theology," in *The Complete Works*, trans. C. Luibheid (New York: Paulist Press, 1987), 5; col. 1048A, p. 141.

27. Barasch, *Icon*, 159.

28. Pseudo-Dionysius, "The Celestial Hierarchy," in *Complete Works*, 2, 3; col. 141A–C, p. 150.

29. Ibid., 149.

30. Ibid., 150.

lift us "from obscure images to the single cause of everything." Icons lead us to the transcendent because "in a divine fashion we need perceptible things to lift us up to the domain of conceptions."[31]

In these obscure and paradoxical formulations, we find the most complete defense of the claim that visuality is anchored on the desire to perceive the invisible and ineffable, insight on blindness, and light on darkness. "If only we lacked sight," Dionysius sighs, the knowledge of unknowing would be so much easier, a statement that could easily have been made by Moses.[32] But our fallen nature is endowed or damned with the senses, of which vision is the foremost. In the Judaic tradition the repressed desire to see God leads to the pleasures of the flesh;[33] in the Christian, vision becomes productive. By adopting a principle of aggressive visuality, the iconophiles promote the imperial aspirations of Christianity and of the secular powers that accept the sovereignty of its faith. The holy icons of the patriarch act on the world and save the city; they affect the imagination and call on the faithful to organize their lives in *imitatio Christi*. Christian iconology, both politically and spiritually, acts in ways more radically total and far-reaching than had any previous theory of the image. Holy icons do not abolish or transcend the great metaphysical divides of Western civilization, those between divine and human, material and spiritual, eternal and historical. Rather they historicize them, make them part of divine economy. Thus the icon, this most powerful mediating entity, is put at the service of spiritual and political tasks.

Triumphant orthodoxy retains a strong principle of nonrepresentability behind its proliferating images; similarly the aniconic and iconoclastic traditions do not reject entirely the principle of representation. Idol worship and images of divinity based on likeness are prohibited, but nonmimetic signs of the divine are acceptable. The holy of holies in the Jewish temple often hides behind a curtain an image of the cherubim who are God's chariots, a metonymic and not metaphoric reference to God. The Byzantine iconoclasts forbid all iconic representations of divinity, but they accept the sign of the cross, the Eucharist, and good government as permissible signs of God's presence on earth. The desire to stage and hide the transcendent is a permanent theme of both orthodoxy and iconoclasm.

31. Pseudo-Dionysius, "The Ecclesiastical Hierarchy," in *Complete Works*, 1, 5; cols. 376D–377A, p. 199.

32. Pseudo-Dionysius, "On Mystical Theology," 2; col. 1025, p. 138.

33. Halbertal and Margalit, *Idolatry*, chap. 1; L. Cochan, "The Unfinished and the Idol: Towards a Theory of Jewish Aesthetics," *Modern Judaism* 17 (1997): 125.

Political Power and the *Speculum Mundi*

Secular rulers have adopted similar positions with regard to the por-
trayal and dissemination of their images. Gods, emperors, and kings
hide the ultimate signs of their power, make them distant and invisible.
The kings of Persia would never be seen by their subjects, to whom
they spoke from behind a screen. Often, as in the temple in Jerusalem,
there is nothing concealed behind the elaborate veils and curtains. In
Japan, only the emperor can enter the inner sanctum of the main tem-
ple, where a mirror is hidden in a chest. The Roman emperors, however,
took a more aggressive attitude towards their portraits. André Grabar's
classic treatment of imperial portraiture concluded that the dissemina-
tion of these images was part of a deliberate policy.[34] Contemporary
scholarship treats imperial art as a nuanced, "dynamic dialogue between
ruler and subject, court and ruler, public and artist, artist and em-
peror."[35] But the conclusion is similar to Grabar's: "Rarely has art been
pressed into the service of political power so directly as in the age of
Augustus."[36] A direct line can be traced between the early Roman adop-
tion of Hellenistic cults, with their elaborate classical depictions of gods
and emperors, and the eventual triumph of aggressive iconophilia in
Byzantium. The theology of the icon was simply its most advanced, and
to date unsurpassed, philosophical and political justification.

The Roman emperor Diocletian introduced in the third century an
imperial cult that equated the emperor with his portrait. Strict legal
rules codified and extended preexisting conventions, granting to impe-
rial portraits all the honors given to the emperor; any breach of the
rules governing their reception and veneration amounted to lèse-
majesté. Imperial portraits were ceremoniously sent to all the provinces.
Provincial authorities received each portrait outside their capital and
led it into the citadel in a procession that was followed by festivities
during which they and others paid homage to the portrait. The image
of the emperor was taken to all public buildings; it adorned courtrooms
and presided over judicial proceedings; and "Imperial bearers" were ap-
pointed to carry it in public processions.[37] And when an emperor was

34. André Grabar, *L'empereur dans l'art byzantin* (Paris, 1936; London: Variorum Re-
prints, 1971).

35. Robin Cormack, "The Emperor at St. Sophia," in *Byzance et les images* (Cycles
de conferences du Louvre sous la direction d'André Guillou et Jannic Durand) (Paris:
La Documentation française, 1994), 232.

36. Paul Zanker, *The Power of Images in the Age of Augustus*, trans. Alan Shapiro (Ann
Arbor: University of Michigan Press, 1990), v.

37. S. R. F. Price, *Rituals and Power: The Roman Imperial Cult in Asia Minor* (Cam-
bridge: Cambridge University Press, 1984), 189.

deposed or a territory seceded from the empire, the change was confirmed through the ceremonial removal and destruction of his portraits. In one such instance, after Caracalla's victory over his brother, Geta, the destruction of all portraits of Geta was ordered. Many were effaced while other were covered with foul-smelling substances as part of the ritual of *damnatio memoriae*.[38] As Setton puts it, "Since an Emperor cannot be present to all persons, it is necessary to set up the statue of the Emperor in law courts, marketplaces, public assemblies and theatres—in every place, in fact, in which an official acts, the imperial effigy must be present, so that the Emperor may thus confirm what takes place, for the Emperor is only a human being and he cannot be everywhere."[39]

The symbolic and moral function of imperial art was accepted by early Christians, despite their attacks on pagan idolatry. The Church fathers argued that pagan rulers had placed their statues in public places in order to turn their subjects from crime and delinquency through the awesome sight of the kingly statue. Gregory II chastised the first iconoclastic emperor, Leo III, for the removal of pictures from public places because he thought that it freed the mob to gossip and play the harp, cymbals, and flutes, activities the patriarch considered both trivial and dangerous.[40] Athanasius, in the fourth century, summarized the justification of this second attitude quite succinctly: "The likeness of the Emperor in his image is exact, so that a person who looks at the image sees in it the Emperor; and he again who sees the Emperor recognizes that it is he who is in the image . . . the image might say, 'I and the Emperor are one; for I am in him and he is in me.' He who worships the image in it worships the emperor also; for the image is his form and appearance."[41] And Saint Basil affirms: "Honour which is paid to an image pertains to the prototype."[42]

From the perspective of contemporary aesthetics such claims sound absurd. But if we examine the form of imperial portraits, a form that

38. Belting, *Likeness and Presence*, 107. The symbolic removal and destruction of portraits of leaders after the overthrow of a political regime was repeated again during the fall of communism. Statues of Lenin and Stalin were toppled or disfigured throughout Eastern and Central Europe. See generally, David Freedberg, *The Power of Images* (Chicago: University of Chicago Press, 1989), chap. 14.

39. Kenneth Setton, *Christian Attitude Towards the Emperor in the Fourth Century* (New York: Columbia Univeristy Press, 1941), 196. See also Peter Goodrich, Introduction, in Pierre Legendre, *Law and the Unconscious: A Legendre Reader*, ed. P. Goodrich (London: Macmillan, 1997).

40. Nicaea II, *Actio I* (Mansi 12:977).

41. Quoted in Pelikan, *Imago Dei*, 38.

42. Basil, *On the Holy Spirit*, xviii. 45 (PG 32:149; NPNF-II 8:28).

survived well into modernity, we can get an insight into the moral aspect of cult images. Imperial portraits are the best example of what Grabar has called "typological" art: they have an emblematic character and are organized in a series. Iconic seriality appears first in the imperial cults of the early empire. The statues of Augustus, which proliferated both in the East and the West, followed closely formulaic depictions of the emperor in mythical guise, initially developed in Rome and then faithfully copied throughout the empire. A uniform conception of the "emperor's appearance and that of his family prevailed, and these images in turn, owing to the new political order, became models for clothing and hair styles—in life no less than in art—throughout the Empire."[43] This iconic regime led to a simplification and standardization of artistic forms but proved invaluable for the creation of a strong sense of a unified and ideologically coherent empire. The emperor's portrait stood at the center and in "the compact, pyramidal structure of Roman society entirely oriented towards it apex, the image of the emperor easily became the model for every individual."[44]

This trend was continued in Byzantium and was sanctified by the Church fathers. Eusebius authoritatively defined the status of the Christian emperor when he wrote in 336 A.D.:

> God has designed the kingdom on earth to be an image of the kingdom in heaven; he urges all men to strive towards his radiant kingdom. And in this heavenly kingdom, the emperor, who is dear to God, shall in future participate, for he has been endowed by God with natural virtues and has received in his soul the outpouring of God's favour. The emperor has become rational through the universal Logos, he has become wise from his communion with Wisdom, good through his association with the Good, and just from his connection with Justice.[45]

This statement fixed the visual language of Byzantine imperial portraiture for ten centuries. Emperors appear invariably in full-length frontal portraits with all their finery and pomp as the representatives of God on earth and, despite limited efforts at individualizing the images through the inscription of the name of the emperor, a "consistent Byzantine representation of imperial power" can be found "in which all the Dynasties agree."[46]

These formulaic images have two aspects: they stage the aura of imperial power and divine affinity by placing the imperial face within a

43. Zanker, *Power of Images*, 302.

44. Ibid., 336.

45. Quoted in D. J. Geannokoplos, *Byzantium, Church, Society and Civilisation Seen through Contemporary Eyes* (Chicago: University of Chicago Press, 1984), 17–18.

46. Cormack, "Emperor at St. Sophia," 234.

regulated continuum of past and future emperors, and they are also power's *prosopopoieia*, superimposing a face on the glory of the empire. The new emperor will come to occupy a place in an eternal space; he will slot in, as it were, in a series that confirms his divine partnership by meeting the requirements of kingly representation. Descriptions and even portraits of future emperors circulated before their enthronement preempting the succession and placing the future emperor within the visual regime of imperial power. Nicephorus narrates how the emperor Heraclius on a mission to meet the king of the Avars brought with him a portrait of his sister, whom he wanted to marry to the king. But in another story we are told that imperial messengers were sent to the four corners of the empire to find a bride for the young prince, carrying with them a portrait of the future empress.[47] According to Dagron's felicitous phrase, imperial icons have a prospective function, they link the future of the empire with the regulated present of imperial representations. Being part of a repeated and eternal series confirms the emperor's secular divinity.

In this sense, while the emperor's portrait is always the same because God is eternal and unchanging, it is also peculiarly invisible. Liutpard of Cremona, a western visitor of Constantinople in the tenth century, narrates the following story. Emperor Leo VI, wishing to test the loyalty and alacrity of the imperial guards, went out one night in disguise. As he approached the palace, he was challenged three times by guards and claimed that he was looking for a brothel to spend the night. The guards arrested him twice and twice he bribed them and went free. On the third occasion, he was chained, beaten up, and put in a cell. When the soldiers left, he called the prison guard and asked him: "My friend do you know the emperor Leo?" "How could I know him as he is a man I do not remember ever seeing? Certainly on public occasions when he passes by, I have seen him from a distance (for you cannot get close) but I felt I was looking at a marvel not a man."[48]

Causing viewers to see a marvel and not a man and linking secular with divine power is the essence of imperial portraiture. Religious imagery was initially an instrument of imperial aggrandizement, but after the seventh century the emperor becomes the representative of God on earth and, "standing before his Master, appears to men as both the image of the divine Pambasileus on earth, and as the apostle of the true faith, of orthodoxy itself."[49] Kantorowicz has famously described the

47. Gilbert Dagron, "L'image de culte et le portrait," in *Byzance et les images*, 131.

48. Cormack, "Emperor at St. Sophia," 250.

49. James D. Breckenridge, *The Numismatic Iconography of Justinian II* (New York 1959), 91–92.

king's two bodies, the mortal human body and the imperishable *persona ficta*, which incarnates the eternal and mystical communion of church and empire. The evolution of this double body follows iconographic developments. After the conversion of Constantine, the picture of the emperor appeared on the front of coins and the sign of the cross on the back. But following the change of sovereign, the image of Christ replaced that of the emperor. The iconoclastic emperors replaced Christ with images of themselves and their ancestors, which were again removed after the victory of the defenders of the icons at the second Council of Nicaea, in 787. The unity of the empire becomes identified with the unity of the faith, and coinage followed the changes in imperial policy, indicating the close link between power, territory, and image. The typological imperial portrait with its unalterable characteristics regulates the artistic representation of the Other, as the mystical body of emperor and state and its disciplined visibility indicates its invisible source. Strangely, it was the iconoclastic emperors who, in replacing the image of Christ with their own and those of their ancestors, turned the secular principle of succession through parentage into the transcendent basis of imperium. In doing so, they prepared the road for the modern monarchies for which blood has largely replaced divine provenance.

Holy icons follow similar formal patterns. Icons, Dionysius's veils or symbols, represent ideas, not phenomena or subjects. They are limited attempts to capture divine archetypes. Their painters are not creative artists but a medium used by the Holy Spirit to convey these metaphysical truths through the reproduction of standardized forms. Like the saints, with whom they were often compared, they participate in an act of divine creation, but like the medieval manuscript copyists, they make no individual contribution. The artist's hand is directed by God; his identity disappears to allow the image of the saint to come forth. The formal justification for this great labor of copying was that ancient icons—those painted by Saint Luke, who was wrongly reputed to have seen the historical Christ—and veronicas prove the authenticity of the witness. Leaving aside these unconvincing explanations, the fact remains that a great chain of images deluged the empire and, assisted by imperial portraiture, installed an elaborate panorama of representations in its four corners.

Byzantium was the first empire to use aesthetics to create and propagate an all-inclusive perception of the world. There are two aspects to this early society of the spectacle: the elaborate iconography created a sense of identity by providing the community with an ideal, made visible through iconic representations, to aspire to. But its greater innovation

lies at the level of the individual psyche. Theodore the Studite, the great defender of the icon, wrote during the second iconoclastic controversy that "if that which is absent can be contemplated by the mind and cannot be also seen in a visual representation, then it denies also itself to the mind's eye."[50] Nicephoros, in his more polemical mood, puts the same idea in starker terms: "Not only Christ, but the whole Universe will disappear if there is no circumscription or icon."[51]

The holy and imperial images offer a complete *speculum mundi*, a total visual organization of the world that furnishes the faithful with models of what they should see, think, and dream. The icon is an aesthetic, moral, and political category that incites the beholder's imagination to superimpose his individual features onto its schematic outlines, to anticipate, as had viewers of the portrait of the future empress, what he should look like and become. The faithful would be moved to tears in front of icons depicting the martyrdom of the saints, to joy by images of their triumph, and to spiritual love through the icons of the Virgin, and they would be tempted to imitate these exemplary lives. Fear and trembling would be created by icons of the Last Judgment, where Christ rewards the faithful and consigns sinners to the fires of hell. Dionysius the Areopagite argued that lions, oxen, eagles, and horses painted on holy icons turned the minds of the faithful to the angelic orders and presented invisible powers to the human eye. Michael Psellus, an eleventh-century philosopher, commenting on the "image and likeness" passage of Genesis writes that " 'image' is the capacity of imperfect human beings to perfect themselves, or to attain the true likeness of God. 'Likeness' is a process of perfection through virtue, in which the body participates through progressing to true beauty. Beauty is thus an ethical category. We can either advance on the way to the good or, equally, can lose our way through 'incapacity for beauty.' "[52] By linking the order of vision with a moral vision and an emerging conception of aesthetic beauty, the Byzantine world created the most effective way of capturing a person's soul. After Byzantium all empires will be empires of the senses.

The two iconic models for imposing and authorizing imperial power, despite their surface differences, each include both a moment of darkness and a surfeit of light. The first is based on invisibility, on hiding

50. Quoted in Belting, *Likeness and Presence*, 154.

51. Nicephoros, *Discours contre les iconoclastes*, ed. and trans. M. J. Mondrain-Baudinet (Paris: Klincksieck, 1990), 244D, pp. 9, 86.

52. This is based on M. Psellus, *Scripta Minora*, 1:141-14, summarized in "Appendix: Texts on the History and Use of Images and Relics," in Belting, *Likeness and Presence*, 529–30.

the ultimate bearer of power, God or emperor, and prohibiting the exhibition of his portrait. Here the order of representation is premised on a metonymic transfer of meaning from the infinite to the invisible finite and from the all-seeing to the unseen. But despite the prohibition, ultimate authority must be staged in full pomp in a place that hides nothing. Irrespective of particular historical and political circumstances, visibility is grounded on the invisible, representation rises on the ground of the unrepresentable, the support of power is a powerful void which must be both staged and hidden. If images, icons, and idols mediate between gods and men, the living and the dead, the rulers and the ruled, the most powerful image is this image of nothing. Claude Lefort has argued that in modernity, power becomes empty.[53] But the history of the image indicates that well before the coming of modernity the place of power was vacant. Rulers knew this simple and terrifying fact, and they staged the most elaborate scenes to display this most empty of places. The hidden gives value to the apparent and the invisible gives power to its guardian. As Luis Aragon put it, joining the normative and the aesthetic, "On a fait des lois, des morales, des esthétiques, pour nous donner le respect des choses fragiles."[54]

The second regime rests on extreme visibility, on a garrulous proliferation and dissemination of the image, which is treated as a sign of presence and a symbol of power. The two orders of iconophobia and iconophilia, however, are not opposed and alternating regimes but rather the two necessary moments in every authorized system of representation and power. Icons of power presuppose the elaborate representation of nothing, which underpins its mystique. The regulated distribution of royal and divine icons, signs, and emblems establishes a legitimate and legitimizing system of visibility and disperses it throughout the territory as model and symbol of representational validity. Power and form, politics and aesthetics, territory and image come together in an integral system in which the writ of the emperor or of God is coextensive with the display of their picture.

The Image of Law and the Philosophical Imagination

The inner relationship between the beautiful and the good or the just is a permanent theme in Western philosophy and art and unites the different perspectives of Plato and Dante, Kant and Hegel. For Plato,

53. Claude Lefort, *The Political Forms of Modern Society* (Cambridge: Polity Press, 1986), chaps. 1, 2.

54. Louis Aragon, "Système Dd," in *Littérature*, no. 15 (July–August 1920), 8–9.

the beautiful turns the senses from the world of appearances to the contemplation of Ideas, in which the form of the good and the beautiful are united. Kant strives to make the beautiful the symbol of the good but in his later writings accepts that this connection is under continuous threat. While the beautiful belongs to the eternal realm of contrasting forms and is indifferent to history, the good evolves.[55] In his late anthropology, Kant's dialectic of seduction shows how both good and evil can appropriate beautiful forms. The example he uses is female adornments, which can be used for just or unjust purposes. Here Kant joins the Reformation debates that associated idolatry with the folly of women.[56] Hegel avoids Kant's difficulty by historicizing the relationship and bringing the normative and the aesthetic together, as elements of positive law, in the ethical life, or *Sitlichkeit*. Whether symbolic or historical, the link between the beautiful and the just is evident in the various representations and statues of Justitia that adorn the courts of law and other public buildings of the great European cities. Justice is presented as a beautiful Greco-Roman figure with her scales, sword, and—from the sixteenth century on—blindfold, which, according to art historians, represent respectively the balance and harmony of law, its force, and its impartiality.[57]

All this is well known. The link between law, order, and harmony or between justice and beauty forms a consistent theme in the writings of the humanist lawyers both in England and continental Europe.[58] The maxim *nihil pulchrius ordine* ("nothing more beautiful than order") captures well the classical position.[59] But is there a link between the holy icons of the Byzantines and the modern imagery of law? In other words, does the iconic mediation between divine and human or spiritual and material survive the Protestant tradition of *sola scriptura* and the positivization of law? As was noted in the introduction to this volume, Kant's separation of the faculties had momentous consequences for jurisprudence. But Kant was also deeply interested in the relationship between

55. See Alexis Philonenko, "Le juste et le beau chez Kant," in *Archives de Philosophie du Droit*, "Droit et Esthétique," 40 (1996): 56–63.

56. Goodrich, *Oedipus Lex*; Costas Douzinas, "*Whistler* v. *Ruskin*: Law's Fear of the Image," *Art History* 19 (1996): 353.

57. On the iconography of justice, see Robert Jacob, *Images de la Justice: Essai sur l'iconographie du Moyen Âge à l'âge classique* (Paris: Léopard d'Or, 1994); D. Curtis and J. Resnik, "Images of Justice," *Yale Law Journal* 96, no. 8 (1987): 1727; Paolo Ferreira da Cuhna, "Le balance, le glaive et le blandeau: Essai de symbologie juridique," in *Archives de Philosophie du Droit*, 106–20.

58. Costas Douzinas and Ronnie Warrington, *Justice Miscarried* (Edinburgh: Edinburgh University Press, 1995), chap. 4.

59. Pierre Legendre, *Les enfants du texte* (Paris: Fayard, 1992), 55.

the law and the prohibition on imagery: "Perhaps there is no more sublime passage in the Jewish law than the commandment [against images]. This commandment can alone explain the enthusiasm which the Jewish people, in their moral period, felt for their religion when comparing themselves with others, or the pride inspired by Mohammedanism."[60] Kant gives a second example of the sublime in his discussion of the genius: "Perhaps nothing more sublime was ever said and no sublimer thought was ever expressed than the famous inscription on the temple of Isis (mother Nature): 'I am all that is and that was and that shall be, and no mortal has lifted my veil.' "[61] This passage appears in his discussion of "aesthetic ideas" in the *Analytic of the Sublime*. Aesthetic ideas, Kant writes, are representations of the imagination that "strain out beyond the confines of experience . . . and no concept can be wholly adequate to them,"[62] "sensible forms," the "attributes of an object, the concept of which, as an idea of reason, cannot be adequately presented."[63] The examples he gives include poetic attempts to present "invisible beings, the kingdom of the blessed, hell, eternity, creation" and the way in which "Jupiter's eagle, with the lightning in its claws, is an attribute of the mighty king in heaven, and the peacock of its stately queen."[64] Kant follows here the aniconic tradition that associates invisibility with the presentation of God, or more generally the transcendent. The two examples are divine laws about the presentation of divinity and they are the most sublime because God cannot be represented.

Kant uses the Second Commandment to make a philosophical and a political point. He is answering the criticism that, if the ideas of the law and of freedom were deprived of sensual representations, they would lose their "force or emotion," would be "attended by lifeless and cold approbation,"[65] and would be unable to move people. But this is not the case. For Kant, the sublime feeling is created as a reaction to the presentation of the nonrepresentable. The imagination casts aside the barriers of the sensible world and, presented with the noniconic infinite, becomes unbounded by the senses. "For where nothing any longer meets the eye of sense, and the unmistakable and ineffaceable idea of morality is left in possession of the field, there would be need

60. Immanuel Kant, *The Critique of Judgment* (Oxford: Oxford University Press, 1973), 127.

61. Ibid., 146, 160; P. Lacoue-Labarthe, "Sublime Truth," in J. Librett, ed., *Of the Sublime: Presence in Question* (New York: State University of New York Press, 1993), 71–108.

62. Ibid., 176.

63. Ibid., 177.

64. Ibid., 176, 177.

65. Ibid., 127.

rather of tempering the ardour of unbounded imagination to prevent it rising to enthusiasm, than of seeking to lend these ideas the aid of images and childish devices for fear of their being wanting in potency."[66] Kant supplements his position with a psychological argument closely linked with Reformation iconoclasm. Images can limit the spiritual powers of the imagination and make people passive. "For this reason governments have gladly let religion be fully equipped with these accessories, seeking in this way to relieve their subjects of their exertion, but to deprive them, at the same time, of the ability required for expanding their spiritual powers beyond the limits arbitrarily laid down for them."[67] Regulated imagery makes people passive while sublime invisibility becomes the law.

We find similar ideas in the writings of Edmund Burke, whose empiricist theory of the sublime stands opposed to Kant's metaphysics.[68] Burke's politics and aesthetics associate the sublime with language and verbal expression and the beautiful with vision and imagery. The sublime is the feeling generated before ineffable, distant, terrifying power. People submit to the figure of God, king, or father because these male figures of power generate feelings of awe and pain.[69] They make us submit through an overwhelming force that cannot be fully comprehended. But this political aesthetic of sublimity must be protected from visualization. An image or a painting gives a clear idea of its object, leaves nothing to imagination or doubt, and can be judged according to conventional criteria of aesthetic beauty. "A clear idea," Burke remarks pithily, "is therefore another name for a little idea,"[70] a sentiment echoed by Schopenhauer. A wax model of a human figure in which the "imitation of nature reaches its highest degree [leaves] nothing over for the imagination to do. . . . [Rather,] we are wholly satisfied with the impression of a work of art only when it leaves something behind, that we, with all our reflection on it, cannot bring down to the clarity of a concept."[71] The sublime is obscure, it overawes; but our attempt to comprehend what overwhelms the mind and defies reason may also be a source of intense pleasure.

Burke uses this analysis to give the aniconic tradition a political inter-

66. Ibid., 127–28.

67. Ibid., 128.

68. Edmund Burke, *A Philosophical Enquiry into the Origins of the Sublime and the Beautiful*, ed. J. T. Boulton (Notre Dame: University of Notre Dame Press, 1958); *Reflections on the Revolution in France*, ed. J. G. Pocock (London: Hackett, 1987).

69. Burke's patriarchal sublimity is echoed in Freud's totemic myth of the genesis of law and is a key theme in Pierre Legendre's theory of the "paternity of law."

70. Burke, *Philosophical Enquiry*, 63.

71. A. Schopenhauer, *Die Welt als Wille und Vorstllung* (Leipzig, n.d.), 2: 222–23.

pretation. Invisibility, darkness, and visual deprivation are the political signs of sublimity: "Despotic governments, which are founded on the passions of man, and principally upon the passion of fear, keep their chief as much as may be from the public eye. The policy has been the same in many cases of religion. Almost all heathen temples are dark."[72] In Burke's hierarchy of the sublime, language comes before imagery, unwritten law, convention, and custom before written, positive law. For Burke, Saxon customs "operate better than laws" and provided the basis for later laws and the constitution, which only fashioned or finished what had been created by the ancient oral tradition. "All your sophisters cannot produce anything better adapted to preserve a rational and manly freedom than the course we have pursued, who have chosen our nature rather than our speculations, our breasts rather than our inventions, for the great conservatories and magazines of our rights and privileges," writes Burke.[73] A visible, written constitution is "criminal."[74] The real constitution is an "organism, something like a human body, constituted as a community of senses with distinct powers and privileges, a mixed being of natural and conventional behaviour, a creature of biology and habit, pleasure and pain,"[75] preserved by immemorial custom.

Kant and Burke agree that transcendent power and absolute sovereignty are nonrepresentable and that the interdiction on representation is the most sublime of all laws. The modern sublime is abstract and negative; its proper form is that of law and its proper content the proscription on representation. And not only is the form assumed by God's dislike of images legal, the law itself cannot be properly represented through "images and childish devices." The absence of icons of God and of law leads to the creation of the images of eagles, peacocks, and serpents. In a paradoxical fashion, the prohibition on images becomes the transcendental condition of imagery. This is the crucial moment at which the idea of invisibility passes from divine to secular law and from theology to jurisprudence. The law becomes the absolute or transcendent force of modernity, expressed in the theory of the sublime. The immanence of the divine in history, exemplified by the economy of the

72. Burke, *Philosophical Enquiry*, 59.

73. Burke, *Reflections on the Revolution in France*, 31.

74. Edmund Burke, *Appeal from the New to the Old Whigs*, quoted in W. J. T. Mitchell, *Iconology: Image, Text, Ideology* (Chicago: University of Chicago Press, 1986), 141.

75. Mitchell, *Iconology*, 142. Burke's position on the English constitution was an important, although often unacknowledged, influence on nineteenth-century constitutional writings from Bagehot to Dicey and still lurks behind contemporary debates on British parliamentary soversignty, membership in the European Union, and the introduction of a bill of rights.

holy icon, becomes the immanence of law. As God withdraws from history, sublime law succeeds in the key function of bringing the modern subject into existence.

For Kant, it is subjection to the law that creates the free subject of modernity.[76] Thought is commanded by the law of reason, which formulates universal principles, the concepts, categories, and schemas necessary for the regulation and classification of sensuous feelings and external representations. The sensuous will, which would respond to external stimuli solely according to considerations of pleasure and pain, is subordinated to the rational will, which follows universal and necessary categories. Similarly with the moral law, which the subject obeys and thus becomes free. Every moral command is an answer or a direction as to what I ought to do or become in a particular situation. But before any formulation of an actual command, the fact that a moral command exists indicates that the law has already taken hold of me. To inquire about what I should do in a particular moral dilemma implies that I already feel that I ought to do something; the feeling of being bound, of having been put under obligation precedes any particular sense of duty or command. The law is already in place; it has captivated me before I know or follow it. It is always before me like a strange fact, which Kant calls the fact of reason. Its specific formulation is the categorical imperative, under which we must follow in every action a maxim that could become a principle of universal legislation. This law has no content but is pure form, the form of the universal; it is the expression of absolute practical necessity and can never become known or seen outside or beyond its sentences. The modern subject is created in this double movement in which we are subjected to the law while we imagine ourselves as autonomous and legislating the norms of our subjection. The law arrives with reason; it is pure and without origin or lawgiver. We are given to law before we know what the law demands.

But this invisible law must be staged, in the same way that the absent presence of God was staged before modernity. Hegel relates an important story from Jewish legal sources that illustrates the point. A triumvir in Pompey, curious to know the secret behind the closed doors of the tabernacle, entered the innermost of the temples. There he looked for a "being," an essence offered to his meditation, something meaningful to command his respect. He thought he was entering into the secret, before the ultimate spectacle, but found instead an "empty space." Feel-

76. For a fuller analysis of this crucial point, see Douzinas and Warrington, *Justice Miscarried*, 137–50.

ing mystified, disappointed, and deceived, he concluded that "the genuine secret was entirely extraneous to them, the Jews; it was unseen and unfelt."[77]

Based on his administrative, positivist, literal understanding—that secrets must be hidden from view but should exist in some place—the triumvir expected the law to be incarnated in an image, text, or tablet. The "empty space" convinced him that the Jews could not understand this. But the failure was on the side of the obsessive Roman iconophile, who could not understand the necessity of this elaborate staging. The law is sublime precisely because its place is empty, because its priests and judges guard this nothing; its secret is, exactly as the triumvir discovered, that there is no secret. We do not know what the law is but this lack of knowledge is constitutive of law's operation, in the sense that we must feel duty bound and obligated before any particular duty or any concrete law is formulated. As in Kafka's story "Before the Law," the law is always somewhere else, in the next room, deferred and unseen, awesome in its power, a sign of the transcendent apprehended in its absence.

Once the indispensable function of staging sublimity has been performed, we enter the world of images. The triumvir and Kafka's man from the country are good examples of the law-and-image-driven modern subject. It is through images, the splendid curtains and canopies of the tabernacle or the terrifying images of guards and judges ("The mere sight of the third doorkeeper is more than I even can stand," says Kafka's first doorkeeper), that the subject can sense the terror of the absent and deferred image of the law. Coming to the law, being subjected to the law, is about seeing, about images and imagining, about having the image of the law implanted in the soul. We can only know the law through its representatives and their images—more or less terrifying—their robes, fur or silk, their pates and wigs, their noses and gavels. As with the earlier theological tradition, the law becomes the paradoxical combination of blindness and insight.

Images, Law, and the Constitution of Self

The persistent link between law, image, and desire indicates the important synchronic or anthropological function of the relationship. The separation and binding between images, words, and things, the question

77. Quoted in Jacques Derrida, "Devant la Loi," in A. Edoff, ed., *Kafka and the Contemporary Critical Performance: Centenary Readings* (Bloomington: Indiana University Press, 1989), 208.

of representation of self and other, lies at the heart of the constitution of subjectivity. According to a basic psychoanalytic insight, the subject comes into existence by entering the symbolic order of law and language, which, in the name of the Father, separates the pre-Oedipal infant from the maternal body and inscribes loss, absence, and lack in the midst of self. This lack is partially addressed through identification with signifiers, words, and ideal images; the operation of the image, however, has received less attention than that of language in discussions of this process of subjectivization. In the famous "mirror stage" the infant experiences a sense of jubilation when she first recognizes her image and, through the reflection, identifies with a whole and complete body.[78] But that image is external to the child's sensual experience of a disjointed and disobedient body. The body is made present for the subject by means of its mirror image or double, posed outside of itself, or ex-posed. The ego does not precede the image but is made in the image of the image. It is in this sense that Lacan would claim that the ego and its unity are imaginary, that is, visual and illusionary, the result of a bodily wholeness and completeness imagined through this projection of the uncoordinated body onto an adorable visual other.

The basic law or interdiction that creates humanity as a speaking species is that of division and separation: from the maternal body through the Oedipal law of the Father, from one's one body through the narcissistic identification with its image, from the other as subject and object through their negation or nihilation in the sign. The *ego* from the start is *alter*. The function of the originary prohibition is to split the subject from corporeal existence and bond her to signs, words, and images. But this necessary division and bonding is not without its dangers: signs can drift and threaten life unless an *arche* (origin and principle) of representation is assumed or provided, a place from which image and word originate and upon which they are anchored. The first task of every culture is to institute and guarantee regimes of imagistic and linguistic representation, which both separate and bond words and things and thus allow the assembly of the biological, social, and unconscious dimensions of human life in the figure of the person (*persona* in Latin is the mask actors put on stage during performances).

According to the French historian, jurist, and psychoanalyst Pierre Legendre, the normative structures of society are charged with the task of establishing and manipulating this assembly so that the subject's

78. The *locus classicus* for this analysis is Jacques Lacan, "The Mirror Stage as Formative of the I," in *Écrits: A Selection* (London: Routledge, 1995). See Goodrich, Introduction to *Law and the Unconscious*, for commentary and references. See also Hal Foster, "Obscene, Abject, Traumatic," in this volume.

alienation in the sign becomes part of the dialectic of her formation.[79] For Legendre, society is a generalized or social mirror in which the work of institutions is to transfer the narcissistic "I love myself" into "I love another," establishing thus the necessary relation of the subject to the (image as) other. This function requires a ritual display or staging of the principle of representation, which entails two crucial tasks: First, the social mirror must stage the negativity essential for the subject's introduction into the relationship with alterity or the symbolic. Separation is domesticated and loss and absence accepted through their reference back to a foundational image from which all power to legislate and all ability to attach signs to objects emanate. Second, and at the same time, the imagistic representation of divinity or royalty must retain the distance and protect the radical alterity that separates the human and divine worlds, self and other. The inner sanctum is empty; the most apposite sign of divinity and royalty and the emblem of the law is the zero. The *antiprosopon* of the patriarch's icon, the nonface or the other of the face, ensures that the face and its eyes come to vision. *Antiprosopos* in Greek is "the representative," he who stands in for the face, and by extension for the person, of someone else. But all *antiprosopeia*, "order of representation," is based on the invisible or terrifying *antiprosopon* ensconced in the limited attempts to picture radical otherness. The Christian *Imagoes Dei* reconcile humanity to its inescapable limitation. The absolute other cannot—must not—be seen, but its existence and power must be asserted and staged. This is why the absent founding image must be staged, in order to allude to the terrible force or transcendent power that lies behind all subjectivity, power, and law. Because representation is fragile, it needs the absolute image as its foil or support—while presenting it as its fount and origin.

The ritual mirror must also guarantee the principle of resemblance that supports the differentiation, multiplication, and identification of specular objects. Augustine argued that for signs to attach to things or beings and become their likeness, their limited bond must participate in a *similitudo absoluta*.[80] Christ as the natural *Imago Dei* is the metaphysical prototype of all resemblance, underpinning not just the limited likeness of the material icon but the whole order of representation. The absolute image both secures and domesticates separation and, by staging the principle of resemblance and iconicity, binds signs and images to things.

79. Pierre Legendre, *Dieu au miroir: Etude sur l'institution des images* (Paris: Fayard, 1994); Legendre, "Introduction to the Theory of the Image," *Law and Critique* 8, no. 1 (1997): 3; Legendre, "The Other Dimension of Law," *Cardozo Law Review* 16, nos. 3–4 (1995): 943–62; Legendre, *Law and the Unconscious*.

80. See J.-F. Lyotard, *Libidinal Economy* (London: Athlone, 1993), 66–76.

Through the recognition of the absolute otherness of the divine image, narcissistic desire—desire for the self in its image—is transposed into an acceptance of radical otherness (of the image) and into desire for the other. Two basic anthropological functions are therefore at stake behind the war of images: division, negativity, and otherness and likeness, mimesis, and representation. In this sense, the power to stage representation links the normative structures with the world of forms, relates politics and aesthetics, and supplies the symbolic order with its absent foundation.

Law and the Normative Screen

In modernity, as sovereignty becomes dispersed and the law acquires a relative autonomy from political power, these tasks—the dividing and bonding of signs and things, the valorization or exclusion of particular representations—have been gradually and partially transferred to the legal institution and art. The sublime feeling replaces the awe felt in front of the divine image, and the law, the legal form of absolute command, becomes the guarantor of individuality and freedom, in other words of the process of forming the subject. While laws, rules, and regulations proliferate and affect every aspect of social relations, the law of law is absent. We are surrounded by laws but we do not know where the Law is. Let us conclude by briefly examining a court case that exemplifies these points.

Whistler v. Ruskin is a libel suit brought in 1878 by the London-based American painter James McNeill Whistler against the English critic, essayist, and polemicist John Ruskin. Ruskin's libel related to eight paintings Whistler exhibited at the Grosvenor Gallery in London in 1877. They included four portraits and four "nocturnes." The nocturnes were night views of the Thames. In their moody composition and color and in their name, which evoked pieces of music, these paintings were an attempt by Whistler to move away from the pictorial realism he had been taught by Courbet in Paris. One of the more abstract pictures, *Nocturne in Black and Gold: The Fire Wheel* (fig. 2.1), a view of fireworks and a falling rocket over Cremorne Gardens, was called by *Punch* "a tract of mud. Above, all fog; below, all inky flood; For subject—it had none."[81] Another, *Nocturne in Blue and Gold* (fig. 2.2),

81. Quoted in Linda Merrill, *A Pot of Paint: Aesthetics on Trial in Whistler v. Ruskin* (Washington, D.C.: Smithsonian Press, 1992), 36. Merrill's reconstruction of the record of the trial from contemporary sources is a fine forensic achievement. Whistler's own account of the trial, initially published as the pamphlet "Whistler v. Ruskin. Art and Art Critics," is now reprinted in Whistler, *The Gentle Art of Making Enemies* (Dover, 1967), 1–89. For a dicussion of the case, see Douzinas, "Whistler v. Ruskin."

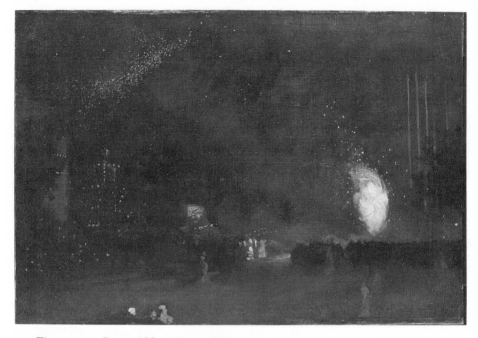

Figure 2.1: James Abbott McNeill Whistler, *Nocturne in Black and Gold: The Fire Wheel*, 1875, oil on canvas. Tate Gallery, London.

showed in the words of Oscar Wilde, who was at the opening of the exhibition, fireworks "breaking in a pale blue sky, over a large dark blue bridge [Battersea Bridge], and a blue and silver river."[82]

Ruskin's view of Whistler's paintings was published in a series of letters addressed to "the workmen and labourers of Great Britain." Letter 79, entitled "Life Guards of New Life," said about Whistler:

> For Mr. Whistler's own sake, no less than for the protection of the purchaser, Sir Coutts Lindsay [the owner of the Grosvenor] ought not to have admitted works into the gallery in which the ill-educated conceit of the artist so nearly approached the aspect of wilful imposture. I have seen, and heard, much of Cockney impudence before now; but never expected to hear a coxcomb ask two hundred guineas for flinging a pot of paint in the public's face.[83]

We will concentrate on two characteristic passages, one from the cross-examination of Whistler by Ruskin's counsel, Sir John Holker, the attorney general of England, and another from Holker's address to the

82. Merrill, *Pot of Paint*, 36–37.

83. Fors 79 (July 1877), in *Works of John Ruskin* (London: George Allen, 1903–12), 29:158.

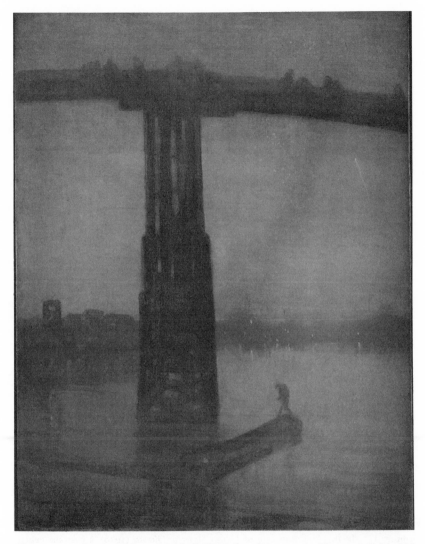

Figure 2.2: James Abbott McNeill Whistler, *Nocturne in Blue and Gold: Old Battersea Bridge*, c. 1873–1875, oil on canvas. Tate Gallery, London.

jury. Showing *Nocturne in Black and Gold* to Whistler, Holker asked him what it showed. Whistler responded that it was a night piece and represented the fireworks at Cremorne. "Not a view at Cremorne?" continued the attorney general, alluding to the tradition that treats art as graphic, pictorial representation. "If it were called 'A view of Cremorne' it would certainly bring about nothing but disappointment on the part of the beholders," responded Whistler. It was only "an artistic

arrangement" and for that reason it was called a nocturne. "You do not think that any member of the public would go to Cremorne because he saw your picture?" pressed Holker, to which Whistler rather dejectedly agreed that his picture would not give the public "a good idea of Cremorne." In this mimetic semiotics, "titles function as captions, with images illustrating the words" and Whistler's paintings by not offering a representation of their themes amounted to "pictorial perjuries" that "not only withheld material facts but also bore false witness."[84] The central aspect of the case concerns the relationship between object and image, in other words, the authorized meaning of representation, a task transferred from the theology of the icon to the jurisdiction of the law.[85]

Holker opened his final address to the all-male jury by asking them to accompany him on an imaginary visit to the Grosvenor Gallery.

> We would find "nocturnes," "arrangements" and "symphonies" surrounded by groups of artistic ladies—beautiful ladies who endeavor to disguise their attractions in medieval millinery, but do not succeed in consequence of sheer force of nature—and I daresay we would hear those ladies admiring the pictures and commenting upon them. For instance: a Lady, gazing on the moonlight scene representing Battersea Bridge, would turn round and say to another, "How beautiful! It is a 'nocturne in blue, and silver.' Do you know what 'a nocturne' means?" And the other would say, "No, but it is an exquisite idea. How I should like to see Mr. Whistler, to know what it means!"[86]

And the ladies would "admire and adore" and "pour incense upon the altar of Mr. Whistler," although they would not understand a thing. We may draw a response from Whistler's aesthetic manifesto, the "Ten o'Clock Lecture," which he delivered in 1885:

> Know then all beautiful women that we are with you. Pay no heed, we pray you, to this outcry of the unbecoming—this last plea for the plain.

84. Merrill, *Pot of Paint*, 145, 236.

85. This regulation of the order of representation is a permanent theme of twentieth-century law. In the American case of *United States v. Olivotti* (1916), a customs court, following Holker, introduced a "representational test," according to which, art is an "imitation of natural objects, chiefly the human form, and represents such objects in their true proportion of length, breadth and thickness, or of length and breadth only." The test was partially overruled in the customs case of Brancusi's *Bird of Flight* (1928) in which the court grudgingly accepted the development of "a so-called new school of art whose exponents attempt to portray abstract ideas rather than to imitate natural objects" and designated the abstract sculpture as art because "it is beautiful and symmetrical in outline, and while some difficulty might be encountered in associating it with a bird, it is nevertheless pleasing to look at and highly ornamental' and was produced by 'a professional artist.' " For a full analysis of contemporary legal regimes of representation see my forthcoming *Legal Iconology*.

86. Merrill, *Pot of Paint*, 165–66.

Your own instinct is near the truth—your own wit far surer guide than the untaught ventures of thick heeled Apollos. . . . For art and joy go together, fearing naught and dreading no exposure.[87]

It is impossible not to contrast those two views of women, beauty, and art. The indolence and silliness of women, their artistry and beauty are symbols for the "ill-educated conceit," the "monstrous extravagance" of Whistler's "fantastic things." Standing against the folly of beauty and femininity is the law's "reasonable man." In Holker's imagery, the male members of the jury taken on the tour of the gallery represent common sense and honesty. Men, unlike women, understand what they see—a bridge is a bridge and is not like a "telescope," a "fire escape," or a "whale," Holker's descriptions of the nocturne. Things come with their natural images attached to them and with their price tags, so many guineas for so many hours of work. Men have a deal with reason and cannot be hoodwinked. Indeed, manly common sense is the obvious language of reason and of law. Whistler on the other hand, who "does not see things as other people do," is conceited and incomprehensible, extravagant and effeminate, eccentric and slightly deranged, an American and therefore an impostor and jester.[88]

Throughout the iconoclastic wars, the sinful pleasures of pictures were linked to women. Images are like women, who use images and adornments to seduce and corrupt, and they seduce women and the uneducated, who forsake God and his word for the passing attractions of material form. The "image is an harlot, and man is no otherwise bent on worshipping it, if he may have it and see it, than he is bent to fornication in the company of a strumpet,"[89] writes Parker in his *Scholastical Discourse against Symbolising*. Stillingfleet in his *Discourse on Idolatry* refutes the argument that the honor given to images is addressed to the prototype, comparing it to "an unchaste wife plead[ing] in her excuse to her husband, that the person she was too kind with, was extremely like him, and a near friend of his, and that it was out of respect to him that she gave him the honour of his."[90] The image is a woman, idolatry a feminine vice in which body and spirit become confused.

Holker's strategy follows the old quarrel between word and image and indicates its political and legal significance. His commonsense semiotics and misogyny are based on the time-honored "natural" bond between object and image. It is the legalization of the iconoclastic theme,

87. Whistler, *Gentle Art*, 153.
88. Merrill, *Pot of Paint*, 168.
89. Parker, quoted in Goodrich, *Oedipus Lex*, 62.
90. Stillingfleet, quoted in ibid., 63.

according to which images "mirror" the world, coupled with the fear of image as feminine, sensual, emotional against reason and common sense. Our case is a good example of law's involvement in the politics of visuality. It is an early attempt to interpose a "legal screen" between the subject and the social gaze, to filter the objects of vision and to determine the way in which we see and are given to the world to be seen. The screen defines and colors the gaze and is responsible for the visual regime of a society and epoch and the way people experience the effects of the gaze.[91] The first and foremost target of the normative screen is representation as such, the assignment of certain ways of seeing as natural, normal, or truthful. But as a collection of authoritative images and material practices, the screen also offers "a repertoire of representations by means of which our culture figures all of those many varieties of 'difference,' through which social identity is inscribed."[92] The religious "chain of icons" was such an institutional arrangement, through which certain representations were normatively validated. Through these historically changing imagistic regimes the sensual body and approved icons come together and create what can be called the "normative" body of the individual, of the future empress, of the faithful *imitator Christi*, or of the follower of cultural icons, the Dianas and Mother Teresas of our era.

The war of images involves, therefore, three vital anthropological tasks. The first is concerned with the internalization of absolute otherness and the domestication of death. The second organizes the field of representation, defining what passes as true or natural, with the obvious normative connotations of those designations. The third, more detailed, flexible, and historically changing, is about positive evaluations of certain images within the dominant regime of representation that are ascribed a culturally specific normative superiority against other, competing ones. The first establishes the human subject; the second is about what passes as true in a society; the third determines what is to be accepted as good or beautiful. Modern law contributes to all three. It is no surprise therefore that the modern order of images is always accompanied by laws and regulations, by a code that tells us how to see, what it means to perceive (*aesthesis*) and understand the image, and how to link the sign, visual, or graphic with its signatum and stop its endless drifting. It is in this sense that *imago est veritas falsa*. As a creation of law

91. Kaja Silverman, *The Threshold of the Visible World* (New York: Routledge, 1996), chaps. 4–6. The screen introduces "social and historical variability not only into the relation of the gaze to the subject-as-spectacle, but also into that of the gaze to the subject-as-look" (p. 135).

92. Ibid., 19.

and power, the image is unnatural, false; but as the necessary support of our humanity, it is the only truth we have. In acknowledging the *ars juris*, the aesthetic dimension of law, we open the institution to the ethics of otherness and the justice of the senses or of Justitia, the feminine principle of transcendence that challenges the patriarchy of sublime Law.

PART

II

THE
LAW OF
IMAGES

THE MOLDING IMAGE

GENEALOGY AND THE TRUTH OF RESEMBLANCE IN PLINY'S NATURAL HISTORY, BOOK 35, 1-7

Georges Didi-Huberman
TRANSLATED BY PETER GOODRICH

The History of Art Always Begins Twice

Historians of art often believe that they deal only with objects. In reality, these objects are organized, given life and meaning, by relations. Even though they are frequently unconscious, these involve choices that both history and criticism should require to be elaborated. Absent such development, the objects themselves risk being misinterpreted, devalued, or reduced to trivial projections of a generally anachronistic and inapposite "spontaneous philosophy." Before speaking of an "image" or "portrait," for example, it is necessary to pose the historical and critical question of the relations that constitute it. The most basic of these relations—the most obvious and yet also the most unwitting—is without doubt the relation of resemblance. It is easy to understand that the relation of resemblance is essential, both practically and theoretically, to all aspects of art history: it is essential, I would say, to the point of excess, so much so that it must be understood as overflowing its epistemic field to precisely the same degree that it supports it. By the same token one could say that it is assured a founding position in the intelligibility of each object, and of each figurative ensemble.

It seems appropriate, therefore, to evaluate the content of the relation of resemblance at the very point where the history of art constituted itself as a discourse. What point is this? We should admit that this cannot be a single point: at the very least it is a system of dots. Here as elsewhere it is futile to look for the "original origin." The absolute source does not exist, and we know equally that a large part of the Greek

literature devoted to the figurative arts has been lost, that we know almost nothing of all the possible first Western "histories of art."[1] Yet in this landscape of lost things certain landmarks remain. At the risk of simplification—though without, I hope, being too misled by this—we ought to recognize that the history of art had at least two beginnings: it was born once with Pliny the Elder, in 77 A.D. (the date of the *Natural History*'s dedicatory epistle to the emperor Vespesian);[2] it was born a second time, nearly fifteen centuries later, with Vasari who, in 1550, dedicated his *Lives* not to an emperor but to a pope and "to the most illustrious and very excellent prince Cosimo of Medici."[3]

These two beginnings make a system. On the one hand, the Vasarian Renaissance represented itself as a repetition of the Roman "birth" of the history of art as personified by Pliny. The *Natural History* never stopped being a spontaneous model for discourses on the pictorial and sculptural arts; Vasari's terms were often presented as a literal translation of notions derived from Pliny.[4] In short, the Vasarian modern was presented explicitly as a resurrection of the Roman ancient, across the "dark age," *vecchio*, which, in the eyes of the Florentine historian, the Middle Ages had imposed. On the other hand, and here we move beyond the point at which a superficial reading of these texts normally halts, the Vasarian Renaissance also proceeds as a surreptitious reversal of many of Pliny's terms. Precisely because it generally remains unnoticed, this last point deserves to be expanded: the humanist tradition that developed out of the academic milieux of the sixteenth and seventeenth centuries modified all the basic conceptions it attributed to Pliny, and particularly those of the "image," "resemblance," and "art" more generally. Vasari's legacy leads us frequently to read, and as we will observe subsequently to translate, Pliny's words according to an order of intelligibility that completely betrays the meaning of the arguments the *Natural History* deploys in relation to the figurative arts.

The stake of this reversal can be understood in terms of the radical difference that separates Pliny's project from Vasari's. Where Vasari

1. A. Reinach, *Textes grecs et latins relatifs à l'histoire de la peinture ancienne*, in *Recueil Milliet*, ed. A. Rouveret (1921; Paris: Macula, 1985).

2. Pliny, *Natural History*, trans. H. Rackham (Cambridge, Mass.: Loeb Classical Library, 1952). I will refer throughout to the dual-language text of this edition while making substantial changes to update the translation.

3. G. Vasari, *Le vite de' più eccelente pittori, scultori ed archittetetori, 1550–1568*, ed. G. Milanesi (Florence: Sansoni, 1878–1885); translated as G. Vasari, *Lives of the Painters, Sculptors and Architects*, trans. A. B. Hinds (London: Dent, 1927).

4. Thus, for example, *ingegno* for *ingenium*, *studio* for *studium*, *invenzione* for *inventio*, *diligenza* for *diligentia*, *facilità* for *facilitas*, *sottigliezza* for *subtilitas*, *maestà* for *maiestas*, *veustà* for *venustas*.

inaugurated a closed epistemic regime to govern the discourses on art (a regime according to which the history of art constituted itself as a "specific" and "autonomous" knowledge of figurative objects), Pliny's text offered the encyclopedic arborescence of an open epistemic regime, in which figurative objects were no more than one among many manifestations of human art. What Pliny understands by the term *artes* is coextensive with the entire *Natural History*, and as a result the aesthetic notion of art is not a part of his principal definition. There is "art" every time people use, instrumentalize, imitate, or go beyond nature. The exemplary art, according to Pliny, is medicine, and it is to this that the *Natural History* devotes its most extensive expositions. The art of painting, in the sense we understand it today, takes up only one part of book 35, at the end of a monumental work.

What Vasari means by "arts," as we know, is something entirely different.[5] The whole impetus and object of the *Lives* rest upon a highly specific, "wild" or inflamed, *aesthetic* and humanistic definition of art. The encyclopedic or anthropological opening of Pliny's project thus sees itself reduced, to the point where it becomes nothing more than the subject of an academic discussion group, the *Accademia delle arti del disegno*, for which Vasari claims the greatest privilege and uniqueness. It is as far removed as possible from other human enterprises and above all from manual labor. The closed, or at least highly restricted, regime set out in the *Lives* makes the *imitazione della natura* the prerogative of the liberal arts practiced by certain academicians outside of the common law. It rapidly becomes clear that the privilege and liberty of these academicians derives from their social status as courtiers. Vasari's enterprise indeed owes its very existence to the role of its author within the court society of his day.

Even if Pliny at one point remarks that in Greece the art of painting was forbidden to slaves,[6] his overall conception of art is Roman—explicitly "anti-Greek"—and based upon a *similitudo naturae* that is legitimized anthropologically by reference to the common law. Painting, in this account—in common with the other arts, such as agriculture, medicine, or the art of war—has meaning as much by virtue of a relation to the social and legal world as to that of material or natural forms. This relation, one of respect or *dignitas*, is at the heart of what Pliny understood by "art," by "image," and by resemblance. I believe it influences

5. For discussion of the theoretical status of Vasari's history, see the preliminary schema developed in Georges Didi-Huberman, *Devant l'image: Question posée aux fins d'une histoire de l'art* (Paris: Minuit, 1990), 65–103.

6. Pliny, *Natural History*, bk. 35, par. 77 (9:319); parenthetical numbers refer to Rackham translation cited above.

all lines of division that can be drawn between the principal categories developed by Vasari—notions of history, of imitation, of cultural aesthetic, of *licenza*, and of rhetorical *invenzione*—and those that can be inferred from Pliny's moralism, particularly those of symmetrical origin, of death, of imprint, of civic cults, of *dignitas*, and of strict genealogical transmission. It is helpful at this point to trace, even if only in outline, and to analyze these different lines of division across which an academic conception and a juridical conception of visual objects face each other.

"Resemblance Is Dead"

The first dividing line occurs where Vasari proposes an *order of the idea* in pictorial practice. It is by reference to this, for example, that he can give the concept of *disegno* its intellectualist meaning. Panofsky also uses this notion to argue that the history of the theory of art can only be elaborated under the authority of the word *idea*.[7] Pliny the Elder, by contrast, developed his entire project by reference to a material order and claimed this in his preface as a justification for the inelegant and nonrhetorical character of the knowledge that he intended to transcribe:

> Because the matter that I treat is barren, because it relates to the natural world, that is to say, to life, and to its most lowly elements (*sterili materia: rerum natura, hoc est vita, et haec sordidissima sui parte*), it requires the use of foreign and rustic terms, or even barbarian names, for a large number of objects.[8]

Could this "barren," vulgar materialism, so distant, for example, from Cicero, allow for a conception of art? Apparently not, if one believes certain commentators, such as Eugene Sellers or Raymond Schoder, who spontaneously conclude that Pliny's materialism is fundamentally inappropriate to all aesthetic thought.[9] It is certainly true that the start of book 35 would surprise a reader who expected something like a *De pictura* before its time: the first history of Western art begins by posing the problem of painting *not* in terms of representation (good or bad imitation of nature), of artistic genres (portrait, landscape) or of stylistic periods (archaism, classical maturity, mannerist decadence). Here it is

7. E. Panofsky, *Idea: Eine Beitrag zur Begriffsgeschicte der älteren Kunsttheorie* (Leipzig-Berlin: Studien der Bibliothek Warburg, 1924). It is significant that Panofsky hardly cites Pliny the Elder at all. On the idealism of Vasari and its neo-Kantian resurrection by Panofsky, see Didi-Huberman, *Devant l'image*, 89–103, 153–68.

8. Pliny, *Natural History*, Preface, pars. 12–13 (1:9).

9. E. Sellers and K. Jex-Blake, *The Elder Pliny's Chapters on the History of Art* (1896; Chicago: Ares, 1976), p. A. See also J. Isager, *Pliny on Art and Society: The Elder Pliny's Chapters on the History of Art* (London: Routledge, 1991), 9–17.

a question of nothing more than brute matter (metals, rocks, and the *terrae* turn out to be the true "subject"—in Pliny's terms, the *materia*— of the book) and activities that Vasari would name *artisanales*, such as engraving, molding, and dyeing, in relation to which the terms *painting* and *sculpture* would not even appear.[10]

The second dividing line concerns the investment of the order of discourse in the temporal status of the art of painting. Vasari's schema is well known. There is a golden age, then the medieval eclipse, followed by a period that "resuscitates good art" (following the most obvious meaning of the word *rinascita*) and literally opens into the modern age. With modernity comes the specific historical understanding of the evolution of painting in three great periods, which in turn form the general plan of the *Lives*. Vasari's history, though cyclical, has a fundamentally teleological and triumphalist tenor. Its highest point, as we know, bears the name of Michelangelo. There is nothing comparable in Pliny the Elder. His praise of the painter Apelles, for example, assumes neither an explicit sense of history nor a teleology of art nor any praise of "modernity."

Rather than simply assuming, as is often done, that Pliny's work lacks any "spirit of history" or "sense of progress," let us pay close attention to the peculiar model of temporality that the *Natural History* suggests in relation to pictorial questions. One cannot help but notice that the beginning of book 35 suggests a divided or even torn temporality. It is at the heart of this tear that the words *pictura* and *imago* appear, as if these words—the stakes of the entire question—should be understood differently and specifically according to two heterogeneous times. The time we spontaneously wait for, of course, is that of *history*, but it does not appear until the fifteenth paragraph, that is to say, at the point where Pliny, in posing the question of the "beginning of painting" (*de picturae initiis*), an invention contested by the Greeks and the Egyptians, embarks upon his list of famous artists.[11] This view of beginnings—this trivially historical point of view—has been the focus of attention of the exegetes, to the point of entirely eclipsing, in certain editions, the fourteen paragraphs that precede the expression *de picturae initiis*.[12]

What do these first fourteen paragraphs of book 35, the paragraphs that appear before the beginning of history, have to say? They enunciate the origin, that is to say, an absolutely distinct temporal order that has nothing whatsoever to do with Vasari's historical chronology. The ori-

10. Pliny, *Natural History*, bk. 35, par. 1 (9:261).

11. Ibid., bk. 35, par. 15 (9:271), where the term *initia* is, in my opinion, incorrectly translated as "origin."

12. As, for example, in Sellers and Jex-Blake, *Elder Pliny's Chapters.*

gin is anthropological, juridical, and structural. It is for this reason that in the first fourteen paragraphs Pliny claims a *Roman* origin for the notions of "image" and "painting," an origin outside of the historical determinism that gives rise to the question, in paragraph 15, of whether the beginnings of painting are Egyptian or Greek. This temporal scission is fundamental: it opposes historical *teleology*, which will be Vasari's prime concern, to a *genealogy* of the image and of resemblance, which Pliny expresses in terms of law, justice, and right.

This genealogical point of view leads immediately, in paragraphs 2 to 5 to be precise, to a crucial paradox, which, according to the present analytic schema, reveals a third dividing line. Where Vasari begins his history by speaking of resurrection, renaissance, and "immortal glory," the *eterna fama* of "men who have never perished and who have never been defeated by death,"[13] Pliny introduces his genealogical perspective by means of the observation of a death. One quickly understands that, for Pliny, the beginning of the history of art implies the death of an origin, to which it nonetheless lays claim as the source of legitimacy and the law for any "dignified" notion of the image and of resemblance.

When Pliny states in paragraph 2, for example, that he will discuss "what remains of painting" (*quae restant de pictura*), it seems to me that he plays on the form of words. On the one hand, the phrase indicates the content one would expect in an encyclopedic treatment: "that which remains to be said of painting."[14] On the other hand, it suggests a melancholic meaning, as if this art that Pliny will consider exists only in a vestigial state, as the phantasmatic survival of a disappearance.[15] For Pliny, this Roman of the first century, *art no longer exists*, whereas for Vasari art becomes the object of history only to the extent that it can be "resuscitated" from its medieval ashes—the paradox being that what Vasari sees being resuscitated is nothing other than Roman art, most notably that of the first century.

What is it then that dies in this death of art? Nothing more and nothing less than the origin of art. But what then, for Pliny, is the origin of art? His answer is as precise as its translation has been inadequate. In the fourth paragraph he writes: *imaginum pictura*, and clarifies immediately that what he means by this is the production and transmission

13. Indeed this is the text on the frontispiece of the 1568 edition of the *Lives* (*Hac sospite nunquam hos periisse viros, victos aut morte fatebor*).

14. Pliny, *Natural History*, bk. 35, par. 2 (9:261). The expression *quae restant de pictura* echoes the expression *restant terrae* from paragraph 1.

15. The expression in this meaning echoes other formulae employed by Pliny in similar contexts, such as *imaginum pictura . . . in totum exoleuit* (*Natural History*, bk. 35, par. 4), *ars moriens* (bk. 35, par. 28), or again *cessavit deinde ars* (bk. 34, par. 52).

of "extreme likenesses."[16] *Imago* and *pictura* are without doubt two very simple words in everyday speech that do not seem to pose any problems of translation. Pliny's phrase is thus rendered as follows:

> The painting of portraits [*imaginum quidem pictura*], which used to transmit extreme likenesses of persons [*maxime similes*] down through the ages, has now fallen completely into disuse [*in totum exoleuit*].[17]

Now we understand that for Pliny the Elder resemblance is already dead. The chain of its transmission *in aeuum*, "across the generations," is already broken. Before naming the agent of this interruption, of this disappearance, we should investigate first the name that Pliny gave to the object that has disappeared: *imaginum pictura*. Only then can one glimpse that this simple expression carries within it the entire tear or rending of which I have spoken, the original breach of the history of art.

All academic translations of the *Natural History* translate *imaginum pictura*, naturally enough, as "painting of portraits,"[18] a genre that flourished most particularly in Pompeii and in the rural region where Pliny had his villa. Commentators have not failed to express surprise at the phrase "the painting of portraits . . . has now fallen completely into disuse," which, from an art historical perspective, is manifestly inaccurate.[19] The solution to this difficulty does not lie in claiming that Pliny was blind or an idiot, but rather in asking whether, when discussing the *imaginum pictura* in the context of paragraphs 1 to 14, he might not have been discussing something completely different. The question thus becomes: if *imaginum pictura* really does mean "painting of portraits" in the context of a history of art that has already begun, what does it mean in the present context, that of the origin of art?

Imprints of the Face, Imprints of the Law

It is in reality a fourth dividing line that manifests itself in the apparently minuscule question of how to translate the phrase *imaginum pictura* in Pliny's text. Vasari's legacy leads us to think that the status of all figurative objects should be expressed in terms of the history of styles, of good

16. Ibid., bk. 35, par. 4 (9:261).
17. Ibid., bk. 35, par. 4 (9:261).
18. "Pittura del ritratto," in the Italian edition of S. Ferri, *Storia delle arti antiche* (Rome: Palombi, 1946). "Painting of portraits," in the English edition of H. Rackham.
19. See J.-M. Croisille in the French edition who, following S. Ferri, remarks on the "strangeness of Pliny's remarks, made at a time when an apparently vivacious tradition of realistic portraiture existed" (Ferri, *Storia*, 133).

or bad *disegno*—which is to say, judgments of taste—or, more briefly, in terms of activities or artistic genres, in which the portrait has its place among the other forms of pictorial composition. Pliny's text at the beginning of book 35, however, forces us to think of the status of the figurative object according to the category of *imago* (modestly translated as "image"), a category that can rapidly be understood to refer neither to "painting" in its usual sense (I mean the painting of a picture), nor to artistic genres in their usual sense, but rather to a juridical genre whose protocols are described in great detail in paragraphs 6 and 7:

> In the halls of our ancestors it was otherwise [*aliter apud maiores*]: portraits were the objects displayed and destined to be looked at, not statues by foreign artists [*non signa externorum artificum*] nor bronzes nor marbles, but rather wax models of faces [*expressi cera uultus*] were set out, each in their own niche. One was thus furnished with images [*imagines*] to be carried in procession at family funerals, and whenever some member of the family died, the entire family, past and present, would attend. The family tree was traced in lines on the wall near the painted portraits [*imagines pictas*]. The family archives were kept filled with records and other written memorials of their achievements in office. Outside the house and in its doorway, there would be other representations [*imagines*] of these heroic spirits, with spoils taken from the enemy fastened to them, which even those who subsequently bought the house were not permitted to unfasten. Thus the house would celebrate for eternity, and irrespective of changes in ownership, the triumphs of those that had lived there.[20]

Reading this text we are constrained by a paradox, a cleavage between the differing points of view implied in the expressions *imaginum pictura* and *imagines pictae*. On the one side, we should recognize that "painting," the *pictura*, is here named in advance of any history of painting, that is to say, prior to all presuppositions of artistic genres and even before the notion of an individual "painting." Painting here is nothing more than a material process to be used in finishing the wax molds of the faces of the "ancestors"—the Romans of the Republic—so as to achieve an "extreme likeness." On the other side, we should observe that the "image," the *imago*, is here named before any history of the portrait, that is to say, before any presuppositions of the artistic character of visual representation. The image is nothing other than a ritual support derived from private law: a molding of resemblance destined to legitimize the position of the individual in the genealogical institution of the Roman *gens*.[21] Before becoming the site of an encounter between

20. Pliny, *Natural History*, bk. 35, par. 6–7 (9:265).

21. For a theoretical approach to this institution, see P. Legendre, *L'inestimable objet de la transmission: Etude sur le principe généalogique en Occident* (Paris: Fayard, 1985). For a more specific and historical point of view, see Y. Thomas, "À Rome, pères citoyens et

the high idea of painting and the specialized genre of the imitation of individual traits, the *imaginum pictura* appeared as an encounter of the most barren kind (*sterili materia*), between matter and a rite. This paradoxical encounter, however, is not without its effects upon the ideas that we form spontaneously of art, the image, the portrait, and resemblance. It generates further dividing lines and produces supplementary paradoxes.

A fifth dividing line can be deduced from the material and processual aspects upon which Pliny insisted before declaring that the Roman *imagines* were nothing other than "wax models of faces" (*expressi cera uultus*). Far removed from the Vasarian tradition, in which the portrait was defined as an optical imitation (at a distance) of the individual portrayed, or better, as an illusory simulation of his visible presence, the Roman notion of the *imago* supposes a duplication by means of contact with the face, a process of imprinting (taking a plaster mold of the face itself), then physically expressing the shape obtained (realizing a positive wax print by way of the mold). The *imago* is not, therefore, an imitation in the classical sense of the term; it is not a pretense and it does not require any *idea*, any talent, any artistic magic. On the contrary, a molded image is produced by adhesion, by direct contact of face with plaster, matter with matter.

On the other hand, and this is our sixth dividing line, the genealogical cult described by Pliny opposes term by term the aesthetic culture elaborated by Vasari. A portrait, according to Vasari, is good or bad, and the criteria that permit such judgment are located in the closed, self-legislating world of the *accademia*. By contrast, Pliny evaluates images as just or unjust, legal or illegal. An image derives its legitimacy from a juridical space on the boundary of public and private law, a space traditionally named the *ius imaginum*, or "law of images."[22] It is in light of such law that the visual objects described by Pliny lead, as I have suggested, to a common social domain and not to the separate domain of the academy. His history thus could not be "specific," in the sense

cité des pères (IIe siècle J.C.–IIe siècle après J.C.)," in A. Burguière, C. Klapisch-Zuber, M. Segalen, and F. Zonabend, eds., *Histoire de la famille* (Paris: Armand Colin, 1986), 1: 195–229. For an anthropological description of Roman practices of *imagines* see, most notably, F. Dupont, "Les morts et la mémoire: Le masque funèbre," in F. Hinard, ed., *La Mort, les morts et l'au delà dans le monde romain* (Caen: Centre de Publications de l'Université de Caen, 1987), 167–72.

22. Among the many possible references, see J. Marquardt, *Le culte chez les Romains,* trans. M. Brissaud (1878; Paris: Thorin, 1889), 1:146–73; J. Marquardt, *La vie privée des Romains,* trans. V. Henry (1864–1879; Paris: Thorin, 1892), 1:283–87; T. Mommsen, *Le droit public romain* (Paris: Thorin, 1982), 1:84–89; A. Dubordieu, *Les origines et le développement du culte des Pénates à Rome* (Paris: Ecole Française de Rome, 1989), 93–122.

imagined by Vasari and much later by Panofsky: the *Natural History* elaborates an expansive view, that of an *anthropology of resemblance*, which exceeds in all aspects the "disciplinary" point of view of the humanistic history of art.

Resemblance by Generation and Resemblance by Permutation

At the moment when Pliny took up his pen to write what remains the first history of Western art, the juridical and anthropological efficacy of the image only survived as an expression of republican nostalgia: *imaginum pictura . . . in totum exoleuit*. What then, in Pliny's eyes, is the cause of this disappearance? By what agency did resemblance—the extreme likenesses of the images of the ancestors, the just resemblance of the *ius imaginum*—come to die? The response of book 35 inaugurates a seventh dividing line, thanks to which we can discern with slightly greater precision the ethical difference that separates Pliny's conception of the (originary) image and Vasari's (historical) art.

Pliny, like everyone else—Vasari included—defined human art as an imitation of nature. Yet this definition was, without exception, subject to cultural mediation, to an ethic and even a politics. Thus, *similitudo naturae* is conceived, throughout the *Natural History*, according to a line separating two notions with which Pliny was obsessed—particularly at the beginning of each book—namely, *dignitas* and *luxuria*. If, before approaching history, book 35 gives an exposition of the cult of ancestral images, it is because Pliny wished to establish a trajectory by reference to an originary rather than a historical point, one that seemed to him to express the *dignitas* appropriate to the world of figurative representations, which used painting as one of its constitutive materials. This dignity and the resemblance that it assumed was, for Pliny, already dead, killed by nothing other than *luxuria*. We are left meanwhile with the insight that even though the historical world of art has gone beyond the sphere of the artisan (or so Vasari thought) and equally beyond the sphere of religion (according to Hegel), it has left behind it, as a vestige, as mourning, the very dignity that originally constituted it.

What is *luxuria*? Morally speaking, it is lust (the vice tied to excess); aesthetically speaking, it is luxuriance; structurally speaking, it is unproductive expenditure, excess or transgression as such. The usual translation by the word *luxury* seems much weaker than the vocabulary tied to *luxuria* in Pliny,[23] which includes terms such as *deliciae* ("delights"),

23. Pliny, *Natural History*, bk. 35, par. 3 (9:263) (*nec cessat luxuria id agere*).

desideria ("desires"), *temeritas* ("blind rage"), *auaritia* ("covetousness"), *obscenitates* ("obscenity"), and even *insania* ("madness").[24] All of these terms are summoned at the beginning of book 35, as a countermotif to the *imago*, or rather as an expression of the decadence and the indifference with which Pliny's Roman contemporaries had come to regard the "dignified" notions of image and resemblance.

Pliny castigated first of all the *luxuria* of the materials his contemporaries indulged in, at ludicrous expense, in the "undignified" decoration of their homes. Beyond even the "moral insanity" of "carrying the entrails of the earth"—marble—into their bedrooms,[25] Pliny accused them, in their pictorial practices, of lying through the use of materials that for him constituted "false marble," painted marble by means of which they hoped to reinvent nature to the extent of imposing "nonexistent tasks" upon it.[26] The luxury and insanity of marble went hand in hand with the "delights" and "obscenities" of precious metals: shields of bronze, gilded walls, silver effigies—all these objects were repugnant to our moralist historian. Their error lay in attracting the eye to the matter used and not to the resemblance as such: "They leave behind them portraits that represent their money [*imagines pecuniae*], not themselves."[27]

The second *luxuria* is that of the body: it is luxuriance as such, the sexual excess evoked in the fifth-paragraph description of "images of Epicurus" decorating the bedrooms of those who indulged in orgies and wife swapping. "Indolence has destroyed the arts" (*artes desidia perdidit*), wrote Pliny, suggesting moral decadence by a subtle play of words: the dignified use of wax (*cera*) in the making of ancestral images is dissolved in aid of an undignified usage, one that coats the body with a *ceroma* (a mixture of wax and oil) to no greater end than promoting the various genres of physical exercise.[28]

The third *luxuria* is nothing other than resemblance as such: it concerns the relations set up between the form of the body and the materials informed and figured by human labor. It becomes apparent that the "indolence [that] has destroyed the arts" is nothing other than a certain immoderate taste for art itself. It is a decadent taste for resemblances

24. Most notably, ibid., bk. 14, pars. 1–6; bk. 21, pars. 1–4; bk. 33, pars. 1–3, 148; bk. 34, pars. 1–4.

25. Ibid., bk. 36, pars. 1–4 (10:3).

26. Ibid., bk. 35, pars. 2–3 (9:263). It should be remarked here that Pliny depicts as decadent the painting that Vitruvius (*De architectura*, VII, 5, 1) considered to be the origin of painting.

27. Ibid., bk. 35, 4–5 (9:263). It is helpful to link this critique of *pecuniae* to the critique of money that Pliny develops elsewhere (bk. 33, pars. 48–50).

28. Ibid., bk. 35, par. 5 (9:265).

that are neither "natural" nor "individual": for usurped, untruthful, and, when all is said and done, monstrous resemblances:

> The distinction between individual traits is ignored; heads of statues are exchanged for others [*statuarum capita permutantur*], about which before now satyrical verses have circulated: so universally is a display of material preferred to the fact of recognising oneself in an image. And in the midst of all this, people tapestry their walls with old pictures, and they prize the likenesses of strangers [*alienasque effigies colunt*], while as for themselves they imagine that honour only consists in the price, and for this their heirs will break up the statues and haul them out of the house with a noose. Consequently nobody's likeness lives [*nullius effigie vivente*] and they leave behind them portraits that represent their money, not themselves [*imagines pecuniae, non suas*].[29]

Here under the heinous label of *luxuria* we find an array of practices that Vasari would later cite as evidence of the development of a historical consciousness of art. Consider the modern montages of archaeological fragments, the art galleries where "people tapestry their walls with old pictures," the growing importance of a market in antiquities where works of art are exchanged and sent on—as Vasari himself traded in the drawings of earlier masters—and finally the entire practice of connoisseurship and of art history. All of these activities, for Pliny the Elder, represented no more than greed, obscenity, madness. These three *luxuriae* constitute a system. Once the *Natural History* invokes one of them, the other two rapidly follow: thus "hunger for gold," which is criticized in book 33, is linked to critiques of excessive refinement in the engraving of domestic objects and of the perversion of which those who "used vessels of gold in satisfying their indecent necessities."[30] Similarly, the figurative arts, painting and sculpture, are associated with the financial *luxuria* of collectors, which is in turn tied to the *luxuria* of the omnipresent erotic iconography of Roman art.[31]

It should be remarked further that this veritable system of excess clusters on the figures of certain emperors notorious for their erotic, ethical, and aesthetic abominations. It is thus no surprise to see Nero depicted in the third paragraph of book 35: he appears, here and elsewhere, as the emblematic figure of this infamous troupe. Paralleling Suetonius,[32] who made a precise catalog of imperial extortion—the aes-

29. Ibid., bk. 35, pars. 4–5 (9:263).
30. Ibid., bk. 33, pars. 49–50, (8:41).
31. See notably the excellent synthesis in C. Johns, *Sex or Symbol? Erotic Images of Greece and Rome* (1982; London: British Museum, 1993).
32. Suetonius, *Lives of the Twelve Caesars*, Nero XXVIII–XXXI. The same articulation of the three *luxuriae* can be found in Seneca, *Letters to Lucilius*, XIV.

thetic *luxuria* of Nero figuring exactly between the depiction of his obscenities and consumption and that of his "parricides"—Pliny the Elder, throughout book 35, evokes the remarkable monstrosities, of which Nero was the proof, by way of contrast with the dignity of resemblance. When he encouraged the artists of his day to invent impossible and deceitful marbles, when he ordered them to cover his *Domus aurea* with grotesques, when he made them paint in colossal proportions upon linen canvases one hundred and twenty feet high, when he substituted a simple copy for Apelles' *Aphrodite Anadyomène* without a second thought—on each occasion Nero transgressed what Pliny viewed unequivocally as the truth and the intrinsic dignity of all *similitudo naturae*.[33]

Is it possible in the contemporary moment to name the structural principle that organizes this system of oppositions between *dignitas* and *luxuria?* A remarkable feature of the lines of division established by Pliny is that in the end they come close to converging with a problematic that contemporary anthropology seems to recognize as foundational. This problematic, which consists of inquiring what, in a given society, is not exchanged, is explored by Maurice Godelier in terms that resonate with the most contemporary critiques of generalized exchange. Following on from Lévi-Strauss, it is imperative to inquire into a novel structural necessity: "In all societies, at the same time as there is exchange there must also exist certain fixed and stable mooring points, social relations and identities which are removed from exchange and at the same time allow it to take place, which while founding and limiting it also rise up as its boundaries and its limits."[34] Certainly for Pliny the Elder, the *imago* constituted such a "limit" within the republican tradition of Roman society. It was a juristic reference point that could prohibit resemblance from trading itself and allow it to be transmitted genealogically. It is for this reason that Pliny insisted on the inalienable character of the ancestral images, or *spolia*, set out in the atrium and

33. Pliny, *Natural History*, bk. 35, pars. 3, 51, 91 (9:263–65, 299, 329).

34. M. Godelier, *L'Enigme du don* (Paris: Seuil, 1996). The text continues: "Today, in our capitalist society in which all or almost all things find their equivalent in money, and where persons and things do not *exist* if they cannot be measured and metamorphosed into money, reality becomes more and more irreal, the world dematerialises. It becomes more and more a world of signs which are themselves signs of signs which appear more real than the reality which they signify. Yet there are still reasons to doubt that everything in the real will be transformed into symbols, symbols which finally will simply be symbols of nothing. . . . The human task is to learn to recognise themselves in the doubles that they created and which escape them and become strangers to them and indeed come to dominate them. It is an age-old task and now more than ever it needs vigorously to be pursued."

"around the doorways" (*circa limina*) of the Roman household, "which even those who subsequently bought the house were not permitted to unfasten. Thus the house would celebrate for eternity, and irrespective of changes in ownership, the triumphs of those that had lived there."[35]

Two verbs used by Pliny in the very first paragraphs of book 35 give a precise sense to this fundamental dividing line that we are seeking to discern: the first, which is applied to the "dignified cult" of ancestral images, is *tradere*; the second, applied to the "luxuriant" culture of works of art, is *permutare*.[36] The first names what remains for Pliny the life of resemblance—its natural law, its human jurisdiction, its genealogical dignity. Its constituents, in more exact terms, are to transmit, to give, to teach, all notions implied by the Latin notion of *traditio*. It places future generations under the immovable gaze of past generations. It gives the relation of resemblance a truth, a movement that is less spatial than temporal: a truth comparable to that transmitted by the face of our parents—one that cannot be exchanged at will and so lose itself in the facticity of a purely aesthetic circulation.

The verb *permutare* appears as the exemplary form of the death of resemblance. Pliny introduces the term by way of evoking the practice of "switching the heads of statues" (*statuarum capita permutantur*)—a practice that was widespread both in the imperial Roman world and during the Renaissance when Vasari was writing. We still encounter the results today, as evidenced by the inscription *testa non pertinente* under so many antique busts in Italian museums. The patrician who places Greek statues in the atrium of his home, in Pliny's view, is simply invading or infecting the genealogical space with "effigies of strangers."[37]

It is enough to run through the whole of the *Natural History* to realize that, for Pliny, the theoretical values attached to *permutatio* mirror exactly those of the *luxuria. Permutatio* is bound, above all else, to the world of exchange, of commerce, of money, and of the *auaritia* despised by the Roman encyclopedist: There was *permutatio* when the dictator Fabius Maximus altered the exchange value of Roman currency so as artificially to enrich his government.[38] There was *permutatio* when unequal values were exchanged abusively, as for example when Indians naively swapped their precious stones for lead.[39]

Permutatio is not restricted, however, to designating the abusive ex-

35. Pliny, *Natural History*, bk. 35, pars. 6, 7 (9:265).
36. Ibid., bk. 35, pars. 2, 4 (9:263–65).
37. Ibid., bk. 35, par. 4 (9:263).
38. Ibid., bk. 33, par. 46 (8:39).
39. Ibid., bk. 34, par. 163 (9:245).

change of materials. It also refers to the exchange of bodies, and in this respect it plays a role in the passage in book 35 suggesting the obscenity of "Epicurean" practices. In a sexual orgy everything, in effect, is mixed, everything is "turned upside down" (the other meaning of *permutare*); even the feminine is there switched with the masculine.[40] *Permutatio* thus also refers to sexual inversion, the "perversion of human morals" that Pliny never ceased to bemoan: it ruined good familial *generatio*, and the *transmissio* of integrity and dignity. We should not in the end be surprised that the notion of resemblance, which Pliny located culturally in the practice of ancestral images, receives its most general theoretical definition in terms of the model of the *imago*, which governs the "purity" of genealogical transmission and the constancy of a civic *dignitas*.[41]

There are two genres of resemblance in Pliny's view. The legitimate ones are resemblance by generation (the means of expressing its natural law) or by transmission (the means of expressing its juridical institution). The illegitimate one is resemblance by permutation, which unsettles both natural law and juridical institution. Legitimate resemblance institutes molded images, masks "engendered" by the direct impression of the face in plaster, cast in wax and painted so as to honor all noble Roman families. Illegitimate resemblance proliferates artificial images, simulacra in which resemblance becomes a simple exchange value, one of substitution, inversion, and perversion. The Pompeiian patrician who exhibits his collection of busts in the space that should be occupied by his family images, the megalomaniac emperor who grafts his own image onto a statue of Zeus—these are not people who are content to display fictional montages: they lie as to their actual origin, they deny their anthropological substrate, they commit the crime of "lèse-resemblance," they dare to treat genealogical transmission as a mere game of rhetorical exchanges and aesthetic substitutions.

The "fundamentalist" aspect of Pliny's arid judgment is as frightening as it is coherent. If it closes itself to all "foreign culture"—in a man-

40. Ibid., bk. 35, par. 5, (9:263). One also thinks of the text of Seneca (*Letters to Lucilius*, XIV, 95, 20–21 [4:94]), where *luxuria* is said to confuse the sexual genres, and so is blamed for giving women what are properly masculine diseases: "The greatest doctors, the founders of medicine, said that women do not lose their hair, and that they never suffered from gout of the feet. Meanwhile (in our day) one sees them with no hair and afflicted by gout. An unexpected change in feminine nature? No, it is a victory of women over their constitution; equalling men in their debauch, they also match him in his physical miseries. They age just like men, they drink just as much; in gymnastics, at orgies, they challenge the men."

41. One thinks here of the juridical expression *dignitas non moritur*, often discussed by P. Legendre, most notably in *Dieu au miroir: Etude sur l'institution des images* (Paris: Fayard, 1994), 99 (where, unfortunately, no legal analysis of the Roman *imago* is offered).

ner that is mitigated when addressing Athenian Greece but all the more
hateful when addressing pergamumian "Asiatic" culture, as in the pas-
sage where our author, who was a career soldier, deplores "the conquest
of Asia that first introduced luxury into Italy" (*Asia primum deuicta lux-
uriam misit in Italiam*)[42]—it is to defend not only the immemorial qual-
ity of an autochthonous juridical world but also the theoretical model
of a genealogically conceived resemblance. Art imitates nature, Pliny
says, only on condition that this imitation is thought of in the sense of
a strict line of descent. The phrase *natura omnium parens*, "nature is
the parent of all things," recurs throughout the *Natural History*.[43] Seen
through this lens, all the arts must make objects whose resemblance to
nature is equivalent to the resemblance of sons—generically and genea-
logically, naturally and institutionally—to their fathers.

An illuminating example of Pliny's way of thinking about resem-
blance comes in his discussion of grafting. This question is already ex-
emplary because it relates to an art—agriculture, which in its turn is
legitimated by a certain use of resemblance—that lies at the border of
nature and culture. Art imitates nature and also sometimes, as Cicero
said, "comes to the aid of nature" (*naturam adiuuat*). It does so when it
prolongs nature's own movements, as Lucretius explains by way of re-
lating the *insitionis origo*, the "origin of the graft":

> The example of seeding, the origin of the graft was given [to humanity]
> by nature itself, the creator of all things [*rerum primum natura creatrix*],
> which showed them that berries and acorns that have fallen on the
> ground, in their season, will produce swarms of offshoots soaring upwards
> at the foot of trees. It is from this that the idea of grafting new stems
> onto branches, and of layering new shoots in the ground, originated.
> Then they tried endless new cultures in their dear little fields, and saw
> wild fruits slowly soften by dint of the attention and care lavished on the
> land.[44]

In a similar manner, Pliny writes that "nature [itself] teaches" grafting
to humanity.[45] Such is the movement of *dignitas* and of filiation, the
movement of true resemblance. Men, however, as we know, are terrible
children: they amuse themselves by turning meaning upside down, by
ignoring every boundary, by transgressing the basic humility implied
by the hierarchical relation of resemblance. They believe that they can
go beyond their *parens* and abandon themselves to the *luxuria* of games
of switching likenesses. To illustrate the high point of this *permutatio*,

42. Pliny, *Natural History*, bk. 33, par. 148 (8:111).
43. Ibid., bk. 27, pars. 2, 8, 146 (7:389, 393, 481); bk. 29, par. 64 (8:225).
44. Lucretius, *De rerum natura*, 5:1361–66.
45. Pliny, *Natural History*, bk. 17, par. 99, (3:46).

Pliny gives the most extraordinary of examples, drawn from Nero's aesthetics, that of an agricultural grotesque, a tree that has been excessively grafted. The technique in question is neither the simple graft nor the cleft graft, but "grafting by combining," for which Pliny uses the verb *miscere*, which means to mix up, to confuse, to turn upside down:

> Near the waterfalls of Tibur, we saw a tree grafted in all manner of ways, loaded with fruits of all different kinds (*omni genere pomorum*), carrying walnuts on one branch, acorns on another, elsewhere grapes, pears and figs, pomegranates and various species of apple; but its life was short (*sed huic breuis fuit uita*). Because our experiments can never rival those of nature (*nec tamen omnia experimentis aedsequi [in] natura possumus*).[46]

Here we have both a marvel and a death sentence. The marvel of the tree—a human marvel, a marvel of experiment and not of nature—is that it is still a tree: it is a montage of different trees, a fictitious tree, a "mannerist" or baroque work of art. It breaks the normal cycle of resemblance, the *generatio* or *transmissio* that moves from parent tree to sapling. This is an unfamiliar offshoot, yet it resembles its parents too closely not to be itself the fruit of some fundamental perversion. It is a foreign creature, a hybrid; it resembles by permutation and no longer, strictly speaking, by transmission. Whether viewed as a marvel, a monster, or a work of art, this tree would transgress all limits of the law of resemblance: it would resemble everything, thus it would no longer resemble anything. Having lost its living substrate, it is nothing more than a "rhetorical device" of the plant world. As the corollary of its prodigious or artistic nature, it was bound by fate, as Pliny puts it, to wasting away, to rapid death.

Excessive grafting is thus likened to Nero's aesthetics of the grotesque, or to the gestures of grandiloquent madness that impelled certain emperors to graft their mortal faces onto the bodies of gods. It is a resemblance that is destined towards death, because it is a resemblance without residue, without memory, without tradition, without genealogical transmission. It is a resemblance that touches everything and so overextends and exhausts itself in that space where the genealogical bond assumes a substantial and continuing contact with the origin. It is for this reason that the masks of the ancestors, irrespective of their funerary use, give life to resemblance by perpetuating, from one generation to the next, the face of those who give honor and civic dignity to their *gens*. The imprint appears, in this regard, as the indispensable and unsurpassable model of any legitimate grafting of resemblance: direct contact with the face, the negative imprinting function of the mold

46. Ibid., bk. 17, par. 120, (3:63).

guarantees that each offshoot—each positive printing—will be a legitimate "son," legitimately resembling the face that it expresses. It is also for this reason that the daughter of a noble family who, upon marriage, leaves the paternal home is entitled to reproduce those images and to include them in the genealogical tree of her new house. The technical model of the imprint here reveals its full symbolic efficacy: on the one hand, the immediate and direct mold of the face metonymically guarantees the unique presence of the referent of representation; on the other hand, the positive print ensures the possibility of an indefinite multiplication based upon all the combinations that marriage makes possible. Because it is always there, in the family, and always available to be transmitted by family alliances, the Roman *imago* answers well to a dual— and seemingly paradoxical—anthropological function of limiting symbolic exchange while also incarnating its possibility. That is also, without doubt, its most fundamental juridical power.

THE ICONOGRAPHY OF NOTHING

BLANK SPACES AND THE REPRESENTATION OF LAW IN *EDWARD VI AND THE POPE*

Peter Goodrich

Asurprisingly unremarked feature of Reformation portraiture is the use of blank spaces, unmarked pages, and empty frames in the depiction of artifacts surrounding the subjects being portrayed. In a significant number of paintings over a considerable period of time, let us say between 1530 and 1630, the visual topos of blank or unmarked space is sufficiently common to merit theoretical reflection. To remark simply, as has been the tendency within art history, that these spaces of ironic or nonfigurative representation betray a nascent or unfinished quality to certain portraits hardly serves to develop our understanding of a problematic that has an enduring and in many respects curiously contemporary thematics. A few examples will help introduce this theme before I turn to examine in detail one exemplary portrait, *Edward VI and the Pope.*

The immediate visual context of blank spaces is most usually that of some species of political, mercantile, or legal power. Blank space here marks a potentiality, a space of becoming upon which the sovereign subject will inscribe their fictions, their credit, or their laws. Thus, to take an initial example from the end of our period, in a self-portrait dating from 1620 Sir Nathaniel Bacon (fig. 4.1) is depicted at his desk, on which books and other paraphernalia are piled. One book is open

This paper was delivered originally at the Tate Gallery "Dynasties" Symposium in London, December 1995. My thanks to the participants at the Conference and particularly to Margaret Aston, Valerie Hoare, and Joanna Woodall for constructive criticisms. My thanks also to Kaja Silverman, David Walliker, and to participants in the seminar held at Cardozo Law School, New York, and particularly Arthur Jacobson and Suzanne Stone for comments on a later draft. My thanks finally, and wordlessly, to Linda Mills for further suggestions and commentary.

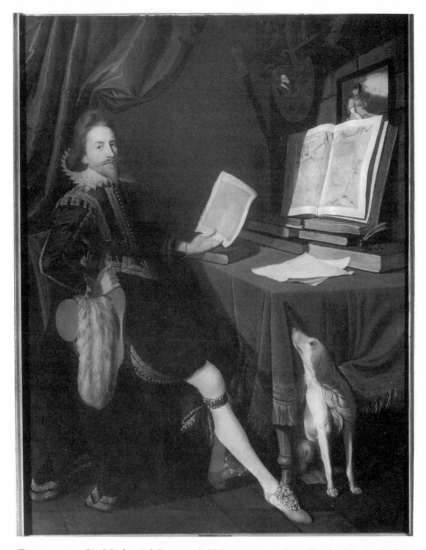

Figure 4.1: Sir Nathaniel Bacon, *Self-Portrait*, c. 1620. Gorhambury Collection; reproduced by permission of the Earl of Verulam. Photo: Witt Library, Courtauld Institute of Art.

and facing him with an elaborate map painted on it. In his hand is a sheet of paper in two tones but with nothing drawn or figured on it. In the context of the open book of maps and other papers bearing geometrical drawings, the first interpretation of the blank sheet is probably that it represents the space of a map that has yet to be drawn, and by extension, of a new world that awaits discovery and charting. The empty

space, or *carta nuda*, itself represents both the potentiality of *terra incognita* and the power or mastery of those who will discover, map, colonize, and claim what the English then viewed as the empty or pagan space of an unknown world.

The blank sheet in Bacon's *Self-Portrait* exists within a context of discovery and conquest, as well as of colonization and conversion, and it would seem appropriate to retain those connotations of political power and religious influence that the blankness of the page may serve to represent. In a second and somewhat earlier example, Cornelis Ketel's *A Man of the Wachendorff Family* from 1574 (fig. 4.2), the context of a blank scroll and unaddressed envelope is both mercantile and religious. On the rim of the circular portrait are the words *sermo dei aeternus caeterna omnia caducia* ("the word of God is eternal, all else is fleeting"). Within the portrait the merchant holds wordless papers or instruments, as if in recognition of the transience and inevitable erasure of all merely human endeavor. Where God inscribes his word upon nature, humanity can only mimic, inscribing ephemeral fictions on parchment or paper. In another sense, the blank sheets represent the power of capital, the potential of business instruments, of unmarked bills, to effect change in the world. The businessman's power lies in his ability to use his "talents" or his credit to creative ends; in the context of this ideal the blank sheets provide spaces upon which the merchant can inscribe his visions of commerce or of worldly wealth. Again, and without any great depth of interpretation, it seems apparent that the blank sheet or scroll has a complex significance, that it is, perhaps paradoxically, a nonfigurative figure or negative sign of a future or external power that irrupts within the frame of painting.

One further introductory example can be taken from the earliest surviving individual portrait of *Elizabeth I when Princess* (fig. 4.3). This unattributed portrait of the future queen dates from 1546 and depicts the princess facing the viewer and holding a closed Bible. On a lectern, next to her right hand, is a large open book whose pages are dramatically blank. Given its position, one might suspect the pages signal the potentiality, the yet unwritten laws and yet unrealized power, of the future queen's reign. Indeed, Elizabeth herself seems to have interpreted the portrait along these lines. In a letter dated 15 May 1547, which apparently accompanied the portrait, she remarks upon the relation of visible to invisible, of figure to ghost or spirit in the following terms:

> For the face, I grant, I might well blush to offer, but the mind I shall never be ashamed to present. For though from the grace of the picture the colours may fade by time, may give by weather, may be spotted by

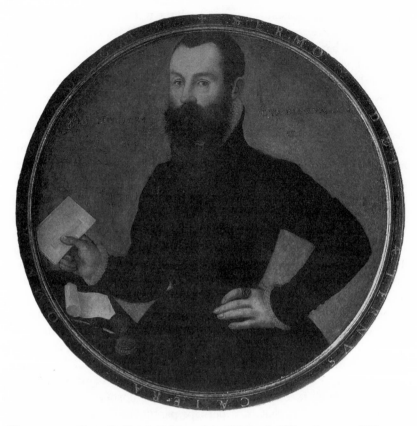

Figure 4.2: Cornelis Ketel, *A Man of the Wachendorff Family*, 1574. Rijksmuseum, Amsterdam.

chance, yet the other nor time with her wings shall overtake, nor the misty clouds with their lowerings may darken, nor chance with her slippery foot may overthrow.[1]

Whether or not the letter refers directly to the specific portrait under discussion, the Anglican thematic that links power to invisible causes, and simultaneously denigrates the corporeal figure or plastic face of presence as both impermanent and deceptive, is important.

In all three of these examples, the blank space is linked closely to power and to its theological formulations. The blank space is neither innocent nor indifferent, indeed it signifies a greater power and allows us to formulate an initial hypothesis relating to this topos. The failure

1. Cited in Janet Arnold, "The 'Pictur' of Elizabeth I When Princess," *Burlington Magazine* 123 (1981): 303–4 (spelling modernized).

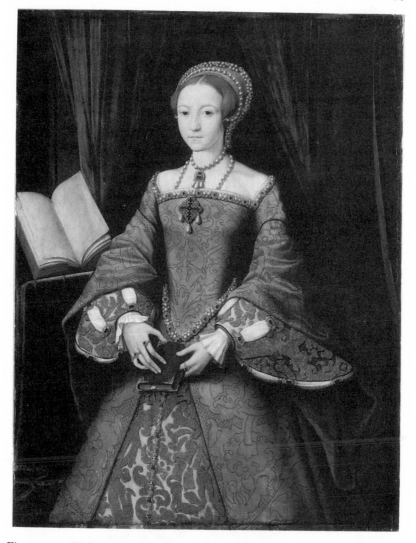

Figure 4.3: Unknown artist, *Elizabeth I when Princess*, 1546. Royal Collection, © Her Majesty Queen Elizabeth II.

to comment upon this visual curiosity of Reformation portraiture may well relate precisely to the excessive meaning of the figure of blankness or unrepresentability. The blank space interrupts and disrupts the figurative scheme; it is a rupture or fracture of the closed space of the portrait.[2] More than that, it is the sign of an outside breaking into the

2. Of particular importance with respect to the theme of irruption or of rending or tearing is Georges Didi-Huberman, *Devant l'image: Question posée aux fins d'une histoire*

representation of the face, and in the end may itself figure the impossibility of portraiture, the inevitable failure of all attempts to figure "the other"—which, in Elizabeth's words, neither time nor clouds nor chance can overthrow. The empty space is never simply empty: it sublimates, it displaces, it transgresses and so acts as the most extravagant and most paradoxical or liminal of figures. The most powerful example of this theme can be taken from a group portrait that was originally thought to be chronologically as well as thematically contemporary with that of *Elizabeth I when Princess.*

An Allegory of the Reformation

The Tudor group portrait, *Edward VI and the Pope; or, An Allegory of the Reformation* (fig. 4.4) has been the subject of considerable art historical and interpretative controversy. Recently it has been reinterpreted dramatically in Margaret Aston's meticulous and detailed study *The King's Bedpost.*[3] Aston argues convincingly, on the strength of internal evidence, that the painting, originally thought to have been composed in 1547, should be dated some twenty years later and, in light of that fact, should be interpreted as a warning addressed either to Queen Elizabeth or to Thomas Howard, Duke of Norfolk, concerning the dangers of idolatry or of a relapse into Roman ways and papal superstition.[4] It will be my argument that the picture does indeed warn against images but that the most remarkable feature of this doctrinal message is expressed in the emblematic blank panels or framed empty spaces that bisect and structure the painting.[5] It is this representation of the unrepresentable nature of power, this inscription of the facelessness of the source of law, this iconography of nothing, that expresses the novelty of the painting and of the doctrine it inscribes.

In synoptic terms, the picture shows a bloated and dying King Henry

de l'art (Paris: Minuit, 1990). See also, though here in the context of cinema, Kaja Silverman, *The Threshold of the Visible World* (New York: Routledge, 1996), 39–83.

3. Margaret Aston, *The King's Bedpost: Reformation and Iconography in a Tudor Group Portrait* (Cambridge: Cambridge University Press, 1993).

4. Ibid., 6–12, 214–18. The earlier view is to be found in Roy Strong, "Edward VI and the Pope: A Tudor Anti-papal Allegory and Its Setting," *Journal of the Warburg and Courtauld Institutes* 23 (1960): 311–13; R. Strong, *Tudor and Jacobean Portraits* (London: HMSO, 1969), 1:344–45.

5. On the biblical source of its doctrinal message, and most specifically the argument that the Second Commandment prohibits idolatry because it circumscribes divinity through its denial that creation may yet take new forms, that it may yet become other, see Arthur Jacobson, "The Idolatry of Rules: Writing Law According to Moses, with Reference to Other Jurisprudences," *Cardozo Law Review* 11 (1990): 1079.

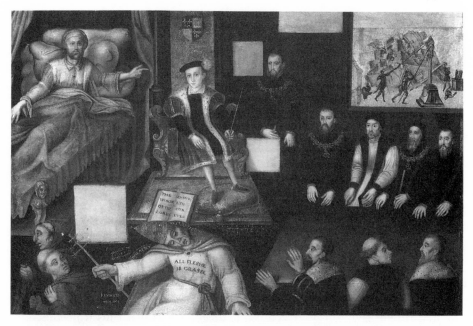

Figure 4.4: Unknown artists, *Edward VI and the Pope; or, An Allegory of the Reformation*, c. 1568–1571. Courtesy of the National Portrait Gallery, London.

VIII, lying in bed and pointing past his son Edward VI to his councilors. In the foreground of the picture, the pope has his head bowed under the weight of what is presumably the holy book on which is written "the worde of the Lorde endureth forever." Beside the pope are written the words "Feyned holiness" and "idolatry," while on his chest are inscribed the words "All fleshe is grasse." In a political reading the picture not only depicts the passing of power from Henry to Edward but also represents the legitimation of that transmission of power through the denunciation of papal authority and the Roman creed. The visual elevation of the king above the pope serves to remind the viewer that the context of the picture is that of the expulsion of papal superstition (the "tincture of Romanism") and the annexation, or in the Reformers' terms the restoration, of the power of Rome to the English crown and to a common law that had long pretended to have jurisdiction over matters both spiritual and temporal.[6] The English Reformation, it was argued,

6. The reformist claim is made most strongly in Bishop Aylmer, *An Harborowe for Faithfull and Trewe Subjects against the late blowne blaste* . . . (Strasborowe: n.p., 1559), fol. E 4 b, praising the continued succession of the English constitution as "the witness of time, the candle of truth, the life of memory, the lady of life, and the register of antiquity. Wherefore let no man disdain histories or find fault with us." The strongest legal version of this claim to English antiquity is to be found in Sir John Fortescue, *De laudibus legum*

did no more than return the two orders of law to their inherent source: "We have overthrown no kingdom, we have decayed no man's power or right, we have disordered no commonwealth. There continue in their own accustomed state and ancient dignity the kings of our country of England."[7] In doctrinal terms the supremacy of the Crown and the legitimacy of Edward's accession is portrayed in this painting through a combination of words and images that literally and visually indicate the priority of the (vernacular) word over the (romanist) image. In its humble way, the painting is "a variant on the theme of *ut pictura poesis*, painting as poetry, on the lines of *ut pictura scriptura*, painting as prose or verbal communication. It carries (or rather it carried or was intended to carry) its own explication, in written captions that were an integral part of the composition."[8] What is peculiarly striking and as yet inadequately explained is the ironic fact that rather than representing the priority of the word in the form of writing, the painting makes dramatic use of spaces free of both the "paint of Rome" and the marks of the "inke divinitie."

One specific and essential feature of reformist doctrine, or of the new rule of law, can be traced in the diagonal axis that runs from the top right to the bottom left of the picture. In the top right corner, directly above the king's council, who will advise and govern during Edward's minority, is an inset picture of the tower of Babel burning and in ruins while in front of it soldiers topple and smash statues and other plastic images. At the bottom left, below Prince Edward's dais, literally under his feet, the pope and his monkish entourage are being driven out of the frame and explicitly labeled idolaters. Connecting these two extreme points are five explicitly drawn and framed empty panels or blank spaces.

Art historians have previously assumed that these blank spaces simply

Angliae (1468; London: Gosling, 1737), 32–33, claiming that "neither the law of the Romans, which are cried up beyond all others for their antiquity, nor yet the laws of the Venetians, however famous in this respect. . . . Nor, in short, are the laws of any other kingdom in the world so venerable for their antiquity." The theme is repeated in these terms throughout the later tradition, perhaps most famously by Sir Edward Coke, *Reports* (1610; London: Rivington, 1777), pt. 1, fol. B 1 a: "But if you will give any faith to them [the Annals], let it be in those things they have published concerning the antiquity and honour of the common laws: first they say that Brutus, the first king of this land. . . ." This antiquity or proximity to nature, and so to natural law, made common law in principle a unitary jurisdiction. For discussion of this dual *topos* within the Inns of Court, see Peter Goodrich, *Languages of Law* (London: Weidenfeld & Nicholson, 1990), 71–90. See also Goodrich, "Salem and Bizance: A Short History of the Two Laws," in Goodrich, *Law in the Courts of Love: Literature and Other Minor Jurisprudences* (London: Routledge, 1996).

7. John Jewel, *Apologia Ecclesiae Anglicanae* (London: n.p., 1562), fol. G i b.

8. Aston, *King's Bedpost*, 1.

indicate that the picture was unfinished or that previously painted text had been erased. According to Aston, however, these blank spaces were drawn and redrawn on the panel on which the picture was painted "so as to define the places where the texts were to go." She notes that "when the picture was examined by infra-red reflectography, it was revealed that these tablets, or framed spaces for texts, were an integral part of the original composition. They seemed, indeed, to have been the feature that was most important to whoever organized the elements of the composition."[9] It is surprising and I will suggest indicative of the more complex legal meaning of the painting that although these central empty panels were obviously of immense importance, although there are words elsewhere in the picture, and although there is even a shadow across one of the blank tablets, examination revealed no traces at all of any inscriptions: "the five lead white spaces remain uncompromisingly blank."[10]

I will argue that this is neither "unfortunate," nor a sign of the erasure of text nor of the incompletion of the painting.[11] The assumption that empty panels in a Reformation painting of the transmission of power mean nothing more than that text has been lost, forgotten, or omitted is unsupported by evidence and implausible both in principle and in terms of the political and legal context of the work. The blank frames are rather to be understood as crucial if paradoxical visual representations of the Reformers' iconoclastic doctrine and direct expressions of the new, imageless or literal form of law. The first blank space, within the frame of the inset picture of the tower of Babel, clearly indicates a doctrinal intention. Juxtaposed to a depiction of the fall of idolatrous pretension, the space provides an explicit (framed) origin and significance to the blank panels. It is this order or iconography of nothing that I will endeavor to trace and to interpret.

Most obviously, the picture warns in diverse ways of the dangers of idolatry and of the "image-worship," "image-service," and "dumb ceremonies" that the Reformers associated with Roman Catholicism.[12]

9. Ibid., 3.

10. Ibid., 4.

11. Ibid., 1: "It is unfortunate for us that most of the verbal messages of the painting are lost for ever."

12. See, for an early example, William Tyndale, *An Answer unto Thomas Mores Dialogue* (London: n.p., 1530), fol. C x b, H 3 b, and also Robert Barnes, *A Supplicatyon made by Robert Barnes doctoure in divinitie unto the most excellent and redoubted prince kinge henrye the eyght* (Antwerp: S. Cock, 1531). The other major English sources for such a doctrine are Bishop John Hooper, in *Early Writings of John Hooper (1547–1551)*, ed. Simon Carr (Cambridge: Parker Society, 1843); John Foxe, *The Acts and Monuments* (London: n.p., 1563).

In its representations of image breaking and of the demise of the pope, the picture portrays the Lutheran doctrine of *sola scriptura*. But while words and images clearly contribute to the meaning of the picture, the five blank panels must also be accounted for. Aston's study of the painting irrefragably indicates that these frames were crucial to the composition and were at several junctures repositioned, without ever being inscribed. Even in the most immediate visual terms, the shadow cast by Edward over the lower corner of the frame beside his dais suggests that the emptiness of the panel was both complete and intended. The fact that the largest empty frame is placed between Henry and the fallen pope again suggests a considered doctrinal emphasis to the scene. These white spaces, empty panels or tablets, are, I will argue, of considerable structural and so also doctrinal significance to the work; they represent or rather emblematize its principal theme, that of the transmission of power through imageless forms.

I am aware that it may appear presumptuous for a lawyer to attempt a further interpretation of a picture that has been so comprehensively studied. Not least for this reason, I will not attempt an art historical reconstruction of the painting but rather a jurisprudential commentary focusing upon and interpreting its blank spaces as what Freud would have termed the "other scene." I will thus be considering the unconscious meaning of the picture, both in its original context and in that of its present-day interpretations. In a psychoanalytical sense, the image is precisely the figure of unconscious thought or dream work; it is peculiarly apposite that the picture to be analyzed here is literally permeated with *lacunae* or gaps, that it revolves visually around white surfaces, blank spaces, or empty frames. They are tropes of a new doctrine and of new beginnings, but they also represent the empty page of the book of law, the anticipation of and preparation for inscription, the moment of power, of legislation or of judgment. I will argue, therefore, that the allegory of the blank page, unmapped space, or *tabula nuda* has a peculiar significance within *Edward VI and the Pope*. Certainly in legal terms the empty tablets are signs that can be used to reconstruct another or further set of meanings.

Three aspects of the absent signs or empty tablets are jurisprudentially crucial. The first issue dates back, at least in textual terms, to the second century and is that of *tabula picta*. In immediate terms, the issue raised by Roman lawyers was that of ownership: Who owns the blank panel upon which an artist paints an image? The answer depended in early law upon the relation of image to substance, and was dealt with in terms of ownership by accession: the image, at least for Roman lawyers, was a real thing, a living relic or soul, and had greater substance

than the support upon which it was painted. The second issue relates specifically to the recurrence in the Reformation of the much earlier debate over the *ius imaginum*, or law of the image. The Reformers argued that the Second Commandment forbade all plastic or figurative representations of divinity, including crosses and ornate vestments, and it is this doctrinal argument that I will pursue.[13] The specific example I will use concerns "aereall," or vanishing, signs and can be formulated most succinctly in terms of the role of the image in the transmission of divine and latterly secular power. The issue can be addressed best historically in terms of *utrumque ius*, or the enfolding of one law, the canon law, into another, the secular. *Edward VI and the Pope* represents a massive transfer of jurisdiction, a transmission that took place by means of a movement or reformation from image to imageless writing, from the ghostly power of the Church to the bare letters of law. The third aspect of the picture then concerns the genealogy of power, a transmission that takes place not only through the death of the king, but more profoundly through the movement from one form of representation to another, from image to what rhetoricians termed "painted words," from the false truth (*veritas falsa*) of the picture[14] to what could be termed the dissimulation of writing, and specifically the writing and rewriting of law.[15]

The allegory of the Reformation represented in *Edward VI and the Pope* can thus certainly be taken as a warning or homily or moral tale intended for Elizabeth or Howard. At another level, however, it is a representation of the birth of a modern and potentially unitary legal power in the monumental form of the king's arrogation of authority over the church as part of his "imperial crown." The picture in this sense represents the enfolding of two jurisdictions and two laws, a superimposition in which the principles of spirit and lineage, of image and authority are translated from the domain of conscience to that of law. In this respect the picture, and specifically the blank panels or white

13. One of the most influential versions of this argument is to be found in John Calvin, *Institutes* (1536 ed.; London: Collins, 1975), 21: "The ultimate evasion is that they call them [i.e., images] 'the books of the uneducated.' . . . From one word they could have learned more than from a thousand crosses of either wood or stone." The most influential English version of this argument is to be found in James Calfhill, *An Answere to the Treatise of the Cross* (London: Denham, 1565).

14. On the "false truth" of the picture, see Andreas Alciatus, *De notitia dignitatem* (1530; Paris: Cramoisy, 1651), 190: "*Quid est pictura? Veritas falsa.*"

15. The dissimulation of writing was referred to in the maxim *qui nescit dissimulare nescit regnare* ("he who knows how to dissimulate knows how to rule"). See George Puttenham, *The Arte of English Poesie* (London: Field, 1569), 155, sub "*allegoria.*" For a recent discussion of this theme, see Jacques Derrida, *Dissemination* (Chicago: University of Chicago Press, 1981).

spaces, represents a peculiar and ironic or at least paradoxical triumph of reformist doctrine. The empty tablet or virgin page represents the power and potential of the word: the blank panel is an image, but it is an image that makes way for the word, an image that should be read "like the words in books."[16]

In a somewhat more polemical vein, although one well in keeping with the doctrinal and cultural context of *Edward VI and the Pope*, the reinterpretation of the picture through its empty spaces or blank images has a certain broader hermeneutic significance. The Reformists' call to read the image as a transparent sign or as writing inaugurates a new legal code of literalism and of print. What is at issue in the new law is not simply a novel hermeneutic, a Judaic emphasis upon the text, upon writing and its erasure, but also an unconscious return to an antique tradition in which *imago* and *ius*, image and law, were one and the same. The empty tablets can serve to recollect that the writing of law has archetypically taken place through the destruction of idols or false images, that the representation of power has required an icon of legitimacy, an inaugural image or first law which cannot take either a figurative or literal form.[17] The power of the image is thus given its strongest expression in an empty space or blank frame. The power of law exceeds representation; its image is an absence, an iconography of nothing, an empty space that is both not yet and immanent, both a becoming and an always already there, but in its nature unseen.

The context of the painting is a common law that, through the English Reformation and the Henrician Act of Supremacy, had arrogated the spiritual jurisdiction and its courts of conscience to the Crown. At the level of constitutional doctrine it enfolded two laws into one and thereby, it was claimed by the Reformers, it restored to the crown its "ancient jurisdiction over the State ecclesiastical and spiritual."[18] The common law could now in principle take jurisdiction over all disputes and so represent itself as a unitary law expressive of both divine and

16. Tyndale, *An Answer*, sig. xiiiv.

17. This theme is pursued in detail in Pierre Legendre, *Dieu au miroir: Etude sur l'institution des images* (Paris: Fayard, 1994), 185–89, and in legal terms in Peter Goodrich, *Oedipus Lex: Psychoanalysis, History, Law* (Berkeley: University of California Press, 1995).

18. See 1 Eliz Cap 1 (1559), Act of Supremacy. This theme is central to the Elizabethan establishment of an Anglican Church. See, for a further example, Dr. W. Fulke, *T. Stapleton and Martiall (two popish heretics) confuted and their particular Heresies Detected* (London: Middleton, 1580), 14: "the protestants are returned to the ancient faith which was in this land before Augustine came from Rome, which was not so much good in planting faith where it was not, as in corrupting the sincerity of faith where it was before he came."

human will.[19] In terms of our picture, this annexation of spiritual laws into common law jurisdiction gains a further expression in the merging of the unwritten law of the immemorial with an unseen and unrepresentable higher law. It will be my argument that the picture thus replicates, at the level of common law doctrine, the impossible unity that constitutes the word as both divine and human, both spirit and flesh. The expulsion of Rome would allow a return to an English *ius imaginum* and to a common law that had always claimed a divine source and origin in a complex unity of different laws: "Justice and law of nature are proved to be of one substance . . . of one quality and nature and therefore one. . . . Just as Christians say 'I am in the Father, and the Father is in me' so too law of nature may say 'I am in justice and justice is in me.'"[20] It is to the image of that impossible justice or absolute antiquity, the *ius imaginum* of English law, that the new textual order had to lay claim. To do so required neither image nor writing but rather the blank space within which an unrepresentable power and legitimacy could, paradoxically, be invisibly inscribed.

Tabula Picta

In theological and so also legal terms, the Reformation was concerned overwhelmingly with the status, the power and the peril, of images. Within what was still in practice a dual polity, a civil and ecclesiastical state, all aspects of public life were affected by the changing definition and role of images. In the wake of printing, the text was to replace the image as the principal form of communication of power.[21] To displace

19. The best discussion of this theme, from a legal perspective, can be found in the works of the Reformation barrister Saint German, *A Treatise Concerning the Division between the Spirituality and the Temporality* (London: Redman, 1534) and *Salem and Bizance* (London: Bertheleti, 1533), which argue that the spiritual jurisdiction had to be subordinated to that of the common law. As to the survival of the ecclesiastical jurisdiction, see Richard Cosin, *An Apologie for Sundrie Proceedings by Jurisdiction Ecclesiasticall, of Late Times by Some Challenged and Diversely Impugned* (London: n.p., 1591).

20. Sir John Fortescue, *De natura legis naturae et de eius censura in successione regnorum suprema* (1466), in *The Works of Sir John Fortescue, Knight* (London: private distribution, 1869), 234. Concern with the proximity of common law to natural law, by virtue of its age and its immemorial qualities, pervades the later tradition and allows for the constant claim that the Anglican Reformation restores common law to its rightful supremacy over other jurisdictions. See, for example, Aylmer, *An Harborowe*, defending common law against the foreign jurisdictions, and specifically the Roman law invoked in John Knox, *The First Blast of the Trumpet against the Monstrous Regiment of Women* (1558; Princeton, N.J.: Associated University Press, 1985).

21. For a general description of this process, see Elizabeth Eisenstein, *The Printing Press as an Agent of Change* (Cambridge: Cambridge University Press, 1980); for commen-

the image with the word was necessarily to revert to a tradition of writing and of written law, or *ratio scripta*. The word could contain the truth without confusing sense and reference, and it is this property of text that made it the ideal form for the inscription of law outside the idolatrous domain of image and *pictura*. Text, in the language of Roman law, was a faithful instrument; it acceded or yielded to the truth, it did no more, according to the English reformist barrister Saint German, than carry the message of "him who sent it," for the benefit of all to see.[22]

To understand the status of the blank space or tablet is to understand the space of inscription or written law. For the Inns of Court of the Tudor period, the privileging of law over ritual or arbitrary power was to be understood explicitly in terms of the displacement of the image by the word and by writing. This much remarked renaissance of the tradition of written law within the Anglican jurisdiction made use of the language of Roman law: to remedy the irrationality and confusion of common law, it was necessary "in our law to use the same remedy that Justinian did in the law of the Romans [and] to bring this infinite process to certain ends," namely to a textual form.[23] With respect to the *ius imaginum*, and specifically the legal status of the image, English law had from an early time recognized the glossatorial reduction of the image to the status of writing. As early as the last quarter of the twelfth century, in the anonymous work of *Lectura* on Justinian's *Institutes*, the glossatorial inversion of the early Roman privileging of the image over the word was formulated explicitly in terms of the accession of the image to the tablet, for the same reason that writing acceded to the text.[24] It is this issue that I will address, initially through a reconstruction of the history of the *ius imaginum* upon the specific issue of the power of the image.

The first legal issue raised by the empty tablets is that of *tabula picta*.

tary in relation to common law, see Peter Goodrich, "*Ars Bablativa:* Ramism, Rhetoric and the Genealogy of English Jurisprudence," in Gregory Leyh, ed., *Legal Hermeneutics* (Berkeley: University of California Press, 1992).

22. See Saint German, *Treatise concerning the Division*, sig. xiv. For a strong expression of the contrary view, see Sir Thomas More, *The Confutacyon of Tyndale's Answere* (1532), in *Collected Works* (New Haven: Yale University Press, 1973), 636.

23. Thomas Starkey, *A Dialogue between Reginald Pole and Thomas Lupset* (1535; London: Chatto and Windus, 1948), 174. For a discussion of the renaissance of Roman law in the Inns of Court, see particularly John Baker, ed., *The Reports of John Spelman*, no. 94 (London: Selden Society, 1978), 2:28–51.

24. See particularly the *Lectura*, text and translation, in Francis de Zulueta and Peter Stein, *The Teaching of Roman Law in England Around 1200* (London: Selden Society, 1991), at 2.1.34: "whoever is in possession of the tablet is entitled to keep the painting" (*uterque enim possidens, cum ab eo petatur permittitur offerre retinere; non enim licet auctori quod reo non permittatur*).

The question of who owns an image, namely, the artist or the person who owns the panel upon which it is painted, is formulated in early Roman law in terms of ownership by *accessio*, or accession. According to Gaius in the *Institutes:*

> 73. [W]hat a man builds on my land becomes mine by natural law, although he built on his own account, because a surface (*superficies*) accedes to the land.
>
> 74. Much more is this the case with a slip which someone has planted in my land. . . .
>
> 77. On the same principle it has been held that what another has written on my missive (*cartulis*) or parchment, even in letters of gold, is mine, because the lettering accedes to the missive or parchment. . . .
>
> 78. If someone has painted upon my panel (*tabula*), namely an image (*veluti imaginem*), the contrary is held, the opinion preferred being that the panel accedes to the image.[25]

Gaius's formulation of the *ius imaginum* gives priority to the image and should be understood as an extreme interpretation of the significance or power of the image in that the image alone, in contrast to land, crops, and writing, takes precedence over the substance that sustains it. Gaius's interpretation is disputed by the more iconoclastically inclined Paulus, who is reported in the *Digest* as stating: "Whatever is written on my paper or painted on my board at once becomes mine. Although in the case of a painting (*pictura*) some writers have held the opposite, on account of a painting's value (*pretium picturae*), yet where one thing cannot exist without the other, it necessarily accedes to that other."[26] Although the dispute as to images is remarked upon, the image has for Paulus become a picture, and the picture, like writing, is a transparency that accedes to the panel, to bare wood.

The disputed interpretations are repeated in later law. Justinian in the *Institutes* adopts Gaius's solution, justifying his conclusion by stating that it is "in our view better to make the tablet accede to the image. It would be ridiculous for a picture by Apelles or Parrhasius to accede to a tablet worth almost nothing."[27] In canon law, however, a different· position, closer to Paulus, is developed by Gratian in *De consecratione*. Here the image is assimilated to writing, and the maxim *pro lectione*

25. Francis de Zulueta, ed., *The Institutes of Gaius* (Oxford: Oxford University Press, 1946), pt. 1, 85. In *Digest* 41.1.9 (Gaius) the same interpretation is given, although on this occasion the word used is *pictura* rather than *imaginem*.

26. *Digest* 6.1.23.3 (Paulus).

27. Peter Birks and Grant McLeod, trans. and eds., *Justinian's Institutes* (London: Duckworth, 1987), 59 (*Institutes* 2.1.34).

pictura est, the picture takes the place of knowing how to read, is inter-
preted as explicitly reducing picture to text, image to writing.[28]

What marks the difference between blank tablet or bare wood and the
image, what distinguishes the iconic from the mundane, is precisely
the status or legality of the image. The *imago* is not the same as *pictura;*
the word *imago* means apparition, phantom, ghost, and is often applied
to figures of divinities and ancestors as objects of religious devotion,
but not to painted portraits. Historically the imago was a funerary image
and was the seat of the deceased's soul; it was that which remained
after the body decayed and in consequence had extraordinary religious
significance as relic or vestige, the living remains, the soul of the de-
ceased.[29] Under the *lex Julia* on treason, we thus find that "persons are
liable if they melt down statues or images (*statuas aut imagines*) of the
Emperor."[30] Only later did the image come to be regarded not as a
surviving virtue but as a mere likeness, a simulation or imitation. Gaius,
and following him Justinian, transmitted the law of pre-Christian
Rome, which included this exception—based on the religious signifi-
cance, in an age of *pietas*, of images of gods or ancestors painted on
panels—to the general rule of *accessio*.

In the English reception of Roman law, as remarked above, it was
the glossatorial position that prevailed, and the image, like writing, was
taken in law to accede to the *materia* upon which it was painted. In the
Tudor Inns of Court, the renaissance of Roman law provoked concerns
among adherents to the reformist doctrine with its hostility toward im-
ages. The *ius imaginum* had for a time to take a place secondary to the
call for a written text of common law, a systematization that would bor-
row from the civilian tradition both the language of written reason, or
ratio scripta, and the textual form of representation of power.[31] In adopt-
ing the reformist position in relation to the priority of the word, the

28. Gratian, *De consecratione*, dis. 3, c 27. For discussion of this point, see Pierre
Legendre, *Désir politique de Dieu: Etude sur les montages de l'Etat et du Droit* (Paris: Fayard,
1988), 228–32.

29. For discussion of the legal history of this point, see Thomas Glyn Watkins,
"*Tabula Picta:* Images and Icons," *Studia et Documenta Historiae et Iuris*, 50 (1984): 383.

30. *Digest* 48.4.6 (Venuleius Saturninus).

31. See Richard Taverner, *Institutions of the Lawes of England*, 1540, CUL syn 8.53.53,
arguing for a *Corpus Iuris Communis Anglicani*. See also John Rastell, *The Expositions of
the Terms of the Lawes of England* (1527; London: Totell, 1566), which introduced the
written word of common law into the Inns of Court. For a later example, see Sir Thomas
Smith, *De republica Anglorum* (London: H. Middleton, 1565). For a recent and significant
discussion, see Richard Ross, "The Commoning of the common Law: The Renaissance
Debate over Printing English Law, 1520–1640," *University of Pennsylvania Law Review*
146 (1998): 323.

common lawyers reinstated a theory of an originary law inscribed in England and accessible only to the common lawyer. In place of the image, which Fortescue had already warned against, there was the transparency and the antiquity of the word as the expression of the legitimacy of a peculiarly English constitution and law.[32]

In short, the *ius imaginum* was both more significant and more complex an issue than art history has generally recognized. The law of images, of which the debate over *tabula picta* was an unconscious repetition, concerned honor, nobility, and identity as well as power and law. The reason of the image was the reason of a law of succession in which the image represented lineage and its power derived explicitly from the fact that it delineated the legitimacy of rule. The image was a memorial upon which the title, honor, identity, and power of the heir was founded. Nobility was predicated upon the right to images: the image was the unique and legible sign of genealogical right and so of social and political place. The law of images was the law of political inheritance and social power: "the *imagines*, or *ius imaginum*, were the only ensigns of hereditary power."[33]

What is at stake in the debate over *tabula picta* is thus much more than the unconscious preservation of an ancient cult of images. The stake is that of transmitting a genealogical form of power: the image becomes the prototype of power, an emblem or institution in relation to which the subject can be defined.[34] The image is both name and substance, *ossa* and *nomen*, of law. It represents the structural quality or divine lineage of a legality that comes to the ancestors from the spiritual or unseen realm, from the absolute, and to the present not simply from

32. Fortescue, *De natura legis naturae*, 232, arguing that what is at stake in the image and in writing is the archive or memory of the origin of law. The Holy Spirit (*ymaginem*) engenders a law of nature from which justice and then law derive.

33. John Selden, *Titles of Honour* (London: Stansby, 1614), fol. C 2 a. Selden here draws upon an extensive literature within the Inns of Court as, for example, Gerard Legh, *The Accedens of Armory* (London: R. Totell, 1562), and Abraham Fraunce, *Insignia Armorum, Emblematum, Hieroglyphicum et Symbolorum* (London: Orvinus, 1586). The principal sources for this discussion were Bartolus de Saxoferrato, *Tractatus de insigniis et armis* (Venice: n.p., 1475 ed.), and Andreas Alciatus, *De notitia dignitatem* (Paris: Cramoisy, 1651 ed.). For a broader historical discussion of funerary images, see Florence Dupont, "The Emperor God's Other Body," in M. Feher, ed., *Fragments for a History of the Human Body*, pt. 3 (New York: Zone Books, 1989); Georges Didi-Huberman, "The Molding Image. Genealogy and the Truth of Resemblance in Pliny's *Natural History*, Book 35, 1–7," in this volume.

34. On the relations of power to image and image to kinship, see Pierre Legendre, *L'inestimable objet de la transmission: Etude sur le principe généalogique en Occident* (Paris: Fayard, 1985), esp. 47–64, and Legendre, *Dieu au miroir*; partially translated in *Law and the Unconscious: A Legendre Reader*, ed. Peter Goodrich (London: Macmillan, 1997).

the unseen or dead but from the lineage of those who would rule either the family or the realm, *patria* or *familias*.[35] The imago was the sign of the inherited right. It was the equivalent of tradition, the inscription of identity, nobility, and knowledge, the mark of power and of legitimacy, the vestige of a truth that was, in Selden's words, both first and *instar omnium*.[36] Moving to a Reformation idiom, the question of the relation of image to panel is reformulated in terms of the substantiality of images, the reality of the phantom, and is addressed in terms of the conflict between image and writing as the appropriate representation of the power or truth of law. The law of accession treated power as having a real presence in the image. For the Reformers the blank panel represented the possibility, the threat as well as the potential, of an image that had as yet no significance in itself: the blank panel was *tabula nuda*, free of any phantasm that might confuse the eye of the soul by conflating sense and reference, sign and substance. The image was to be replaced by the picture, and in reading the picture the threat of the image could be translated into the security and stasis of writing. In Selden's formulation, "hardly was any so idolatrous that could not upon mature consideration . . . confess a unity of nature in the multiplicity of Names . . . *lex in verba, dux in exercitu, hoc est in mundo Deus*."[37]

Aereall and Vanishing Signs

The second issue thus develops from the first. The doctrinal impetus toward destruction or erasure of images, is reflected in the blank tablets of *Edward VI and the Pope*, and can serve to recollect the stake of the war over images and the accession of the image to writing which was heralded in the maxim *pro lectione pictura est*. What was at issue in the destruction of the external image was control of the inward image, the "mind's eye" or eyes of the soul (*oculi anima*).[38] The issue of the phantasm, of image as substance or real being, was posed most strikingly in terms of the Reformation debate over the idolatry of "aereall" and other vanishing signs. The specific question was whether the sign of the cross made on the forehead, in the air, or with water could be idolatrous.

35. Adapting a medieval gloss, we could say that *imago ossibus inhaerent*, the image inheres in the bones.

36. Selden, *Titles of Honour*, fol. C 4 b.

37. Ibid., 3–4.

38. The terminology comes from John Jewel, *A Defence of the Apology of the Church of England* (London: Fleetstreet, 1567), 272–73: "There are eyes of the spirit (*oculi spiritus*) which are able to see things that are not seen, and have no being . . . for *oculi anima*, the eyes of the soul, will pass through all obstacles, whereas *oculi corporales*, that see visible things, cannot do so much."

Such signs vanished almost immediately; their materiality was transient and so in one sense it would be hard to conceive of them as objects of false worship, or *latria*. For the Reformers, however, the vanishing sign was the exemplary idol by virtue of being that much closer to the model it replicated. At issue for the Reformers was first a question of the causality and so of the legitimacy of power. Robert Parker, in *A scholasticall discourse against symbolizing with Antichrist in Ceremonies*, put it thus: "The cross aereall hath more need to be abolished than the material. . . . As in the mother, so in the daughter. Provided that the cross aereall be acknowledged the mother of the material."[39] Thus a second issue arises, that of the reality or substance of the image as something that lives on after death: "The image is, and always was, a vanishing aereall shadow, like the ghost or shade of one dead. . . . The cross aereall is more dangerous because in *similitudinem umbrarum, transeunt et intereunt* [in the likeness of images they cross over and are undone], they vanish and pass away like shadows."[40] Thus the less material or the more evanescent the form of signification, "so much the quicker is the passage *ab imagine ad rem significatem*,"[41] from the image to the thing signified, which is to say, the phantom, the soul, the cause of action.

Two points deserve to be stressed. First, the image, whether a vanishing or plastic sign, was taken to be dangerous explicitly because it represented both the divinity and the genealogy of power. The image represented the causal principle of power: we are what we are by virtue of whence we came. Second, what was problematic with the image as a representation of the impossible unity of substance and form was not its power but rather its legality. The dispute as to vanishing signs is a dispute as to the permissible or licit forms of the signs of the invisible. In the Reformers' argument the proper form of signification of invisibility or perfection was not what Calfhill termed the power of the air but rather the word, and in its purest form that word was spoken: God was heard but never seen, his voice was known but not his face.[42] The Reformers depicted the word as the licit keeping of the tradition, using exactly the same language as that which conveyed the error of image worship, for "those things which are spoken, are images of their souls."[43] The emphasis upon the scriptures was thus secondary to a conception of an oratorical word that was, in its strictest sense, the presence of the

39. Robert Parker, *A Scholasticall Discourse against Symbolizing with Antichrist in Ceremonies: Especially in the Sign of the Crosse* (London: n.p., 1607), 47–48.

40. Ibid., 47–48 (emphasis added).

41. Ibid., 49.

42. Calfhill, *Answere to the Treatise*, sig. 64v.

43. Ibid., sig. 65v.

Father in the Son: writing was in this respect artificial memory, a visual image—though a permitted one—of a precedent sound or speech. The dual nature of all signs was thus transmitted from the visual to the verbal, from the imagistic to the rhetorical and graphic, but the structure of seeing and reading were analogous.

The reversal that took place was not at the level of the structure or hierarchy of reference but rather at that of the lawfulness of specific types of sign: whereas the image had previously been the mark of memory, the book of the illiterate, the symptom or model of presence, that role was now to be taken by the word and the image was to be subordinated to it. Allowing that in the age of print the text was the principal type of the word and scripture the first source of faith, it follows that the image became an aspect of, and internal to, the text. Where in civil law previously the image took the place of knowing how to read, the text now took the place of knowing how to see: "we have not images of their bodies, but of their souls, for those things which are spoken . . . are images of their souls [and] the written lives of holy men are printed unto us, as certain lively images."[44] The irony of this position is of course that the word becomes an image.

In Jewel's *Defence of the Apologie of the Church of England*, we thus encounter the following description: "The word of God has different meanings according to its various properties and effects: where it multiplies it is seed, where it cuts the heart it is sword and divides flesh from spirit; where it binds together it is called net, where it washes us clean it is called water; where it enflames, it is called fire; where it feeds— bread; where it opens and gives entry—the key."[45] There could hardly be a more figurative or less prosaic definition of word or scripture. The word was a sign which was to displace the image. In its true form the word was to be read as a figure, as the prototype or exemplar of divine causes, as *verba visibilia*, as a sensible image, as light or sign of an absent truth; in its most radical formulation, even literal interpretations of the law by means of the text were a species of "ostentation or sophistry" in that it was the unwritten law, "graven not in stone but in the heart," that was to reveal the truth: *corde creditur ad iustitiam*, he who believes with the heart will do justice.[46] In explicitly legal terms, we may simply note that the same principle, that of interpretation of the letter of the law, was equally figurative; Coke, for example, states that in *lectione non*

44. Ibid., sig. 64v.
45. Jewel, *Defence of the Apology*, 144.
46. John Jewel, *An Apologie or Answere in Defence of the Churche of Englande* (London: n.p., 1562), fol. A viii b.

verba sed veritas est amanda—in reading it is not the words but the truth that should be loved.[47]

The blank tablets or empty spaces of *Edward VI and the Pope* now have a second significance, that of the displacement of the image to make space for the power of writing and, more specifically, the legitimacy of secular law. The passage of power is only partially represented in the figures of Henry VIII and Edward VI. The blank spaces represent a transition more profound and intangible than royal succession, the passage of the truth or reality of the imago, of Selden's origin or *instar omnium*, to the letter of the law. The image moves from figure to word—arguably from body to soul, from the dead to the living.

The third issue raised by the blank panels can be elaborated in terms of the enfolding of one law into another, the peculiarly English arrogation of powers spiritual and the courts of conscience to the secular or common law. The tablet or blank surface displaces the image; it represents a law of the heart, a law with images, a soul yet to be inscribed. Equally it is an internalization of power. The image is in doctrine nothing, or in reformist terms *idolum nihil representat quod subsistat;* it is *rei mortua*, to be replaced ironically by *littera mortua*, or the dead letter, the cold prose of law.[48] The clearest illustration of this principle of prosaic representation of the cause of power and, simultaneously, of the transfer of truth from ecclesiastical to secular law can be taken from another instance of bare or imageless wood representing the seat of power.

Phantasms of the Mind

The issue of the status of wood in civil reverence can be reconstructed from an exchange between the Anglican bishop Dr. Edward Stillingfleet and the recusant divine Thomas Godden. In *A Discourse concerning the Idolatry practised in the Church of Rome*, Stillingfleet had defended the Anglican prohibition on the worship of images (*latria*), but distinguished civil worship and gave as an instance of permissible civil reverence the honor given to the chair of state.[49] It is against this example

47. Sir Edward Coke, *The Reports* (1610; London: Rivington, 1777), pt. 3, fol. C 7 b.

48. N. Sander, *A Treatise of the Images of Christ and of His Saints: and that it is unlawfull to breake them, and lawfull to honour them* (Omers: J. Heigham, 1624), 109.

49. E. Stillingfleet, *A Discourse concerning the Idolatry practised in the Church of Rome* (London, 1671), 91–92. The same position and example can be found in William Perkins, *A Warning against the Idolatrie of the Last Times* (Cambridge: Legat, 1601), 96–97. For discussion of the latter text and its context, see Margaret Aston, *England's Iconoclasts: Laws against images* (Oxford: Clarendon Press, 1988), 408–15.

of civil worship that Godden reacts, and toward the end of his treatise entitled *Catholicks no Idolaters or a full Refutation of Dr Stillingfleet's unjust charge of Idolatry against the Church of Rome* he relates an anecdote that inverts the Anglican arguments against images, using them to ridicule those engaged in accepted forms of civil reverence: A gentleman passing the royal court, Godden writes, observed a countryman being apprehended at the entrance to the court by the "yeoman guards" because "the clown, it seems, would have gone into the Presence covered. They pulled him back, and told him that when he went into that room he must pull off his Hat." The peasant challenged that demand on the ground that he saw nothing in the court but a chair and a canopy. On being informed that it was the king's chair of state and that "he must do it to the chair out of respect for the King," the countryman demands to know "whether any worship at all were due to the Chair or no?" Mimicking the scholastic argument against Saint Basil,[50] the peasant reasons that the reverence or worship shown to the chair has either to be the same as that given to the king or distinct from it. If the same, then proper regal worship would be given to something beside the king, "which were treason." If distinct, then the chair would be worshiped "with regal honour for itself, and not relatively, which were for a man to submit himself to a piece of wood."[51]

Aside from more general arguments as to the inconsistency of the Anglican position (for example, that it allowed people to bow at the name of Jesus or to kneel at the altar), Godden's argument is that the countryman's objections arise from a peculiarly English empiricism, or indeed stupidity. The argument that a chair is a chair is a chair and no more denies all sense of aesthetics, of history, and of the symbolic. It also indicates an extreme inability to distinguish, or radical resistance to, the division between the visible world, or "spectacle of things," and the invisible force of which it is the spectacle.[52] The Protestant position against the image is presented by Godden both as repressive and as denigrating the subject that worships: civil worship simply implies, as does the use of images, an ability or intelligence capable of distinguishing "like proportionable reverence" from the honor due divinity. In scholastic terms, *honor est in honorante,* honor resides in the mind which

50. The often cited iconophilic topos attributed to Saint Basil is the maxim *honor qui eis exhibetur, refertur ad prototypa* ("honor shown to [images] refers to the prototype").

51. Thomas Godden, *Catholicks no Idolaters or a full Refutation of Dr Stillingfleet's unjust charge of Idolatry against the Church of Rome* (London: n.p., 1672), 179.

52. Calfhill, *An Answere,* sig. 169v: "The world itself is a certain spectacle of things invisible, for that the order and frame of it, is a glass to behold the secret working and hidden grace of God."

gives it. More than that, the image is simply writing, a mark of memory, a trace that can touch, depict, or reflect the colors of the soul but does not dissimulate that it is an image: "if one thing hath connexion with, or analogy to another, although invisible, when the former is represented to a person that understands the analogy or connexion there is between them, it is apt to bring to his remembrance the latter. Hence it is, that although the soul of man cannot be drawn in colours, yet when the body to which it is united, is represented in picture, the representation serves as a means to bring to our minds the perfections or graces of the soul which informs it; and not to draw them down to the figure and lineaments of a body drawn upon a Table, or carved in an image."[53] Within this perspective *latria* (honor due exclusively to God) and *dulia* (honor that also belonged to God, but which could also be given to images) can be distinguished by virtue of the difference of their object, one ending in or terminated upon the divine substance, the other relative to the signs or marks of divine governance or dominion.

More significantly, in terms of our picture, the Anglican response of Stillingfleet to Godden's work reverts explicitly to legal argument. The original claim had simply been that there was a categorical distinction to be made between divine worship and civil worship and that "bowing towards the Chair of State" or the king's picture or garments was "of the same nature with putting off of our Hats" while in court or church— it was a relative or inferior honor and should be conceived as a natural act of reverence, similar to "that way which the ancient Christians did use to direct their worship."[54] At a more fundamental doctrinal level, the argument in relation to the Chair of State was linked to a distinction between two forms of law. Divine worship was to proceed without the use of either external or "inward images" for the reason that God had so prescribed. In the case of the reverence shown the chair of state, a separate and more secular source of law operated: "All expressions of respect depend on custom and the Prince's pleasure, or the Rules of the Court, the only question a man is to ask, is, whether it be custom of the Court, or the will of the Prince, to have men uncovered."[55] It is the law, custom, or common practice of the court that determines the material or secular issue of reverence, and while it entails an element of symbolism and of indirect representation, the knowledge of civil matters and common laws was, at least for Stillingfleet, distinct from those

53. Godden, *Catholicks no Idolaters*, 84.

54. Stillingfleet, *Discourse concerning the Idolatry*, 91–94.

55. Edward Stillingfleet, *A Defence of the Discourse concerning the idolatry practised in the Church of Rome, in answer to a book entituled, Catholikes no Idolaters* (London: Robert White, 1676), 849–50.

images that purported to relate to a God whose essence was invisibility and whose substance was a self-presence that denied the possibility of any further representation: divinity could neither be painted, nor through any "creature, nor phantasm of God in our minds" be portrayed.[56]

Conclusion

What such a conclusion means can be reformulated in terms of the blank tablets and the causal principle of power. The tablet represents nothing, and nothing is the ideal form of transmission of power. A blank panel, an empty chair, wood, parchment, or text are the ideal or lawful types of sign of truth. What they have in common is that they are vanished signs, and so allow for the inscription of a law whose letters will accede to the permanence of their textual representation. In the legal terms of the glossators, the letter was a silent messenger. *Edward VI and the Pope* illustrates a most signal feature of the modern form or scripture of power. Just as reformist doctrine demanded that the plastic image accede to the invisible form of truth, so too the textual inscription of law was to efface itself in the name of a literal or pure meaning. Where the picture had classically taken the place of knowing how to read, the text, and specifically the printed word, was to take the place of seeing. The *specular* forms and visual symbols of legal power were to be displaced by an imageless art or "solely scriptural" representation of law. In each case, in the domain of the visual as in that of the literary and legal, the doctrinal purpose was comparable. It was that of transmitting an absolute authority, God or law, which was to be inscribed invisibly upon the heart and read directly by inner eyes.

The imageless space or blank prose of law are pursued by an irony that the Reformation recognized and which contemporaneity has begun to recollect in the various forms of its concern with images. If my thesis is correct, the Reformation transposed the image—specifically the power of the image—from a plastic to a scriptural form. This transmission occurred simultaneously with the annexation of the powers of the Church to the laws of the Crown. What has been forgotten as much by legal doctrine as by art historians is that the power of the image and in consequence the authority of the word is dependent upon an unrepresentable origin or source. The blank panel is a paradoxical representation of an infinite space, of the limitlessness of inscription, of a divine power that is both law and more than law. In jurisprudential

56. Stillingfleet, *Discourse concerning the Idolatry*, 79.

terms, the empty panel or blank tablet serves to depict a law that both precedes and exceeds language, a law that is beyond memory and beyond the power of inscription, a law of nature and of God. It is precisely the law of law that the empty space both reveals and conceals in its display of nothing.

The blank tablets also represent an inner law, a faith or *caritas* that internalizes the inexpressible or unrepresentable character of the source of law and the site of power. Where the Reformers said, "Take off the paint of Rome and you undo her," the postmoderns will say, "Take away the literality of law and you undo her." *Edward VI and the Pope* represents a movement in doctrine from the simulation of images to the dissimulation of writing, from painting to printing, from conscience to a laicized form of law. What I have tried to argue is not only that the blank spaces are of crucial significance to the interpretation of the doctrinal import of the painting but also that they represent the transformation of a specific principle or form of power from the visual to the scriptural. In this sense, the empty spaces represent the impossible form or duality of power, namely that it must be both external and internal, spiritual and corporeal, obeyed and desired. Both painting and writing depend upon a prior and empty space. Whether internal or external, painted or written, the law had to invest that space of origin or of ultimate authority with a divine or transcendent significance. The blank tablet teaches us that power cannot in the end be represented in images any more than the source of law can be inscribed or written down. Where Margaret Aston argues that this picture "may once have spoken with silent words,"[57] I will add that it may eventually come to represent with blank images, empty tablets, or unwritten panels.

This argument may be posed finally in terms of justice and its visual representation. What in the final instance is significant about the blank spaces that both structure and signal the transmission of power in the portrait is their refusal to offer a figuration or face of power. The principle of sovereignty and of authority or legitimacy is captured most graphically or strikingly in the framed blankness that depicts an absolute, and so absent, source, an invisible first principle, the *causa causans* that makes both power and law possible. The representation of sovereignty as being in essence unrepresentable, the nonfiguration of an invisible and so also indefinite principle or frame, first imagines power—the inestimable object of transmission—as the condition of possibility of law. The structural order of law is faceless and invisible because the source of law is so characterized. The laws of nature upon which secular law is based

57. Aston, *King's Bedpost*, 218.

operate by means of "aereall" or phantasmatic causes, and so, according to the classical principle of *imitatio imperii* ("imitation of the empire"), every delegate or shadow of the higher law should bear its form and so depends upon an unrepresentable other, a deity or death as origin and cause. In a deeper or at least less formalistic sense, the blankness of the tablets, the empty spaces that signify the possibility of law, can be understood as representations of the "aporia" of justice and of law.

Drawing upon recent expositions of the incalculability of justice as opposed to the reiterative quality of legal rule, it can be argued that the Reformation depiction of the empty space of power precisely designates, in a visual form, what has recently been termed the indeterminate space or aporia of justice.[58] It is here, in other words, that law again encounters aesthetics, across that space of fiction or of creative indetermination that is both the source and the creative possibility of justice. The space of justice, in other words, is prior to or other than law, it is disjunctive and undetermined, an indefinite creative possibility rather than a presumption, prescription, or prejudgment. To borrow from the critic Giorgio Agamben, "Justice is the handing on of the forgotten. . . . It is not the transmission of memory [but] the transmission of oblivion."[59] Justice, in short, is an empty space. More than that, it is the necessity of creating that emptiness, of keeping that blankness free of precedent or prior inscriptions, precisely so that something new, something that is not unjust, may be imagined. Put differently, justice as the recognition of and authentic response to the other in their singularity requires a momentary suspension of law. In philosophical terms this suspension of legality, this irruptive requirement of justice, is an emptying of the subject who judges, it is an attempt (perhaps impossible) to acknowledge and momentarily to discard prescribed rules and prior determinations. To recognize the uniqueness of the object of judgment is to accept that it is not known or decided in advance. The blank space would here represent the motion of judgment as the movement of becoming. It is that space of becoming, that subtle and unacknowledged possibility of justice, that fiction of subjective legislation, that *Edward VI and the Pope* lucidly and strikingly portrays in the ironic and perhaps unwitting form of blank frames or empty spaces.

58. This theme is spelled out in Jacques Derrida, "Force of Law: The Mystical Foundations of Authority," in Drucilla Cornell, Michel Rosenfeld, and David Gray Carlson, eds., *Deconstruction and the Possibility of Justice* (New York: Routledge, 1992). For an incisive reading of that text, see Margaret Davies, *Delimiting the Law: Postmodernism and the Politics of Law* (London: Pluto, 1997).

59. Giorgio Agamben, *The Idea of Prose* (Minneapolis: University of Minnesota Press, 1995), 79.

PART

III

THE ART AND ARCHITECTURE OF JUSTICE

THE FUNCTION OF THE ORNAMENT IN QUINTILIAN, ALBERTI, AND COURT ARCHITECTURE

Piyel Haldar

Consider we like cheese well enough, but we still cover it up.[1]

General Remarks on the Relationship between Law, Rhetoric, and Aesthetics

It has often been remarked that from the seventeenth century onward English common law completely eliminates the medieval conceptualization of law as a form of "art." Yet the image of law remains one of splendid environments within which the arcane and esoteric rituals of trial procedure are conducted. What will be argued here is that law continues to be structurally dependent upon aesthetic principles and remains grounded in the rhetoric of the image. This is manifest most explicitly in the physical architecture of the legal environment, more particularly, in the rhetorical figure of the ornament, which has served to instill oratorical practice with ideas of style, identity, exclusivity, and exclusion. This rhetorical function has not disappeared from Western legal systems but has been displaced and is to be found in the variety of architectural styles in which court buildings have been built since the seventeenth century.

A few preliminary remarks upon the ambivalent relationship between

I am grateful to Costas Douzinas, Adam Gearey, Lynda Nead, Paul Raffield, and Peter Rush. Peter Goodrich helped sharpen my ideas and provided me with invaluable references.

1. Wilhelm Busch, cited in Brian Vickers, *In Defence of Rhetoric* (Oxford: Oxford University Press, 1988), vii.

law and aesthetics may help identify what is at stake in such a relationship. The medieval art of law (*ius est ars aequi et boni*) defined the place through which divine justice spoke. As the medieval historian Ernst Kantorowicz once noted, it defined the judge as a poet, a sovereign artist who created the legal world according to fictions based on the precepts of natural law.[2] Furthermore, as an art, law was specifically identified as a genre of rhetoric. The oratorical skills of the medieval lawyer combined the *techne rhetorike*, based upon Aristotelian reasoning, with the *techne poietike*, the art of imaginary evocation. In this sense the art of law may be regarded as having created a specifically exegetic domain that revealed and regulated the relationship between God and man. Rhetoric, in other words, both rationalized and declared a higher authority. To exercise the rhetorical arts was to persuade by appeal to reason *and* to speak in a voice worthy of a transcendent divine authority. The art of law, particularly in the domain of rhetoric, was a solemn art designed to invoke the figure of God as a principle of causation that instituted and governed the forms of social and personal life: "Through harmony [rhetoric] holds human communities together. He who would put asunder what God has brought together for the good of men deserves the name of public enemy."[3] From Isocrates and Posidonius to Cicero, from Quintilian to John of Salisbury, the combination of reason and speech (*ratio* and *oratio*) formed the theoretical foundation necessary to normalize the subject's relationship to God. Put briefly, the premodern aesthetics of law evoked a generative principle that functioned as a regulatory ideal.

Modern common law replaces the supposed irrationality of a premodern legal system based upon art and conjecture with forms of critical inquiry based upon scientific techniques of rationality, proof, and demonstration. With the invention of printing, the development of lawyers' logic, and the advent of modern legal science the practice of reading the law became isolated, at least in theory, from questions of moral value. Influenced by the overall intellectual climate during the seventeenth century, the common law mind persisted in exiling the rhetorical and poetic arts from its imagination.[4] Philosophers had already sought to bring an end to Renaissance humanism by warning against the effect

2. Ernst Kantorowicz, "The Sovereignty of the Legal Artist: A Note on Legal Maxims and Renaissance Theories of Art," in *Selected Studies* (New York: J. J. Augustin, 1965).

3. Ernst Robert Curtius, summarizing John of Salisbury, in *European Literature and the Latin Middle Ages* (London: Routledge & Kegan Paul, 1979), 77.

4. On the direct influence of philosophy and science on seventeenth-century common law, see Barbara Shapiro, *Probability and Certainty in Seventeenth Century England* (Princeton: Princeton University Press, 1983).

of rhetoric and imagination upon reason and the mind's cognitive faculties.[5] Descartes had rejected rhetoric in search of a pure philosophy. Hobbes, in his *Elements of Law*, had denounced rhetoric in public life as a tool that, rather than persuading, coerced an audience into submission. Arguably, however, it was John Locke who most influenced common lawyers in reconceptualizing attitudes toward evidence and trial procedure. Locke, and his disciple Lord Chief Baron Gilbert, a lawyer who is commonly regarded as instigating modern evidence scholarship, famously attacked the study and practice of rhetoric as intellectually disreputable, as an "instrument of error or deceit," and as mere wordplay that renders illegitimate the otherwise natural connection between words and ideas.

> [I]f we could speak of Things as they are, we must allow, that all the Art of Rhetorick, besides Order and Clearness, all the artificial and figurative application of Words Eloquence hath invented, are for nothing else but to insinuate wrong Ideas, and move the Passions, and therefore by mislead the Judgment; and so indeed are perfect cheat: and therefore however laudable or allowable Oratory may render them in Harangues and popular Addresses, they are certainly, in all Discourses that pretend to inform or instruct, wholly to be avoided; and where Truth and Knowledge are concerned, cannot be thought but a great fault, either of the Language or Person that makes use of them.[6]

Meaning ceases to be at home in poetic language, a language that reveals, occults, or creates truth. In these epistemological terms, logic, proof, and demonstration continued to pursue higher levels of rationality and objectivity and culminated in the positivist idea of evidence as a science of proof. By identifying rhetoric as one of the "arts of fallacy" the seeds are sown whereby a concern for these poetic and artistic functions might well have disappeared from contemporary theories and the practice of law. The two disciplines of art and law are now theoretically

5. The denigration of rhetoric in the seventeenth century is more substantially explored in Thomas M. Conley, *Rhetoric in the European Tradition* (Chicago: University of Chicago Press, 1990). See also Chaim Perelman and Obrechts Tyteca, *The New Rhetoric: A Treatise on Argumentation* (Notre Dame: Notre Dame University Press, 1969); J. J. Murphy, *Rhetoric in the Middle Ages* (Berkeley: California University Press, 1974); Vickers, *In Defence of Rhetoric*; and J. Metzger, *The Lost Cause of Rhetoric* (Carbondale: Southern Illinois University Press, 1995).

6. John Locke, "Essay on Human Understanding," bk. 3, chap. 10, in *Works* (Oxford: Clarendon Press, 1975). See Lord Chief Baron Geoffrey Gilbert, *The Law of Evidence: To Which is Prefixed his Abstract of Locke's Essay* (London, 1760), in which verbal ornament is explicitly sacrificed in favor of judgments based upon evidence and demonstration. The concept of probability becomes a scientific one and moves away from the realm of rhetoric, according to which it was defined as plausibility and conjecture.

wrenched apart to the extent that any commitment to intellectualizing the two disciplines together tends to be marginalized. Indeed, the question of the relationship between art and law would not merit much attention or interest, were it not for the fact that both disciplines hide their relationship to each other and from each other. Yet nothing prevents the aesthetic scene of law from surviving under another guise. The repression of rhetoric, in other words, did not entirely banish rhetoric from law; it rather succeeded in denigrating and masking its uses. The idea that will be pursued here is that the art of law continues to exist, performing its own "other" regulatory scene behind and beneath the scientific pretensions of modern law and its courtroom procedure.[7] More specifically, law depends structurally upon rhetoric both to organize and to express its rule. I wish to suggest that in order to understand the way aesthetics operates in modern legal practice, and in order to understand its effects, an examination of humanist art theory seems essential. For once legal procedure became based upon moral certainty and rationality, the whole realm of aesthetic experience became isolated from law. The invention of modern common law procedure depended upon a form of repression that exiled the aesthetic and humanist notion of rhetoric to the separate and subjugated domain of art theory. Thus, once law specifically denies the moral value of the medieval arts in favor of less conjectural and more scientific approaches, the expressive function of the old rhetoric becomes assimilated by the discrete arts.

It is important to remember that the Renaissance developed a more or less discrete artistic genre, evident across the fine arts, that stressed the importance of expression and rhetoric in governing the emotional responses of the reader of literary texts or the viewer of paintings. Elements of rhetoric were well utilized by Renaissance artists to arouse emotions in the audience as an instrument of persuasion. Furthermore, the fact that rhetoric constitutes a domain of intersubjective discourse rendered it an appropriate communication system for those humanist authors who sought to reconstitute the ideal of human life freed from its bondage to the ecclesiastical and political orthodoxy of the Middle Ages. Thus, one possible method of recuperating an understanding of the role art plays in legal discourse might be to focus upon that discourse which is theoretically other to law itself, namely humanist art theory. For, ironically, law inevitably has to rely upon art. This is quite evident

7. The irony of the modern disavowal of rhetoric has been pointed out by many twentieth-century humanists. In the words of Curtius, "Rhetoric itself impresses modern man as a grotesque bogey . . . a subject which even the literary specialist hardly knows by name because he deliberately shuns the cellars—and foundations!—of European Literature" (*European Literature,* 79).

in the iconographic and architectural forms that continue to character-ize the legal environment.[8] The persistent dependency of law upon rhet-oric is, in effect, manifest in the physical architecture of law and can be reconstructed through the analysis of the tropes and figures of court-room design. Indeed, what happens when art is exercised according to the requirements of the legal profession, when it takes on the responsi-bility for designing court buildings and decorating the legal arena? Do we not see the return, or survival, of rhetoric in a different guise, yet nevertheless within its familiar aesthetic context? To understand the contemporary relatives of classical, medieval, or humanist rhetoric, we need not invoke specialized research on the pragmatics of legal commu-nication or even invent forms of "new rhetoric" or neo-Ciceronianism.[9] Instead, we will rely upon the more classical sense of figure and figura-tion adopted by humanist art theory and manifested in courtroom archi-tecture.

In this context, this essay seeks to examine the fate of the rhetorical ornament (*ornato*). It is a figure taken up in architectural discourse, and, as I shall argue, there is a very strong sense in which ideas of the orna-ment continue to perform functions essential to the legal world. Ac-cording to classical rhetoric, the figure of stylish ornament referred to what was beyond the clarity and lucidity of argumentation. Yet rhetori-cal ornaments were not regarded as the mere embellishment of lan-guage. For Quintilian, they were absolutely necessary in the cultivation of eloquence in court cases and bore expressive and cognitive values.[10]

In broad historical terms, however, the explicit study of rhetorical ornament was marginalized in law well before the overall decline in rhetoric (indeed, ornament might be one of the main reasons for that overall decay, as it tends to characterize oratory as secondary and im-pressive rather than as persuasive, pragmatic, or expressive). But as soon as the flowers of rhetoric begin to dry in the field of law, they germinate and flourish elsewhere, namely in the field of Renaissance architecture. Ironically, architecture may well be the "proper" home of the rhetorical ornament. Hersey, for example, argues that the rhetorical notion of

8. It seems fair to agree with Brian Vickers's thesis that the Renaissance arts pick up on the expressive function of rhetorical tropes and figures. See Vickers, *In Defence of Rhetoric*, 341.

9. Contemporary studies in rhetoric are largely characterized by attempts to recu-perate the values associated with lost rhetorical traditions in order to formulate a new rhetoric. See, for example, Perelman and Tyteca, *New Rhetoric*. For an overview of the twentieth-century renaissance in rhetoric, see Conley, *Rhetoric in the European Tradition*, which includes, in its historical overview, a brief critical analysis of the neo-Ciceronian rhetoric adopted by Jürgen Habermas.

10. Quintilian, *Institutio Oratoria*, trans. H. Butler (London: Heinmann, 1922), 3.7.3.

trope emerges from the use of the architectural trophy in classical build-
ings.[11] Architecture, in this respect, might legitimately claim a historical
priority to law, for it lays the foundation for the development of rheto-
ric. The reincorporation of ornament as a feature of architecture during
the Renaissance indicates not merely that architecture bears the residue
of legal rhetoric but that the rhetorical had always been part of the
material of architectural theory.

The importance of ornament in Renaissance architecture may be
witnessed in the works of Leon Battista Alberti, who devotes four of
the ten books in his treatise on architecture to the question of ornament
in particular contexts. Ornaments are considered in general, in sacred
buildings, in public secular buildings, and in private buildings.[12] While
most scholars seem to agree that Alberti's treatment of architectural
ornamentation is a humanist recuperation of classical Vitruvian archi-
tectural value, it is important to bear in mind the influence of Cice-
ronian rhetoric on Vitruvius's thinking.[13] Whatever the case, it is not
difficult to compare architectural ornament with its use in classical and
medieval rhetoric. In general terms, both the rhetorical and the archi-
tectural uses of ornament share similar supplementary functions, in the
sense that Jacques Derrida and others give to the word *supplement*.[14]
That is to say that while the ornament is embellishment and not part
of the essential, or structural, idea of the building,[15] its function goes
well beyond the surplusage of decoration. The ornament is not merely
what is surplus to the internal requirements of rhetoric, architecture,
or the court. Far from being a profitable accessory, I will ague that
ornamental architecture becomes a necessary condition of, and inextri-

11. George Hersey, *The Lost Meaning of Classical Architecture: Speculations on Ornament
from Vitruvius to Venturi* (Cambridge, Mass.: MIT Press, 1988).

12. Louis Battista Alberti, *On The Art of Building in Ten Books*, trans. J. Rykwert,
N. Leach, and R. Tavernor (Cambridge, Mass.: MIT Press, 1992).

13. Alberti advises painters to familiarize themselves with the poets and rhetors of
antiquity, who could motivate them to discover (*inventio*) and inspire them in giving form
to pictorial themes. Alberti's general designs for buildings were in accordance with spe-
cific rhetorical concepts; temples, for example, were to be built according to the rhetorical
concept of the *genus grande*. Alberti himself had written a brief treatise on rhetoric. See
Vickers, *In Defence of Rhetoric*, 341. For an account of Alberti's interest in rhetoric, see
J. Gadol, *Leon Battista Alberti: Universal Man of the Early Renaissance* (Chicago: University
of Chicago Press, 1969).

14. Jacques Derrida, *Of Grammatology*, trans. Gayatri Spivak (Baltimore: John Hop-
kins Press, 1976), and *The Truth in Painting*, trans. G. Bennington and I. Macleod (Chi-
cago: University of Chicago Press, 1987). More pertinently, see Derrida, "White Mythol-
ogy," in *Margins of Philosophy*, trans. A. Bass (Brighton: Harvester Press, 1982) on the
importance of ornamental metaphors, which have been marginalized persistently
throughout the modern history of philosophy.

15. Alberti, *On the Art of Building*, 6.2.156.

cable from, the essence and meaning of the work, be it the work of an argument or of an edifice, of oration or of fabrication. In a similar vein, Jean-Claude Bonne has recently argued that the function of ornamental borders around Carolingian ivories, for example, is to confer a persuasive power upon the image contained within them. Sacred power is instituted through the very beauty of the border itself, without which the function of the carved ivories would be redundant.[16] Hubert Damisch, to take a further example, argues that for Pliny ornaments set the scene without which figures would not be able to emerge.[17] And the medieval historian, Ernst Robert Curtius, argues that the *ornatus* is the essential rhetorical foundation according to which all the mannerist art forms were able to function.[18]

My argument, finally, is not intended as an analysis of rhetoric in any particular era, but rather attempts to provide a broad historical overview of the subject in order to ascertain the role ornamental rhetoric continues to play. The main part of this essay will examine architecture as ornament in the exemplary case of the courtroom. It will be argued that the aesthetics of law continues within modernity, with the rhetorical and architectural trope of ornamentation serving as a necessary and economical precondition for the work of law, the creation of its ordered world, and the protection of its sense of internal coherence. Moreover, in articulating the relation of the subject to the world and to others, ornament helps create an exclusive space that, above all, seeks to do what it has always done, namely to deny the speech of particular others. Quintilian, it will be noted, explicitly states that rhetorical ornament not only expresses a dignified image of law but constitutes a limit beyond which language becomes associated with the foreign ("Asiatic") and effeminate. Performing these various yet interrelated functions, the ornament thus has an economy essential to the law, to the science or art of maintaining its own domain.

A Brief History of the Ornament and Its Functions

To maintain the argument that ornament in its various guises has always been profitable to Western law, it is necessary to examine first Quintilian's *Education of the Orator*. Here ornament refers to what is beyond the clarity and lucidity of an argument. As the Roman orator makes

16. Jean Claude Bonne, "Les ornements de l'histoire a propos de l'ivoire carolingien de saint Remi," *Annales: Histoires, Sciences Sociales* 51, no. 1 (1996): 37–70.

17. Hubert Damisch, *The Judgement of Paris* (Chicago: University of Chicago Press, 1996), 214.

18. Curtius, *European Literature*, 274.

clear, where ornament is concerned vice and virtue are never far apart. It is difficult from the perspective of twentieth-century legal theory to appreciate fully the moral values associated with brilliance in language, charm in figures, magnificence in metaphors, and artistry in composition. At one level, ornaments are deemed to be supplementary to the essence of language, for without an initial sense of propriety in language ornament would not be possible. Propriety is the precondition to the avoidance of error; only after proper language has been secured can the *appropriate* flourishes of fancy verbiage be added. A paradox emerges, however, from the economy of this argument. On closer examination, Quintilian suggests that without ornament language is impotent as a form of communication. The embellishment of speech is a form of thinking in images (*eikon*); only through ornamentation does language become vivid. Ornaments thus bear an expressive function, as cognitive tools that presuppose the dimension of meaning opened up by rhetoric. In making this argument, Quintilian points to the function of vivid detail—flamings pouring from houses, the crash of roofs and clamor of voices—in enlivening the description of the sacking of a city.[19] Quintilian concludes by stating that "the real power of oratory lies in enhancing or attenuating the force of words."[20] Far from being merely supplementary, there can, in fact, be no power of persuasion without ornament.

For the Romans, then, it was not sufficient for the advocate to speak with lucidity or clarity; he should be at the service of a cause greater than the particular case and should direct his words not solely to persuading the judge but to winning the enthusiastic approval of the world at large. Again, this function of language can only operate through the use of the ornament. Ornamentation not only furthers the particular case but it captivates the audience; when an audience finds it a pleasure to listen to the words of an orator, their attention and readiness to believe are increased. Quintilian illustrates his argument with the example of Cicero, who, in defending Cornelius, received not mere acclamation but thunderous applause.

In terms of recent psychoanalytic jurisprudence, if ornamental rhetoric requires thinking and orating in images, then it testifies to the power of law over the imaginary of its subjects and to its ability to capture the auditor through the paradigms of fascination, belief, and faith.[21] Rhetoric becomes a technique of subjectivity as well as of persuasion and implies a theory of images that seduce the subject and manipulate his emo-

19. Quintilian, *Institutio Oratoria*, 3.8.66–73.
20. Ibid., 3.8.89.
21. Peter Goodrich, "Specula Laws," in *Law in the Courts of Love: Literature and Other Minor Jurisprudences* (London: Routledge, 1996), 95–98.

tions. Indeed, Quintilian is explicit on this point: members of an audience caught up in the sparkle of words, fascinated by a speaker's vivid imagery, do not, in fact, know what they are doing; they are seized by a kind of frenzy, transported by admiration, and caught into believing the institutional power of words and argument. Here, Quintilian quotes Cicero's dictum: "Eloquence which evokes no admiration is, in my opinion, unworthy of the name."[22]

Many of the imagistic examples Quintilian uses to illustrate the importance of ornament denote architectural elements, components of what is artificial and built. Ornamentation is the luxury of words and this luxurious nature derives from artificiality. The example given is of rows of trees planted in *echelon*, which render a garden more beautiful than nature itself. The echelon, as schematized below, is indeed an architectural principle that derives from a particular layout for colonnades:

$$* \quad * \quad * \quad *$$
$$* \quad * \quad *$$
$$* \quad * \quad * \quad *$$

This form of artificial display does not steal away from the mind but glorifies the truth by delighting the audience.[23] In accordance with, for example, the poetic function of the medieval judge, truth derives from, and is glorified through, fictional devices.[24] Moreover, a tiered row of trees has an additional advantage "since this form of plantation enables every tree to derive an equal share of moisture from the soil." Properly speaking, the ornament is the conjunction of beauty and utility, charm and economy. Other examples share similar features of beauty and utility described in terms of what is formed and built:

> A horse whose flanks are compact is not only better to look upon, but swifter in speed. The athlete whose muscles have been formed by exercise is a joy to the eye, but he is also better fitted for the contests in which he must engage. In fact true beauty and usefulness always go hand in hand.[25]

The economic combination of beauty and usefulness alerts us to the principle of exclusion, which as we shall see, is a common feature of ornament in both oratorical and architectural usage. Borrowing from

22. Quintilian, *Institutio Oratoria*, 3.8.29.
23. Ibid., 3.8.10.
24. See Ernst Kantorowicz, *The King's Two Bodies: A Study in Medieval Political Theology* (Princeton: Princeton University Press, 1957), 291–313.
25. Quintilian, *Institutio Oratoria*, 3.8.10–11.

Cicero, Quintilian argues that there is an acceptable style of ornament. This style is neither overelegant nor overadorned but must be used economically. For a "vicious" style of embellishment disguises vice in the name of virtue.[26] The Attics sought to distance themselves the style of speech they termed "Asian" or "Asiatic"—exuberant, frivolous speech "tending toward the strange, based, like mannerism, on the effect of surprise" and associated, in their formulation, with the feminine. Instead they favored a bold masculine style; the ornament has to "glow with health and vigour" and as such ought to be manly, sure, chaste, and free from effeminacy. Cicero distinguishes ornament from what he considers to be the degraded, excessive Asiatic style of oratory in order to render the whole system of Attic rhetoric virile and noble. The vice of Asianism lies precisely in its excess, because such abundance lacks any function or cognitive value. Depraved, degenerate, and debauched, Asianism threatens to corrupt the dignity of the legal forum. Atticism establishes what Roland Barthes, in his study of the ancient rhetoric, calls a "class racism," a racism based upon ethnocentrism as well as upon wealth and power.[27] Quintilian's denunciation of Asiatic rhetoric curiously parallels Pliny's equally xenophobic castigation of *luxuria* (a term that implies lust, luxuriance, unproductive expenditure, and decadence in aesthetic taste).[28] As Georges Didi-Huberman notes, the Plinian notion of dignity (*dignitas*) is vigorously opposed to the notion of *luxuria*, which derives from Asiatic culture.[29] *Luxuria* threatens the juridical order of resemblance conceived in terms of familial and genealogical structures. Both excessive ornament and *luxuria* (in itself a vice tied to excess) thus infect the dignity of the legal image and juridical order. What is ironic is that much later, in the seventeenth century, the very concept of ornament in speech, and not simply excessive ornament, will become the target for a whole barrage of attacks seeking to exclude the feminine and the foreign from legal discourse. Even the "virile" ornament will become identified with the effeminate and the foreign.

It is worth briefly mentioning, for the sake of precision, that the demise of ornamentation in forensic oratory began prior to the seventeenth century with the development during the high Middle Ages of the *ars dictaminis* and the *ars notaria*. Both were epistolary arts developed

26. Ibid., 3.8.43.

27. Roland Barthes, "The Old Rhetoric: an Aide-Memoire," in *The Semiotic Challenge* (New York: Hill and Wang, 1988), 29.

28. See Georges Didi-Huberman, "The Molding Image: Genealogy and Truth of Resemblance in Pliny's *Natural History*, Book 35, 1–7," in this volume.

29. Like excessive ornament, *luxuria* also confuses sexual genres, for it is orgiastic in nature, confusing feminine nature with masculine, thus ruining familial structure and disempowering the patriarchal scheme of things. See Didi-Huberman, "Molding Image."

within royal and ecclesiastical chancelleries as administrative means of correspondence, and both were judged by the criteria of fluidity, accentuation, and rhythm. The *ars dictaminis* concerned, among other things, the furnishings of letters and official documents and was based upon a theory of ornamentation derived from the *Rhetorica ad Herennium*. With the evolution of this new art, ornamental rhetoric became identified with, and subordinate to, the written rather than the spoken word, the scriptural rather than the oratorical. The *ars notaria*, on the other hand, developed as a form of shorthand taught to students of law and concerned the physical forms of writing documents. These notarial skills eventually became much more precise and moved away from their association with the more ornamental dictaminal arts and the pictorialized alphabet.[30] A second stage in the denigration of rhetorical embellishments occurs in the seventeenth century and should be associated with the more widespread attack on rhetoric in the new sciences. This attack was symptomatic of a fear of the influence humanism had had upon sixteenth-century civil and common law.[31] The most powerful and influential attack upon "all eloquence in pleading" is that of Matthew Hale, who considers rhetorical ornament as being able to corrupt and confuse by "bribing our fancies and biasing our affections."[32] Similarly, an Assize sermon delivered in 1671 decries the sorry fact that the "Flowers of Art and Eloquence" are used to dress up and maintain bad causes and that the substitution of "Noise and Passion" could only serve to confuse juries.[33]

Such invectives should be read within the wider context of the Protestant and legal fear of images. As Peter Goodrich has argued, much of Reformation and post-Reformation legal discourse was directed against the use of images and ornaments, against the rhetoric of the image. Anxiety over the use of ornament is symptomatic of a more widespread apprehension concerning the image, but also of the fear of both Papists and foreigners. The concept of the image, for the Protestant Reformers, entails more than the plasticity of devotional objects; it in-

30. For general accounts, see Curtius, *European Literature*, 75; Herman Kantorowicz, *Studies in the Glossators of the Roman Law* (Cambridge: Cambridge University Press, 1938).

31. See Thomas Wilson, *The Arte of Rhetoric* (London: Garland, 1982 ed.). Suffice it to say that the denigration of the ornament takes place over a long period and has far reaching effects. In the field of evidence, scholars such as Thayer, in the nineteenth century, separate the process of reasoning from the course of trial procedure. Such a move further distances the common law trial from the medieval understanding of facts (*materia*) that could not be separated from the act of staging or presentation (*ornamentum*).

32. Sir Matthew Hale, *The Primitive Origination of Mankind* (London, 1677), 262–65.

33. Shapiro, *Probability and Certainty*, 185.

cludes abstract as well as material aspects, and both are associated with an ancient and Papist psychology of the imagination. All images, whether material objects or linguistic embellishments, were regarded as being signs of the Antichrist and were regarded, in the words of Latimer, as "juggling deceits." By the time of Edward VI's reign, the destruction of images became total and set the context in which ornamentation in oratory was to be decried.

In general terms, doctrinal writing during the seventeenth century sought to establish the stability, continuity, and Englishness of the common law, and attacks on rhetoric served that end. This sense of English national identity was constructed not simply by placing the origins of English law within immemorial time but also by proposing a language capable of expressing the inherent reason of the common law. The figurative and persuasive dimensions of legal practice were to be constructed according to the precepts of a rational language and such practice differentiated the English common law from counterpart jurisdictions elsewhere in Europe. The Englishness of the common law from the seventeenth century on relies upon the governance of its own linguistic system. The denigration of the ornament, as the mode of speaking in images, testifies to a fear of what is seductive, strange, outlandish, and foreign. The ornament was also excluded from law as feminine speech, a point emphasized in Goodrich's discussion of Dod and Clever's *A Godlie Forme of Household Government:* "The attributes of rhetorical eloquence or linguistic persuasion appeal to the eye and the ear, the figures are variously beguiling, heretical and clamorous, they break the law and they do so in the manner of the feminine."[34] While for Cicero and Quintilian ornaments were used to distinguish the domestic from the foreign and the masculine from the effeminate and the feminine, for the doctrinalists of the seventeenth century ornaments came to be regarded as the very measure of those attributes of otherness.

According to the physical laws of conservation, nothing decays without leaving a trace. The destruction of images, from the dissolution of the monasteries in 1535 to the Restoration monarchy of Charles II in 1660, was so thorough that all that remain are shards of glass, fragments of statues, torn canvases, and melted precious metals. Yet what of the rhetorical notion of ornament within legal discourse? While disapproved of in legal oratory, the features and functions of rhetorical ornament have left their residue within architectural discourse. And these ornamental features come to be of greater use in the legal environment

34. Peter Goodrich, "Haec Imago," in *Oedipus Lex: Psychoanalysis, History, Law* (Berkeley: University of California Press, 1995).

when the courts themselves become less itinerant and more tied to particular structures (the word *court*, from the Latin *cohors*, signifies an enclosed space). Session houses built during the seventeenth century set a precedent not only for the layout of courtrooms but for the use of ornament in articulating the ideals of the law. In broad terms, the effects of Alberti's treatise on the way architects think about public buildings and the use of ornament to designate their special status can still be felt today. Be they civic or sacred, temporal or spiritual, ornaments continue to demarcate a fixed and solemnized space wherein the rituals of public life and institutional discourse can unfold.

Alberti's treatise testifies to the idea that embellishment and ornamentation cannot totally disappear from public institutional life. As traditional art history would have it, Alberti's humanist revival of antique forms, although influenced by Vitruvius, differs from the latter's schema. Vitruvius had considered the ornament to be integral to the building and notes that the architectural orders, as ornaments par excellence, should be considered the most important element of classical architecture. Columns were more than mere physical supports for roofs; they marked the sacrificial space of temples (the design for the Ionic, for example, was based upon the model of skulls skewered onto poles). Alberti, on the other hand, is often said to treat structure and ornament as separate entities. It is clear, however, that for Alberti, such a separation cannot properly be maintained. The ornament is more than an auxiliary to beauty and goes well beyond mere utility; for not only do ornaments increase the convenience and life of the building, they also provide figures which indicate this divine purpose.[35] The practice of dedicating the walls of a building to gods, for example, is considered to be a form of ornamentation that emphasizes the particular purpose of those walls. Their purpose is sacred in that they both unite and protect citizens by enclosing them within a particular space.[36]

It is interesting to note that in determining the proper purpose of buildings, ornaments become closely connected to the idea of interdiction. Interdictions, like dedications, operate as a form of ornament in themselves.

A most appropriate way to make a place more dignified is through good taste and ingenious measures such as the laws that prohibit any male from entering the temple of Bona Dea . . . likewise at Tanagra no female may enter the grove of Eutonostus.[37]

35. Alberti, *On the Art of Building*, 6.2.156.
36. Ibid., 7.1.190.
37. Ibid., 6.4.161.

Alberti devotes a lengthy paragraph to embellishing this argument, list-ing examples of laws that prohibit certain categories of persons from entering particular buildings, interdictions that benefit the buildings both by maintaining their purpose and by improving their beauty. The use of interdiction as ornament thus helps keep a building free of the unseemly and unsightly. Ornament is thus essential not only to the building itself but to its operation. The ornament lays the foundation upon which buildings become identified and used in particular ways.

The Use of Ornaments in the Supreme Court of the State of Israel

Asithis, son of Nicerinus and King of Egypt, under whom the law was passed allowing a debtor to borrow on the security of his father's dead body, when building a pyramid of brick, first drove wooden piles into the marsh to make the foundations and then laid bricks on top of this. It is recorded that the excellent Cresiphus, who was responsible for the famous temple of Diana at Ephesus, was not so rash as to lay the founda-tions of so vast a building on land that was uncertain or insufficiently firm, and once a clear and level site had been chosen, which was likely to be free of earthquakes, he threw down a layer of crushed charcoal, and on top of this a layer of animal hides. I hear that some stones used to build the foundations of public works in Jerusalem were twenty cubits long and at least ten high.[38]

If ornaments continue to demarcate the overall use of court buildings it should be possible to trace their deployment in modern court archi-tecture. The Supreme Court of the State of Israel, situated in Jerusalem, is one example of the many new-style courts. The building, it is sug-gested, attempts to "calibrate the relationship between the individual and the collective through mutual agreement."[39] As is often the case in contemporary court architecture, the court tries to democratize the law, to flatten the hierarchical structure, and to disguise the alienating atmo-sphere of "superordination" in the courtroom. Members of the judiciary and the public, for example, approach the courtroom at the same level. In one sense, the current trend toward building courts that are simple in style and shorn of excessive ornament signifies a move toward a more Attic, virile, and virulent image of law. A conscious effort is made by planners and builders to escape the protean decor, the intricate plas-terwork, the beveled mirrors, or the gilt-framed full-length portraits

38. Ibid., 3.5.39–40.
39. Clare Melhuish, "Ada Melamede and Ram Karmi: Supreme Court of Jerusalem and House in Tel," *Architectural Design* 66, nos. 11–12 (1996),: 35–39, at 36.

that have been prevalent in court architecture since the seventeenth century. In another sense, however, this minimalist approach to the legal environment is already a stylistic expression of the rational principles of law. Even the simplest of lines is already a division that organizes an exclusive space. As Clare Melhuish has pointed out, the semiotics of the Supreme Court building in Jerusalem derive from an understanding of tradition and articulate a sense of national and legal identity as well a profound need for order.[40] Modern court architecture, however, does not eradicate the need for ornament in order to articulate these ideals of rationality, order, and identity. All recent buildings have, with varying degrees of success, made use of the rhetorical ornamentation in order to capture and celebrate "one of the most fundamental set of principles upon which our society is based."[41]

In its urban and topographical context, the Supreme Court building, according to its architects, Ada Karmi Melamede and Ram Karmi,[42] attempts to create a formal presence by situating itself in relation to nearby government buildings, reinforcing the judiciary's links with the executive and legislative spheres of state. Moreover, the building attempts to link old and new Jerusalem and religious and secular traditions. The vernacular architecture provides a reminder that this court of law has been built and located in Jerusalem, and ornamentation within the building serves to reinforce this sense of identity. Indeed, upon entering the building, one is immediately confronted with a grand stairway made from "Jerusalem stone" and constructed to resemble the steps and stone alleys found in the old town of Jerusalem. Along the right side of this flight of steps is a wall constructed from stone found in archaeological excavations near the Great Western Wall. The wall is in fact a representation of the Western Wall, also known as the wall of justice, and extends upward through all three floors of the building, serving to reiterate a point made by Alberti:

> [T]he most capacious of cities . . . is the circular one; the best defended, that protected by a wall of undulating bays, *as Jerusalem had been*, according to Tacitus: within the bays the enemy will not go unchallenged,

40. Ibid.

41. Lord Chancellor, "Court Design Guide," cited in Hugh Pearman, "Court Napping," *Perspectives* (October 1995). Pearman's article is symptomatic of a conservative thinking that deems architects to be subject to the requirements of law, thus celebrating G. E. Street's designs for the royal courts of justice as the archetype whose results "were glorious and appropriate" (31). Pearman dismisses many of the new courts in England for not having built appropriate environments.

42. The architectural descriptions are to be found in Josef Sharon, *The Supreme Court Building, Jerusalem*, trans. A. Mahler (Jerusalem: Joel Bidan Ltd., 1993).

and against the curtains he will not employ his war machines with any
sure sign of success.[43]

Thus the replica of the great wall signals the basic premise of legal
discourse, which is to maintain governance over its own internal linguis-
tic system. Such ornamental features testify to the rhetorical power of
law to establish defenses against a foreign order of signs, to exclude the
otheror measure the other only in terms of legal discourse. The outsider
can only be heard inside the legal space once she has accepted and
adopted the language and protocols of the law. The effect of fabricating
a model of the great wall, and of constructing an idealized model of the
ancient streets of old Jerusalem, is one of excluding the contingency of
the quotidian. Such an effect is continually replicated throughout the
features of the building. The use of natural light is made possible by a
huge curved wall or curtain of glass, situated at the top of the flight
of steps and overlooking the city. On one level, this might well be an
application of Alberti's dictate to architects that "with the chamber of
justice, because of its need to accommodate larger numbers for debate,
the apertures must be more large and prominent than those in a temple
or senate house."[44] Yet here is also an ideal perspective from which
to view the city. Ideal because this is a theoretical view, free from the
imperfections and corruption of the everyday. It provides for "the
earthly projection of the Heavenly Jerusalem,"[45] eliding the uneasy,
whirling life of the Jewish, Muslim, Christian, and Armenian quarters
that lie within the old walls. From here the agitated swarm of city life
becomes submerged memories arrested by vision, "immobilised by
eyes"[46] that view the city only as a whole. This panoptic view, deter-
mined by the architecture, orders the exterior expanse within a flat,
cartographic plane, rendering the city readable. It represses past events,
surrendering them to a silent sepulcher of memory, a monumental ne-
cropolis of untraceable and unacknowledged happenings. Through the
use of ornament, the confusing flow of human events, circumstances
and turmoil, desires and appetites, appears to have been negated and
excluded from within the court itself. This juridical view informs, and

43. Alberti, On the Art of Building, 3.5.39.

44. Ibid., 5.9.77–78.

45. Louis Marin, Utopics: Spatial Play (London: Macmillan 1984). "Geographic space
is the transcription of the 'metaphysical,' beyond this world, in the represented earth"
(206). Indeed the very layout of the city, particularly the Christian city, is designed to
manifest the particular doctrines and principles of the community and to "subdue the
flux of the soul." See also Richard Sennett, The Conscience of the Eye: The Design and Social
Life of the City (London: Faber and Faber, 1990).

46. Michel de Certeau, The Practice of Everyday Life (London; University of California
Press, 1984), 91.

is symbolic of, a controlled and complicitous relationship between the sovereignty of law and the visitor. For the visitor, elevated to the position of the all-seeing viewer, does not simply see a jurisdictional space, but determines her own cognition and power to see by virtue of this artificial and unbroken exposure. The strength and poverty of this architectural reflection lies in the very idea that this can only ever be a fantasy of absolute visibility.

The formal entrance to the courts, situated on the first floor, is designated as a gatehouse. The arrangement is redolent of the series of doorways in Kafka's *Trial*, where each gatekeeper is more powerful than the last. Certainly the doubling of the entrance serves to strengthen the principle of interiority and to regulate more intensely that which comes in. It must be remembered that the entrance, as a point of access to the outside world, also provides a liminal space that, like the window, frames the outside world from the inside. This second portal into the Supreme Court provides yet another sense of liminality, for the gatehouse is conical in shape. Its pyramidal roof tapers to an apex where yet another window allows in and directs a shaft of natural light. In the symbolic terms set out by the architects, the entrance to a court of justice must be marked by the geometric form of a triangle ascending toward the source of natural light and hence toward justice. Within this court building, justice is often represented as coming from above through circular windows (the circle representing the nature of justice, natural light its purity). This architectural feature seems to allude to the Shekinah in the Jewish tradition. The Shekinah is the last of ten attributes (*Serifot*) that articulate the presence of the divine. As Giorgio Agamben has pointed out, the isolation of the Shekinah surrenders divinity to knowledge. Within the cabalistic tradition the isolated *serifot* "loses its positive power and becomes harmful (the Cabalists said that it 'sucked the milk of evil')."[47] Such an ornament nonetheless retains its rhetorical power to persuade, to seduce us into believing that justice is inevitable and immediate within this space. Through this ornamental representation, justice is completely identified with, and assimilated to, the law.

This curious pyramidal inner gate not only articulates a sense of divine justice but also commemorates the constancy of law itself. For the space of this architectural feature is expressly intended to evoke Absalom's Tomb, an ancient monument located in Jerusalem's Kidron valley, which, in itself, is a testimony to the constancy of the rule of law. The biblical figure of Absalom provided justice to those Israelites who

47. Giorgio Agamben, *The Coming Community*, trans. Michael Hardt (Minneapolis: University of Minnesota Press, 1993), 81.

would not be heard by the king; having no sons, he built the architec-
tural monument to himself lest his name be forgotten.[48] In the Middle
Ages his story became an important source in justifying the replacement
of ancient legal procedures with Roman law. The *Moralia Regum*, writ-
ten in the twelfth century by the lawyer Ralph Niger, relates the story
of Absalom as an analogy for legal interpretation:

> David signifies justice, in its widest sense, his sons the various kinds of
> legal procedure. Amnon, who seduced his sister signifies barbarous old
> customs; the favourite son Absalom signifies Roman law; as Absalom puts
> to death Amnon in revenge for his barbarity, so Roman law supersedes
> the evil custom of the ordeal.[49]

The rhetoric of the architectural ornament again signifies a sense of
constancy, identity, and exclusion (in this instance, the exclusion of the
pagan ordeal), whatever the contingencies of history might otherwise
suggest. This sense of constancy in the identity of law is reinforced
throughout the building. The five courtrooms are lined up, one next
to another, along a long stretch of corridor. The entrance to each court
is set into the simulated Western Wall and made to look like the gate-
ways found in the old city of Jerusalem. The marble floor of the corridor
is separated from the wall itself by a long, narrow strip of mirrored
glass. The reasons given for this are twofold. First, the mirror reflects
the Western Wall in such a way as to make its roots seem eternal. Sec-
ond, the glass provides a physical intermediary between two types of
material, the stone of the wall and the marble of the floor. In architec-
tural terms, however, the strip of mirrored glass reflects a tradition of
orthogonality; of measuring and regulating the conditions of existence
through the inscription of linearity. The line represents the correct
form of measuring and geometricizing justice. According to Alberti, it
is the function of linearity (or of "lineaments," "perfected in the imagi-

48. The account of Absalom's history in the Old Testament does not necessarily lend
itself to such a tenacious ideology of law. Absalom, the third and favorite son of David,
is described in the book of Samuel as a lawless insolent who murders his eldest brother
Amnon to avenge his sister Tamar. After a period in exile he is restored to favor through
the good offices of Joab. Later, when uncertainty seems to have arisen as to succession,
Absalom organizes a revolt. For a time he seems completely successful; David with a few
of his followers and personal cohorts flees across the Jordan, leaving to Absalom the city
of Jerusalem and the main portion of the kingdom. The usurper pursues the fugitives
with his forces but is defeated in the "wood of Ephraim" and killed by Joab, who finds
him caught by his hair in an oak tree. The curious motif of Absalom may be read as
symbolic of a certain chivalry and affection displayed by David, to whom the loss of his
treacherous son brings on a grief that more than outweighs his own safety and restoration.

49. H. Kantorowicz and B. Smalley, "An English Theologian's View of Roman Law:
Pepo, Irenius, Ralph Niger," *Medieval and Renaissance Studies* 1 (1941–43): 237–52.

nation") "to prescribe an appropriate place, a proper scale, and a grace-
ful order for whole buildings and for each of their constituent parts."[50]
In the context of a court of law, the ornamental features of this strip
of glass signal and settle the overall use of the building as a space within
which justice, rationality, and scientific order prevail. Put differently,
the identity of law, as a practice built upon scientific rationality, is in
itself founded upon those aesthetic and rhetorical principles it purports
to exclude.

Conclusion

If justice needs to be seen to be done, if it has to be ostentatious, it is
because law continues to demand faith. Law needs to stand out from
the mundanity of other institutions and therefore needs an ornate archi-
tecture. What the modern legal environment inherits from Albertian
aesthetics is the sense of a political and ideational economy using orna-
mental architecture to designate positions in a circuit of power that
constitutes the higher echelons of civic life. The elegance of legal archi-
tecture provides the background against which justice is seen to be done;
it advertises itself as a select and exclusive space in which a monopoly
over the administration of justice according to rational precepts is sup-
posed to reigns. These ornamental features not only demarcate a dis-
crete place; they also surround and attempt to seal legal discourse, de-
fining its coded dimensions by marking off what may properly be
articulated in the solemnity of law's majesty and mood. Ornaments con-
tinue to establish the identity of law by delineating the categories of
those that are excluded: the Asiatic, the feminine, the irrational, the
aesthetic. Architecture is foundational to a legal discourse that subordi-
nates it to the level of the extraneous, a legal discourse that projects
architectural discourse to the outside. The law has always been, and
continues to be, structurally dependent upon aesthetics, upon the rheto-
ric of the ornament, to elicit faith in its ideals and principles. And this
can be reconstructed through an analysis of the tropes and figures of
the design of court buildings.

It cannot be claimed, therefore, that the rhetorical function of the
ornament has been excluded from Western legal thinking. The rhetoric
of exclusion remains manifest in the tangible and physical materiality
of courtroom architecture. The function of the ornament has been dis-
placed but survives, emblematic of the way classical figures of closure

50. Alberti, *On the Art of Building*, 1.1.4.

have continued to develop in order to establish the insular identity of Western legal systems (whether common law or otherwise).

What is at stake in establishing the identity of a legal system through an aesthetic environment? Alberti recalls how magicians would fix on the roof of the Royal Basilica in Babylon "four gold birds which they called the tongues of the gods: These they claimed had the power to reconcile the mind of the crowd to the King."[51] The anecdote is a derivation from Philostratus's account in the *Vita Appollonii*, where it is said that ancient wizards used to bind wrynecks to the wheels of ships, claiming that they drew men's hearts along with them and charmed them into obedience. The shift from emphasizing the passivity of the hearts of men to emphasizing their minds suggests more than Alberti's typical fascination with the psychological.[52] The humanist revival of learning was based upon the hitherto suppressed relics of a pagan past in order to reappropriate the lost energies of antiquity. In this sense, humanism is seen to be about the emancipation of the subject as the sovereign perpetrator of his own will, free from the constraints of theological dogma and despotism. But this theoretically emancipated subject is endowed with a life that springs from an exterior cause reflected in the specular field of images and texts. Ornaments provide a focal point of reflection. And it is precisely at this point that law takes hold of the subject's mind. It is these nontechnical features, these ornaments, that bear the power to reconcile the mind of the subject to the force of the Law. Does legal science, one wonders, in continuing to rely upon these ornamental figures of superordination, constitute the subject of law in an Asiatic or feminine form.

51. Ibid., 6.4.162.

52. The heart was considered not only to be the source of the vital forces of being, but also the *core* of subjectivity, faith, and affective life. According to medieval doctrine, the heart was the place of concealment made possible by the visceral "inside," where breath can be trapped. On the status of the heart as the interiorized place of inscription, and on the concept of the writing received in this innermost sanctum of the medieval body, see Jean Starobinski, "The Inside and the Outside," *Hudson Review* 26 (1975): 333–51.

✦ S I X ✦

THE FESTIVAL OF JUSTICE

PARIS, 1849

Katherine Fischer Taylor

"**T**his ancient palace, formerly the dwelling of our kings and subsequently the temple of Justice . . . has witnessed great displays of pomp, magnificent solemnities, but none deserves so much as this one to be called the *Festival of Justice!*" With these words Dupin *l'aîné*, chief prosecutor of the French supreme court and one of the ceremony's triad of planners, opened his speech at the inauguration of the Second Republic's magistrature in the Palais de Justice of Paris on 3 November 1849.[1] The festival evoked a polarized image of French justice from the press. Take the visual reportage of the popular weekly *L'Illustration*. It distilled the ceremony to a two-page spread, offering full-page tableaux of its two major events, set in unlike interiors of the courthouse, paired across the magazine's gutter: the French magistrature taking communion in the thirteenth-century Gothic Sainte-Chapelle, juxtaposed to the judges taking oaths of office in the seventeenth-century classical waiting hall or Salle des Pas Perdus (fig. 6.1).[2] Sequential moments are converted to synchronic comparison, in a mass-culture variant on the British architect Augustus Welby Pugin's book *Contrasts*. Neither tableau presents the judges at their usual work in the courtroom but both position them in relation to the larger social and political world, legitimating themselves according to typically opposed rhetorical modalities: on the one hand, the sacred communion, enhanced by an appeal to the sensations of participants in the newly restored chapel; on the other, the oath as secular contract effected through the voluntary exercise of reason in a setting structured according to

1. *Journal des débats*, 4 November 1849, 3.
2. *L'Illustration* 14 (10 November 1849): 168–69.

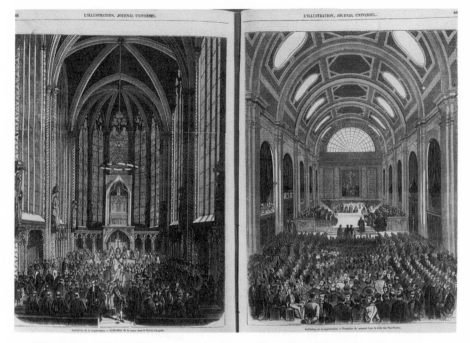

Figure 6.1: Views of the mass in the Sainte-Chapelle and the oath-taking cere-
mony in the Salle des Pas Perdus. *L'Illustration* 14 (1849): 168–69. Courtesy of
the University of Chicago Library.

explicit rules of social and visual order. Multiple points of contrast con-
tribute to that differentiation: dim polychrome light from the stained
glass beneath the dark vault versus clear glass and skylights; intimacy
versus a vast, distanced vista; near-fusion of architectural parts and jum-
ble of bodies versus serial regularity. The loan of the crucifixion not-
withstanding, the domain of reason separates from the domain of faith
and feeling, and there is little question where the judges ought to be at
home. Sober justice was scarcely the place for the festivity proclaimed by
its organizers, as the leading judicial newspaper hastened to point out.[3]

In recuperating a familiar image of justice as an autonomous domain
radiating reason, this reportage acknowledged the ceremony's conserva-
tive agenda but negated its novelty. The Second Republic installed the
magistrature unchanged in order to end a protracted debate on judicial
reform following the revolution of 1848, and to proclaim instead the
continuity and autonomy of French justice. Yet the event itself was ex-
traordinary. It was the first time since the ancien régime that political

3. "Institution de la magistrature," *Gazette des tribunaux*, 30 October 1849, 1306–7.

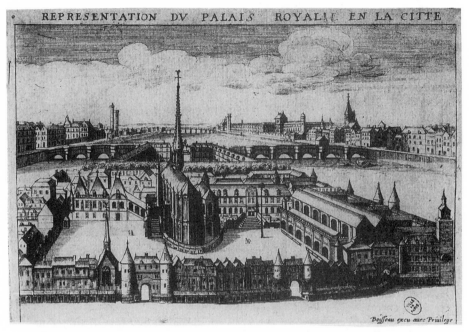

Figure 6.2: Boisseau, bird's-eye view of the Palais de Justice, looking west, print, c. 1650. Musée Carnavalet, Cabinet des arts graphiques.

power had intervened at the courthouse to host a public event. It was the first time government had convened and displayed the judiciary to the public in a national assembly on judicial ground. It drew unprecedented attention to the individuals who dispensed justice and to their contingent relationship to the agents of church and state, who presided over the mass and oaths of office. Its formulation as a festival enhanced that novelty, drawing attention to the experience of participants and presenting a unified sequence of governmental processions, mass, and oath taking, as the modern rejoinder to the ancien régime's visitations to its law courts. Staging the festival in the Palais de Justice generated the comparison, for these buildings were the birthplace of centralized justice in the Middle Ages and remained the locus of justice at the center of Paris on the Ile de la Cité despite the postrevolutionary transformation of the legal system (fig. 6.2). Ancien régime monarchs had traced the same route, from a mass in the Sainte-Chapelle, whose spire dominates the complex, to the vast Salle des Pas Perdus on the other side of the entrance courtyard, identifiable by its paired barrel vaults, for a *lit de justice* in the adjacent courtroom of *Parlement*. The Revolution had purged the law courts of the legislative prerogatives that mandated the *lits de justice*, severing the old link between justice and executive and

legislative politics and reducing the magistrature to an ostensibly technical body for enforcing the newly codified law, which assumed an independent authority. From an emanation of divine royal power that presumed to talk back to the king, precipitating the major political crises of the prerevolutionary period, justice had been reconstituted as a still center, a legitimating origin, and a vanishing point in the symbolic map of power constituted by the capital city. By bringing an explicitly political inauguration into the Palais de Justice, the festival of justice disturbed that peace.

These images and scenes belong to a discourse on the aesthetic and political character of modern French justice, half a century after its launching in the revolutionary and Napoleonic periods. The inescapable tension they manifest between modes of normalizing reason and sensual, sympathetic apprehension has a history as well as a philosophy.[4] This essay reconstructs a largely forgotten episode in the history of civil justice in France, one that crystallized a more gradual transformation from a focus on the abstract codes of law to an emphasis on embodied judging, with a concomitant change in judicial style. The earlier image of justice concentrated on the abstract, disembodied text of the codes of law, which were supposed to be universal and timeless. Individuals who associated themselves with the codes—even Napoleon—represented themselves as transparent to the universal will encoded in the law.[5] This was especially true of courtroom magistrates, whose latitude

4. As treated by Martin Jay, "Must Justice Be Blind? The Challenge of Images to the Law," and Costas Douzinas, "*Prosopon* and *Antiprosopon*: Prolegomena for a Legal Iconology," in this volume.

5. The premise that the law expresses "la volonté générale" is proclaimed in the *Déclaration des droits de l'homme*, which was attached to each of the republican constitutions of the revolutionary years; see Georges Burdeau, "Essai sur l'évolution de la notion de la loi en droit français," *Archives de philosophie du droit et de sociologie juridique* 9 (1939): 7–55. The Napoleonic constitutions did not reiterate this tenet but did not repudiate it either. Lacking the divine right of the royal dynasties, Napoleon needed an alternate source of legitimacy and appropriated the republican idea; the idea that he ruled by the will of the people was bolstered by his sponsorship of plebiscites and of the new *Code civil des Français*. A synthesis of previous laws, the code was characterized by its jurist-authors as a product of natural reason verified by tradition and experience, not the imposition of a willful new government. See *Discours préliminaire*, reprinted in Antoine Fenet, ed., *Recueil complet des travaux préparatoires du Code civil* (Paris: Imprimerie de Ducessois, 1827, 15 vols.), 1:463–67. Even Napoleon's retroactive appropriation of the code, which he renamed the Code Napoléon in 1807, suggests that the emperor was as much in need of the generalized authority of the code as the code was in need of an ostensible author like Napoleon. The difficulties of claiming Napoleon as author are evident in the legislative proceedings of 3 September 1807, in *Archives parlementaires de 1787 à 1860: Receuil complet des débats législatifs et politiques des chambres françaises* (Paris: Paul Dupont, 1867), 2d ser., 9:615–16.

in judging was dramatically curtailed in the postrevolutionary state. The appropriate demeanor for the modern magistrate was austerity and self-restraint, which served to minimize his own contingent role as a human agent imposing justice so as to emphasize the abstract impartiality of the codes.[6] This modern justice had enjoyed its festivals, including the Festival of the Law of 1792, but early revolutionary festivity shunned the courthouse and marginalized the judge, affirming instead the cult of universal reason in a natural, open-air setting.[7] By contrast, the fête of 1849 put a spotlight on judges and their courthouse. Such a celebration of individuals invested with power evoked the discredited mode of monarchical splendor, in which display of grandeur had signaled the king's personal power over his subjects. Dupin explicitly recalled the historical function of such royal display in the judicial context in his speech at the ceremony.[8] But in reviving display as the mode for representing justice, the ceremony of 1849 was contending with the altered political culture of constitutional and representative government, in which the judiciary was construed less as an agent of the ruler than as a separate power conferring legitimacy upon the state. The festivity fashioned for justice in 1849 took on a different meaning in its modern

6. The restriction of discretion in judgment is summarized in Jean-Pierre Royer, *La Société judiciaire depuis le XVIIIe siècle* (Paris: PUF, 1979), 181–82; enforcement of the precept that judges must apply, not interpret, the code is recounted by André-Jean Arnaud, *Les juristes face à la société du XIXe siècle à nos jours* (Paris: PUF, 1975), 10–11, 31–32, 53–60. Eighteenth-century members of the judicial *Parlement* were enjoined to remain modest in the face of the temptation (often embraced) to self-indulgence and luxurious entertaining. After the Revolution, however, the old norm of austerity was invoked in reaction against that taint of luxury and against the former liberty of legal interpretation. See Marcel Rousselet, *Histoire de la magistrature française des origines à nos jours*, 2 vols. (Paris: Plon, 1957), 2:70–87; Thomas John Schick, "The Parisian Court of Appeals and its Magistrates, 1848–1914," doctoral dissertation, political science, Columbia University (1977), 98, 172–75.

7. I am drawing on Mona Ozouf's analysis of the revolutionary effort to fashion a new festival mode that simultaneously avoided the risks of the sensuous and spontaneous and of the contrived and imposed, in her *Festivals and the French Revolution*, trans. Alan Sheridan (1976; Cambridge, Mass.: Harvard University Press, 1988); on the importance of a natural rather than architectural setting, see 127–32. Although the Festival of the Law of 1792 represented the law as an authority imposed upon its subjects rather than immanent in them, it should be considered in relation to its originating event: the killing of the mayor Simoneau while he was upholding unpopular law on grain prices during a riot. Simoneau was made to epitomize supreme and spontaneous sacrifice to the law among its very enforcers, suggesting that the law was after all immanent among its agents. See Ozouf's interpretation, 66–82, and the more detailed account by Marie-Noëlle Polino, "Quatremère de Quincy et la fête de la loi en l'honneur de Simoneau, maire d'Etampes (juin 1792)," in R. Chevallier, ed., *La révolution française et l'antiquité* (Tours: Centre de recherches A. Piganiol, 1991), 285–309.

8. *Journal des débats*, 4 November 1849, 3.

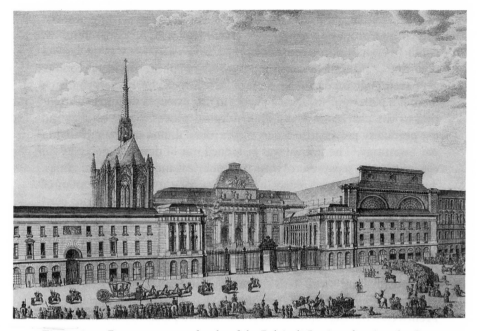

Figure 6.3: Ransonette, east facade of the Palais de Justice, showing the Cour du Mai just after its completion, engraving commemorating Louis XVI's *séance royale* of 17 November 1787. Bibliothèque Nationale, Cabinet des estampes. Photo: Bibliothèque Nationale, Paris.

judicial staffing rather than the codes. By 1848 it was evident that every overthrow of regime since the first revolution had undermined the ideal of a universal, text-based justice in which judges played a minimal role. Each new government sought to install judges sympathetic to its altered principle of sovereignty; these purges indicated that justice stemmed as much from human political activity as from transcendent values. The timeless, absolute authority of the codes had also been challenged on philosophical and practical grounds; historicist jurists had reasserted the importance of judicial interpretation in applying the codes, so as to adapt their general precepts to changing social circumstances. Thus the plausibility of justice and its reform depended on the source of juridical authority—of both the codes and the magistrature—posited by each regime. On the one hand, the codes were supposed to distill the general will, certified by elected legislators; in this sense they were grounded in an ideology of popular sovereignty that supported varying degrees of constitutional, representative government. On the other hand, the

head of state and his administration directly controlled the appointments and promotions of judges. Moreover, two constitutions had stipulated that justice emanated not from the populace but from the sacred body of the head of state, evoking the archaic principle of divine right, according to which the king demonstrated his divine authority through the attribute of justice, which he delegated to a body of judges for enforcement.[15] In effect, the source of justice was twofold: universal will for the law, and the personal will of an executive for the judges. This marriage of convenience became uncomfortably obvious after every revolution, when the new government needed to reconfirm its magistrature, yet required the legitimacy afforded by a justice that transcended politics.[16]

While the replacement of constitutional monarchy by a republic made possible an alternative to compromise, the Second Republic's reform debate swung from one pole to the other. Republicans proposed to make judges responsible again to the sovereign people, based on "universal" suffrage. Legislators considered literally minimizing the magistrature, reducing its numbers and hierarchical levels and replacing government appointments of tenured career judges by elections. Elections seemed to offer a magistrature transparent to the republican principle of sovereignty, purged of overtones of monarchic will and display. Yet

15. *Charte constitutionnelle du 4 juin 1814*, arts. 13, 57; *Charte constitutionnelle du 14 août 1830*, arts. 12, 48. The monarchical principle of personal justice, which could be either *retenue* or *déléguée*, is summarized in François Olivier-Martin, *Histoire du droit français des origines à la Révolution* (Paris: Domat Montchrestien, 1948), 518–19.

16. Legislative debates over judicial reform in 1849 acknowledged the political criticism that the Restoration had earned through its ill-disguised judicial purge (10 April), and the vulnerability even of tenured judges to the influence of an executive that controlled promotions (9 August). *Compte-rendu des séances de l'Assemblée nationale constituante (4 mai 1848–27 mai 1849)*, 10 vols. (Paris: Henri & Charles Noblet, 1849–1850), 9:547 (10 April 1849); *Compte-rendu des séances de l'Assemblée nationale législative (28 mai 1849–2 décembre 1851)*, 17 vols. (Paris: Panckoucke, 1849–1851), 2:302–3 (9 August 1849).

On nineteenth-century judicial purges, including de facto purges effected by requiring a new oath of loyalty to a new head of state, the account by the reform-minded jurist and historian Georges Picot remains useful; *La réforme judiciaire en France* (Paris: Hachette, 1881), 17–145. A recent comprehensive study is the Association française pour l'histoire de la justice, *L'Epuration de la magistrature de la révolution à la libération: 150 ans d'histoire judiciaire* (Paris: Loysel, 1994). Despite the focus of the convener of this conference, Robert Badinter, on political values and representational issues (pp. 8–9, 163), the chapter on the Second Republic does not mention the installation ceremony treated here, or its implications. On the rise of a historical interpretation of the codes, see Julien Bonnecasse, *La Pensée juridique française de 1804 à l'heure présente*, 2 vols. (Bordeaux: Delmas, 1933), 1:350–76; Donald Kelley, *Historians and the Law in Postrevolutionary France* (Princeton: Princeton University Press, 1984); Arnaud, *Les juristes face à la société*, 64–70.

as the government turned increasingly conservative under Prince-President Bonaparte, legislators abjured even diluted judicial reform, claiming that change would jeopardize the apolitical aura of justice.[17] The Second Republic closed the question by reconfirming the magistrature it had inherited from its predecessor, the July Monarchy. It declared confidence in the personal probity of its politically heterogeneous magistrates—drawing attention, in the process, to their individual agency in justice. Head of cabinet and minister of justice Odillon Barrot, initially an advocate of elections, convened the chief magistrates of France to Paris for a novel installation, in which they would swear a "professional" oath rather than the usual political oath of loyalty to the head of state.[18]

This resolution hinged on the implications of the oath. The republican position, implemented by the provisional government of Ledru-Rollin in its decree of 1 March 1848, had been to eliminate oaths of public office altogether on the grounds that they were redundant; oathlessness functioned as an index of complete transparency between government and individual, of reciprocity between social and personal interests. By contrast, the prince-president's party of order insisted on the need for an oath in order to demarcate public office from ordinary private life, reinstating a difference between them and thus opening the way to displaying social authority as a value and agency in its own right. Yet the magistrature's professional oath, in appealing to internalized rather than external authority, retained an equivocal aspect of transparency. As the core of the installation ceremony, the oath regained the role it had held since the revolutionary festivals as the modern means of reconciling ostensibly sovereign individuals with social institutions, rehearsing the social contract through a performative act at once voluntary and coercive.[19] The ambiguity of this central feature

17. For an overview of this reform debate, see Picot, *La réforme judiciaire*, 97–121, and his reprints of the progressively diluted versions of the reform bill on 373–92; Schick, "Parisian Court of Appeals," 211–24. Also see the retrospective account by one of the leading actors, Odillon Barrot, *De l'Organisation judiciaire en France* (Paris: Didier, 1872), 53–59.
18. The text of the oath is specified in the law of 8 August 1849: Duvergier, ed., *Collection complète des lois* 49 (1849): 268, including an excerpt from the *exposé des motifs* referring to the new oath as a *serment professionel*, in contrast to the standard *serment politique*.
19. Ozouf, *Festivals and the French Revolution*, 280; Jean Starobinski, *1789: The Emblems of Reason*, trans. Barbara Brey (1973; Cambridge, Mass.: MIT Press, 1988), 101–4. Also, in Raymond Verdier, ed., *Le Serment*, 2 vols. (Paris: Editions du centre national de la recherche scientifique, 1991): Jean Fezas, "Le Serment, lien social et lien politique," 1:226; François Billacois, "Le corps jureur: Pour une phénoménologie historique des gestes du sermon," 1:99. On the oath as an individualist and thus potentially divisive

rendered the event tolerable to proponents of quite different positions.

Ironically, the drive to increase judicial transparency resulted in its obverse: a ceremony not only materializing the magistrature as a corporate body before the public, but celebrating its permanence by affirming judicial tenure regardless of political revolution. It was necessary for the installation simultaneously to credit the new regime with protecting the magistrature and to proclaim this previously suspect, embodied justice to be above politics. The ceremony enacted a rebirth of justice from politics, followed by a cutting of the umbilical cord between the two, enabling justice to seem autonomous.

From these needs followed a series of decisions about the place, time, and physical character of the ceremony. As the organizers were aware, past installations had taken the form either of a swearing-in of the chief magistrates of the superior courts before the head of state, after which the magistrates returned to their courthouses to administer the oath to their colleagues and the lower jurisdictions, or of appointments of individual courts on their own individual premises, presided over by a visiting minister of justice.[20] This ceremony in 1849 was the first occasion for which a national assembly of chief magistrates was convened on judicial ground rather than at the palace of the head of state. Moreover, Minister Barrot appropriated the date and traditions of the judiciary's annual *rentrée* ceremony, held at the end of summer vacation. Normally the date of an installation was arbitrary, at the government's convenience and soon after the requisite decree or law. The delay between the passing of the law and the installation was expanded from two months in the *projet de loi* to three in the law of 8 August, suggesting that the government tailored it specifically to accommodate the *rentrée*. Usually the *rentrée* was an internal professional affair for each jurisdiction, with a few guests, but in this case a national assembly of magistrates was presided over by the government before a large public—probably the first public event other than trials staged in the Palais de Justice since the revolution of 1789.[21] In seeking unprecedented splendor, the organizers measured themselves against the historical associations of the Palais by conceiving the installation as a modern replacement for the ancien régime ceremony of the *lit de justice*, in which kings visited their magis-

strategy, however, see in the same collection Claude Langlois, "Le Serment révolutionnaire 1789–1791: Fondation et exclusion," 2:394–95.

20. An article reviewing previous installations was published by *Le Droit* and reprinted in the *Moniteur universel*, 1 November 1849, 3448.

21. Public seating installed in the Salle des Pas Perdus accommodated twelve hundred, according to the *Gazette des tribunaux*, 4 November 1849, 1307.

trates in their highest courtroom to accomplish political business, most notoriously to impose the royal will on a recalcitrant court.[22] They sited it as close as possible to the Grand'Chambre where the *lits de justice* had taken place, but which they considered too small for their own grand design.[23] Yet the political overtones of the *lit de justice*, namely the historic tensions between the head of state and the judiciary and between their styles of claiming authority, would haunt the ceremony—especially after President Bonaparte provoked fears about his will to power by unexpectedly firing his cabinet just before the ceremony, which he then personally attended, rather than permitting his ministers to represent him.[24] It was not easy to fashion a persuasive demonstration of judicial autonomy.

One way the government sought to fix that claim was by juxtaposing the parts and locales of the ceremony, introducing the mass in the Sainte-Chapelle as a counterpart to the oath taking in the Salle des Pas Perdus. In keeping with its general reconciliation with the church, after an anticlerical hiatus in Paris that had lasted through the July Monarchy, the Second Republic reinstated the mass as a traditional part of the *rentrée*. But rather than the usual mass in judicial quarters, the Second Republic resurrected the royal tradition of a mass in the Sainte-Chapelle before the *lit de justice*, thereby cementing its alliance with the church and the medieval decor and ceremony that the church had rediscovered so as to draw expressly on religion as well as justice to legitimate itself.[25] Unlike the ancien régime, the Second Republic presented the Sainte-Chapelle and the Salle des Pas Perdus as pendants of differentiated character, sites of religious and secular institutions that framed and presided over an ostensibly apolitical social order through the agency of their equally tenured staffs. To this end, a judicial mass

22. *Gazette des tribunaux*, 30 October 1849, 1306.

23. Dossier on the planning of the ceremony, F/21/769, Archives Nationales (hereafter cited as AN).

24. On Bonaparte's action, see the *Journal des débats*, 1 November 1849; Louis Girard, *La IIe République (1848–1851)* (Paris: Calmann-Lévy, 1968), 197–203; Pierre de La Gorce, *Histoire de la Seconde République française*, 2 vols., 4th ed. (Paris: Plon, 1904), 2: 250–57. For talk of his ambitions, see *L'Illustration* 14 (1849): 162.

25. On the traditions and location of the *rentrée* mass, which continued up to 1900, see Rousselet, *Histoire de la magistrature*, 1:351–58. On the mass at the Sainte-Chapelle preceding the *lit de justice*, see Sarah Hanley, *The Lit de Justice of the Kings of France: Constitutional Ideologies in Legend, Ritual and Discourse* (Princeton: Princeton University Press, 1983), 88, 302, 307–8; Emile Clairin, "Le Palais de Justice d'autrefois," *La nouvelle revue* 68 (1 December 1923): 233, and 69 (1 January 1924): 51. The presumption that the party of order required obvious alliance with the church was evidently unruffled by the crisis over French policy toward the pope and republicans in Rome that precipitated Bonaparte's firing of his cabinet just before the ceremony.

in the Sainte-Chapelle became a fixture of the *rentrées* after 1849 for as long as this religious observance continued. Thus the government met the neo-Catholic statesman Montalembert's demand, during the judicial reform debate, "that the river of progress . . . take its course between two unshakeable banks, between the temples of the law and of God."[26] In so doing, the ceremony was affected not only by political struggle but by a specifically architectural battle over the relationship of the Sainte-Chapelle to the Palais de Justice.

Architecture

If the political battle over judicial reform assumed the form of reasoned debate presided over by abstractions, the architectural battle between the buildings where the ceremony would take place deliberately engaged the emotions and appealed to the sensations, specifically the faculty of sight. Here the present narrative makes a parallel swerve from abstractions to visual images. Nineteenth-century participants entering that sensual realm of affect, a realm the rationalist notion of law regarded as false, would ultimately experience its intrinsic importance to the conduct of judicial business, and some would even acknowledge that rhetoric was as important to the ideal of transparency as it was to avowed festivity.

While the ceremony was first being conceived, during the summer of 1849, war broke out between the temple of God and temple of the law at the Palais de Paris. While the temple of the law was undergoing the ambitious modernization and expansion that generated the present-day buildings, the Sainte-Chapelle, in the midst of the complex, was being separately restored by the state as a model for the new practice of historic preservation. In July of 1849, when a new architect, Jean-Baptiste Lassus, took over the Sainte-Chapelle restoration, he sought to reverse what he regarded as over a half century of injury to his monument by the courthouse.[27] Invoking a seventeenth-century bird's-eye

26. *Compte-rendu des séances de l'Assemblée nationale législative* 9 (10 April 1849): 537.
27. Lassus was promoted to chief architect by a decree of 11 July (AN, F/21/2018, "Sainte-Chapelle") and began his campaign of complaint to the administration with a letter dated 26 July (Archives de la Commission des monuments historiques [hereafter cited as AMH], carton 1222). Recent studies dealing with the Sainte-Chapelle restoration are Jean-Michel Leniaud's biography of Lassus, *Jean-Baptiste Lassus ou le temps retrouvé des cathédrales* (Geneva: Droz & Paris: Arts et Métiers graphiques, 1980), and Leniaud and Françoise Perrot, *La Sainte-Chapelle* (Paris: Nathan & CNMHS, 1991). The following account of the controversy over the relationship between the Palais and the chapel differs from those of Leniaud (the primary one being in *Jean-Baptiste Lassus*, 111–13) in emphasis, in its concern with both sides, and in linking the controversy, as Lassus did, to the ceremony of 1849. It is based on the following documents: AMH, carton 1222

view by Boisseau to demonstrate how the chapel had originally domi-
nated the complex of buildings (fig. 6.2), Lassus deplored the way the
entrance courtyard of the Palais had been rebuilt in neoclassical style
in the 1780s, with a new south wing abutting and screening out the
view of the Gothic chapel (fig. 6.3).[28] Ransonnette's late–eighteenth-
century engraving of the Cour du Mai emphasizes its absolute symmetry
and classical regularity, which was then even more striking than it is
today, after alterations to neighboring buildings begun in the late 1840s.
Lassus blamed the inflexible symmetry of the courtyard architecture for
replacing the original picturesque interplay between the chapel and the
even larger volume of the Salle des Pas Perdus, on either side of the
courtyard, and for projecting a banality of character that could not com-
pare to the magic of the Gothic chapel, which Lassus and other neo-
Gothicists taught their contemporaries to appreciate anew.

But the new circumstance that provoked Lassus in 1849 was the way
Louis Duc, the architect of the Palais, was reconstructing the south
wing of the Cour du Mai. Duc's partial plan shows how he intended to
transform the wing from a series of rooms into a continuous monumen-
tal corridor that would extend all the way westward through the Palais
(fig. 6.4; cf. fig. 6.7).[29] In the interests of developing this grand circula-
tion axis, Duc's corridor engaged two buttresses of the Sainte-Chapelle
porch, where it connected with the Palais by a door; the plan shows
Duc's new masonry, which the photograph renders in gray, embracing
the old buttresses, in black. It was this half meter of contact that out-
raged Lassus. In a campaign carried into the daily and professional
press, Lassus dramatized this architectural intimacy in the language of
rape. The drawing Lassus made for the British neo-Gothic journal the
Ecclesiologist, contrasting the preclassical relationship between the Palais
and the chapel porch to the current one, illustrates his verbal accounts
of how the massive, banal neoclassical masonry was throwing itself upon

and the bound volume titled "Dossier relatif aux travaux d'isolement de la Sainte-Chapelle
du Palais à Paris 1837–1849"; AN, F/21/5914; and the Département de la Seine, *Docu-
ments relatifs aux travaux du Palais de Justice*, text volume and atlas of plates (Paris: Typo-
graphie Charles de Mourgues frères, 1858), esp. *pièces annexes*, 299–319 (hereafter cited
as *DRT*).

28. In reporting the crisis at the Palais, Lassus sent a copy of the Boisseau view to
the *Ecclesiologist*, which published it. See n. 30 below.

29. From a set of plans for the renovation of the south wing of the Cour du Mai,
signed by Duc and his adjunct architect Dommey and dated 19 October 1845; archives
of the Palais de Justice, collection of the Cour d'appel, Paris. The project was designed
in accord with the agreement over the relationship of the Palais and the chapel reached
by Duc and Félix Duban, Lassus's predecessor at the Sainte-Chapelle, in 1844; construc-
tion began in 1848. For brevity's sake, I shall refer to Duc alone as the architect of the
Palais, as he was regarded as chiefly responsible for its design.

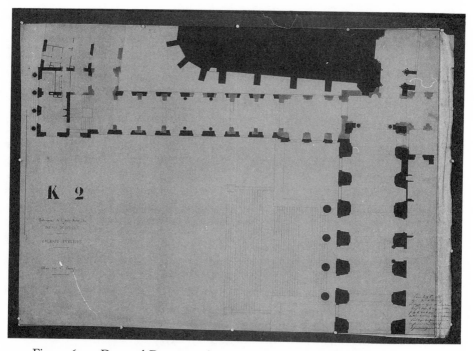

Figure 6.4: Duc and Dommey, drawing from a 19 October 1845 project to renovate the south ("right") wing of the Cour du Mai, first (main) floor plan. Collection of the Cour d'appel de Paris.

the delicate, precious chapel (fig. 6.5, right side).[30] Ideally Lassus wanted a freestanding Sainte-Chapelle; while he acknowledged the need to maintain the original access to the porch (and thus the upper chapel)

30. "The Ecclesiological Movement in France. By MM. Lassus and Viollet le Duc. No.1. The Sainte Chapelle, Etc. By M. Lassus," *Ecclesiologist* 10 (February 1850): plates inserted between 300 and 301. A sketch for the print by Lassus survives in AMH, carton 1222. The wording of Lassus's statements became increasingly extravagant. He alerted his employer, Minister of Public Works Lacrosse, to the "soudure intime" of the Sainte-Chapelle and the Palais, resulting from a sort of shotgun marriage forced upon his predecessor in the agreement of 1844, which would prove "une honte pour notre époque" (letter of 26 July 1849, AMH, carton 1222). To his allies he wrote, for example, of "la brutalité avec laquelle les constructions nouvelles du Palais de Justice viennent s'adosser et se souder aux parties importantes de la Sainte-Chapelle" (letter to Montalembert, 27 July 1849, quoted by Leniaud, *Jean-Baptiste Lassus,* 111). The *Journal des débats* was eventually persuaded to join Lassus's cause, escalating his initial wording: "Il est impossible de se faire une idée de la brutalité avec laquelle ces lourdes maçonneries modernes viennent se jeter sur le porche si fin et si élégant qui précède cette chapelle" (8 August 1849). Lassus's letter of September 8 to the minister of the interior uses precisely the same wording (AN, F/21/5914).

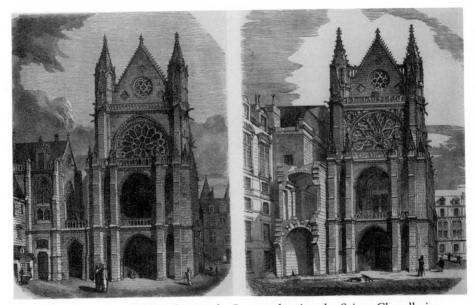

Figure 6.5: Print after a drawing by Lassus, showing the Sainte-Chapelle in its original and current states. *Ecclesiologist* 10 (February 1850): between 300-301. Courtesy of the University of Chicago Library.

from the Palais, he wanted to distance the two structures, physically and visually, by allowing nothing more than an open-air bridge to connect them.[31] He wanted the Sainte-Chapelle, in its capacities as a church and an artistic monument, set apart as a special realm of value, distinct from the mundane judicial world whose architecture he and his associ-

31. Lassus and Duban both wanted the upper chapel returned to religious use and acknowledged that the chief constituency for services was the magistrature, for whom the route between the porch and the Palais offered the best access. They were adamant, however, that this connector signal its status as the route to a sacred realm through its architectural form and that it not be incorporated into a general circulation system for the Palais. Lassus, report of 24 August 1849, AMH, "Dossier relatif aux travaux d'isolement"; Lassus, letter of 8 September 1849 to the minister of the interior, AN, F/21/5914. Leniaud (*Jean-Baptiste Lassus*, 113) and before him Paul Léon (*La vie des monuments français* [Paris: Picard, 1951], 348–49) have pointed out that Lassus and his allies rejected the (generally classical) principle that great monuments should be freestanding. Lassus demanded isolation of the Sainte-Chapelle rather because he considered its form to be incompatible with the neighboring parts of the Palais, as he explained in *Journal des débats*, 12 August 1849, 2. In other words, he insisted on the need to isolate buildings of unlike value, thereby participating in the increasing specialization of space in the nineteenth-century city. On the latter, see Henri Lefebvre, *The Production of Space*, trans. Donald Nicholson-Smith (1974; Oxford: Basil Blackwell, 1991).

ates described as representing nothing more exalted than an office building.[32]

Lassus's suggestively excessive language reinforced this vision, casting the Sainte-Chapelle as female counterpart to the masculine Palais and evoking the recent sequestration of the home as a feminine realm of ethical and aesthetic value, set apart from the public, masculine realm of economic and political affairs.[33] Like the home, the church had been feminized, ministering primarily to women as the new guardians of social ethics, whereas the courthouse dispensed justice in affairs managed by men.[34] Moreover, Lassus regarded religion as interdependent with the Gothic architecture of the Sainte-Chapelle: only an age of faith— his beloved thirteenth century—could have produced the Gothic flowering of the arts, which bore witness to a long-lost organic social harmony and which, if painstakingly restored, could reinspire contemporaries. For Lassus saw social divisiveness in the architectural banality of the Palais de Justice, indicative of a secular institution powerless to inspire divine harmony.[35]

32. In the first article broadcasting Lassus's alarm to the public (and possibly written by Lassus), the *Journal des débats*, 2 August 1849, 2, described the Palais buildings as "sans style et sans valeur aucune"; the *Revue archéologique* 8 (April–September 1851): 578, characterized them as "cette architecture néo-classique . . . dont les pierres, entassées jusqu'au ciel, constituent une vaste et froide série de geôles, de greffes et de cabinets d'instruction." Paraphrasing their opponents, Duc and Dommey wrote, "le Palais de Justice est assimilé à des bâtiments de bureaux qui feraient obstacle à l'effet d'un monument artistique" (*DRT*, 310).

33. Accounts of the latter phenomenon include Joan Landes, *Women and the Public Sphere in the Age of the French Revolution* (Ithaca: Cornell University Press, 1988); Lynn Hunt, *The Family Romance of the French Revolution* (Berkeley: University of California Press, 1992); Clare Moses, *French Feminism in the Nineteenth Century* (Albany: State University of New York Press, 1984); Michelle Perrot, ed., *A History of Private Life*, vol. 4, *From the Fires of the Revolution to the Great War*, trans. Arthur Goldhammer (1987; Cambridge, Mass.: Harvard University Press, 1990).

34. On the feminization of the church, see Michela De Giorgio, "The Catholic Model," in Geneviève Fraisse and Michelle Perrot, eds., *A History of Women in the West*, vol. 4, *Emerging Femiminism from Revolution to World War* (Cambridge, Mass.: Harvard University Press, 1993), 166–97, esp. 168–70; Ralph Gibson, *A Social History of French Catholicism* (London: Routledge, 1989), 180–90. The gendering of legal affairs as masculine is evidenced by the fact that married women needed spousal authorization to bring a law suit (article 215 of the Civil Code). Article 213, requiring that the wife obey her husband and the husband protect his wife, provided the basis for defining married women as legal minors; this principle was only repealed in 1938. See Nicole Arnaud-Duc, "The Law's Contradictions," in Fraisse and Perrot, *History of Women in the West*, 4:80–113, esp. 105; Theodore Zeldin, *France 1848–1945: Ambition and Love*, rev. ed. (Oxford: Oxford University Press, 1979), 343–44, 357.

35. See especially Lassus's article with Albert Michiels, "Architecture religieuse et civile," in Paul Lacroix, ed., *Le Moyen-âge et la Renaissance: Histoire et description des moeurs et usages, du commerce et de l'industrie, des sciences, des arts, des littératures et des beaux-arts*

In terms of Turner's phases of a social drama, Lassus launched the conflict by projecting a breach of normal social relations onto Duc and the Cour du Mai. The ensuing crisis and its redressive arbitration obliged Duc as well as Lassus to move beyond the tactical politics of the moment and externalize certain core articles of faith.[36] Through a prestigious government-appointed committee, Lassus and his allies called on Duc to sacrifice the merely mechanical symmetry of the Cour du Mai by rebuilding its south wing to defer to the Sainte-Chapelle. This offensive obliged Duc to articulate a defense of the old Cour du Mai, whose character thus became a vehicle for thinking through the question of the architectural representation of justice. Where Lassus had construed the structure's neoclassical form as at once transparent to a divisive social order and the agent of forceful aggression—not only subartistic but actively destructive—Duc insisted that its radical simplicity and clarity were rhetorically expressive of the Enlightenment cult of universal law, declaring that it was necessary to respect the successive forms through which the architecture of the ancient Palais had expressed its role as an instrument of social order (figs. 6.3, 6.9).[37] Thus he argued that the Cour du Mai, with its dogmatic imposition of the Doric architectural order, displayed a "rigid, inflexible architecture conceived all of a piece" with a "simple and imposing character," and maintained that the ensemble, "though without claim to the status of a chef d'oeuvre, had all the qualities appropriate to its topos."[38] It is as though its columns constituted pillars of law, an idea that Jean-Nicolas-Louis Durand and Jean-Thomas Thibault had hypostasized in their celebrated project from the revolutionary year II for a temple to equality, which literally transformed the piers of the portico into stelae inscribed

en Europe, 5 vols. (Paris, 1848–1851), 5: fols. 1–18, and Lassus, "Considérations sur la Renaissance de l'art française au XIXe siècle," in Lassus, ed., *Album de Villard de Honnecourt* (Paris: Imprimerie nationale, 1858), esp. 40. As Lassus's close associate, the antiquarian Troche, declared in the first nineteenth-century guidebook and monograph devoted to the Sainte-Chapelle, "Tout, dans sa structure et sa décoration devient un sujet de prédication et d'enseignement pour le peuple." Nicolas Michel Troche, *La Sainte-Chapelle de Paris* (Paris: Boucquin, 1853), 27. For a general discussion of Lassus's views in relation to his milieu, see Leniaud, *Jean-Baptiste Lassus*, 119–24; for an overview of contemporary linkages between aesthetic theory and sociopolitical notions of unity, focused on the legitimist Catholic coauthor of an 1825 monograph on the Palais and the Sainte-Chapelle, see Michael Paul Driskel, "The 'Gothic,' the Revolution and the Abyss: Jean-Philippe Schmit's Aesthetic of Authority," *Art History* 13 (June 1990): 193–211.

36. Turner, *Dramas, Fields, and Metaphors*, 38–41.

37. As argued in an official report of 30 September 1849, published as *Rapport sur l'isolement de la Sainte-Chapelle* (Paris: Vinchon, imprimeur de la Préfecture de la Seine, 1849) and reprinted in *DRT*, 305–19, esp. 310.

38. *DRT*, 313.

with normative texts prescribing the virtues supporting equality's rule (fig. 6.6). Giving visual form to the commonplace metaphor of the temple of law indicated how law might operate both as ethical standard and as structural compulsion. Yet for Duc, the canonical aspect of the Cour du Mai's architecture only made it more exemplary of the ideal of order.[39]

While defending the Cour du Mai as expressing what he called a positive idea, Duc himself eschewed its archaic rigidity. In his own modernization of the Palais, he countered with an inclusive master plan, arguing that present-day architects like himself had reconceived classical order in systemic rather than merely formalistic terms, enabling it to integrate so heterogeneous a group of buildings as the Palais (including the Sainte-Chapelle, which had originally been built as an integral part of the Palais). In extending the wings of the Cour du Mai as the armature giving physical access to the entire modern Palais, Duc agreed to narrow the corridor where it passed the Sainte-Chapelle porch—as is evident in his amended plan of 1847 (fig. 6.7) and in a plan showing the current state of the Palais (fig. 6.8). And in exchange for substituting a flat roof for the original attic mansard on the south wing, he was allowed to preserve the unity of the Cour du Mai facades. Duc's notion of an appropriative, flexible classicism capable of absorbing the Sainte-Chapelle prevailed over Lassus's exclusive view of styles, and his alternative to the Cour du Mai took strongest form in the west entrance facade, which he was already conceptualizing, in 1849, as its modern pendant (fig. 6.16). While self-consciously retaining the element of the portico, Duc reconceived the image of justice set by the Cour du Mai, complicat-

39. On Durand and Thibault's project, see Werner Szambien, *Jean-Nicolas-Louis Durand 1760–1834. De l'imitation à la norme* (Paris: Picard, 1984), 45–47. Engravings of it were published, with some changes, chiefly a politically opportune switch of dedication from equality to public happiness, in G.-E. Allais, A. Détournelle, and A.-L.-T. Vaudoyer, eds., *Projets d'architecture et autres productions de cet art qui ont mérités les Grands Prix* (Paris, 1806); if Duc knew of the project, he might well have been intrigued by additional features, such as its animated capitals, suggestive of Denderah, the Egyptian temple that also fascinated Duc. Durand and Thibault's project merges two revolutionary means of representing the law in buildings—incorporating text into the facade and maintaining the tradition of a temple to the law with an entrance portico; for these modes, see Mark Deming and Claudine de Vaulchier, "La Loi et ses monuments en 1791," *Dix-huitième siècle* 14 (1982): 117–30. The use of architecture as a metaphor for order or law remained current during the drafting of the legal codes and in their cult during the nineteenth century; see, for example, the writing of Cambacérès, in Fenet, *Receuil complet*, 1:2. Lassus regarded the controversy he launched over the Sainte-Chapelle as a skirmish in a war over architectural styles that had taken shape in Paris when the neo-Gothic church of Sainte-Clotilde was proposed in 1846; the battle turned in part on the question of whether the Gothic exhibited lawfulness in the way that classical architecture did; see Lassus's dispatch to the *Ecclesiologist*, 298.

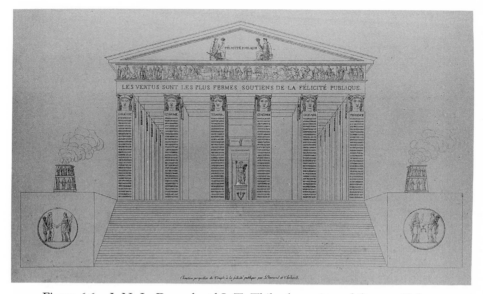

Figure 6.6: J.-N.-L. Durand and J.-T. Thibault, project of the year II for a temple to equality, with the dedication revised to "la félicité publique." Each pier is inscribed as a different virtue, above the names of citizens who exemplify it. Perspectival elevation, engraving from Allais, Détournelle, and Vaudoyer, eds., *Projets d'architecture . . . qui ont mérité les grands prix* (Paris: Détournelle, 1806), pl. 28. Special Collections, Golda Meir Library. University of Wisconsin, Milwaukee.

ing the aspect of transparency that Lassus had criticized and enriching the austere image that had resolved for Lassus into a sign of aggressive force. But this lay in the future. As of 3 November 1849, the day of the judicial ceremony, both sides had only made their pleas; their unresolved crisis spilled over into the design and experience of the festival.[40]

The Ceremony

The Ministry of Justice dramatized the architectural clash in the ceremony it produced to stabilize the magistrature, not merely dividing the event between the two sides but handing Lassus the opportunity to make a spectacular case for his cause. For the ceremony officially doubled as the inauguration of the astonishingly colorful restoration of the

40. Agreement was reached in December 1849; demolition of the stonework abutting the Sainte-Chapelle porch was delayed until the summer of 1851, and the detailing of the new connector between the porch and the Palais was not resolved until early 1852 (annotated drawings in the architects' archives, now in the collection of the Cour d'appel de Paris).

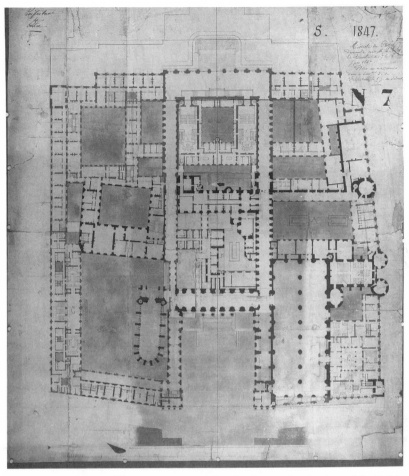

Figure 6.7: Duc and Dommey, master plan for the modernization of the Palais de Justice, first (main) floor, 1847 with later corrections. The Cour du Mai or east entrance is at the bottom of the plan and the projected west entrance at the top. Collection of the Cour d'appel de Paris. Photo: Jacques Vasseur.

Sainte-Chapelle as we know it today, though the work would not actually be completed for nearly twenty years. Moreover, since the very connection between the Sainte-Chapelle and the Palais was in dispute, this decision occasioned a circuitous, elaborate procession of participants between the ceremony's two locales, highlighting the division and the problematic Cour du Mai in between. By accepting that complication and by allowing Lassus to spectacularize the mass in the Sainte-Chapelle, the organizers upped the ceremonial ante and drew attention to the aesthetics of this presentation of justice, garnering the kind of

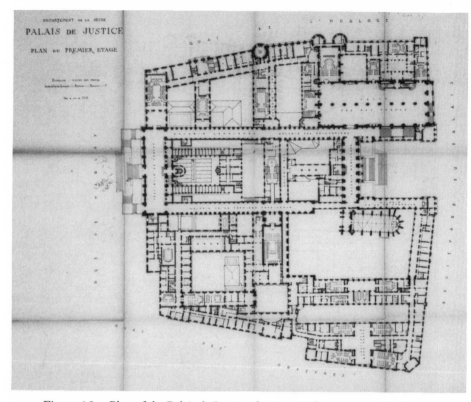

Figure 6.8: Plan of the Palais de Justice, first (main) floor, in completed twen-
tieth-century state. Collection of the Cour d'appel de Paris.

reception we have already noted in *L'Illustration*'s diptych. Thus, this
closer look at the ceremony asks how style participated in its claims
about the character of modern French justice, considering its visual as-
pects as distinct from but overlapping with the speeches and oaths that
verbally defined the event.

The heads of justice who coordinated the design of the festival were
aware of the architectural politics of their quarters: Barrot, who as head
of cabinet and minister of justice conceived the oath and its ceremony
and served as the intermediary between the judiciary and executive gov-
ernment, together with President Portalis and Chief Prosecutor Dupin
of the Cour de Cassation, the highest jurisdiction in the French system,
which considered itself the heir of the ancien régime's *Parlement* at the
Parisian Palais de Justice. As the local host for the festival, the Cour de
Cassation employed its own special architect, Louis Lenormand, rather
than Duc, for the portion of the ceremony in the courthouse. Even

without Duc's involvement, the architectural battle was inevitably invoked when the minister decided to include the Sainte-Chapelle and work with Lassus on that portion of the festival.[41]

Structuring the festival as a diptych also drew attention to political agency within the ceremony. The movement it necessitated between the two scenes gave rise to processions that celebrated Bonaparte's status as head of state and convenor of the event. The day began with the future emperor's military procession into the Cour du Mai, where he was met by the chief magistrates at the top of the stairs. Coming on the heels of Bonaparte's imperious firing of Minister Barrot, how could it not recall ancien régime arrivals of the king to reclaim the Palais de Justice as his own—as specified in the inscription of a late-eighteenth-century engraving, "*L'arrivée du Roi à son Palais de Justice*" (fig. 6.3). Care was taken to redecorate the Cour du Mai for this event, masking the royal emblems that figure in the engraving, which commemorates Louis XVI's arrival on 19 November 1787 for his last formal session in the Paris *Parlement*—a *lit de justice* in all but name—just after completion of the neoclassical Cour du Mai. Placards covering the emblems proposed that the prince-president of 1849 was merely paying his respects to the republican temple of the law and its priests (fig. 6.9 shows the decorations as they were retained, with partially revised inscriptions, for another government ceremony a week later).[42] Yet the next step belied such modesty: Bonaparte, followed by members of government, led the magistrates in procession back out of the Cour du Mai, down the boulevard du Palais, and into the separate courtyard of the Sainte-Chapelle, where they were met by Archbishop Sibour of Paris and his clergy. Order of precedence in procession was of keen interest to participants, and here it necessarily articulated the subordination of the magistrates to their explicitly political confrères in government.[43] Signifi-

41. On the planning of the ceremony, see AN, F/21/769, "1850. Dossier: Travaux pour l'installation de la magistrature." Barrot appears to have overseen the Sainte-Chapelle preparations alone, through informal meetings with Lassus: *Moniteur universel*, 28 October 1849, 3376; AN, F/21/769. On Lenormand's role, also see AN, F/21/3399 and F/21/2370. The following reconstruction of the ceremony and its decor is also drawn from reports in the *Moniteur universel* (25 October; 28 October; 2 and 3 November; 4 November; 5 November), the *Journal des débats* (1 September; 13 October; 31 October; 4 November), the *Gazette des tribunaux* (30 October; 4 November), and *L'Illustration* 14 (1849): 161, 167–70.

42. On the decoration of the Cour du Mai on 3 November, see AN, F/21/3399 (Lenormand's *attachements*) and the description by the *Gazette des tribunaux*, 4 November 1849, 9.

43. Official guests at the festival included representatives of executive government (cabinet ministers, the military, foreign diplomats), the legislature, the clergy, other national and local governmental bodies, and the nonjudicial legal professions. The proces-

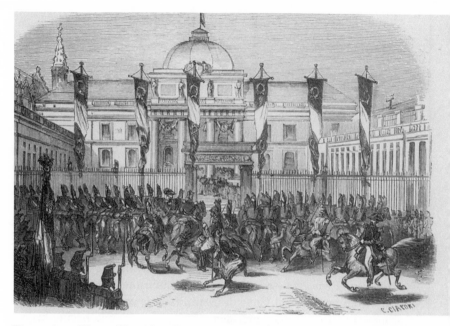

Figure 6.9: View of President Bonaparte arriving at the Cour du Mai for the
prize-distribution ceremony of 11 November 1849, which reused most of the
decoration from the judicial ceremony of 3 November. *L'Illustration* 14 (1849):
180. Courtesy of the University of Chicago Library.

cantly, during the month of preparations before the ceremony, the
connecting route between the two interiors had been elaborated from
initial plans for a modest internal passage to this opportunity for open-
air procession in view of crowds along the street.[44] Moreover, ap-
proaching the Sainte-Chapelle through its own courtyard and entering
by a temporary stair that Lassus improvised in place of the demolished
original replicated the way kings had traditionally arrived for a mass
preceding a *lit de justice*.[45] Lassus knew the painting by Jean-Baptiste

sion to the Sainte-Chapelle included only executive government members, but presum-
ably all attendees of the mass processed back to the Salle des Pas Perdus.

44. Lenormand, report of 24 December 1849 to the minister of public works, AN,
F/21/769.

45. The newspaper account of the ceremony described the stair as a temporary
wooden one erected on the plan of the former masonry stair (*Moniteur universel*, 2 and
3 November 1849). The original had led to the porch of the upper chapel since at least
the reign of Louis XII. Although Lassus admired its form and made documented recon-
struction drawings of it, he ultimately came to doubt that a stair had existed at the time
of the chapel's construction and eliminated it, maintaining that it was better to have access
to the upper chapel from the Palais alone; see Lassus, "La Sainte-Chapelle du Palais,"
in *Paris dans sa splendeur*, 3 vols. (Paris: H. Charpentier, 1861), 1:21.

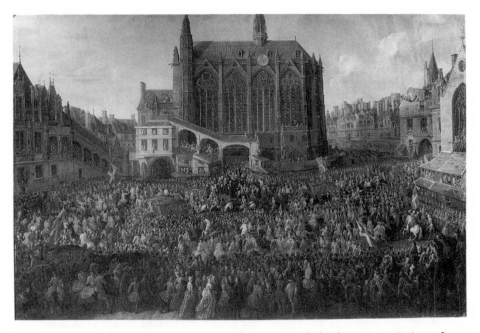

Figure 6.10: Jean-Baptiste Martin, *Départ après le lit de justice*, painting of Louis XV and his retinue in the courtyard of the Sainte-Chapelle, leaving the Palais after the *lit de justice* of 1715. Musée de Versailles. Photo: Réunion des Musées Nationaux, France.

Martin commemorating the procession at the *lit de justice* of 1715, complete with red robes evoking royal authority; similar robes were worn by the magistrature in 1849 (fig. 6.10).[46] Yet the inclusion of the mass in the *lit de justice* had enacted the tenet that justice emanated from God to the king and from the king to his magistrature, while in the Second Republic the mass represented the equality of all lay participants before a higher power.[47]

Inside the Sainte-Chapelle, participants discovered another type of authority, that of the church, enhanced by a multimedia re-creation of religious ceremonial from the thirteenth century, which Lassus and his associates regarded as its most persuasive moment. Lassus treated the

46. Lassus, "La Sainte-Chapelle," 21. A project drawing of 1783 by Couture labels the staircase as the king's route into the Palais; Louis XVI shifted the entrance to the rebuilt Cour du Mai in 1787. Couture's drawing is recorded by Alfred Bonnardot, "Iconographie du vieux Paris," *Revue universelle des arts* 7 (1858): 138. Martin's painting is reproduced in color by Rousselet, *Histoire de la magistrature*, 2: facing 360, and Leniaud and Perrot, *La Sainte-Chapelle*, 106–7.

47. That the recent replacement of the cabinet was due to differences between Bonaparte and his government over policy toward Rome was a small irony of this spectacle.

ceremony as an opportunity to sway contemporaries to the Gothic re-
vival cause through sheer aesthetic impact. As he reported afterward to
a British colleague:

> One may say already that our cause is won, and the recent inauguration
> of the Sainte Chapelle . . . has greatly aided that result. . . . During nine-
> teen days, the crowd never ceased pressing through the portal. . . . One
> can hardly form an idea of the immense impression produced upon the
> crowd. . . . You will easily understand, Sir, the eagerness with which I
> seized the opportunity which presented itself, of giving an idea . . . of the
> decoration of a chapel of the thirteenth century. . . . [I]t was an excellent
> opportunity of pleading the cause which we advocate.[48]

Surprise was an important ingredient, for the results of the Sainte-
Chapelle restoration were not yet known to the public and, indeed, were
only hastily made to simulate completion for this occasion. Though art
historians have largely forgotten this event, nineteenth-century archae-
ologists like A.-N. Didron considered it so important that they recorded
it in documents like the lithograph by Philippe Benoist, certified as ac-
curate in advertisements for its sale (fig. 6.11).[49] What the lithograph
could not record is the initial shock of the chapel's brightly painted
surfaces, emulating the stained-glass windows and harmonizing, report-
ers said, with the colorful costumes of participants—incorporating the
latter into a chromatic unity. And while it includes the medieval fittings
hastily simulated in cardboard, we must add the sound of the thirteenth-
century music reconstructed in order to complete the effect of the
Gothic harmony of the arts and work its social magic. The event began
with a squabble over the fact that Bonaparte's chair in the chancel had
been placed on a higher platform than the facing chair for the head of
the delegation from the legislature.[50] Didron claimed that the music
subdued and unified unruly protagonists in awe of a higher power.[51]

 This sensational appeal met with mixed response from the public—
not only the enchantment Lassus sought, but also skeptical resistance.
By challenging the Gothicist premise that the arts were once at a simul-
taneous apogee, some contemporaries undermined Lassus's message
that aesthetic harmony went hand in hand with theocratic social har-

48. Lassus, "Ecclesiological Movement," 298.
 49. Published by Chapon in 1850 and priced at eight francs, the lithograph was en-
dorsed and advertised by Lassus's associate, A.-N. Didron, in his journal *Annales archéolo-
giques* 10 (1850): 171.
 50. *Journal des débats*, 4 November 1849, 1.
 51. Didron, "Chants de la Sainte-Chapelle," *Annales archéologiques* 9 (1849): 309–18.
See also the pamphlet by Félix Clément, who prepared and conducted the music: *Chants
de la Sainte-Chapelle tirés de manuscrits* (Paris: V. Didron, n.d. [1849]).

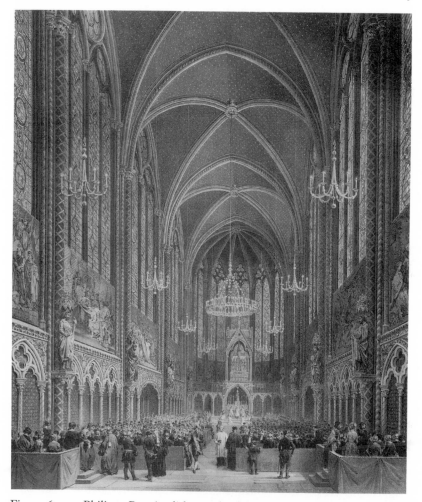

Figure 6.11: Philippe Benoist, lithograph of the mass of 3 November 1849 in the Sainte-Chapelle, 1850. Bibliothèque Nationale, Cabinet des estampes. Photo: Bibliothèque Nationale, Paris.

mony.[52] Another commentator resisted the brilliant coloration, calling it barbaric because it promoted a visual fusion of elements where the modern eye demanded the ordered compartmentalization provided by neoclassicism. Never mind that even the ancient Greeks had painted their architecture; modern man should restrain such theatrical impulses

52. For instance, Théodore Nisard, "Examen critique des chants de la Sainte-Chapelle," *Le Correspondant* 26 (1850): 596–618, excerpted for reprint in the *Revue archéologique* 7 (April/September 1850): 373–84.

and represent himself through the austere self-restraint expressive of reasoned self-government.[53]

That message was read into the decor of the Salle des Pas Perdus. The *Gazette des tribunaux* commended Lenormand for avoiding the gaudiness of a *fête publique* (fig. 6.1, right side). It praised the way he appropriated one nave of the two-aisled hall, setting it up to look like a judicial audience in a courtroom instead of a public fête and drawing attention to its sober Doric detailing.

> The magnitude of the Salle des Pas Perdus and the simple, severe style of its architecture permitted no hesitation over the choice of site [for the ceremony]. . . . We can only applaud the architect for having conserved almost intact the work of Jacques de Brosse [the architect of the seventeenth-century hall]. It must be underscored that the ceremony of 3 November should not have the character of a *fête publique*, in which richness and brilliance necessarily play a big part, but rather that of a courtroom, where all the detailing must be solemn and worthy of the greatness of its topos. The arcades, pilasters, entablature, were therefore completely preserved, but because the extreme simplicity of their lines could have made for an excessively cold effect, vast draperies . . . decorate the arcades without disguising their form.[54]

Not only did Lenormand confine his bunting within the architectural frame, but he brought an unaccustomed visibility to the notoriously gloomy interior by opening the bull's-eye windows in the barrel vault to daylight, providing the natural source of "enlightenment" requisite to the rule of reason. His chief addition to the architecture appealed primarily to the mind: the logocentric decoration of panels of inscriptions narrating the history of French justice as the rise of the bourgeois, law-abiding state. The *Gazette des tribunaux* subscribed to the notion, suggested by this decor and articulated in speeches at the ceremony, that the ancien régime magistrature had prefigured the style and substance of modern self-government, through self-sacrificing loyalty to the law and self-restrained demeanor contrasting with monarchic splendor. Similarly the age and austerity of the seventeenth-century hall seemed to contribute to the message that the reinstallation of the magistrature represented judicial continuity and autonomy. As Bonaparte

53. See the *feuilleton* by an anonymous reviewer of the ceremony of 1849, "Pr. H.," "Beaux-Arts. Restauration et décoration des monuments publics. I. La Sainte-Chapelle," *Le National*, 27 November 1849, 1–2.

54. "Institution de la magistrature," *Gazette des tribunaux*, 30 October 1849, 1306–7.

himself declared in his speech at the ceremony, in modern times it was heads of state who changed, while the magistrature never died.[55]

To see it this way, one had to discount the sheer pageantry of this event, including the unprecedented display of the magistrature to the public, who watched from balconies and bleachers at the back, as well as the fact that the government, especially Bonaparte, standing before his elevated fauteuil, had displaced the judiciary from its place at the bench to the subordinate position of litigants and lawyers (fig. 6.12).[56] It is useful to recall that one of the ceremony's key organizers, the influential magistrate Dupin *l'aîné*, characterized the event as "a festival of justice," and to note that the architect declared that only a "sordid" budget kept him from creating a more dazzling display.[57] Finally, of note was the difference in costume between Bonaparte, in the military uniform of the National Guard, and the magistrature in its ceremonial robes, which originated in castoffs of ancien régime monarchs. Here the head of state and his cabinet members assumed the relatively restrained clothing that had replaced display as the style appropriate to modern power, while the magistrature formed a brilliant display in the old style.[58]

In fact, the speeches made by Bonaparte and others offered two dif-

55. Speech reprinted in "Institution de la magistrature," *Journal des débats*, 4 November 1849, 4.

56. The hall was set up like a "salle d'audience," and the proportions of the Salle des Pas Perdus nave lent themselves to the longitudinal basilican arrangement of the courtroom, which enhanced hierarchy. By contrast, the layout adopted in the larger but similarly rectangular hall of the Exposition universelle of 1855, where prizes were distributed to participants, was arranged as an amphitheater, with the emperor's platform centered on the long side wall rather than the narrow end wall, increasing spectators' access to the proceedings. See Armand de Barenton, "Clôture de l'exposition universelle" and the accompanying illustration, *L'Illustration* 26 (24 November 1855): 343–46.

57. Dupin's speech, reprinted in the *Journal des débats*, 4 November 1849, 3; Lenormand's statement that he observed "une économie presque sordide" is in his report of 24 December 1849 to the minister of public works, AN, F/21/769.

58. French royal tradition required that king and his leading judges wear the same costume to indicate their mutual identification. See Garapon, *L'Ane portant des reliques*, 70, and Rousselet, *Histoire de la magistrature*, 1:325. By differentiating their costumes, nineteenth-century heads of state thus effected a visual separation between the executive and the judiciary powers. Louis-Napoleon's appearance in National Guard uniform followed the precedent set by Louis-Philippe, who had adopted this uniform to distinguish his rule as a citizen-king from the traditions of absolute monarchy. See Michael Marrinan, *Painting Politics for Louis-Philippe: Art and Ideology in Orléanist France, 1830–1848* (New Haven: Yale University Press, 1988), 3–19. Regardless of the distinctions between the National Guard and the army (the former was, in principle, a civilian militia responsible for enforcing order within France as opposed to a professional force concerned with foreign threats), the uniform allied the executive with the agents of force rather than justice.

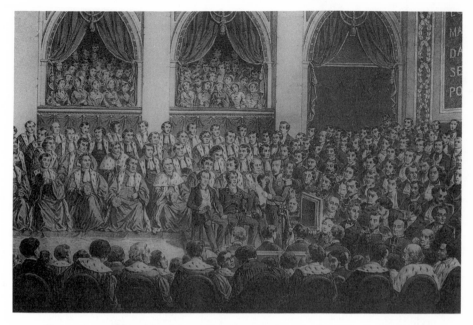

Figure 6.12: Vignette of the oath-taking ceremony in the Salle des Pas Perdus, with President Bonaparte at the center. Bibliothèque Nationale, Cabinet des estampes. Photo: Bibliothèque Nationale, Paris.

ferent models for the new magistrature: the army, for its force and obedience to command, and the clergy, for its moral authority. Received in their time as unexceptionable, these comparisons can be taken both as clues to historically changing norms for institutions and as a commonplace version of a philosophical tradition reflecting on the relationship between force and justice. The minister of justice Rouher and the president of the Cour de Cassation Portalis described the magistrature as keeping order like the army and, more specifically, as visually representing the force that the army literally embodies. Thus Rouher said that the judicial ceremony would "render visible to the eyes . . . that force which was truly indestructible." Like Pascal, as glossed by Louis Marin, these jurists presumed that the paraphernalia of justice visually represent the potentiality of force (whereas the army simply embodies force) and that such representation multiplies and perpetuates its power. But, especially in the postrevolutionary state, the power of judicial representation lies equally in its eclipse of its own debt to force. And, as we noted at the outset, the installation ceremony was an occasion at which the relationship between political power and justice was both

explicitly acknowledged and re-effaced. It was necessary for reaffirmed justice to *look* noncoercively persuasive. Thus the archbishop insisted on a comparison of the magistrature to the clergy, describing both as visually splendid and as agents of peace and prosperity and making reference to their pairing in the ceremony. In his speech, visual splendor effaces the taint of coercion and renders lawfulness desirable.[59] It was this clerical model that prevailed.

The ceremony witnessed a separation between force and justice, an austere style of executive action and a festive style of ostensibly apolitical authority. Given the new prominence of judges in the representation of justice, the former neoclassical austerity appropriate to the disembodied law could have assumed a dangerously arbitrary, political look. If heads of state could be willful, arbitrary, and short-lived, magistrates would be benevolent and permanent. Feminized display, retained from judicial tradition and borrowed from the feminized church, now served to moderate the personal power of the judges. Drawing on religious festivity to represent the magistrature at this event, the government bridged the gulf that Lassus had tried to effect between religion and justice by representing both as apolitical agents of social order, different but parallel. As for politics, we have already noted that the ceremony took place in circumstances that anticipated Bonaparte's ambitions, infusing his spare costume of action with an aura of force. When Bonaparte made his coup d'état two years later, Dupin observed, in his additional capacity as a member of the legislative assembly: we have the law on our side, but those gentlemen have force on theirs.[60] Dupin's widely circulated *mot* crystallized what had already happened to the judiciary: justice had visually separated from force.

The image of a justice distinct from force was completed in a sequel ceremony. At the judicial mass the archbishop had declared that justice

59. The speeches are reprinted in the *Moniteur universel* and the *Journal des débats* (both 4 November 1849). On Pascal's reflection on force and justice, see Louis Marin, *Portrait of the King*, trans. Martha M. Houle (1981; Minneapolis: University of Minnesota Press, 1988), 16–36. Of course the circumstances in which the comparisons were made in 1849 were not those of Pascal's absolutist state, and what was meant by a reference to the army or the clergy was historically specific. Traditions were invoked for and adapted to particular circumstances. While the institutional comparisons could prompt a historical discussion of the relative status and representational mode for various public bodies, that project is beyond the scope of this essay.

60. Robert and Cougny, *Dictionnaire des parlementaires françaises* (Paris: Bourloton, 1890), 2:492; also La Gorce, *Histoire de la Second République française*, 2:512; Maurice Agulhon, *The Republican Experiment 1848–1852*, trans. Janet Lloyd (Cambridge: Cambridge University Press, 1983), 141.

and religion should shine like the sun that ensures fertility and prosperity.[61] Immediately following the festival of justice, the government enacted that tableau, using the Palais and the Sainte-Chapelle to host the prize ceremony for the 1849 exposition of agricultural and industrial products. The occasion gave new life to the traditional association of justice with prosperous abundance, an image *L'Illustration* suggested in framing its vignette of the event with vine-draped, nubile muses to productivity (fig. 6.13).[62] Lenormand simply revised the inscriptions and softened the Doric architecture of the Salle des Pas Perdus with bundles of flags and additional bunting to give that judicial interior an extra degree of festivity. Such an event held in the Palais de Justice was in its way as extraordinary as the judicial ceremony, for the state had gone to great expense during the first half of the century to expropriate the merchants who had traditionally occupied stalls in its corridors and along its facades and to isolate justice as a specialized, "dignified" zone of activity. While thrift was clearly a reason to reuse the ceremonial setup from the judicial installation, more is needed to explain why the government would violate the former principle of separation to create a ceremonial parallel between justice and commerce. By 1849, it had become productive to present the Palais de Justice as the host of prosperity and justice as benevolently festive.

Representation

Allegorizing justice was of the essence in that fading Republican moment, belying Lassus's claim that modern justice had become transparent, drained of representational significance. Stirred by the social drama of 1849, Duc was moved to infuse his modernization of the Palais de Justice with the allegorical character of the festival of justice, superseding the austere neoclassical image of Napoleonic-era justice. As it happened, Duc was already reconstructing a historic visual allegory of justice for a monumental decoration at the Palais, the French Renaissance clock face on the corner tower, whose restoration the government inaugurated in 1851 (fig. 6.14). In the two figures flanking the dial, he orchestrated a juxtaposition of Force to Justice, adapting the original iconography; this juxtaposition became a motif he extended even into architectural form in conceiving his own frontispiece for modern

61. *Journal des débats*, 4 November 1849, 3.
62. The 11 November ceremony was reported by the *Moniteur universel*, 12 November 1849, the *Journal des débats*, 12 November 1849, 1, and in illustrated form in *L'Illustration* 14 (1849): 179–82.

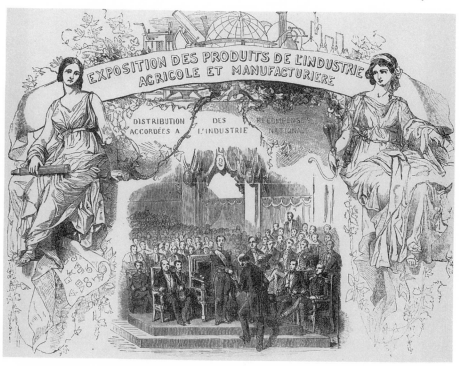

Figure 6.13: Vignette of the prize-distribution ceremony in the Salle des Pas Perdus, with President Bonaparte at the center, 11 November 1849. *L'Illustration* 14 (1849): 181. Courtesy of the University of Chicago Library.

French justice, in answer to the Cour du Mai. What drove this persistent fascination with allegory?

A broad explanation has been offered by Christian-Nils Robert in his study of the allegory of justice that emerged and proliferated in early modern Europe, in a form like that of Duc's ostensibly sixteenth-century clock at the Palais de Justice. Robert has argued that it was relatively secular, democratic forms of government (the city-states of central Europe) that typically propagated visual allegories of justice, while the absolutist monarchy continued to rely mainly on the effigy of the king. He relates the allegory of Justice to the city-state's need for an emblem that abstracted power and dissociated it from the individual men at the helm of government. The emblem of Justice not only represented justice but allegorized and legitimated the state and its executive power. Thus in France, allegories of justice appeared considerably later than in city-states and did not truly proliferate until after the Revo-

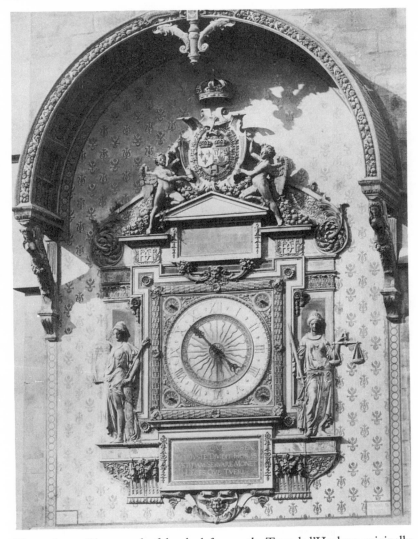

Figure 6.14: Photograph of the clock face on the Tour de l'Horloge, originally designed by Germain Pilon and completed 1585, restored by Duc and Dommey 1852. Bibliothèque Nationale, Cabinet des estampes. Photo: Bibliothèque Nationale, Paris.

lution because the king's person and his *lit de justice* embodied justice. Republican moments stimulated allegorizing.[63]

63. Christian-Nils Robert, *La justice. Vertu, courtisane et bourreau* (Geneva: Georg, 1993), 113–18. Cf. the more limited version of this argument in Jacob, *Images de la Justice*, 229, 240–41.

One might add that the allegory that flowed from 1789 tended to avoid the corporate implications of judging to focus on the still more impersonal aspect of Law, which had rarely drawn visual expression before the codification movement of the revolutionary and Napoleonic periods.[64] The Second Republic, as we have seen, made for a renewed allegorizing of Justice but in more complex form: it figured forth Justice in the living persons of its magistrature and the historic buildings where it originated, blending corporate judicial authority with the abstracted emblem of state power afforded by the traditional allegory of Justice. Whereas the judiciary had functioned as a lightning rod for anticorporate sentiment because of the prerevolutionary *Parlement*'s legislative presumptions, the Second Republic's failed reform debate indicated that this civil service was going to endure. The judiciary could become emblematic of the French state's extensive *fonctionnaire* sector precisely because it was ideologically positioned outside executive government as the secular counterpart to the church in regulating private life.[65] Its ostensibly paternalistic role in reconciling ordinary citizens to the law would only grow in the circumstances of the Second Empire and the Third Republic. For instance, Emperor Louis-Napoleon's Saint-Simonist encouragement of commercial and industrial development increased the pressure of capitalist expansion on the judicial system, obliging judges to bring the Napoleonic codes, predicated on a highly individualistic model of social activity, into line with the reality of social and economic interdependence. In an ambience of solidarism opposed to the social Darwinism articulated in the common-law culture of Britain, the Third Republic would develop a notion of judging that gave new emphasis to the judge's discretion, as he "individualized" his verdicts to adapt the general precepts of an aging legal code to the specific circumstances of litigants. In such practices, the festival of justice's living allegory survived Bonaparte's coup and assumed new meanings. At the same time, it was woven into the architectural fabric of the Palais de Justice by Duc.

To understand Duc's architectural relationship to the social drama of 1849 and the allegory it generated, we must first take stock of where he stood in his modernization of the Palais de Justice. Having recently

64. On the rarity of allegorical representations of written law before the nineteenth century, see Robert, *Justice*, 42.

65. The French distinguish public or administrative law, managed from within executive government, from private law, the domain of the ordinary courts lodged at the Palais de Justice. But, as the reform debate attests, the cognoscenti were well aware of administrative manipulation of judicial careers. Judges were of course *fonctionnaires*, and even lay jury service, restricted in France to the criminal courts, would be redesignated as a state *fonction* rather than a voter's right under the Second Empire.

completed his first master plan, Duc was thinking about its detailing, an aspect he would constantly revise, even during construction (fig. 6.7). He was bedeviled by the Cour du Mai. He had swung round from volunteering to demolish its problematic wing next to the Sainte-Chapelle[66] to protecting the ensemble as the generator of the circulation scheme he proposed for the entire building complex, with a pendant entrance facade and vestibule to be added at the west. In planning that pendant, he had already decided to create an answering colonnade, but only after entertaining several radically different alternatives;[67] his own physiognomy of justice was supposed to update the neoclassical one but it was not yet clear how. First he needed to finish work on new judicial quarters at the east, to either side of the Cour du Mai. These were under construction in 1849: separate areas for the penal section of the Paris Tribunal in buildings enclosing the Sainte-Chapelle courtyard, and for the civil chambers off the Salle des Pas Perdus, in a reconstructed wing stretching to the north quay.

It was at this juncture that Lassus launched his attack, questioning the meaning of the Cour du Mai and its very ability to signify. Duc's exchange with Lassus has special interest because most of the extant documents for Duc's design are drawings or administrative documents of a more routine sort. So heated was the conflict and so high its stakes that it provoked a reexamination of the problems of symbolic expression in architecture, and specifically of the character of the justice so ostentatiously reinstalled at the festival. As we have seen, the exchange turned on the plausibility of an image of justice as transparent to a lawful order. What emerged was something of a crisis for the cause of transparency, a crisis whose larger social context is suggested by the story of the festival of justice. Where a norm of austerity for the magistrature had once signified a self-restraint transparent or deferential to universal law, austerity now hinted of force; the new emphasis upon the magistrature necessitated a less forceful image of beneficent, feminized splendor. Similarly, the courthouse architecture that had once, as Duc pointed out, signified its service to the rule of law through the rigidity of its Doric order, could now strike Lassus and his constituency as devoid of artistry and transparent to an underlying force capable of aggression against the Sainte-Chapelle and threatening to society at large. To sal-

66. Françoise Bercé, ed., *Les premiers travaux de la Commission des monuments historiques, 1837–1848* (Paris: Picard, 1979), 92.

67. Two schemes are recorded in the master plan of 1847, where a western entrance with Gothic buttresses is juxtaposed to a classical version with a colonnade, presented in the overlying flap (fig. 7). See my "Le Code et l'équité," 93, for an illustration of the project of 1838 by J.-N. Huyot.

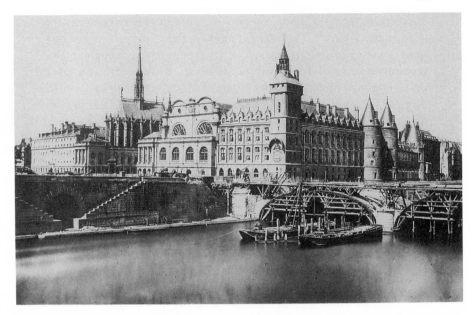

Figure 6.15: Baldus, photograph of the north and east facades of the Palais de Justice, taken from the right bank, c. 1859. Bibliothèque Nationale, Cabinet des estampes. Photo: Bibliothèque Nationale, Paris.

vage and update the neoclassical courthouse image, Duc would boost its rhetoric, incorporating the architectural emblem of Law into a facade so enriched in sculptural complexity and noncanonical in architectural detailing that some of his contemporaries would find it portentously opaque. His reconstruction of the architectural image of modern justice was marked by this encounter not only with the image of law but equally with the traditional iconography of force and justice as he worked on the judicial sectors flanking the Cour du Mai.

Duc began thinking about the allegorical tradition for representing justice and related qualities in sculpture while reconstructing the French Renaissance clock face by Germain Pilon on the Tour de l'Horloge at the northeast corner of the Palais, a prominent urban landmark that had been destroyed in the revolutionary climate of 1794 because it subsumed judicial images under royal ones (figs. 6.14, 6.15). It is striking that the completion of this clock face in March 1852 drew more attention from the government administration and the public than the completion of the new and eagerly-awaited judicial quarters for the Tribunal between 1851 and 1855. However modest, it was the first public event to mark completion of a phase in the modernization project, and it signaled, through a project billed as a historic restoration, the start of the

energetic support Bonaparte's new regime would give to the reconstruction of the Palais.[68] The inauguration of the clock face generated a press commentary that focused on its iconography, including Duc's reconstruction of Pilon's pair of allegories flanking the dial. Based on sixteenth-century descriptions and rediscovered fragments of the original decoration, the restoration deviated from the historical evidence in this feature. Pilon had juxtaposed a Justice with her scales to an allegory of Piety with an open book, presumably the Bible, but Duc eliminated religion, setting aside the juxtaposition of religion to justice that had been featured in the festival. Piety is replaced with a secular figure who holds the rounded tablets of the law in one arm, the *main de justice* in the other, and bears down upon the fasces. The new Justice (bearing the combination of scales and sword that defined the allegory of Justice from the sixteenth century) seemed clear to all, but the identity of her counterpart caused some confusion. The press accounts I have identified offer three separate appellations derived from her various attributes: Law, Force, and Power (*Pouvoir*). This allegory originated as Law alone in Duc's earliest scheme, following the metamorphosis of the book into the tablets of the law, and was labeled as Law by her sculptor, Armand Toussaint, when he entered his pair of bas reliefs in the salon of 1850–51; as such, she represented a modernization in the allegorical tradition.[69] Nevertheless, Force and Power were more compelling identifications to the Parisian press of 1852, and Force was the majority explanation, absorbing Law and mirroring that symbolic separation of justice from executive force and political power witnessed by the festival of justice.[70]

68. The scaffolding that had covered the clock face for four years was removed on 22 March, a public unveiling that was widely reported in the daily and art press; during the preceding month, the clock face was inspected from the scaffold by the prefect of the Seine and the city council, who also granted permission to the public for similar study. The modernization of the Tribunal received little attention; building inaugurations were normally reported in the newspapers, but there is no record of a formal inauguration for either the civil section, put into use between November 1853 and April 1855, or the penal section, partially occupied by November 1851 and completed as of April 1853 (although the major judicial newspaper, the *Gazette des tribunaux*, and *Le Droit* did note the successive appropriations of parts of the new quarters).

69. In the first project for the reconstruction of the clock face, a drawing of 1842 in the collection of the Cour d'appel de Paris, her only attribute is the tablets of the law.

70. Press commentary identifying her as Force includes the *Moniteur universel*, 22 March 1852, 457; an anonymous broadside, *Notice historique du cadran de la Tour de l'Horloge du Palais de Justice de Paris* (Paris: Durand, n.d.), probably produced for sale to the crowd that came to see the new clock face (copy in the Musée Carnavalet, Cabinet des arts graphiques, G.C. VI A); *L'Artiste*, 5th ser., 8 (1 April 1852): 79; A. L., "Cadran de la Tour de l'Horloge," *Encyclopédie d'architecture* 2 (1852): 42–43; and "Sur les horloges," *Magasin pittoresque* 20 (October 1852): 331. She was identified twice, as Force and as Law,

Duc's recourse to an iconographic tradition juxtaposing force to justice was not so remarkable in itself; more interesting is the role it assumed in his architectural design for the modernization of the Palais. A tradition of judicial allegory juxtaposing Force and Justice and representing Justice herself in separate acts of repression and beneficent protection had persisted alongside the newer image of Law in courthouse iconography of the first half of the century, especially in the French provinces, where new courthouses and renovations proliferated while Parisian authorities dallied over their own modernization. Yet in the typical provincial courthouse, as at the Cour du Mai, allegorical decoration and building type coexisted, each bounded by its own conventions for expressive variation, with little interaction. For instance, the statues of Justice, Force, Prudence, and even Abundance atop the portico of the Cour du Mai had little effect on its architectural form or its specifically architectural character. Two documents underscore how Duc, by contrast, carried his encounter with allegory into his architectural forms.

The first of these followed soon upon the inauguration of the clock face. In September 1852, Duc's office produced a telling construction drawing for the facade of the new wing containing the penal courtrooms for the Paris Tribunal. A detail of a capital in the form of a female head, it carried a note that the alternating male and female heads on this facade represented, respectively, force and justice.[71] In Duc's hands, force and justice no longer shared a gender; masculine force revealed the femininity of justice. In the complementary sectors for the penal and civil chambers of the Tribunal, to either side of the Cour du Mai, Duc developed that polarity, emphasizing austerity in the penal division and richness in the civil, where cornucopias distributed literal fruits of justice onto one of the courtroom ceilings.

The second document brings us back to the Cour du Mai: a celebrated letter of 1856 from Duc to a colleague, allegorizing the classical orders and the arch and vault as complementary but opposing systems

in a preliminary article by N.-M. Troche, "La Tour de l'Horloge," *Revue archéologique* 6 (October 1849–March 1850): 413, and then as Law alone in the same journal, 9 (April–September 1852): 60. A notice in the *Journal des débats*, reprinted by the *Moniteur universel*, 12 March 1852, 403, described her as Power, as did the critical piece, "Restauration du cadran de l'horloge de la tour du Palais de Justice," *Revue de l'architecture générale* 10 (1852): 123. The press indicated familiarity with the sixteenth-century descriptions of Rabel and Corrozet that identified Pilon's allegory as Piety, and Duc's awareness of Rabel is attested by a letter of 1847 excerpting the passage, in the architects' archives now in the collection of the Cour d'appel de Paris. Yet contemporaries appear not to have commented on the discrepancy.

71. Drawing in the collection of the Cour d'appel de Paris, inscribed in Duc's hand "deux têtes représentant la force et la justice."

Figure 6.16: Marville, photograph of the west facade of the Palais de Justice, between June 1875 and 1878. Bibliothèque Historique de la Ville de Paris.

of meaning.[72] Here the constituent elements of architecture assumed contrasting roles in quasi-mythic terms of masculine idealism and force (the orders) versus feminine flexibility and accommodation (the arch and vault). At the east end of the Palais, Duc set off the ideality of the Cour du Mai by juxtaposing it to a rich new street facade for the adjacent Salle des Pas Perdus that emphasized the barrel vaults within (fig. 6.15). And in his west entrance, centered in a long facade of new construction, he deployed his own parable of orders and vaults in an architectural composite, a sculpturally softened volume with a richly carved and layered facade, fusing the capacious French Renaissance palace with the peristylar temple (fig. 6.16). Here the orders regained an ideal, rhetorical status, but at the price of the old value of transparency.

In the changing social conditions of latter nineteenth-century Paris, the codes could only survive in combination with a magistrature that accommodated the law to the new circumstances at hand, a magistrature with a discretionary power that was best represented in positive terms.

72. Originally published by Paul Sédille, "Joseph-Louis Duc, Architecte (1802–1879)," *Encyclopédie d'architecture*, 2d ser., 8 (1879): 70.

The particularizing mode of judgment, deploying the senses to attend to the material circumstances of a specific case, abetted the larger cause of the normalizing, abstracted mode of judgment usually associated with civil law culture. Thus festivity gained a place in the aesthetics and ethics of French justice, even in the criminal courtrooms capable of handing down the most devastating verdicts. Moreover, the example inevitably set by the Parisian courthouse, as well as transformations in judicial practice, effected a change in the neoclassical courthouse type in France at large and set a hardy image of French justice into the twentieth century. This transformation has hardly been noted, even in the explicit reflection on the aesthetics of French justice that has found its moment in the 1990s.[73] Current circumstances open that system to question more than ever before, with the fraying of the welfare state and of cultural hegemony as a means of unifying a diversifying population enmeshed in international economic and political processes, the turn to justice to address issues traditionally left to the explicitly political sphere, and the simultaneous launching of an ambitious new program of renovation and construction of courthouses, within whose walls the performance of justice will be refashioned. The question at the core of this historical study remains central: how justice configures power for a culture so suspicious of power's representation.

73. *La Justice en ses temples;* Jacob, *Images de la Justice;* "Les Palais de justice," special issue of *Monuments historiques* (January–February 1996); "Construire pour la justice," special issue of *Archicréé* (May–June 1995), both instigated by the conference "Palais de Justice: Héritages et projets," organized by the Association française pour l'histoire de la justice and the Centre de recherches sur l'histoire de l'art et l'architecture moderne of the CNRS, Paris, January 1994; on the current practice of justice, Antoine Garapon, *Le Gardien des promesses* (Paris: O. Jacob, 1996).

LAW AND JUSTICE IN ENGLAND AND FRANCE

THE VIEW FROM VICTORIAN LONDON

Jonathan P. Ribner

I n his classic study of the English Constitution (1867), Walter Bagehot disparagingly characterized the legislative assemblies of Napoleon III as "symmetrical 'shams.'" "The French Chambers," wrote Bagehot, "are suitable appendages to an Empire which desires the power of despotism without its shame; they prevent the enemies of the Empire being quite correct when they say there is no free speech; a few permitted objectors fill the air with eloquence, which every one knows to be often true, and always vain."[1] Bagehot's complaint that despotism lay behind the sharply tailored symmetries of French government has a crude antecedent in a caricature published in *Punch* during the panic that followed the coup d'état of Louis-Napoleon in December 1851. *Interior of a French Court of Justice, 1852* (fig. 7.1) reflects the English idea of legality across the Channel at a moment when many Britons shuddered before the prospect of Gallic tyranny imported by French invaders.[2] Presiding, amid the crush of shakos and bayonets, are three saber-bearing magistrates seated before drumheads, their papers weighted with model cannon. The best hope in this ferocious venue is exile to French Guiana, whose capital, Cayenne, serves as a crowning inscription.

Scorn for French legality and justice—hardly a new theme at midcentury—was intensely felt during the French Revolution. Revolutionary legislators, who liked to compare their laws to the Ten Command-

1. *The English Constitution*, ed. R. H. S. Crossman (Ithaca: Cornell University Press, 1996), 179, 256.
2. For this emotional climate, see J. Ribner, "*Our English Coasts, 1852:* William Holman Hunt and Invasion Fear at Midcentury," *Art Journal* 55, no. 2 (summer 1996): 45–54.

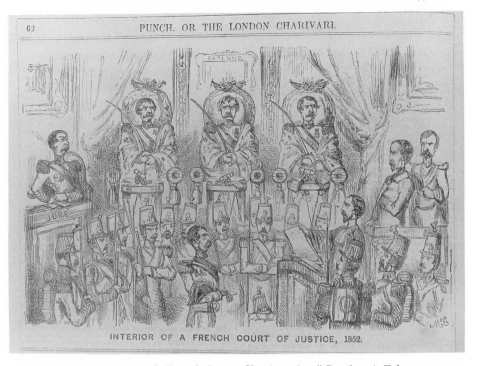

Figure 7.1: "Interior of a French Court of Justice, 1852," *Punch* 22 (7 February 1852): 62, wood engraving. Reproduced courtesy of Wellesley College Library, Wellesley, Mass.

ments, were given short shrift by James Gillray in *The Apotheosis of Hoche* (1798; fig. 7.2). Here, the deceased Anglophobe general who annihilated a counterrevolutionary assault force at Quiberon, plays a guillotine-lyre above a devastated landscape amidst a satanic host of *sans-culotte* cherubim. Between a pair of apocalyptic beasts are roundheaded tablets inscribed with a satanic inversion of the Ten Commandments: "Thou shalt murder," etc. Gillray's print grotesquely echoes Edmund Burke's denunciation, in 1790, of the French Revolution and its "monster of a constitution." The French legislators, Burke argued, had violently disrupted their nation with ill-fashioned laws. It is Britain's reverence for its ancient, national heritage, on the contrary, that provides the sole guarantee of liberty. In Burke's England, liberty "has its gallery of portraits, its monumental inscriptions, its records, evidences, and titles."[3]

The contrast—so troubling to Burke—between English respect for

3. *Reflections on the Revolution in France*, ed. Thomas H. D. Mahoney (Indianapolis: Bobbs-Merrill, 1955), 39, 229.

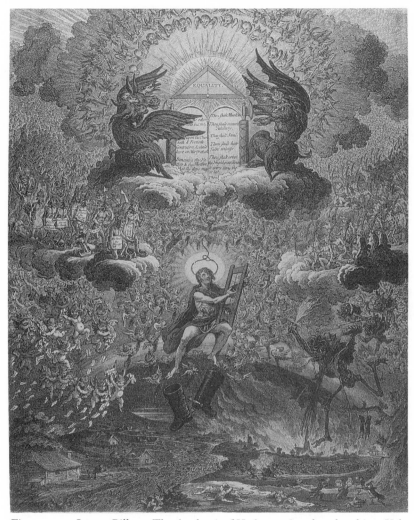

Figure 7.2: James Gillray, *The Apotheosis of Hoche*, 1798, colored etching. Yale Center for British Art, Paul Mellon Collection, New Haven, Conn.

tradition and the disastrous French penchant for legislative abstraction and innovation is given visual expression in the two most famous images of Parliament and the National Assembly, John Singleton Copley's *Death of the Earl of Chatham* (1779–1781) and Jacques-Louis David's drawing, *The Tennis Court Oath*, exhibited in the Salon of 1791 (figs. 7.3, 7.4). Copley's painting is a memorial to a great Whig orator, William Pitt the Elder, the first Earl of Chatham, who suffered a stroke on

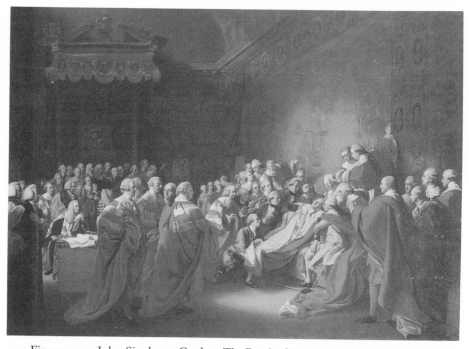

Figure 7.3: John Singleton Copley, *The Death of the Earl of Chatham*, 1779–1781, oil on canvas. Tate Gallery on loan to the National Portrait Gallery, London. Courtesy of the National Portrait Gallery, London.

7 April 1778 in the heat of parliamentary debate.[4] While representing a stirring example of patriotic devotion to office, Copley also provided a tribute to the dignity that Bagehot would later hold up as essential to the function of Parliament. With hushed respect, the legislators turn to their fallen colleague, whose Christ-like attitude is redolent with the sanctity of Parliament itself.

Copley imbued a parliamentary incident with the close-pressed familial sentiment characteristic of the deathbed scenes that enjoyed such appeal in the late eighteenth century.[5] This weave of public and private bonds also resonates in Burke's discussion of the deeply traditional aspect of English government: "We have given to our frame of polity the image of a relation in blood, binding up the constitution of our country

4. See Jules David Prown, *John Singleton Copley*, 2 vols. (Cambridge, Mass.: Harvard University Press, 1966), 2:276–91, and Emily Ballew Neff and William L. Pressley, *John Singleton Copley in England*, exh. cat. (Houston: Museum of Fine Arts, 1995), 36–39.

5. For deathbed scenes, see Robert Rosenblum, *Transformations in Late Eighteenth Century Art*, 2d ed. (Princeton: Princeton University Press, 1969), 28–39.

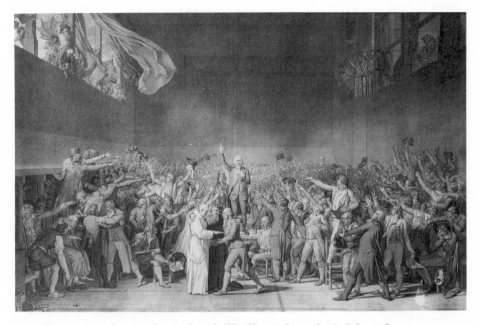

Figure 7.4: Jacques-Louis David, *The Tennis Court Oath*, Salon of 1791, pen and brown ink and brown wash on paper. Louvre, Paris; on loan to the Musée National du Château de Versailles. Courtesy Caisse Nationale des Monuments Historiques et des Sites, © Arch. Phot./S.P.A.D.E.M., Paris.

with our dearest domestic ties, adopting our fundamental laws into the bosom of our family affections, keeping inseparable and cherishing with the warmth of all their combined and mutually reflected charities our state, our hearths, our sepulchres, and our altars" (p. 38).

Copley's august parliamentary chamber bears no resemblance to the tennis court chosen, ad hoc, as the site for an oath of unity and common purpose by the self-proclaimed National Assembly (20 June 1789) after its members were denied access to the royal audience hall at Versailles. David's packed composition is choreographed by a centripetal force that mirrors the new spirit of national solidarity at the same time that it recalls the assembly's insistence upon the unity and permanence of the nation's legislative power. Embodied in this demonstration of unanimity is a cherished revolutionary belief: "Law is the expression of the general will." So proclaimed the Declaration of the Rights of Man and Citizen, that "national catechism" of universal principles placed at the head of the constitution, which at the time of the Salon of 1791 was less than a month old. In their collective energy, David's superbly muscled lawgivers reflect the unbounded confidence in the benevolent, creative

capacity of the legislator voiced in the revolutionary song "Ça Ira": "Du législateur tout s'accomplira" (The legislator will accomplish everything).

Such enthusiasm speaks of the thrilling novelty of constitutional government in late-eighteenth-century France. Unlike the English Constitution, which untidily incorporates a venerable historical record of laws and conventions—and which is not a single document—France's constitutions were crafted as palpable cult objects. Thus, for example, the Convention's stillborn Constitution of Year One was enclosed in a cedar ark during the Festival of Unity and Indivisibility of 10 August 1793, organized by David. This cult of the law was reflected in a consolidation of power in the legislature that climaxed under the Terror. Weakened by the Directory's Constitution of Year Three, legislative power was brutally seized by Napoleon in an act of contempt for the lawgivers and their constitution. Across the Channel, Gillray responded with the print *Exit, Libertè a la François! or Buonapart closing the farce of Egalitè* (1799).[6] Here, the English satirist restaged as slapstick the critical moment of the coup d'état when, on 19 Brumaire, the general confronted the lawmakers of the Council of Five Hundred with the nullity of their constitution as his brother Lucien had the outraged assembly forcibly dispersed.

Once in power, Napoleon encouraged the mythic magnification of his own stature as giver of laws. Likened to a deified Caesar by the ideal portrait statue by Antoine-Denis Chaudet that stood before his *Corps législatif*, Napoleon framed this legislature as a faint shadow of its mighty revolutionary predecessors. Barred, under pain of discipline, from debate on the laws it voted into place, this mute assembly was presided over by the poet Louis de Fontanes.[7] "He is both the terror and the hope of peoples . . . ," Fontanes declared of the dictator before the *Corps législatif* on 5 March 1806. "As soon as the wise saw him . . . they recognized in him all the signs of domination."[8]

Surprisingly, England played a significant role in the life of this outspoken imperial apologist. In October 1785, the young French poet traveled to London in an unsuccessful search for subscribers to a *correspondance littéraire* that he was planning to launch with his friend Joseph Joubert. In a letter to Joubert of 20 January 1786, Fontanes wrote of a

6. *Sic.* For this image, and for the French art discussed herein, see J. Ribner, *Broken Tablets: The Cult of the Law in French Art from David to Delacroix* (Berkeley: University of California Press, 1993).

7. See Norbert Alcer, *Louis de Fontanes (1757–1821): Homme de lettres et administrateur* (Frankfurt: Peter Lang, 1994).

8. *Collection complète des discours de M. de Fontanes* (Paris: Domère, 1821), 44–45.

recent visit to the studio of Benjamin West.[9] Notwithstanding his low opinion of English painting,[10] Fontanes was impressed by an eighteen-foot-high painting, *Moses Receiving the Laws* (1784), commissioned circa 1780 by George III for his chapel in Windsor Castle and now in Westminster Palace (fig. 7.5).[11] This painting, intended as the principal component of the altarpiece, typifies the aggressively declamatory aspect of an ambitious ensemble whose program reflected the influence of Dr. Richard Hurd. This cleric shared with the monarch a high regard for William Warburton's *Divine Legation of Moses Demonstrated*. Warburton's text, begun in the late 1730s and left incomplete at his death in 1779, defended the interdependence of church and state and demonstrated the workings of divine providence in the events of sacred history. West's *Moses Receiving the Laws* represents an audacious Protestant revival of militant Counter-Reformation imagery from the Continent. A likely model is Ludovico Carracci's *Transfiguration* (1593, Bologna Pinacoteca), a work Sir Joshua Reynolds had held up to his students as a worthy model for emulation (*Discourse* II). To Fontanes, West's neo-Baroque theatrics must have sharply contrasted with the latest French fashion in painting—the spartan and chilly neoclassicism that had triumphed with David's *Oath of the Horatii* in the previous year at the Paris Salon.

As striking as Fontanes's attraction to West's *Moses Receiving the Laws* is the way he described it to Joubert. It represented, he wrote, "*Moses descending Mount Sinai, carrying the twelve tablets to the Hebrews.*"[12]

9. Offering a rare French commentary on late-eighteenth-century British art, this text deserves to be better known: "Je connais peu de tableaux plus médiocres que le tableau original de *Wolfe*, par West. La gravure est très belle. Ce West est un quaker de la Pensylvanie. Je l'ai vu deux fois, je lui ai parlé; il me paraît au-dessus du chevalier Reynolds qui ne m'a fait aucun plaisir. Ce que j'ai remarqué de plus frappant dans l'atelier de West, c'est un *Moïse* descendant du mont Sinaï et portant les douze tables au peuple hébreu. L'ordonnance m'a paru imposante. J'ai aussi fort goûté un *Jérémie dans le désert*, que couronne un ange [*Call of the Prophet Jeremiah* (1784), also part of the Windsor Chapel ensemble]. En général, le choix de ses sujets me plait beaucoup. Il est de la secte des illuminés et il se plaît à reproduire toutes les scènes susceptibles d'enthousiasme et d'inspiration. Son coloris est assez flatteur. Mais, en général, il manque d'expression et de vie." *Correspondance de Louis de Fontanes et de Joseph Joubert (1785–1819)*, ed. Rémy Tessonneau (Paris: Plon, 1943), 27–28.

10. "Cette école anglaise, qui est dans sa naissance et qui expose tous les ans ne fera jamais de grand progrès; la terre et le soleil et le génie des habitants le défendent." Ibid., 28.

11. For this painting, see Helmut von Erffa and Allen Staley, *The Paintings of Benjamin West* (New Haven: Yale University Press, 1986), cat. no. 258, and Jerry D. Meyer, "Benjamin West's Chapel of Revealed Religion: A Study in Eighteenth-Century Protestant Religious Art," *Art Bulletin* 57 (1975): 247–65.

12. *Correspondance de Louis de Fontanes*, 28.

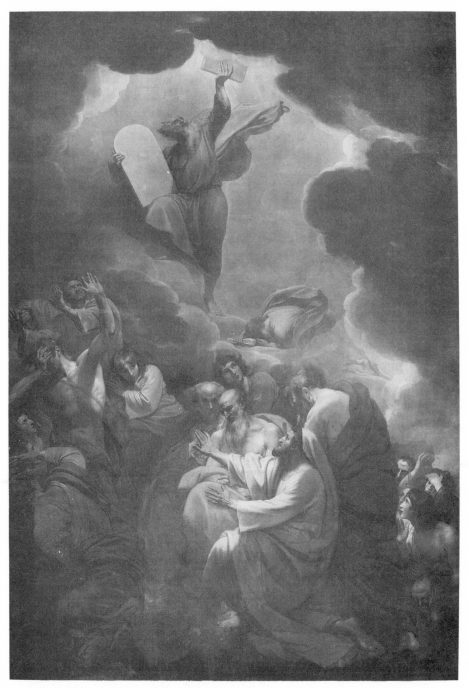

Figure 7.5: Benjamin West, *Moses Receiving the Laws*, 1784, oil on canvas. Westminster Palace, London. Courtesy Department of the Environment, London, Crown copyright reserved.

This odd description evinces a characteristically French ignorance of the Old Testament. Before the early nineteenth century—when Chateaubriand's *Le génie du christianisme* popularized the notion of the literary excellence of Hebrew scripture, French readers' knowledge of the Jewish Bible was generally limited to brief paraphrases in the catechism and in popular digests of *histoire sainte*. It is likely that Fontanes's reference to "twelve tablets" arose from a confusion of the Ten Commandments with the Twelve Tables of Roman law. Such a slip suggests that the French poet's attraction to *Moses Receiving the Laws* was enhanced by the Enlightenment enthusiasm for ancient legislators that led Rousseau, for example, to ecumenically bestow praise on the laws of both Moses and Muhammad in *The Social Contract*.[13]

During the Revolution, Fontanes experienced the consequences of the apotheosis of the legislature embodied in David's *Tennis Court Oath*. A pious moderate at the start of the Revolution, Fontanes wrote a poem in honor of the 1790 Festival of the Federation. In the following years, he came to know the darker aspects of regenerated France. During the Convention's siege of Lyon, Fontanes's Lyonnaise wife lay in a barn outside the stricken city, giving birth. A portion of the poet's literary papers went up in flames with his wife's house. This traumatic period deeply colored Fontanes's politics. He authored a petition for mercy presented to the Convention by a group of Lyonnais. Under the Directory, Fontanes was compelled by the antiroyalist coup of Fructidor (4 September 1797) to leave France. His exile included five months in London, where he served as mentor to Chateaubriand during the gestation of *Le génie du christianisme*. Shortly before 18 Brumaire, Fontanes returned to Paris. There he would soon embark on a Napoleonic career that, following his selection as president of the *Corps législatif* (1804), included appointment as grand master of the imperial university (1808). As the empire's chief educator, Fontanes worked to increase clerical influence on the curriculum. Given his attachment to throne and altar, it is hardly surprising that Fontanes cut a dazzling figure in the army of Napoleonic officials who rallied to the restored Bourbon monarchy. His prerevolutionary appreciation of West's bombastic image of divine legislation is recalled by the theocratic draft that Fontanes provided for the preamble to the Bourbon constitutional charter of 1814:

> A power greater than peoples and monarchs made society and molded the different governments of the earth. It is our duty to manage them

13. See David A. Wisner, "The Cult of the Legislator in France, 1750–1830: A Study in the *Esprit Philosophique* and the Political Imagination of the French Enlightenment," doctoral dissertation, University of Rochester, 1992.

rather than to explain their principles. The older their foundations, the more we reverence them. Whoever tries too hard to understand them errs; whoever imprudently tampers with them can bring all to ruin. Whoever is wise respects them and bows before that majestic obscurity that must cloak both society and religion in mystery.[14]

This poetic negation of the Enlightenment heritage contrasts with the plain English in which Bagehot later discussed the role of the monarch. At the same time, a common chord is struck by these dissimilar voices. Secrecy, argued Bagehot,

> is essential to the utility of the English royalty as it now is. Above all things our royalty is to be reverenced, and if you begin to poke about it you cannot reverence it. When there is a select committee on the Queen, the charm of royalty will be gone. Its mystery is its life. We must not let in daylight upon magic.[15]

For the practically minded and liberal Bagehot, the compelling mysteries of monarchy were inseparable from governmental efficiency. Efficiency was less important to Fontanes, whose lofty preamble was shorn of its poetry in the final version. Both writers, however, were determined to protect the august and mysterious aspect of government from the corrosive effects of modern history.

The case of Fontanes indicates that the ancient enmities dividing England and France need not blind us to submerged parallels and points of contact. In spite of their nations' very different constitutional and legal histories, English and French artists, writers, and caricaturists expressed strikingly similar attitudes toward the professional representatives of law and justice during the nineteenth century.

In politics, as in art, French innovations were sometimes British imports. Just as David's *Tennis Court Oath* employs the compelling mixture of modern historical narrative and grand manner rhetoric pioneered in London by Copley and West, so too, for example, did the constitutional charter granted to France in 1814 by Louis XVIII imitate England's bicameral parliament, dividing the French legislature into an elected Chamber of Deputies and a royally appointed Chamber of Peers. En-

14. "Un pouvoir supérieur à celui des peuples et des monarques fit la société et jeta sur la face du monde des gouvernements divers: il faut plutôt en diriger la marche qu'en expliquer les principes. Plus leurs bases sont anciennes et plus elles sont vénérables; qui veut trop les chercher s'égare; qui les touche de trop près devient imprudent et peut tout ébranler. Le sage les respect et baisse la vue devant cette auguste obscurité qui doit couvrir le mystère social comme les mystéres religieux." Quoted from Archives Nationales AB XIX, 340, pp. 108 (bis)–109, in Pierre Simon, *L'Elaboration de la Charte constitutionnelle de 1814* (Paris: E. Cornély, 1906), 111.

15. Bagehot, *English Constitution*, 100.

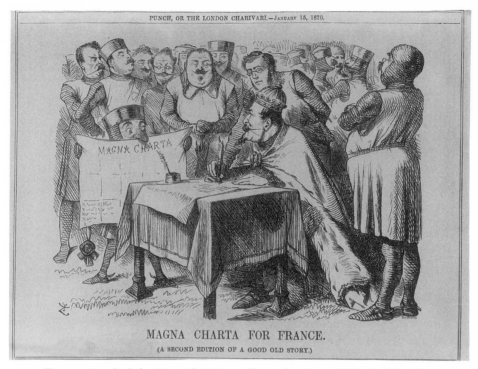

MAGNA CHARTA FOR FRANCE.

(A SECOND EDITION OF A GOOD OLD STORY.)

Figure 7.6: Sir John Tenniel, "Magna Charta for France," *Punch* 58 (15 January 1870): 15, wood engraving. Reproduced courtesy of Wellesley College Library, Wellesley, Mass.

glish distrust of France, however, made it difficult to acknowledge French governmental reform without condescension. A *Punch* caricature by Sir John Tenniel from 1870 (fig. 7.6), for example, characterizes Napoleon III's recent liberalization of the empire as an anachronistic imitation of the Magna Carta. With labored concentration, the emperor copies the ancient document held up by an armored Mr. Punch.

This is not to say that imitation was solely a French affair. France was advantaged over its rival by a long tradition of monumental decorative painting. Contributors to the project of 1841–1863 for paintings to adorn Pugin and Barry's new Westminster Palace are known to have emulated the German Nazarenes.[16] Less familiar is the French lineage of this Victorian ensemble—the most ambitious officially sponsored decorative undertaking of the regime. The Westminster program, with its glorification of British of law and justice, had ample French prece-

16. For the German influence, see William Vaughan, *German Romanticism and English Art* (New Haven: Yale University Press, 1979), chap. 6.

dent. In addition to the decoration, under the July Monarchy, of the palaces of the Chambers of Deputies and Peers—which include three major cycles by Delacroix—the paintings commissioned by the Bourbon Restoration in 1826 for the chambers of the Council of State in the Louvre foreshadow the Westminster cycle.[17] Seeking to bring immediacy to the abstract themes of law and justice, the Victorians—like the French painters commissioned to adorn the Council of State suite—represented emotionally charged episodes of national history, as in Edward Matthew Ward's melodramatic *Arrest of Lady Alice Lisle*.[18] In this gloomy scene from the reign of James II, the wife of a regicide member of the House of Lords is seized for sheltering two supporters of the Protestant rebel Monmouth—a crime for which she was subsequently tried at the bloody assizes and executed. *The Arrest of Lady Alice Lisle* recalls the most acclaimed painting in the Council of State ensemble, Paul Delaroche's subsequently destroyed *The Death of Duranti*, which represented the last moments of the loyal president of the Toulouse *parlement*—an opponent of the Catholic League who attempted to calm the populace following the murder of the duc de Guise.[19] Delaroche showed Duranti on the verge of being lynched by a mob in the monastery in which he sought refuge. In *The Arrest of Lady Alice Lisle*, Ward imitated the heart-stopping contrast between the unarmed resignation of Duranti and the furious aggression of his assailants. The resemblance is not fortuitous. Prior to fulfilling his commissions for Westminster Palace, Ward went to Paris to consult Delaroche and another painter who contributed to the Council of State ensemble, Eugène Delacroix. Combining such narrative scenes with allegory, both ensembles were intended to glorify institutions whose prestige was not above doubt. In 1834, as Turner and Constable watched the flames consuming the original Westminster Palace, Benjamin Robert Haydon was struck by the ubiquity of "jokes and radicalism" among the onlooking crowds.[20] The Council of State was hardly more esteemed. Functioning as an adminis-

17. For the Westminster Palace program, see T. S. R. Boase, "The Decoration of the New Palace of Westminster 1841–1863," *Journal of the Warburg and Courtauld Institutes* 17, nos. 3–4 (1954): 319–58, and Roger Simpson, *Sir John Tenniel: Aspects of His Work* (Rutherford, N.J.: Farleigh Dickinson University Press; London: Associated University Presses, 1994), 25–47.

18. Reproduced from an engraving, in Boase, "Decoration of New Palace," pl. 50d.

19. For *The Death of Duranti*, see Norman D. Ziff, *Paul Delaroche: A Study in Nineteenth-Century French History Painting* (New York: Garland, 1977), 62–66, and J. Ribner, "Terrorized Parlementaires for the Bourbon Conseil d'État," in *The Play of Terror in Nineteenth-Century France*, eds. John T. Booker and Allan H. Pasco (Newark, Del.: University of Delaware Press, 1997), 58–73.

20. Quoted in Boase "Decoration of the New Palace," 319.

trative court and a consultative committee on legislation, the Council of State was a vestige of ancien régime and Napoleonic executive power. Because it existed outside the control of the Bourbon constitution, the Council of State was keenly disliked by the liberal opposition.

Given the heights to which the French legislature was elevated during the Revolution, its subsequent discredit was all the more spectacular. What a fall there is from David's joyously unanimous patriots of 1791 to the lugubrious ministers in the *Legislative Belly*, Daumier's caricature of the principal legislative assembly of the July Monarchy (1834)! While the illustrations in *Punch* lack the cruel brilliance of Daumier and other contributors to *La Caricature*, the English publication (subtitled, in imitation of another French satirical journal, *The London Charivari*) provides evidence that British lawgivers enjoyed no more respect than their French counterparts. When Mr. Punch opens his Westminster Palace toy box (fig. 7.7), he is delighted to find his "dear old puppets." What could be expected from M.P.s is indicated by a caricature of 1841 in which candidates strike attitudes of false modesty, insincere flattery, and ingenuous gratitude (fig. 7.8).

More inflammatory to the British imagination were lawyers and the courts. The dark passions of Daumier's *Gens de justice* (1845–1848) were echoed in 1850 when Carlyle declared, "Our doom . . . is the Apotheosis of Attorneyism; into that blackest of terrestrial curses we must plunge."[21] In 1867, *Punch* proposed judicial wigs that could be moved with wires to give rhetorical emphasis to stock courtroom postures (fig. 7.9). And, of course, there is *Bleak House* (1853), which teaches that "the one great principle of the English law is, to make business for itself."[22] The novel opens on a foggy afternoon in the High Court of Chancery. There sits the lord high chancellor "with a foggy glory round his head" as members of the court are "mistily engaged in one of the ten thousand stages of an endless cause, tripping one another up on slippery precedents, groping knee-deep in technicalities, running their goat-hair and horse-hair warded heads against walls of words, and making a pretense of equity with serious faces, as players might" (p. 2). Malevolence infects the lawyers of *Bleak House*, regardless of their professional standing. So vile is the lowly, parasitic Mr. Vholes that his chambers are permeated with an unpleasant odor: "A smell as of unwholesome sheep, blending with the smell of must and dust, is referable to the nightly (and often daily) consumption of mutton fat in candles, and to the fretting of

21. Thomas Carlyle, *Latter Day Pamphlets, no.6: Parliaments*, in *Selected Writings*, ed. Alan Shelston (London: Penguin, 1971), 308.

22. Charles Dickens, *Bleak House*, ed. Morton Dauwen Zabel (Boston: Houghton Mifflin, 1956), 416.

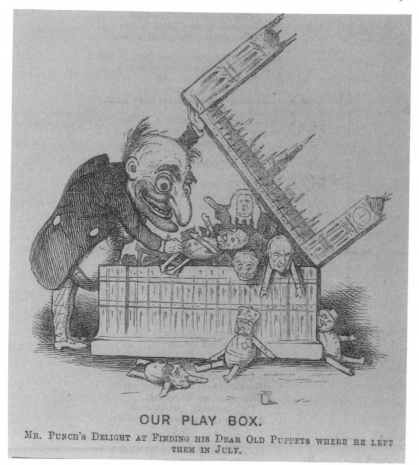

OUR PLAY BOX.

MR. PUNCH'S DELIGHT AT FINDING HIS DEAR OLD PUPPETS WHERE HE LEFT THEM IN JULY.

Figure 7.7: "Our Play Box," *Punch* 48 (11 February 1865): 60, wood engraving. Reproduced courtesy of Wellesley College Library, Wellesley, Mass.

parchment forms and skins in greasy drawers" (p. 415). The powerful, manipulative solicitor Tulkinghorn—described by one of the novel's sympathetic characters as "a confoundedly bad kind of man . . . a slow-torturing kind of man . . . no more like flesh and blood, than a rusty old carbine is" (p. 487)—leads an existence whose unnatural aspect is set into relief as he returns to his London chambers from the home of his aristocratic client in Lincolnshire: "Like a dingy London bird among the birds at roost in these pleasant fields, where the sheep are all made into parchment, the goats into wigs, and the pasture into chaff, the law-yer, smoke-dried and faded, dwelling among mankind but not con-sorting with them, aged without experience of genial youth, and so long

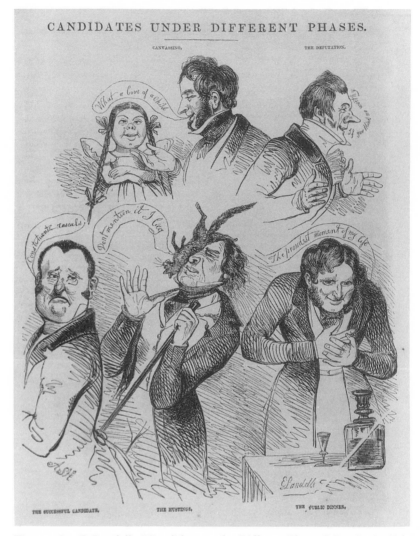

Figure 7.8: E. Landells, "Candidates under Different Phases," *Punch* 1 (17 July 1841): 9, wood engraving. Reproduced courtesy of Wellesley College Library, Wellesley, Mass.

used to make his cramped nest in holes and corners of human nature that he has forgotten its broader and better range, comes sauntering home" (pp. 442–43).

As the French Revolution's cult of the law lost steam, the sacred authority of the lawgiver was transferred to the poet and artist on both sides of the Channel. In *A Defense of Poetry* (1821), Shelley declared that "poets are the unacknowledged legislators of the world." Equation of

LEGAL EFFECTS.

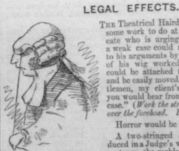

Ex. 1.

The Theatrical Hairdressers' art might find some work to do at the bar. The Advocate who is urging his client's claims in a weak case could add considerable force to his arguments by having the front part of his wig worked by a string, which could be attached to a waistcoat button, and be easily moved. For instance, "Gentlemen, my client's mouth is sealed, or you would hear from him *his* version of the case." (*Work the string, and wig-front falls over the forehead. Ex.* 1.)

Horror would be very simple. (*Ex.* 2.)

A two-stringed effect might be produced in a Judge's wig, when after passing sentence, the reckless felon has thrown a boot at his Lordship's head. (*Ex.* 3.)

But with this novelty a strict rule should be passed that no junior should work *his* wig while his leader was speaking; but it might be

Ex. 2. A Queen's Counsel Horrified.

Ex. 3. Judge.

considered fair, as legal tactics go, for the Defendant's Counsel to work his wig in any way he chose during the address of Plaintiff's Counsel, and both sides should, moreover, be at perfect liberty to work their wigs, as much as ever they liked, during the Judge's summing up.

Again, Counsel wishes to throw doubt upon some witness's evidence.

"Oh, you called him in. (*Turns incredulously to jury.*) He called him in!" (*Pulls string of surprise wig. Ex.* 4.)

When a case is "laughed out of Court" the same principle could be applied to Chief Baron's wig. (*Ex.* 5.)

Ex. 4.

Of course the first to introduce this new Practice of the Courts, would have the right of playing upon such phrases as "Touching a Chord," "Moving tails," "Free-hold from the Crown," and so forth; but, after the first term of use, such legal quibbles should be reckoned among the privileges of Q.C. only.

Ex. 5.

We have some other legal reforms in hand, which will be published in due course.

DENTAL.—If you submit to artificial teeth, you must make up your mind ever after to speak in a *falsetto*.

aesthetic creativity with legislative authority became common coin amid the utopian ferment of Paris during the July Monarchy. Steeped in this exalted climate, the young Jean-François Millet offered a *Self-Portrait as Moses* in 1841 to the municipal council of Cherbourg in the midst of a dispute arising from the town's refusal to pay for a commissioned portrait.[23] While the political career of Alphonse de Lamartine gave substance to the equation of poet with lawgiver, his election to the Chamber of Deputies was not without cost. Lamartine's legislative debut prompted one satirist to ask why this "giant" was going off to "struggle against dwarfs?"[24] One installment of *La Caricature*'s "Great Crusade against Liberty" includes Lamartine in a pathetic counterrevolutionary parade (fig. 7.10).[25] Adjacent to the chamber-potted court, the poet-legislator dreamily weeps as a cornucopia of smoke, inscribed with the titles of his poetry volumes, showers him with honors and coin. Quoting Molière, the caricaturist writes of this modern Tartuffe, "O pauvre homme!" This ridiculous accumulation of emblemata spoofs the ponderous allegorical machinery standard in official decorative art, such as that devoted to the Council of State under the Restoration. Méry-Joseph Blondel's *France, in the Midst of the Legislator Kings and French Jurisconsults, Receives the Constitutional Charter from Louis XVIII* (1827; fig. 7.11), painted for the ceiling of the principal chamber of the Council of State suite, is an example. High above the Seine, the late Louis XVIII, avuncular but august, is enthroned with Wisdom, Prudence, Justice, and Law. At his feet, a regal personification of France humbly receives the Charter. This celestial event is witnessed by an approving assembly of ancien régime monarchs and legists, featuring Montesquieu and Henri IV (holding the Edict of Nantes) relaxing in the unlikely company of Louis XIV.

Allegorical travesty, such as that employed in "The Great Crusade against Liberty" and elsewhere in *La Caricature*,[26] was used to great effect in late-eighteenth-century England, as Gillray's *Apotheosis of Hoche* demonstrates. Such aggressive use of mock allegory to dramatize the

23. Reproduced in Ribner, *Broken Tablets*, pl. 9.

24. [F. de Montherot], "A Lamartine, Député; à Beyrouth, Syrie," January 1833, in *Mémoires poétiques* (Paris: J. Techener, 1833), 101.

25. Gerd Unverfehrt, Klaus Lankheit, and Jurgen Döring, *La Caricature: Bildsatire in Frankreich 1830–1835 aus der Sammlung von Kritter*, exh. cat. (Münster: Westfälisches Landesmuseum für Kunst und Kulturgeschichte, 1980), cat. no. 90.

26. See the parody of Prud'hon's painting of 1808, *Vengeance and Justice Pursuing Crime*, in which the fleeing criminal is Louis-Philippe in *profil perdu* (*La Caricature*, 13 February 1834), reproduced in J. Ribner, "Henri de Triqueti, Auguste Préault, and the Glorification of Law under the July Monarchy," *Art Bulletin* 70, no. 3 (September 1988): 500.

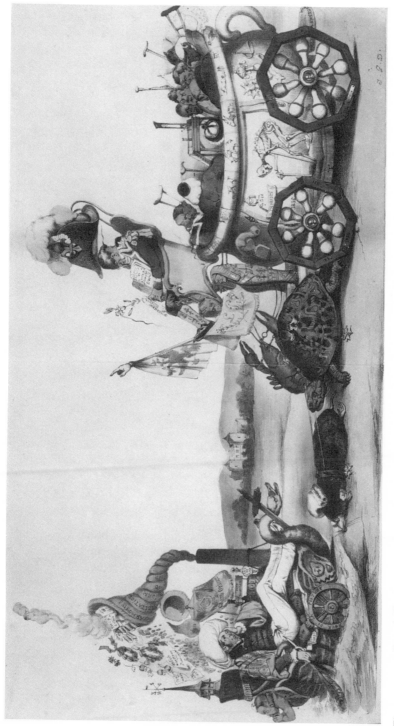

Figure 7.10: Grandville (J.-I.-I. Gérard) and A. Desperret, "Great Crusade against Liberty," pl. 5, *La Caricature*, no. 192 (10 July 1834), colored lithograph. Bibliothèque Nationale, Paris.

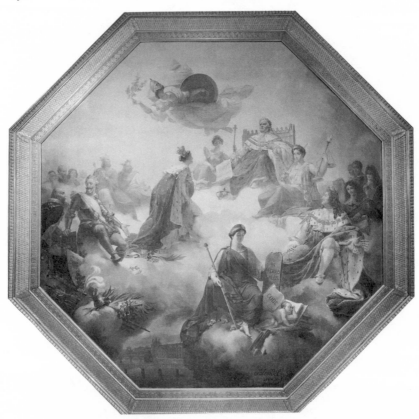

Figure 7.11: M.-J. Blondel, *France, in the Midst of the Legislator Kings and French Jurisconsults, Receives the Constitutional Charter from Louis XVIII,* 1827, oil on canvas mounted on ceiling. Louvre, Paris. Courtesy Caisse Nationale des Monuments Historiques et des Sites, © Arch. Phot./S.P.A.D.E.M., Paris.

disparity between official pretense and sordid fact has a literary counter-part in the insistent pairing, in *Bleak House,* of the inscrutably malevo-lent solicitor Tulkinghorn with the outmoded allegorical ceiling deco-ration that bears witness to his private life:

> Here, in a large house, formerly a house of state, lives Mr. Tulkinghorn. It is let off in sets of chambers now; and in those shrunken fragments of its greatness, lawyers lie like maggots in nuts. But its roomy staircases, passages, and ante-chambers still remain; and even its painted ceilings, where Allegory, in Roman helmet and celestial linen, sprawls among bal-ustrades and pillars, flowers, clouds, and big-legged boys, and makes the head ache—as would seem to be Allegory's object always, more or less. (Pp. 99–100)

Elsewhere, Dickens entwines the narrative of Tulkinghorn's machinations and his violent demise with comic references to the mute impotence of this allegorical decoration. Thus, the lawyer and his ceiling share a common dustiness:

> Plenty of dust comes in at Mr. Tulkinghorn's windows, and plenty more has generated among his furniture and papers. It lies thick everywhere. When a breeze from the country that has lost its way, takes fright, and makes a blind hurry to rush out again, it flings as much dust in the eyes of Allegory as the law—or Mr. Tulkinghorn, one of its trustiest representatives—may scatter, on occasion, in the eyes of the laity. (P. 232)

Following Tulkinghorn's murder, the allegorical, antique figure on his ceiling continues to point to the crime scene "as if he were a paralysed dumb witness":

> So, it shall happen surely, through many years to come, that . . . the Roman, pointing from the ceiling, shall point, so long as dust and damp and spiders spare him, with far greater significance than he ever had in Mr. Tulkinghorn's time, and with a deadly meaning. (P. 504)

An indictment of English justice, the mute Roman on Tulkinghorn's ceiling also points to the problematic condition of allegory in a century preoccupied by fact. This is not only the case in Britain where, for example, descriptive particularity in the accessories of the monument to Captain Richard Burgess by Thomas Banks (1802, Saint Paul's Cathedral, London) jars with the timeless generality of the allegorical program. In nineteenth-century France, where figural allegory was a long-standing national artistic legacy, official allegorical imagery is generally as stale and unconvincing as Blondel's ceiling painting for the Council of State. Delacroix's paintings for the legislative palaces of the July Monarchy are exceptional in this regard and represent the swan song, in a century of social disquiet, of a tradition that had breathed more freely under the ancien régime. At the same time, the preoccupation with justice that underlies *Bleak House* is also manifest in an attraction to the moral clarity of allegory. Thus, Dickens attempts to breathe new life into allegory by couching moral precept in concrete social observation. We see this in characters that function as personifications, ranging from selfishness incarnate (Harold Skimpole) to selflessness (in the guise of Esther Summerson). It is telling, in this regard, that the author wrote with great admiration of the allegorical *Spirit of Justice* that his friend Daniel Maclise painted for Westminster Palace.[27] Notwithstanding Dickens's

27. See his laudatory review of Maclise's cartoon (1845), in *The Dent Uniform Edition of Dickens' Journalism*, vol. 2, *"The Amusements of the People" and Other Papers: Reports, Essays and Reviews, 1834–1851*, ed. Michael Slater (London: J. M. Dent, 1996), 73–80.

Figure 7.12: "Justice," *Punch* 3 (24 September 1842): 129, wood engraving.
Reproduced courtesy of Wellesley College Library, Wellesley, Mass.

enthusiasm, survival of such lofty imagery was tenuous in an era when
Punch, in a jeremiad against the evils of modern society, could offer the
following program: "Justice, the daughter of Truth, debauched by Law,
gives with a solemn smirk, short weight to the poor, and a lumping
pennyweight to the rich" (fig. 7.12).

 Allegorical travesty—whether the target be Hoche, Lamartine, Tul-
kinghorn, or the English system of justice—speaks of a loss of inno-
cence whose cost is suggested by a passage from Samuel Butler's satirical
travel fantasy *Erewhon* (1872) in which the English narrator describes

the solemnity with which the Erewhonians regard their allegorical representations:

> They personify hope, fear, love, and so forth, giving them temples and priests, and carving likenesses of them in stone, which they verily believe to be faithful representations of living beings who are only not human in being more than human. If anyone denies the objective existence of these divinities, and says that there is really no such being as a beautiful woman called Justice, with her eyes blinded and a pair of scales, positively living and moving in a remote and ethereal region, but that justice is only the personified expression of certain modes of human thought and action—they say that he denies the existence of justice in denying her personality, and that he is a wanton disturber of men's religious convictions.[28]

While the narrator represents the apparent naiveté of his hosts with condescension, he is haunted by their faith. This untroubled, literal belief brings to the Erewhonians a spirituality that remains inaccessible to the narrator's European sophistication: "I have seen a radiance upon the face of those who were worshipping the divine either in art or nature—in picture or statue—in field or cloud or sea—in man, woman, or child—which I have never seen kindled by any talking about the nature and attributes of God" (p. 143). Underlying Butler's irony is a sense of loss that recalls Bagehot's warning: "We must not let in daylight upon magic."

28. *Erewhon, or Over the Range* (London: Jonathan Cape, 1960), 141.

PART
IV

OBSCENITY
AND ART

BODIES OF JUDGMENT

ART, OBSCENITY, AND THE CONNOISSEUR

Lynda Nead

Annexing the Obscene

In 79 A.D. the Roman town of Pompeii and the surrounding area were buried by a deluge of ash, rocks, and mud created by a huge volcanic eruption of Vesuvius. Fallout from the eruption turned day into night; though many Pompeiians fled, thousands were buried beneath the sudden torrent. The volcano halted time; it petrified everyday life in the Roman town at the moment of the eruption. To be sure, it was no ordinary moment—it was a moment of fear and panic for the trapped citizens—but as far as the buildings, spaces, and ornaments of the place were concerned, it might have been a day like any other. For centuries the site lay buried and virtually abandoned. Occasional finds were made, pieces of Roman pottery and sculpture, but no significant signs of the existence of the buried city were uncovered until the end of the sixteenth century.

In the middle of the eighteenth century, the king of Naples initiated systematic excavation of the ancient city. In 1748, the first intact fresco and a skeleton were discovered and it became clear that this was a remarkable archaeological site, unlike any previously unearthed remains of the ancient world. As digging continued and the extent of the buried town was revealed, surprising finds were made. In certain buildings lascivious frescoes were uncovered, as was a small marble statue representing a satyr and a goat in sexual congress. The rarity and value of these finds were beyond question. Charles VII transferred parts of the royal collections from Rome and Parma to Naples to form the framework for the display of the archaeological finds from Pompeii and Herculaneum. But a problem immediately arose: what was to be done with the sexually explicit objects, which were turning up with increasing fre-

quency as the excavations proceeded?[1] Their subjects made them a very different kind of cultural commodity from those normally found in fine art collections. It was feared that they might have a dangerous influence on those who saw them, particularly viewers perceived to be morally vulnerable. It was essential that the audience of the erotic finds be restricted to those whose motives and responses could be trusted. It was necessary to annex the obscene, to separate it from the main body of the display by creating a hidden, secret museum.

The British Museum had already created a Museum Secretum to house obscene artifacts from antiquity, and similar arrangements existed in Paris and Rome. A system of this kind had been operating informally at Naples since the obscene works were first uncovered at Pompeii; objects whose sexual content was seen to exceed their archaeological value were placed in a separate room, access to which was granted by the custodian and forbidden to women, children, the poor, and the uneducated. Wealthy gentlemen of taste and education, who could be trusted to move beyond subject matter and respond to antique form, were the exclusive audience for the hidden display at Naples. By the beginning of the nineteenth century, this informal arrangement for restricting access was formalized and the locked chamber became known as the "Cabinet of Obscene Objects." A royal permit was needed to visit the collection, which in 1860 was renamed the "Pornographic Collection."[2]

The isolation of the pornographic works at the Museo Borbonico is a spatial enactment of the possible etymology of the *obscene*, which, although uncertain, may derive from a Latin origin, meaning off or to one side of the stage; that is, beyond the immediate frame of representation or visibility. The museum as a record and display of the spectacular finds at Pompeii is incomplete without its nefarious, hidden collection, but nonetheless its existence must remain secret. The secret museum contains objects that violate the conventions and expectations of the museum exhibit and therefore must be placed beyond public view, to one side of the main display. Obscenity is judged and annexed, and access to its pleasures and dangers is restricted to the same group that

1. The establishment of the secret museum is discussed by Walter Kendrick in his fascinating account of the emergence of the modern category of pornography, *The Secret Museum: Pornography in Modern Culture* (New York: Viking, 1987). He analyzes responses to the archaeological finds at Pompeii and places them alongside sociomedical discourses on prostitution in the period.

2. On the history of the secret museum, see Michael Grant, *Erotic Art in Pompeii: The Secret Collection at the National Museum of Naples* (London: Octopus, 1975). The treatment of erotic artifacts in this period is discussed in Catherine Johns, *Sex or Symbol: Erotic Images of Greece and Rome* (Austin: University of Texas Press, 1982), chap. 1.

first classified the works. The paradox of the secret museum is that it is separate from but part of the main museum; it is known about and a secret.

Annexation implies both separation and unity. It describes a relationship between discrete terms that are joined together, but it may further connote the subordinate or supplementary status of the added term relative to the main term.[3] It is helpful to hold on to the hierarchical ambiguity embodied in the concept of the annex, for it echoes a similar equivocation in the relationship between art and obscenity. Art and obscenity need each other; their relationship is one of mutual dependency in which neither term is necessarily primary or subordinate. The boundaries of the two terms abut each other and each becomes the limit of the other. Obscenity's beginning is art's end; art starts where obscenity terminates. Historically, there are no absolute criteria that determine where an object is categorized in relation to sex and aesthetics, illegitimate and legitimate culture. At any given moment, however, the critical place of definition is the borderline, where art and obscenity brush up against each other and where the matter of distinction becomes most urgent. This would suggest that art and obscenity are in a constant state of definition and redefinition. It might be more accurate, therefore, to conceive of them as social, moral, and cultural processes than as finite categories. As processes, art and obscenity rest upon acts of judgment performed by those who have particular knowledge and power. Since the eighteenth century, these judgments have been based not, as we might expect, on the presence or absence of sexual content, but on the imagined presence or absence of sexual arousal in any given viewing public. In any such judgment, however, the judge must be beyond incrimination. The arbiter may only distinguish art and obscenity from a position that is outside of the attractions and compulsions of sexual representation. The public body may only be regulated, it would seem, by one whose own body is still, composed, and unified, as opposed to aroused, disturbed, and fragmented.

This essay examines the role of the connoisseur in making the judgments that regulate the boundaries of art and obscenity. It draws on some historical moments in this process, when cultural experts come up against the sexual in representation and classify it, and it considers both the nature of this encounter between the connoisseur and obscenity and the fierce and anxious attempts to distinguish connoisseurial

3. This reading of the annex draws upon Derrida's notion of the "supplement" and "supplementarity," although it does not follow the hierarchical relationship assumed in that model. See Jacques Derrida, *Of Grammatology*, trans. Gayatri Spivak (Baltimore: Johns Hopkins University Press, 1976), 141–64.

discourse about the sexual from the sexual, aroused discourse of the obscene. How can a discursive space be established between the cultural judgment of obscenity and obscenity itself? The semantic ambiguity of the annex is once more useful here. In seeking distinction from the obscene, the language of legal and aesthetic judgment all too often finds unity and becomes a part of the corporealized, sensual discourse it seeks to contain and regulate. The judgment of the limits of art and obscenity may ultimately reveal the troubled body of the connoisseur, rather than the uncontrolled mass of women and the mob.

The secret museum at Pompeii presents a fascinating instance of these themes of judgment and incorporation. The paradox of the hidden display reveals the contingent and ragged nature of such aesthetic judgment. On the surface it would seem simple enough: annex those objects that present greatest risk, and regulate the public who may have access to them. But how do you catalog such a display; what discourse is to be deployed to speak of these things? How do you describe those objects without being implicated in the cycle of desire and gratification that is the condition of obscenity? M. L. Barré's eight-volume compilation of the works at the Museum of Naples is one of the most comprehensive guides to the collection published in the nineteenth century.[4] Barré adopted a strategy for dealing with the pornographic collection analogous to that assumed by the curators and custodians of the museum. He isolated those works within his eighth and final volume, which he subtitled the "Musée Secret." Throughout the introductory pages to this volume, Barré seeks to justify his treatment of the obscene works and to assert the cultural purity of his own text. First and foremost, access to the contents of the eighth volume must be restricted in the same way that entrance to the hidden display is guarded by the custodian. The works should only be of interest to historians, scholars, artists, philosophers, and clerics;[5] the problem then is how to keep the book from the rest of the reading public. Barré's solution is to leave all of the quotations from classical writers untranslated, which, given his objects of study and the spread of literacy, he considers to be a necessary, if arcane approach:

> If we were treating another subject, we might be criticised for this extravagance of erudition; here, however, we will no doubt be commended, just

4. M. L. Barré, *Herculanum et Pompéi, Receuil Général des Peintures, Bronzes, Mosaïques etc. découverts jusqu'à ce jour et reproduits d'après Le Antichita di Ercolano, Il Museo Borbonico et tous les ouvrages analogues*, 8 vols. (Paris: publisher unknown, 1840).

5. Ibid., 8:2.

as sculptors are forgiven the overgrowth of foliage that sometimes screens
the nudity of their human figures.[6]

Latin thus becomes the written equivalent of a sculpted fig leaf. The
comparison reveals the true nature of Barré's concern: bodies and sex
and the transference of desire from the sight of the objects to their
written description. The engravers of the illustrations also contribute
to the eradication of the sexual, not, in fact, by introducing fig leaves
to unclothed statues, but by reducing the scale of the genitals.[7] Rather
than adding drapery to the statues, which Barré fears may interfere with
the works' artistic integrity, the engravers miniaturize the genitalia. Re-
duction in scale, it is claimed, results in a reduction in significance, al-
though in the most explicit and erotic works it is necessary to eliminate
the penis altogether. It hardly seems necessary to point out that, far
from reducing the significance of sex, the curious visual results of this
artistic strategy inevitably draw the viewer's attention to the very ana-
tomical parts that the author seeks to efface. The shrunken penises of
the Roman statues are a fulfillment of the desired response of the book's
male viewer, in whom detumescence is the necessary condition of aes-
thetic contemplation and scientific scholarship. To reinforce the impor-
tance of the integrity of the viewer in maintaining the necessary distance
between art and obscenity, Barré restates the point:

> It has been our intention to remain calm and serious throughout. In the
> exercise of his holy office, the man of science must neither blush nor
> smile. We have looked upon our statues as an anatomist contemplates
> his cadavers.[8]

A smile or a blush are sufficient indices of arousal, of a rupture in the
contemplative stillness of the viewing experience. Stasis is the desired
state, both in the viewer and in the viewed object; the implied motiva-
tion of the enlarged penis must be eradicated. In the final move in this
process of denial, the figure is even compared to a corpse. We might
wonder how Barré could have brought himself to use this example, how

6. Ibid.; translation as cited in Kendrick, *Secret Museum*, 16.
7. Ibid., 8:12. "Nos dessinateurs se sont fait une règle analogue: mais, au lieu d'ajouter,
dans les tableaux, des draperies on d'autres accessoires qui auraient pu détruire l'esprit
de la composition et dénaturer la pensée de l'artiste ancien, ils se sont contentés de reduire
à d'étroites dimensions un petit nombre de sujets d'une nudité vraiment érotique. Ainsi
diminués, certains traits trop crus et trop saillant du dessin original ont perdu toute leur
importance; quelquefois même ils ont pu, sans inconvénient, s'évanouir et disparaître tout
à fait."
8. Ibid., 8:11–12; translation as cited in Kendrick, *Secret Museum*, 15.

he could have risked such a comparison. It is as though in searching for an example that is as different as possible from the erotically charged and stimulated bodies of the Pompeiian statues, he inexorably returns to that which is most dangerously close to the original object. The wonder of the finds at Pompeii was the traces and remains of its society as much as the artistic artifacts. Skeletons had been uncovered as well as statues, and the unanswered question was what the obscene objects and sculpted bodies had to do with the people of the town; how did representation relate to behavior? The visual spectacle of dead bodies might also have been familiar to nineteenth-century audiences, given the use in that period of highly naturalistic wax dummies to illustrate anatomical conditions in natural science displays and cabinets of curiosities.[9] The erotic possibilities of viewing the naked or flayed wax exhibits made these displays as risky for the respectable viewer as the museum at Pompeii. But whereas the wax models could be legitimized in the name of science; the classical statues were reclaimed in the name of art. In the context of the bodily remains at Pompeii and the exquisite corpses in the waxwork museums, Barré's appeal to the detached objectivity of viewing a cadaver becomes dangerously unworkable and risks insinuating exactly the affected, aroused response he seeks to deny.

Barré's account of individual works bears all the hallmarks of connoisseurship. He comments throughout on artistic quality, taking particular note of "purity" of line. He also attributes groups of sculptures to individual artists. The nascent techniques of nineteenth-century art history—formal analysis and attribution by style—are thus also deployed to erase the vestiges of obscenity and to reinforce the cultural and, by association, the moral value of the objects in Pompeii's secret museum.

Pompeii enabled nineteenth-century antiquarians to get closer and closer to the borderline of art and obscenity. The closer the connoisseur came to the dividing line, the more exquisite the judgment required. To go right to the edge of legitimate culture and to remain unscathed could be the ultimate display of the supremacy of bourgeois masculinity and of the composed mind over the troubled body. The author of an 1871 account of the "Cabinet Secret" described and illustrated a statue of "Venus Callipyge," a statuette of a partially draped female figure, found at Rome but brought by the king of Naples to the museum at

9. For discussion of these waxwork displays, see Ludmilla Jordanova, *Sexual Visions: Images of Gender in Science and Medicine between the Eighteenth and Twentieth Centuries* (New York and London: Harvester Wheatsheaf, 1989).

Pompeii.[10] According to the text, the statue is located in a space that is neither entirely that of the main museum nor that of the secret cabinet. It is in a "reserved hall" between the two displays, to which access is permitted only under the surveillance of a guardian. The text describes the grace and beauty of the statue, but then things begin to go awry:

> The power of beauty is recognised wherever it manifests itself: the marble seems to palpitate; in contemplating it modesty takes alarm, desire begins to awake, and imagination to kindle; and we are obliged to hurry away in order to restore our agitated senses to their original tranquility.[11]

For the sensitized viewer, beauty itself becomes provocative. In a borrowing from the Pygmalion myth, the marble appears to throb and come alive, producing a similar agitated state in the aroused viewer. Desire and imagination are excited, resulting in a complete loss of composure and the viewer's urgent withdrawal. This astounding passage is a reminder of the risks facing the connoisseur when viewing the nude. It is as though the response to a representation of the body is the benchmark of the judge's aesthetic resilience. The sexual must be held in abeyance in the act of pure aesthetic judgment; it cannot be allowed to exceed the limits of art and result in loss of composure, aroused imagination, and motivated desire.

Annexing obscenity in the museum displays and guides to Pompeii did not deal with the problem of the relationship between art and obscenity in any final sense. Rather, it shifted focus from the objects themselves to acts of judgment and the bodies of the viewing subjects. Historical rarity and aesthetic quality might diminish the affects of sexual content, but this was not guaranteed; even the respectable viewer could let his imagination run riot.

Outlawing the Obscene

The middle of the nineteenth century sees the first attempts to legally isolate obscenity from other public order offenses. In the Vagrancy Act of 1824, the public exhibition of obscene prints was made a summary offense within a range of provisions directed at regulating the public streets. This emphasis on the public display and sale of obscene matter was reinforced in the Metropolitan Police Act of 1839 and the Town

10. Colonel Fanin, *The Royal Museum at Naples, Being Some Account of the Erotic Paintings, Bronzes, and Statues Contained in that Famous "Cabinet Secret"* (London: privately printed, 1871), 5–6.
11. Ibid., 6.

Police Clauses Act of 1847.[12] The first dedicated obscenity legislation was passed in 1857, following an energetic campaign in the House of Lords by the lord chief justice, Lord Campbell. Unlike the rare, valuable artifacts in which obscenity was seen to manifest itself at Pompeii, the objects targeted by Campbell's Obscene Publications Act were the products of cheap, mass culture, made possible by new printing technologies and circulating in the city streets in greater numbers and at lower prices than ever before. The new publications were ubiquitous, promiscuous, and dangerous; if it was no longer adequate to restrict access to these objects by annexing them and guarding entry, then they must be outlawed and, more particularly, destroyed.

John Campbell was the son of a Scottish clergyman and, with the support of various anti-vice societies, had waged a personal campaign to take his bill through Parliament.[13] Campbell was not concerned to change the existing common law definition of obscenity; what he wanted was more rigorous penalties for the dissemination of obscenity and, above all, the destruction of the obscene goods concerned. He sought to withdraw these rogue commodities from circulation, both in economic terms and in relation to a visual economy of public display and viewing.

Campbell's legislation had a hard time passing through the two chambers of Parliament. One of the main areas of concern was the possible interference with private life and the liberty of the subject embodied in the bill's proposed use of search warrants. The other problem concerned the generality of the definition of obscenity. Campbell provided the House of Lords with the current test of obscenity, which applied to works with the single purpose "of corrupting the morals of youth, and of a nature calculated to shock the common feelings of decency in any well regulated mind."[14] It was not his intention that the legislation apply to high culture, or to the private consumption of art, but that it should be directed to the public dissemination of mass-

12. "An Act for the Punishment of Idle and Disorderly Persons, and Rogues and Vagabonds, in that Part of Great Britain called England," 1824, Cap. 83, 5 G. 4 c.83; 1839 "An Act for Consolidating in One Act certain Provisions usually contained in Acts for regulating the Police of Towns," 1847, Cap. 89, 10 and 11 Vict. c.89. The history of obscenity legislation is usefully summarized in Alec Craig, *The Banned Books of England and Other Countries: A Study of the Conception of Literary Obscenity* (London: George Allen and Unwin, 1962), and Geoffrey Robertson, *Obscenity: An Account of Censorship Laws and Their Enforcement in England and Wales* (London: Weidenfeld and Nicolson, 1979).

13. Lord Campbell (1779–1861), biographical notes in *Dictionary of National Biography*, ed. Leslie Stephen (London: Smith, Elder and Co., 1886), 8:379–86. "An Act for more effectually preventing the Sale of Obscene Books, Pictures, Prints, and other Articles," 1857, Cap. 83, 20 and 21 Vict. c.83.

14. *Hansard's Parliamentary Debates*, 3rd ser., 146 (25 June 1857), c.329.

produced obscenity. But the question remained: Why should the act not be aimed at obscenity of all kinds, as determined by the existing definition? Why not the statues from Pompeii or the masterpieces of Western culture? After all, beauty could move the senses as readily as trash, as the experience of the disturbed viewer of the "Venus Callipyge" showed. What distinguished sex in mass culture from sex in high art, other than cost?

One of Campbell's chief opponents in the House of Lords debates was Lord Lyndhurst, whose public career included a period as lord chancellor. An aristocratic figure, Lyndhurst was the son of the American painter John Singleton Copley.[15] The son of the evangelical clergyman faced the son of the artist over the benches of the House of Lords as they battled over the borderline between art and obscenity. Lyndhurst feared the intrusion of fortified legislation and interference in private and apparently legitimate cultural consumption. As it stood, Campbell's bill allowed intervention in private art collections and legitimized cultural philistinism as undereducated and overzealous police officers were given greater power to bring offending objects to court. Lyndhurst imagined one such encounter:

> Suppose now a man following the trade of an informer, or a policeman, sees in a window something which he conceives to be a licentious print. He goes to the magistrate, and describes, according to his ideas, what he saw; the magistrate thereupon issues his warrant for the seizure of the disgusting print. The officer then goes to the shop, and says to the shopkeeper, "Let me look at that picture of Jupiter and Antiope." "Jupiter and what?," says the shopkeeper. "Jupiter and Antiope," repeats the man. "Oh! Jupiter and Antiope, you mean," says the shopkeeper; and hands him down the print. He sees the picture of a woman stark naked, lying down, and a satyr standing by her. . . . The informer tells the man that he is going to seize the print, and to take him before the magistrate. "Under what authority?," he asks; and he is told—"Under the authority of Lord Campbell's Act."[16]

Moreover, Lyndhurst speculated, what was to stop the informant extending his pursuit of obscenity to the original paintings, held in private collections throughout the country? Campbell hurried to reassure the opponents of his bill that Lyndhurst's fears were groundless. Pictures in private collections were not for sale but for contemplation. Furthermore, there was a clear and marked distinction between the pictures Lyndhurst had described and the mass of prints that circulated in Lon-

15. Lyndhurst (1772–1863), biographical notes in Stephen, *Dictionary of National Biography*, 12:182–89.

16. *Hansard's Parliamentary Debates*, 3rd ser., 146 (25 June 1857), c.331.

don shops and possessed no artistic merit whatever. The private posses-
sion and enjoyment of explicit books and images of cultural value were
a matter of "taste" and not a subject for legal intervention.[17]

What is evident in this exchange between the two aging law lords is
that obscenity legislation in the modern period is not simply a question
of the regulation of moral behavior, but has far more to do with the
regulation of cultural consumption. The outlawing of obscenity in this
period is an attempt to shore up official culture and to redraw the
boundaries between the permissible and the forbidden. The new, cheap
forms of mass street culture are legally isolated through the new special-
ist category of obscenity. But whereas the law judges between art and
obscenity in relation to mass culture, the judgment of obscenity in high
culture is a matter of taste. Enter the connoisseur, the man of taste and
judgment, who must police the borderlines of art.

Connoisseurship and the Obscene

In the British Library there is a special collection of erotica. It is known
as the private or locked case and the books within this collection, along
with their readers, are treated differently from other books and readers.
Catalogers' unofficial guidelines suggest that books within this class in-
clude those that are "prone to theft or damage" as well as commercial
or titillating representations of sex.

From the evidence of British Library accession stamps, it appears
that the private case was established around 1857, the year Campbell's
Obscene Publications Act was passed. It is as though the archivist's re-
sponse to the outlawing of obscenity was to create a secret library, in
the tradition of the Musée Secret at Pompeii and for the use of the
same elite circle of rich dilettanti and gentlemen scholars.

The core of this secret library is the books collected by the Victorian
bibliophile H. R. Ashbee, who bequeathed his collection to the British
Library in 1900.[18] Ashbee was a merchant who married the daughter
of a wealthy European entrepreneur and was given a partnership in her
father's business. He amassed a significant fortune and spent much of

17. Ibid., 146 (25 June 1857), c.337, and (3 July 1857), c.865.
18. The best sources on Ashbee and the private case books are Peter Fryer, *Private
Case—Public Scandal* (London: Secker and Warburg, 1966); Peter Fryer, ed., *Forbidden
Books of the Victorians: Henry Spencer Ashbee's Bibliographies of Erotica* (London: Odyssey
Press, 1970); Patrick J. Kearney, *The Private Case: An Annotated Bibliography of the Private
Case Erotica Collection in the British (Museum) Library*, with an introduction by G. Legman
(London: Jay Landesman Ltd., 1981); and Steven Marcus, *The Other Victorians: A Study
of Sexuality and Pornography in Mid-Nineteenth Century England* (London: Weidenfeld and
Nicolson, 1966), chap. 2.

his later life traveling, writing, and collecting books. Under the pseud-onym Pisanus Fraxi, he privately published three volumes cataloging his erotic book collection. The first volume in the series, published in 1877, is titled *Index Librorum Prohibitorum: Being Notes Bio-, Biblio-, Icono-graphical and Critical on Curious and Uncommon Books.* The main title of the volume is a play on the list of forbidden books instituted by the Roman Catholic Church in the mid-sixteenth century as part of the Counter-Reformation, only Ashbee's purpose is to reclaim these books rather than to burn them. There can be little doubt about the respect-able, intellectual intentions of Ashbee's work, although as we have al-ready seen, these things are seldom watertight. Like the catalogers of Pompeii, Ashbee felt compelled, perhaps overcompelled, to demon-strate the legitimacy of his project. He took pains to establish the differ-ence between his catalog and its objects of study, and to emphasize that his own volume was not obscenity but culture, with an investigative and didactic purpose. However, he also wanted to give his readers a feel of the books he was discussing and thus quoted them at some length, rather than simply summarizing their contents. He begins his introduc-tion:

> The passions are not excited. . . . My extracts on the contrary, will, I trust and believe, have a totally opposite effect, and as a rule will inspire so hearty a disgust for the books that they are taken from, that the reader will have learned enough about them from my pages, and will be more than satisfied to have nothing further to do with them.[19]

Ashbee's catalog, then, is not the first step on the path to an addiction to the obscene. On the contrary, it will work as a form of aversion therapy, producing in the reader a vehement disgust for its objects of study. Of course, disgust is a strong response. The disgusted viewer is the affected viewer, highly motivated, in a state not unlike desire. But Ashbee adds a footnote qualifying his statement; a few readers may be trusted to turn their gaze to the erotic books themselves, to move from a metadiscourse on the obscene to obscenity itself:

> This [above] remark applies more particularly to the general reader; I cannot admit so much in the case of the mature and serious student, for whom in many instances it will be necessary to read the works themselves, and not base his knowledge upon my extracts or strictures.

This afterthought performs a textual equivalent to the custodian allowing the wealthy, educated gentleman into the secret museum. Such

19. Pisanus Fraxi, *Index Librorum Prohibitorum: Being Notes Bio-, Biblio-, Icono-graphical and Critical on Curious and Uncommon Books* (London: privately printed, 1877), p. lxx.

readers can test Ashbee's judgments against their own by coming into direct contact with obscenity and resisting its attractions. Finally, unable to let the matter rest, Ashbee reassures his select readers:

> As little, it is my belief, will my book excite the passions of my readers, as would the naked body of a woman, extended on the dissecting table, produce concupiscence in the minds of the students assembled to witness an operation performed upon her.

If there was any doubt when Barré used it about the compromised nature of this image as an index of sexual nonarousal, its repetition by Ashbee should confirm the anxieties these authors feel about the legitimacy of their projects.

Throughout these texts, the strenuous efforts to contain the connotations of sexuality fail; the prose appears balanced on a knife-edge between legitimacy and becoming absorbed within obscenity. For Ashbee, claims to scientific accuracy and objectivity, bolstered by pages of footnotes and attention to detail, are jeopardized by revelations of absorption in his subject, such as this epithet, attributed to the Duke of Halifax and quoted in the preface of the *Index Librorum Prohibitorum:* "the struggle for knowledge hath a pleasure in it like that of wrestling with a fine woman." This flash of ribaldry threatens to undo the entire framework of scholarship that Ashbee tries to establish elsewhere in the text.

In her discussion of the Marquis de Sade's *120 Days of Sodom* and the 1986 Meese Commission Report on pornography, Susan Stewart argues that "pornography and the public discourse on pornography have the same comparative logic."[20] She points to the impossibility of constructing a metadiscourse of desire that does not itself generate desire, and to the failure of sublimation to contain the implications of sexual content. More particularly, she describes the particular conditions of de Sade, which might usefully be extended to the expectant readers of Barré and Ashbee:

> [De Sade] suspended the reader/viewer between complete absorption and complete transcendence, between a subjectivity unbearable in its sexual proximity and an objectivity unbearable in its monstrous distance.[21]

The textual rhythms of Ashbee's text, the erudite footnotes and bawdy epithets, the cataloger's discourse and the lengthy extracts, these claims and counterclaims drag the reader between the states described by Stewart. In the final count, the catalog is neither fully absorbed by its

20. Susan Stewart, *Crimes of Writing: Problems in the Containment of Representation* (Durham: Duke University Press, 1994), 235.
21. Ibid., 237.

subject, nor able to maintain its distance; its status is one of complete
cultural ambiguity.

In the subsequent volumes, Ashbee again throws in the obligatory
claims to cultural legitimacy. In 1879 he admits that, in spite of his aim
as a bibliographer to record the insignificant and trivial, he has been
"attracted by masterpieces, and [has] neglected the unartistic."[22] In the
third volume, published in 1885, he claims that his work is instructional,
illustrating the manners of the past and providing moral lessons for the
present.[23] These justifications mirror developments in the legal judg-
ment of obscenity in this period. The idea of a "public good" defense
against the supposed harmful effects of obscenity was first formulated
by Mr. Justice Stephen in his *Digest of Criminal Law*, published in 1877.
Commenting on uses of the 1857 Obscene Publications Act he submits:

> A person is justified in exhibiting disgusting objects, or publishing ob-
> scene books, papers, writings, prints, pictures, drawings, or other repre-
> sentations, if their exhibition or publication is for the public good, as
> being necessary or advantageous to religion or morality, to the adminis-
> tration of justice, the pursuit of science, literature, or art, or other objects
> of general interest.[24]

In this way, claims of those who seek to legitimize their cultural encoun-
ters with the obscene are now admitted into the legal regulation of ob-
scenity. But Stephen draws the line:

> The justification ceases if the publication is made in such a manner, to
> such an extent, or under such circumstances, as to exceed what the public
> good requires in regard to the particular matter published.

The question thus becomes whether there is an excess of indecency and
whether the requirements of public good can contain needless deprav-
ity. The stage is set for the ascendancy of the connoisseur as cultural
expert who can judge the question of need and excess, testify to the
presence of artistic value, and weigh up the relationship between arousal
and aesthetics in any given representation.

The "public good" defense was eventually written into the 1959 Ob-
scene Publications Act. Among the many statutory changes embodied

22. Pisanus Fraxi, *Centuria Librorum Absconditorum: Being Notes Bio-, Biblio-, Icono-
graphical and Critical on Curious and Uncommon Books* (London: privately printed, 1879),
p. lv.

23. Pisanus Fraxi, *Catena Librorum Tacendorum: Being Notes Bio-, Biblio-, Icono-
graphical and Critical on Curious and Uncommon Books* (London: privately printed, 1885),
p. xl.

24. James Fitzjames Stephen, *A Digest of Criminal Law (Crimes and Punishments)* (Lon-
don: Macmillan and Co., 1877), 104.

in the new legislation was the view that the dangers of obscenity might be justified if experts could establish a degree of cultural value that could outweigh any tendency within the work to deprave or corrupt its likely audience.[25] There are two stages within the operation of the 1959 act. The first is the decision concerning the obscenity of the work; the second, the decision regarding artistic merit. Aesthetic value is thus a justification for the publication of a work already proven to be obscene. The critical evidence in such a case is the body of expert opinion, which can attest to the presence or absence of civilizing values such as art, science, and education.

The connoisseur may be defined in terms of two distinctive qualities: knowledge and judgment. Connoisseurship assumes a thorough knowledge of the subject concerned, which forms the basis of a critical judgment. But what kind of judgment is involved in connoisseurship? The obvious answer would seem to be, an aesthetic sort—the perception and appraisal of pure form, of that which is beautiful. But at the point at which connoisseurship appears to have clearly defined aims and objects, the borders begin to dissolve; cerebral criteria become corporealized and the judgment of artistic form is compromised by the regulation of bodies and behaviors. Connoisseurship may be understood in the narrow sense of expertise within the fine arts; but it also carries a more generalized meaning in which the connoisseur may be an expert in any matter of taste (e.g., wine or food). It is in the move from the narrow to the broader definition that we make the critical shift from the aesthetic distance implied in sight's judgment of form, to the potential physical proximity and transgressive disruption of those other senses, smell, taste, and touch. The moment of transition from the particular appeal to vision to the implication of the other motivated senses is the moment of theorization of the corporeality of the judge or connoisseur, of the troubled bodies on which cultural classification may be said to hinge.

Kenneth Clark's work exemplifies the troubles facing the connoisseur and the role of the art expert in modern judgments of obscenity. Lord Clark occupied a central role within the British art establishment from the 1940s to the 1970s, holding most of the key public positions within British culture in the period: director of the National Gallery London, chairman of the Arts Council, chairman of the Independent Television Authority, and so on. He also played a significant role in popularizing high art through its presentation on television. His broad-

25. For discussion of the "public good" defense in the 1959 Act, see Robertson, *Obscenity*, 43–47, 144, 162–64.

casting reputation was secured by his television series "Civilisation," which was shown in Britain in 1969 and 1970 and was sold throughout Europe and North America. In personal terms, Clark was the embodiment of the modern connoisseur; handsome and immaculately-dressed, mixing with court circles and royalty, attractive to and attracted by the wealthy women in his social set.[26]

Clark's book *The Nude: A Study of Ideal Art* was first published in 1956. It offers a personal art historical survey of the nude within Western culture from classical civilization to twentieth-century modernism. The book has shown an astonishing durability; more than forty years since its first publication, it is still widely sold in bookshops in the most recent of its several paperback editions. The judgment of images of the body poses the most exquisite challenge to the man of taste. How to judge the body without expressing a bodily response? How to articulate an aesthetics of the body without being drawn into a discourse of sexuality and desire? Perhaps the most enduring formulation within Clark's narrative is his differentiation of the naked and the nude, which provides the framework for his subsequent aesthetic judgments. According to Clark, to be naked is simply to be deprived of clothes, to be huddled and defenseless; but the nude presents the body clothed in art, reformed rather than de-formed, balanced, confident, and prosperous. The transformation of the naked to the nude is thus a shift from the actual to the ideal. Clark states: "The nude remains the most complete example of the transmutation of matter into form."[27]

The value of this cultural transfiguration is gauged in terms of its effects on the (male) viewer:

> The Greeks perfected the nude in order that man might feel like a god, and in a sense this is still its function, for although we no longer suppose that God is like a beautiful man, we still feel close to divinity in those flashes of self-identification when, through our own bodies, we seem to be aware of a universal order.[28]

The significance of a judgment of the highest art is the reassurance and integrity that it offers to the connoisseur. If the act of judgment is simultaneously an act of identification, then the appraisal of the classical male nude is a glimpse of the self as divinity. Throughout the pages of *The Nude*, however, another, spectral body appears and disappears; not

26. For an account of Kenneth Clark's life see his two autobiographical volumes, *Another Part of the Wood: A Self-Portrait* (London: John Murray, 1974) and *The Other Half: A Self-Portrait* (London: John Murray, 1977).

27. Kenneth Clark, *The Nude: A Study of Ideal Art* (London: John Murray, 1956), 23.

28. Ibid., 357.

the body in art, but Clark's own body, as it is sublimated, arrested, and aroused by the objects he examines. What also structures the book is a dialogue between a category of art, which is concerned with stylistic procedure and form, and a category of obscenity, which seems to do with excess and lack of boundaries. But the unbounded body clearly pertains both to certain nudes in the history of art and to Clark's own disturbed state on viewing those objects.

It is the viewer's body that is the most troubled and troubling with regard to cultural classification. This debate has its roots in eighteenth-century bourgeois aesthetics. In 1780 the Goettingen Pocket Calendar (Goettinger Taschen Calendar vom Jahr 1780) was published as part of an ongoing interpretation of the concept of taste within a middle-class public sphere.[29] Whereas Baumgarten and Kant had been writing for a learned readership, the almanac was aimed at a well-off educated reading public and was intended to extend the concept of taste within social life. It consisted of a pocketbook containing a variety of articles and essays. The calendar was composed of twelve engravings (one for each month), made by the painter-engraver Daniel Chodowiecki and contrasting tasteful (acceptable) and fashionable (unacceptable) behavior. The plates for July and August oppose two types of connoisseur (figs. 8.1, 8.2). July's connoisseurs stand appropriately still before a female classical statue. They are in contemplative poses, with their hands and arms folded around their bodies, reinforcing the physical distance between them and the statue. In the contrasting image, the connoisseurs indulge in expansive gestures; they converse with each other and gesture toward the statue. More specifically, the furthest figure points to the cornucopia carried by the female figure directly over her pubic area. The man's pointing finger seems to physically touch the statue and the physical distance required by good judgment is transgressed. The plates define correct judgment by example and counterexample; to judge incorrectly is to be motivated and aroused and to place oneself outside good, rational society.

It is, of course, critically important that the test of the connoisseur is the judgment of an image of the female form. The Enlightenment ideal of the contemplative viewing of an art object works to reinforce the unity and integrity of the viewing subject and sets up an opposition within the judgment of culture between aesthetic passivity and sexual arousal. The obscene body is the body beyond representation; without

29. On the formation and circulation of the concept of taste in eighteenth-century German bourgeois society, see Anne-Marie Link, "The Social Practice of Taste in Late Eighteenth-Century Germany: A Case Study," *Oxford Art Journal* 15, no. 2 (1992): 3–14, in which the Goettingen Pocket Calendar of 1780 is discussed.

Figure 8.1: Daniel Chodowiecki, "Kunstkenntnis," from the Goettinger Taschen-Calendar, 1780 (July). Graphische Sammlung, Staatsgalerie Stuttgart.

Figure 8.2: Daniel Chodowiecki, "Kunstkenntnis," from the Goettinger Taschen-Calendar, 1780 (August). Graphische Sammlung, Staatsgalerie Stuttgart.

borders or containment. It is the body aroused and motivated rather than unified and still.

This classification of culture in terms of its harmful affects on the body of the viewer can be traced from the first attempts to annex obscenity in the secret museum at Pompeii and the private case at the British Library through to the operation of the "public good" defense as a justification for obscenity. Following liberal legislation and amendments to pornography laws in Britain in the 1960s, Clark was called as an expert witness before Lord Longford's privately initiated committee on pornography (1972). Asked for his definition of pornography, Clark replied:

> To my mind art exists in the realm of contemplation, and is bound by some sort of imaginative transposition. The moment art becomes an incentive to action it loses its true character. This is my objection to painting with a communist program, and it would also apply to pornography. In a picture like Correggio's Danae the sexual feelings have been transformed, and although we undoubtedly enjoy it all the more because of its sensuality, we are still in the realm of contemplation.[30]

Thus, according to Clark, the connoisseur and expert witness, it is providing incentive to action that expels an image from the realm of art and creativity. The definition applies equally to images from documentary, propaganda, and pornography, in all of which, Clark maintains, the viewer is motivated and disturbed, rather than "bound" by the imagination. Within this account the category of "sensuality" is critical. It describes sexual content that is permissible, where desire is present but transformed or momentarily arrested.

The definition of obscenity is as much concerned with the body of the viewer as with the body imaged. Two bodies are being judged. If the connoisseur is the one who knows, the judge of art, then the connoisseur's body has to be unimpeachable. The integrity of the connoisseur is the guarantee of the cultural worth of the object viewed.

The act of judgment is an act of cultural distinction, in the sense invoked by Pierre Bourdieu in his 1984 study, *Distinction:*

> Taste classifies, and it classifies the classifier. Social subjects, classified by their classification, distinguish themselves by the distinctions they make, between the beautiful and the ugly, the distinguished and the vulgar.[31]

30. Kenneth Clark, evidence to Lord Longford, *Pornography: The Longford Report* (London: Coronet, 1972), 99–100.

31. Pierre Bourdieu, *Distinction: A Social Critique of Taste*, trans. Richard Nice (London: Routledge and Kegan Paul, 1984), 6.

The judgment of art as an act of cultural distinction carries particular social significance. For Bourdieu, the cultural sphere is maintained by the evacuation of vulgar, coarse, and venal pleasures and by the assertion of pure, disinterested, and sublimated ones. It is a hierarchy commonly expressed through the prioritization of form over function and manner over matter. According to Bourdieu, those who are satisfied by "pleasure purified of pleasure" are assured social superiority, and in this way, cultural consumption fulfills the function of legitimating social differences.

When this model is applied to the judgment of the sexual in art, we can see that this form of classification might yield a special legitimating force. If the sacred sphere of culture is characterized by the expulsion of bodily appetite, then what could be more risky, or potentially more rewarding, than to classify the venal, sex itself? What better way to demonstrate cultural disinterestedness and superiority than to come into contact with the sexual and to be—partially, at least—unmoved.

The sexual in art takes the viewer to the frontier of legitimate culture; it allows the viewer to be aroused but within the purified, contemplative mode of high culture. Arousal and contemplation—these two conditions of viewing—must be constantly negotiated in cultural classification and by the connoisseur confronting the nude. This flirtation with the sexual can be seen at work in Clark's evocation of the necessary eroticism of a painted nude:

> No nude, however abstract, should fail to arouse in the spectator some vestige of erotic feeling, even although it be only the faintest shadow. . . . The desire to grasp and be united with another human body is so fundamental a part of our nature, that our judgment of what is known as "pure form" is inevitably influenced by it; and one of the difficulties of the nude as a subject for art is that these instincts cannot lie hidden, as they do for example in our enjoyment of a piece of pottery, thereby gaining the force of sublimation, but are dragged into the foreground where they risk upsetting the unity of responses from which a work of art derives its independent life. Even so, the amount of erotic content which a work of art can hold in solution is very high.[32]

The passage is marked by an uneasiness of tone; instincts are "dragged" into the open and "risk upsetting" the kinds of response that may be more appropriate to a work of art. In the end, Clark resorts to a chemical metaphor in which the "erotic" is present but only just under control. So there are risks facing the connoisseur; risks that those traces and vestiges of the sexual, which are a constant potential of the nude, will become so powerful that they will annihilate the appreciation of pure

32. Clark, *Nude*, 23.

form. Connoisseurship is a mastery of the viewing body, the triumph of the mind over the baser instincts.

In *Distinction*, Bourdieu argues for the reintegration of high and mass culture, not so as to create an undifferentiated cultural continuum, but in order to understand, for example, how different kinds of cultural consumption register social distinction. Such a reintegration is a form of transgression, abolishing the "sacred frontier" that separates legitimate public culture from the rest of ordinary tastes and appetites (for instance, the distinction between the masterpieces in private collections and the mass-produced print culture debated by the House of Lords in 1857). With this act of transgression in mind it is worth recalling more of Kenneth Clark's testimony to the Longford Committee. Commenting on sexually explicit works by Géricault and Rodin, he states: "Although each of these is a true work of art, I personally feel that the subject comes between me and complete aesthetic enjoyment. It is like too strong a flavour added to a dish."[33] It is no accident that the analogy Clark draws to illustrate the excess of sex in art is with food and eating. For the connoisseur is also a gourmet and distinguishes himself through his taste both in culture and in cuisine. Pure aesthetic enjoyment is concerned with form rather than content, with sight rather than taste or smell or touch. Although high culture may hint at sexual pleasure, it must not go beyond what is required for the public good, or force the viewer to withdraw in order to restore his bodily composure. The connoisseur's palate is a sensitive one and too strong a flavor corrupts the aesthetic moment through the reintroduction of food, bodies, and sex.

The connoisseur's vision ultimately fails him and Clark is forced to resort to those other senses, which require a dangerous bodily proximity, to make his judgments:

> French artists . . . have depicted the female body with a sharper sense of provocation than anything which we find in Italy. Round the Venuses or Dianas of the Fontainebleau School hangs a smell of stylish eroticism, impossible, like all smells, to describe, but strong as ambergris or musk.[34]

Here we are left with the humiliating picture of the connoisseur "sniffing" around the canvas. It is surely significant that smell, unlike sight, is beyond words; Clark is only able to invoke the aphrodisiac perfume of ambergris and musk.

And, of course, finally, it happens. As smell is rendered inadequate, the troubled connoisseur is compelled towards touch: "Courbet is the

33. Longford, *Pornography*, 100.
34. Clark, *Nude*, 139.

"NOT IN A PUBLIC LAVATORY BUT ON A PUBLIC STAGE"

THE PROSECUTION OF
THE ROMANS IN BRITAIN

Mandy Merck

Gross Indecency

Even before it opened, Howard Brenton's new play for the National Theatre was in trouble.[1] Three days before its official first night (16 October 1980), the theater's board met to discuss part 1, scene 3, in which a Roman soldier attempts the anal rape of a Druid priest. Advised by board member and barrister John Mortimer, QC, that the play was not prosecutable, they voted to continue it, but in the absence of one key member. The missing man was Sir Horace Cutler, Conservative leader of the Greater London Council, then the city's governing body and a funder of the National Theatre. Two nights later, Cutler emerged from a preview of the play to send a telegram threatening a reconsideration of the council's grant to the National's director, Peter Hall, away in New York. Hall, who had commissioned this and other plays by Brenton, replied in vigorous defense of the production. By 17 October, the day after the opening, the London *Evening Standard* ran his praise of "an ambitious and remarkable piece of dramatic writing" against Cutler's denunciation of "a disgrace to the National Theatre." "My wife," Cutler told the *Standard,* "covered her head during the sodomy scene."

The London critics were no more taken with the play than Lady Cutler was. Within days it had accumulated an unenviable collection of notices, including these from Fleet Street's more liberal papers: "so

1. For this account, I am indebted to Richard Boon, *Brenton: The Playwright* (London: Methuen Drama, 1991), and Philip Roberts, "The Trials of The Romans in Britain," in Ann Wilson, ed., *Howard Brenton: A Casebook* (New York and London: Garland Publishing, 1992).

many misjudgments in the writing and the production that it is difficult to determine where things really went wrong" (Ned Chaillet, *Times*, 17 October 1980); "a vast disproportion between the extravagances of the form and the banality of the thesis" (Michael Billington, *Guardian*, 17 October 1980); "three hours . . . devoid of wit, beauty or drama" (B. A. Young, *Financial Times*, 18 October 1980); "a nauseating load of rubbish from beginning to end" (James Fenton, *Sunday Times*, 19 October 1980). One rare exception to this critical condemnation was provided by a reviewer who had already retired, Sir Harold Hobson, who entered into the vast newspaper correspondence debating the drama in the days after its opening to argue, "*The Romans in Britain* is a deeply serious play which reveals the conviction of its author, Howard Brenton, that the heart of man is desperately wicked, a conviction that has been held by many great and religious writers in the past, and the climax of its first act is as fine and thunderstriking as anything seen or heard on the London stage for a very long time" (letter to the *Times*, 29 October 1980).

But the most important comment on Brenton's play came from a woman who had not seen it—indeed, who never saw it—the then sixty-six-year-old moral campaigner Mary Whitehouse. On 17 October, the *Times* reported that after reading newspaper accounts of the play she had made a complaint to Chief Inspector Robert Shepherd of the Obscene Publications Squad. A day later, the *Guardian* quoted her concern about protecting "young people. I'm talking about men being so stimulated by the play that they will commit attacks on young boys." Whitehouse's horror at the homosexual aspect of the play's representation of violence—a play that also featured, in the description of critic John Lahr, "death by spear, sword and stone," "heterosexual rape," and "blood guzzling"[2]—was not unprecedented. As founder of the conservative pressure group the National Viewers and Listeners Association, Whitehouse was a prominent opponent of explicit sexual representation in the media, particularly representations of homosexuality. The latter orientation, she claimed in her 1977 polemic *Whatever Happened to Sex?*, could be "precipitated by the abnormal (in terms of moral as well as physical norms) sexual behaviour of parents during pregnancy."[3]

Two years earlier, Whitehouse had succeeded in a private prosecution against the editor and publishers of *Gay News* for printing a poem depicting sexual acts between the crucified Christ and the centurion guarding his cross. Despite author James Kirkup's intention to produce

2. *New Society*, 23 October 1980.
3. Mary Whitehouse, *Whatever Happened to Sex?* (Hove: Wayland, 1977), 67–68.

a devotional work in the religio-erotic tradition of the metaphysical po-
ets, with Christ's homosexuality a metaphor for his love of all mankind,
the newspaper and its Anglican editor were convicted of blasphemous
libel, a common law offense not tried previously since 1922. Accepting
the prosecution's arguments that the sole criterion for the crime was
the offensive treatment of Christianity (and only Anglican Christianity;
no other faith is protected by English law), the presiding judge, and
the House of Lords on appeal, refused to hear evidence about literary
precedents or religious intent. Attributing homosexual practices to
Christ was held to be a criminal defamation of both his reputation and
the beliefs of his followers. The consequences were fines and financial
crisis for the newspaper and a still unresolved controversy about
whether such protection should be extended to all religions, a contro-
versy that intensified with the publication of Salman Rushdie's *Satanic
Verses* in 1988.

But these were not the only consequences of the conviction of *Gay
News*. Whitehouse's success in the prosecution of a literary work was,
by 1978, in many ways a remarkable event. Since passage of the Obscene
Publications Act of 1959, with its stipulations that, taken as whole, the
obscene item must "deprave and corrupt" those likely to encounter it
while offering no literary, artistic, or scientific compensation for the
"public good," the law, in the description of the 1979 Home Office
Committee on Obscenity and Film Censorship, had retreated "from
the written word." To the Metropolitan Police, the failure of the prose-
cution of *Inside Linda Lovelace* three years earlier marked a watershed:
"Their view (which appeared from his summing-up to have been shared
by the trial judge) was that it was difficult to imagine what written mate-
rial would be regarded as obscene if that was not."[4] With juries unwill-
ing to convict nonpictorial material for obscenity and prosecuting au-
thorities becoming correspondingly cautious, opponents of sexually
explicit writing were forced to amend the obscenity laws or resort to
other ones. That Whitehouse's motive in using the blasphemy laws
against *Gay News* was not wholly religious may be inferred by her reti-
cence in regard to a far more prominent work of 1970s sacrilege. No
action was taken against *Monty Python's Life of Brian*, a popular film
comedy whose enthusiastic ridicule of Christ and his disciples con-
trasted markedly with a poem in a low-circulation gay weekly celebrat-
ing his carnal love for men.

The same wave of liberalization that stymied the prosecution of sexu-

4. *Report of the Home Office Committee on Obscenity and Film Censorship* (London: Her
Majesty's Stationery Office, 1979), 35.

ally explicit publications also affected British drama, eventually abolishing the lord chamberlain's power to license stage plays in 1968. The Theatres Act of that year applied the "deprave and corrupt" test to plays, as well as permitting the submission of expert evidence to justify performances "in the interests of drama, opera, ballet or any other art, or of literature or learning." A final safeguard was offered in the stipulation that a prosecution of a play could only be instigated with the consent of the attorney general.

When, twelve years later, Mary Whitehouse complained to the Obscene Publications Squad about *The Romans in Britain*, the police referred the matter to the director of public prosecution who, having sent representatives from his office to see the play, advised that a prosecution under the Theatres Act was unlikely to succeed. After a barrister representing the National Viewers and Listeners Association attended a performance and came to the opposite conclusion, Whitehouse asked the attorney general to take action or to grant her association leave for a private prosecution. But at the end of November the attorney general refused to sanction either form of proceedings. Thwarted in its attempt to prosecute under the Theatres Act, the NVLA tried another law. On 19 December, Whitehouse's solicitor, Graham Ross-Cornes, attended the play and questioned its director, Michael Bogdanov. He then sought permission from a magistrate to instigate a private prosecution under section 13 of the 1956 Sexual Offences Act. In the following month, Bogdanov was issued with a summons for procuring an act of gross indecency between two men, actors Peter Sproule and Greg Hicks, on the stage of the National's Olivier Theatre.

Such an attempt to apply the criminal law to a stage play was not wholly unanticipated by those who had drafted the Theatres Act. As Geoffrey Robertson and Andrew Nicol point out, the act is not intended to "protect persons connected with a play from prosecution for actual criminal offences, simply because they happen to be committed on stage."[5] What Parliament sought to prevent was the moral and political censorship of the theater that the Victorians had deemed necessary "for the preservation of good manners, decorum or the public peace."[6] To protect dissident drama, the 1968 act had specifically abolished residual offenses such as conspiracy and, indeed, blasphemous libel in regard to staged performances. However, an error in the drafting of one of its sections left open the possibility of invoking other law against a theatrical production.

5. Geoffrey Robertson and Andrew G. L. Nicol, *Media Law* (London: Sage Publications, 1984), 92.
6. Ibid., 87.

In seizing upon sexual offenses, Whitehouse exploited a loophole that had recently been noted by a Home Office committee. Chaired by the philosopher Bernard Williams, the Committee on Obscenity and Film Censorship published its thoughtful (and duly ignored) report in November of 1979, one year before the opening of *The Romans in Britain*. Chapter 10 considers whether the depiction of illegal acts might be numbered among the possible harms involved in pornography. Noting in passing that the blanket proscription of all such depictions would outlaw "a photograph of someone driving across a double white line," the report turns to the more pertinent question of sexual offenses and the anomalies in their legal treatment. On the legality of group sex, it observes:

> Heterosexual or lesbian behaviour is subject to no sanction dependent upon the number of people involved. Homosexual activity between men, on the other hand, is legal only if it happens between two adults in private, and the presence of a third person creates the presumption that the activity was not in private. It seemed to us that the implied presence of a photographer might serve to make any photograph of a homosexual act arguably one of an illegal act; but it would certainly show an illegal act if it depicted more than two persons.

As the report cautions, the discriminatory logic of the criminal law in sexual offenses would necessitate an "unsatisfactory" distinction between heterosexual and homosexual representations if "any prohibition on pornography . . . depended just on whether or not the act depicted was against the law."[7] But where the Williams Committee consequently advised against prohibiting representations of illegal acts per se, one of their chief witnesses concluded otherwise. Having herself provided written and oral evidence on behalf of the National Viewers and Listeners Association, Mary Whitehouse seized the opportunity offered by the criminal law. In prosecuting *The Romans in Britain*, she employed legislation which had no direct application to any form of representation nor to any heterosexual (or lesbian) practice—section 13 of the Sexual Offences Act.

The offense of procuring an act of gross indecency between men dates back to the infamous Labouchere amendment to the Criminal Law Amendment Act of 1885:

> Any male person who, in public or private, commits, or is a party to the commission of, or procures or attempts to procure the commission by any male person of, any act of gross indecency with another male person, shall be guilty of a misdemeanour, and being convicted thereof shall be

7. *Report of the Home Office Committee*, 130–31.

liable at the discretion of the court to be imprisoned for any term not exceeding two years, with or without hard labour.[8]

Historians disagree about the import of this offense, as well as how it came to be included in legislation originating in a moral panic over the alleged prostitution of young girls. As a proscription of unspecified sexual conduct between members of the same gender, as opposed to a practice understood in terms of acts (the crime of sodomy, which in 1885 was also heterosexually applicable and punishable by sentences of between ten years and life imprisonment), the Labouchere amendment has been hailed as the moment in which (male) homosexuality was first recognized in English law. However, most historians echo John Marshall's argument that, although the amendment "did seem to contain a tacit view of the homosexually inclined man," it was consistent with the 1885 act's overall "emphasis upon sexual decadence, public decency and the protection of youth."[9] The point of convergence, in Jeffrey Weeks's influential account, was the period's concern about the "continuum of undifferentiated male lust, products of men's sexual selfishness."[10] In Judith Walkowitz's interpretation, it was the unfettered libertinage of the male aristocracy, "as homosexuality was associated with the corruption of working-class youth by the same upper-class profligates, who, on other occasions, were thought to buy the services of young girls."[11] Conversely, others have argued that Henry Labouchere's late-night amendment, the eleventh clause in the act, was a cynical attempt by a heterosexual roué to ridicule a social purity initiative by extending it to all practices of procurement.[12] But if his amendment was a ploy to wreck the bill by forcing it into committee, it failed. The Speaker refused to rule the bill out of order and Britain became the only European country to outlaw potentially any sexual contact between men.

Ten years after the Criminal Law Amendment Act, its most cele-

8. Quoted in Leslie J. Moran, *The Homosexuality of Law* (London and New York: Routledge, 1996), 99.

9. John Marshall, "Pansies, Perverts and Macho Men: Changing Conceptions of Male Homosexuality," in Kenneth Plummer, ed., *The Making of the Modern Homosexual* (London: Hutchinson, 1981), 139–40.

10. Jeffrey Weeks, *Coming Out: Homosexual Politics in Britain from the Nineteenth Century to the Present* (London: Quartet Books, 1977), 16.

11. Judith Walkowitz, *City of Dreadful Delights: Narratives of Sexual Danger in Late-Victorian London* (London: Virago, 1992), 278 n. 123. The legal connection between female prostitution and male homosexuality survived for seventy years, to be jointly considered in the 1950s by the Wolfenden Committee, concerned with the reregulation of sexual behavior in public. All three themes—public order, social dominance, and masculine sexuality—emerge in *The Romans in Britain*.

12. Richard Davenport-Hines, *Sex, Death and Punishment: Attitudes to Sex and Sexuality in Britain since the Renaissance* (London: Collins, 1990), 130–32.

brated victim was convicted of seven counts of "gross indecency with another male person." That the accused was a playwright alleged, in the libel suit that led to his trial, to have solicited other men to commit sodomy and other acts of gross indecency, and that his writings were cited as proof of this allegation, as well as that of subverting public morality and encouraging "unnatural vice," makes the prosecution of Oscar Wilde an inverted precedent for that of *The Romans in Britain*. Where the later action founded its prosecution of representations on sexual acts, the earlier one founded its prosecution of sexual acts on representations. As Ed Cohen maintains, the Marquis of Queensberry's defense in the original libel action brought by Wilde initially relied upon literary evidence (notably *The Picture of Dorian Gray*) to demonstrate that the writer, in describing "the relations, intimacies, and passions of certain persons of sodomitical and unnatural habits, tastes, and practices," was himself "posing as a sodomite."[13] It was not until Queensberry's lawyer had extensively questioned Wilde about his own identification with the "vicious views" put forward in his novel, and the effect of those views on public conduct, that—in the wonderful description of the London *Evening News*—"the cross-examination left the literary plane and penetrated the dim-lit, perfumed rooms where the poet of the beautiful joined with valets and grooms in the bond of silver cigarette cases."[14] Forced to abandon his suit against Queensberry, Wilde was arrested for acts of gross indecency on the following day.

Sixty-one years later, the offense under which Wilde was indicted, convicted, and sentenced to two years' hard labor was incorporated within a massive new statute on "sexual crimes," the Sexual Offences Act of 1956. Section 13 of that act retains Labouchere's 1885 wording, and with it the offense's unique combination of specified genders and unspecified acts. Although the 1967 Sexual Offences Act amended the law to permit homosexual acts between two male adults in private, those involving more than two or otherwise than in private continue to be crimes. In regard to the latter, the courts have traditionally been expansive in their interpretation. In a 1976 judgment on a case involving two men masturbating in adjacent toilet cubicles, gross indecency was deemed to include "the mere participation and co-operation of two or more men in an indecent exhibition."[15] Given this precedent, the magistrate's agreement to a private prosecution of the director of Brenton's play for a breach of section 13 was not quite as unlikely as it seemed.

13. Ed Cohen, *Talk on the Wilde Side* (New York and London: Routledge, 1993), 128–29.

14. Ibid., 167.

15. *R. v. Howells* (1976), cited in Moran, *Homosexuality of Law*, 229 n. 14.

A Fate Worse than Death

Opening "north of the River Thames on 27th August, 54 BC,"[16] Brenton's drama of the first Roman invasion of Britain and its aftermath has been described as an anti-imperialist epic.[17] Both the play and subsequent remarks by the playwright draw explicit comparisons between the events portrayed and "the 1980s with another army, the British, blundering around in a foreign country, Ireland."[18] In the introduction to a 1989 collection of his work, Brenton maintains that "the subject of the play is really 'culture shock.' . . . It is a small war on the edge of the known world that gets bogged down, a wretched summer of little achievement and to Julius Caesar of little interest. . . . But for the Celts the appearance of the Roman army is the end of their culture, its touch is death." Of the scene that caused so much controversy, he writes:

> I tried to imagine what it must have been like for three young Celts, seeing Roman soldiers for the first time. I titled the scene "Two Worlds Touch." The Celts had been swimming on a fine summer's day. On the river bank they fool about, brag and laugh, then stretch out in the sun. From out of the trees come three Roman soldiers. They have had a bad day, losing touch with their platoon in a confused skirmish in the trees, and want a swim. The Celts are between them and the river. To the Romans it's nothing, there are three natives, three "wogs," between them and a much needed swim. The Romans kill two of the Celts and grossly abuse the third, who runs off. To the soldiers it is nothing, nothing at all. To the Celts it is worse than death, it is the end of their world.[19]

Brenton was never able to make this statement in court. The trial of Michael Bogdanov began on 15 March 1982, with the prosecution's admission that "the case is not usual; for this type of case the act of gross indecency that you are going to hear about took place not, as is more usual, in a public lavatory but on a public stage in a London theatre and the two men were actors."[20] The jurors were then given a summary of the play up to the rape scene and an explanation of why its director was the person charged: "The case against the defendant is that he directed the play and caused the play to be played on stage in full light on centre stage. . . . [I]n taking the decisions in the way he did, he was himself a party to that act because the law does not does not

16. Howard Brenton, *The Romans in Britain*, in *Plays:2* (London: Methuen Drama, 1989), 2.
17. Boon, *Brenton*, 181.
18. Brenton, *Plays:2*, viii.
19. Ibid., 2, vii–viii.
20. Quoted in Roberts, "Trials of The Romans in Britain," 63–64.

look merely at those who perform an act, but in this case . . . at anyone who stands behind and says, 'Go on.' "[21] Dismissing potential arguments about artistic merit or motive, the prosecution insisted that the question was whether an act of gross indecency had occurred. To establish this, Graham Ross-Cornes was questioned at length about his night at the National's Olivier Theatre. In the first day's cross-examination, the defense established that Ross-Cornes had sat in the balcony, ninety feet from the stage, and that the rape attempt had taken thirty seconds in a running time of almost three hours.

On the second day of the trial, Ross-Cornes's cross-examination continued with a discussion of the difference between reality and simulation. In reply to a question about actual and simulated urination onstage, the solicitor declared, "No doubt there is a difference between the reality and the simulation but I would still say that they are both indecent."[22] Following this, the defense read from the material included in the program notes which set the rape scene in its historical context. This sequence of events encapsulated the overall strategy of the defense: (1) to challenge the accuracy of Ross-Cornes's description of the rape scene; (2) to distinguish between reality and pretense; and (3) to defend, if permitted, the artistic logic of the play. However, in the hope that such a lengthy submission would be unnecessary, Bogdanov's lawyer ended day two with a preemptive strike, arguing that the case against his client contradicted the legal intention behind both the Theatres Act and the Sexual Offences Act, and should be dismissed.

On the following day, the judge replied with a multiple ruling that (1) "conduct in theatres" need not be exempted from the Sexual Offences Act; (2) the Theatres Act did not preclude prosecution for such conduct under the Sexual Offences Act; (3) simulated conduct could be an offense under the Sexual Offences Act; and (4) prosecution of the director—as opposed to any other National Theatre employee—for being party to such conduct was not necessarily "ill-founded." Having gained judicial recognition of all these points, the prosecution then took an exceptional decision. Justifying their move in the interests of the taxpayer and Bogdanov's personal and professional reputation, they withdrew their case. Although she was assigned the prosecution's costs, Whitehouse could claim an important precedent, one that the *Guardian* (19 March 1982) described as an "alarming . . . refusal to distinguish precisely between the simulated and the real."

As for Bogdanov, Brenton, and the defense, they were left without

21. Ibid., 64.
22. Ibid., 65.

a legal platform from which to argue for the play or against the prosecution's application of the Sexual Offences Act to the stage. Nor were they able to exploit an interesting admission in Ross-Cornes's testimony—that sitting "approximately enough, in the Gods"[23] he might have mistaken the thumb of one actor holding his genitals next to the buttocks of the other for the tip of his penis.

Whether the "thumbs-up" defense would have succeeded we shall never know. As earlier judgments on gross indecency suggest, genital contact per se is not required for conviction. Nor, had they been admitted, would Brenton's claims for the gravity of the rape scene necessarily have aided his cause. Played downstage in nearly full light to emphasize its cruelty, "the scene," in Peter Hall's defense of its staging, "is meant to horrify in what is a highly moral play."[24] This may explain why, unlike a heterosexual rape, which occurs offstage, and sundry other assaults, which are enacted more rapidly, the abuse of the young Celt is "sadistic, protracted and presented in detail."[25] The complaint is from Robert F. Gross, who argues that homosexual rape is the play's central figure for imperial conquest. Although that violence briefly mutates into tenderness when another of the soldiers caresses the wounded victim, it quickly changes back when the Celt regains consciousness and curses the soldier in Latin: "Fucking Latin talking nig nog!" the soldier exclaims in surprise, "Suck me off!"[26] As Gross points out, the shame of this effective "feminization" is further represented in the statuette of Venus that Caesar ties around the captive Celt's neck, an affront both to his manhood and to the Druid priesthood for which he is preparing. "Defiled" (in his own words) twice over, the young man abandons all resistance and commits suicide.

To these examples could be added the suggestions by one of the soldiers that the empire's eastern reaches are a hotbed of perversion, that colonial contact involves the risk of a certain re-orientation, as it were: "My friend has been to the Orient. Persia? Funny little ways he's picked up, in his career. But what the fuck do you expect, from a man who's been in Persia?"[27] Such an association of homosexuality with imperial conquest makes consensual anal sex between males virtually unintelligible, as it effectively has been in English law until very recently. Not only was the age of consent held at twenty-one from 1967 to 1994,

23. Robertson and Nicol, *Media Law*, 94.
24. Ibid.
25. Robert F. Gross, "The Romans in Britain: Aspirations and Anxieties of a Radical Playwright," in Wilson, *Howard Brenton*, 76.
26. Brenton, *Plays:2*, 38.
27. Ibid., 34.

but until 1984 the law failed to recognize any difference between the
nonconsensual and consensual buggery of a male aged nineteen. Indeed,
not until the 1994 Criminal Justice and Public Order Act was the crime
of rape redefined to include penile penetration of the vagina or the anus
of either sex. In using buggery to represent military destruction, *The
Romans in Britain* anticipated the American calls to "Saddam-ize" that
modern Persian, Hussein, during the Gulf War. Paradoxically, the
play's "highly moral" representation of imperial aggression is complicit
with the homophobic attitudes that underwrote its prosecution.

Between "Act" and "Representation"

In an observation on the relation between signs and material objects in
the theater, the Prague semiotician Petr Bogatyrev makes an apparently
unexceptional claim:

> On the stage are used not only costumes and scenery, not only theatrical
> props, which are only one sign or the sum of several signs and not a
> material object as such, but also real material objects. The spectators be-
> hold these real objects, however, not as real material objects, but only as
> a sign of signs, or a sign of material objects. If, for example, an actor,
> representing a millionaire, wears a diamond ring, the audience will take
> it as a sign of his great wealth and not care whether or not the diamond
> is a real or fake stone.[28]

Despite the widespread opprobrium which *The Romans in Britain* at-
tracted, few of its opponents appeared to read the play in any other way
than that anticipated by Bogatyrev. No one suggested, for example, that
Brenton, Bogdanov, or the actors in the play were gay. On left and right,
the critics rejected the calls for legal action against criminal conduct to
attack instead the play's perceived failure as a system of signification,
its "intellectual and political crudeness" (Benedict Nightingale, *New
Statesman*, 24 October 1980), its "class confusion and socio-sexual im-
maturity" (Bryan Robertson, *Spectator*, 25 October 1980). In their stated
determination to behold objects on stage as real material objects, Mary
Whitehouse and Sir Horace Cutler seemed the exceptions rather than
the rule. "Perhaps," Cutler fulminated in a letter to the *Guardian* (8
November 1980), "we could have necrophilia with real live [*sic*]
corpses!"

A year earlier, the Williams Report on Obscenity and Film Censor-
ship propounded a distinction between signs and material objects in its

28. Petr Bogatyrev, "Semiotics in the Folk Theater" in Ladislav Matejka and Irwin
R. Titunik, *Semiotics of Art* (Cambridge, Mass.: MIT Press, 1978), 34.

definition of "pornography," a term which, the report argued

> always refers to a book, verse, painting, photograph, film, or some such thing—what in general may be called a *representation*. Even if it is associated with sex or cruelty, an object which is not a representation—exotic underwear, for example—cannot sensibly be said to be pornographic (though it could possibly be said to be obscene).[29]

Following this, the report recommended liberalizing the law on obscenity and indecency by restricting (rather than banning) the sale of an item, "in virtue of offensiveness which arises by reason of the manner in which it portrays, deals with or relates to violence, cruelty or horror, or sexual, faecal or urinary functions, or genital organs."[30] Yet, by extending "portrays" to "deals with or relates to," the Williams Committee itself effectively crossed the line from signs to material objects. This in turn required elaborate qualifications in their report stipulating that such restrictions should not extend to the sale of contraceptives, but could apply to "the kind of sex hardware to be found in many sexshops."[31] As the authors of a subsequent commentary observed, the committee's difficulties reflect

> a deep instability in the concept of representation. This incoherence points us towards the fact that erotic representations (books, videotapes) are typically found alongside a range of other activities and objects (fantasising, underwear, intoxicants, sex aids) used in a variety of erotic and eroticising practices. In other words, the non-representational offensiveness of the sex hardware suggests that the problematic character of erotic representations is not to be looked for in their representational function but in their *use*, as eroticising devices.

Challenging the liberal claim that pornography is a form of representation, and therefore eligible for all the protection which the law affords to expression, the authors ultimately conclude that "pornography is not a representation of real sex but a real practice of sex using representations."[32]

There is much to disagree with in this argument. As I have argued in reply to Catharine MacKinnon, pornography may be a sexual practice, but all sexual practices are not the same.[33] The representation of

29. *Report of the Home Office Committee*, 103.

30. Ibid., 122.

31. Ibid., 125.

32. Ian Hunter, David Saunders, and Dugald Williamson, *On Pornography: Literature, Sexuality and Obscenity Law* (London: Macmillan, 1993), 182–84.

33. Mandy Merck, "MacKinnon's Dog: Antiporn's Canine Conditioning," in Nancy Hewitt, Jean O'Barr, and Nancy Rosebaugh, eds., *Talking Gender* (Chapel Hill: University of North Carolina Press, 1996), 78.

a sexual act may function as a stimulus to masturbation, but masturbating to that representation is not the same as, and need not lead to, performance of the represented act. Conversely, the authors' distinction between "erotic representations" and "fantasising, underwear, intoxicants, sex aids" seems willfully false. In what sense is a fantasy not a representation? What, indeed, of the representational aspects and functions of underwear, intoxicants, and sex aids?

But this is only to concede the central point—that, in Judith Butler's more recent formulation, "the very notion of a sexual practice is precisely that which overrides the distinction between 'act' and 'representation.' "[34] Butler is summarizing the arguments for the reciprocity of representation and sexuality in general, the ways that discursive practices constitute as well as express sexual activities, identities, and "propensities."[35] Her own example is one of homosexuality—specifically, the recent U.S. military guidelines that deem "a statement that the member is homosexual or bisexual" a form of "homosexual conduct" and thus grounds for discharge. She agrees that coming out goes beyond self-description, that such a statement may be intended to elicit similar statements and may well participate in the institution of homosexual communities and politics. How then, she asks, can we distinguish the logic of queer activism from that of American military policy (or indeed, Mary Whitehouse)? Here the military's designation of homosexual declarations as homosexual conduct offers an important avenue of exploration. Although even the Pentagon might acknowledge that not all statements produce intended or predictable outcomes, their guidelines clearly understand avowals of homosexuality to be exceptions to the everyday contingency of communication. Unlike other self-descriptions, that of "homosexuality" is seen to invest the statement with an automatically erotic effect, a prima facie seductiveness. Powering this investment, in Butler's view, is the prohibition of homosexual desire, which both eroticizes it and necessitates its projection outward onto the speaker, an erotic transfer that is then imagined to be transferred back in the act of speaking. The resulting experience of the utterance is thus one of attack or infection, a homosexual assault paradoxically generated by the (putatively heterosexual) listener on her/himself.

As an ascription of homosexual desire to the homophobic, Butler's account is not unfamiliar. What makes it useful to this inquiry is the

34. Judith Butler, *Excitable Speech: A Politics of the Performative* (New York and London: Routledge, 1997), 123.

35. The term is used in a subsequent congressional statute to indicate, in Butler's interpretation, "a natural teleology to homosexual status, whereby we are asked to understand such status as always almost culminating in an act." Ibid., 106.

peculiar performativity that it identifies, not in sexual representation generally, but in the representation of practices which some form of proscription both eroticizes and abjects. This points to a psychological particularity in the subjective response to certain representations which could be compared to the "anomalies" that the Williams Committee noted in the laws governing sexual conduct, anomalies that can be traced back to the interdiction of all sex between men as a threat to social order and of their anal penetration in particular as the gravest of assaults.

Confronted with these legal precedents, a contemporary defense of *The Romans in Britain* would do better to challenge them "to disjoin homosexuality from the figures by which it is conveyed in dominant discourse,"[36] rather than appropriate its abjection to the dubious morality espoused by Brenton and his allies. As Butler argues, the Pentagon's paranoid association of homosexual avowals with infection and assault does not preclude the possibility of other articulations. To acknowledge the discursive effectivity of their guidelines is not to concede the inevitable signification of coming out as aggression. Instead, a critical acknowledgment of this articulation could enable opponents of censorship to analyze the complexly constitutive relations of sexual acts and sexual representations without assuming any final horizon of reference.

In defense of Brenton's play, one might begin by abandoning the attempt to distinguish male homosexuality from its representation and instead consider whether the historic proscription of both might give rise to an erotic response from a straight audience. Here Whitehouse's curious confession that the anal rape scene would be read as an irresistible command to commit similar acts seems more telling in itself than in its warning of copycat assaults on young boys.[37] Despite the best efforts of liberal jurisprudence to separate sex from its simulation, the representation of forbidden pleasures seems, for Whitehouse and her supporters, to have been disturbingly sexy, procuring, perhaps, an effect of arousal as well as dramatizing one. To deny this possibility seems as self-defeating as the defense's neglect of the legal discrimination against male homosexuality that permitted the indictment in the first place. In the case of *The Romans in Britain*, the intensely eroticizing taboo that has made the representation of male homosexuality so vulnerable to prosecution could not be kept offstage.

36. Ibid., 125.
37. Conversely, she also attributed such dangerous arousal to youth themselves, arguing that "this type of play could influence young people. There is a proven link between pornography and serious sex crimes. It is quite overwhelming society." Quoted in Boon, *Brenton*, 174.

OBSCENE, ABJECT, TRAUMATIC

Hal Foster

I n contemporary art and theory, let alone contemporary fiction and film, there is a general shift in conceptions of the real— from the real understood as an effect of representation to the real understood as an event of trauma. There are several ways to think about this shift, yet, as it bespeaks a pervasive turn to psychoanalysis in critical culture, I want to graph it here in those terms—specifically in relation to the Lacanian discussion of the gaze in *The Four Fundamental Concepts of Psychoanalysis*.

This is a notorious text, of course, much cited but little understood (so much so that I will risk another résumé). For example, there may well be a male gaze, and no doubt capitalist spectacle is constructed from a masculinist perspective, but there is little brief for such arguments in *this* seminar of Lacan. For here the gaze is not embodied in a subject at all, at least not in the first instance. To an extent like Sartre in *Being and Nothingness* (1943), Lacan distinguishes between the look (or the eye) and the gaze, and to an extent like Merleau-Ponty in *The Phenomenology of Perception* (1945), he locates this gaze *in the world*. As with language in Lacan, then, so with the gaze: it preexists the subject, who, "looked at from all sides," is but a "stain" in "the spectacle of the world."[1] Thus positioned, the Lacanian subject feels the gaze as a threat, as if it queried him or her, and so it is that "the gaze, *qua objet a*, may

This very partial lexicon of contemporary art and theory is extrapolated from Hal Foster, *The Return of the Real* (Cambridge, Mass.: MIT Press, 1996), where a much more complete discussion of these terms can be found.

1. Jacques Lacan, *The Four Fundamental Concepts of Psychoanalysis*, trans. Alan Sheridan (New York: W. W. Norton, 1978), 72, 75.

come to symbolise this central lack expressed in the phenomenon of castration."[2]

Even more than Sartre and Merleau-Ponty, then, Lacan challenges the presumed transparency of the subject in sight. His account of the gaze mortifies this subject, especially so in the famous anecdote of the sardine can. Afloat on the sea and aglint in the sun, the can seems to look at the young Lacan in the fishing boat "at the level of the point of light, the point at which everything that looks at me is situated."[3] Thus seen as s/he sees, pictured as s/he pictures, the Lacanian subject is fixed in a double position, and this leads Lacan to superimpose on the usual cone of vision that emanates from the subject another cone that emanates from the object, at the "point of light." It is this regard that he calls the gaze.

The first cone is familiar from Renaissance treatises on perspective: the object focused as an image for the subject at a geometral point of viewing. But, Lacan adds immediately, "I am not simply that punctiform being located at the geometral point from which the perspective is grasped. No doubt, in the depths of my eye, the picture is painted. The picture, certainly, is in my eye. But I, I am in the picture."[4] That is, the subject is also under the regard of the object, photographed (as it were) by its light, pictured by its gaze: thus the superimposition of the two cones, with the object also at the point of the light (now called the gaze), the subject also at the point of the picture (now called the subject of representation), and the image also in line with the screen.

The meaning of this last term, the screen, is obscure. I understand it to stand for the cultural reserve of which every image is one instance. Call it the conventions of art, the schemata of representation, the codes of visual culture, this screen mediates the object-gaze for the subject. But it also *protects* the subject from this object-gaze, for it captures the gaze, "pulsatile, dazzling and spread out," and tames it in an image.[5]

2. Ibid., 77.
3. Ibid., 95.
4. Ibid., 96. Curiously the Sheridan translation adds a "not" ("But I am not in the picture") where the original reads "Mais moi, je suis dans le tableau" (*Seminar XI* [Paris: Editions du Seuil, 1973], 89). This addition has abetted the mistaking of the place of the subject mentioned in the next note. Lacan is clear enough on this point; e.g., "the first [triangular system] is that which, in the geometral field, puts in our place the subject of representation, and the second is that which turns *me* into a picture" (105).
5. Ibid., 89. Some readers place the subject in the position of the screen, perhaps on the basis of this statement: "And if I am anything in the picture, it is always in the form of the screen, which I earlier called the stain, the spot" (97). The subject is a screen in the sense that, looked at from all sides, s/he blocks the light of the world, casts a shadow,

This last formulation is crucial. For Lacan, animals are caught in the gaze of the world; they are only on display there. Humans are not so reduced to this "imaginary capture," for we have access to the symbolic—in this case to the screen as the site of picture making and viewing, where we can manipulate and moderate the gaze. In this way the screen allows the subject, at the point of the picture, to behold the object, at the point of light.[6] Otherwise it would be impossible, for to see without this screen would be to be blinded by the gaze or touched by the real.

Thus, even as the gaze may trap the subject, the subject may tame the gaze. This is the function of the screen: to negotiate a *laying down* of the gaze akin to the laying down of a weapon. Note the atavistic tropes of preying and taming, battling and negotiating; the gaze is given a strange agency here, and the subject is positioned in a paranoid way.[7] Indeed, Lacan imagines the gaze not only as maleficent but as violent, a force that can arrest, even kill, if it is not disarmed first.[8] At its more

is a "stain" (paradoxically it is this screening that permits the subject to see at all). But this screen is different from the image-screen, and to place the subject only there is to contradict the superimposition of the two cones wherein the subject is both viewer and picture. The subject is an agent of the image-screen, not one with it. In my reading, then, the gaze is not already semiotic, as it is for Norman Bryson in *Tradition and Desire: From David to Delacroix* (Cambridge: Cambridge University Press, 1984). In some respects his account improves on Lacan, who, through Merleau-Ponty, renders the gaze almost animistic. Yet to read the gaze as already semiotic may be to tame it before the fact, and indeed, for Bryson, it is the gaze that is benign, "a luminous plenitude," and the screen that "mortifies" rather than protects the subject ("The Gaze in the Expanded Field," in *Vision and Visuality*, ed. Hal Foster [Seattle: Bay Press, 1988], 92).

6. Ibid., 103.

7. In "The Gaze in the Expanded Field," Bryson argues that, however threatened by the gaze, the subject of the gaze is also confirmed by its very alterity. (On paranoia as the last refuge of the subject, see Leo Bersani, *The Culture of Redemption* [Cambridge, Mass.: Harvard University Press, 1990], 179–99.) As Bryson notes, other models of visuality are also tinged with paranoia—the male gaze, surveillance, spectacle, simulation, and so on. What produces this paranoia, and what might it serve—that is, besides this paradoxical (in)security of the subject? On the atavism of the nexus of gaze, prey, and paranoia consider this remark of Philip K. Dick: "Paranoia, in some respects, I think, is a modern-day development of an ancient, archaic sense that animals still have—quarry-type animals—that they're being watched. . . . And often my characters have this feeling. But what really I've done is, I have atavised their society. . . . They're living like our ancestors did. I mean, the hardware is in the future, the scenery's in the future, but the situations are really from the past" (extract from a 1974 interview used as an epigraph to *The Collected Stories of Philip K. Dick*, vol. 2 [New York: Carol Publishing, 1990]).

8. Lacan relates this maleficent gaze to the evil eye, to which he attributes the power to blind and to castrate: "The evil eye is the *fascinum* [spell], it is that which has the effect of arresting movement and, literally, of killing life. . . . It is precisely one of the dimensions in which the power of the gaze is exercised directly" (118). For Lacan the evil eye is universal and no equivalent beneficent eye exists, not even in the Bible. Yet much Chris-

urgent, then, picture making is apotropaic: its gestures (think of expressionist painting) are made to arrest the gaze before the gaze can arrest us. At its more "Apollonian"[9] picture making is placating: its perfections (think of neoclassical painting) are intended to pacify the gaze, to "relax" the viewer from its grip. Such is aesthetic contemplation according to Lacan: some art may attempt a *trompe-l'oeil*, a tricking of the eye, but all art aspires to a *dompte-regard*, a taming of the gaze.

I want to suggest that much contemporary art refuses this age-old mandate to pacify the gaze, to unite the imaginary and the symbolic against the real. It is as if this art wanted the gaze to shine, the object to stand, the real to exist, in all the glory (or horror) of its pulsatile desire, or at least to evoke this sublime condition. To this end it moves not only to attack the image but to tear at the screen, or to suggest that it is already torn. This shift from the image-screen, the focus of most postmodernist art in the 1980s, to the object-gaze, the focus of most postmodernist art in the 1990s, is registered most clearly in the art of Cindy Sherman. Indeed, if we divide her work into three rough groups, it almost seems to move across the three main positions of the Lacanian diagram.

In her early work of 1975–1982, from the film stills through the rear projections to the centerfolds and the color tests, Sherman evokes the subject under the gaze, the subject-as-picture, which is also the principal site of other feminist work in appropriation art. Her subjects see, of course, but they are much more *seen*, captured by the gaze. Often, in the film stills and the centerfolds, this gaze seems to come from another subject, with whom the viewer may be implicated; sometimes, in the rear projections, it seems to come from the spectacle of the world; yet sometimes, too, it seems to come from within. Here Sherman shows her female subjects as self-surveyed, not in phenomenological reflexivity (I see myself seeing myself) but in psychological estrangement (I am not what I imagined myself to be). Thus in the distance between the made-up woman and her mirrored face in *Untitled Film Still #2* (1977), Sherman points to the gap between imagined and actual body-

tian art is fixed on the gazes of the Madonna upon the Child and the Child upon us. Typically Lacan focuses instead on the exemplum of envy in Saint Augustine, who tells of his murderous feelings of exclusion at the sight of his little brother at the maternal breast (*Four Fundamental Concepts*, 116). Here Lacan can be contrasted with Walter Benjamin; in Benjamin one discovers the beneficent eye that Lacan denies, a magical gaze that implicitly reverses fetishism and undoes castration, a redemptive aura based on the memory of a primal relationship with the maternal body. For more on this distinction see my *Compulsive Beauty* (Cambridge, Mass.: MIT Press, 1993), 193–205.

9. Lacan, *Four Fundamental Concepts*, 101.

images that yawns within each of us, the gap of (mis)recognition that we attempt to fill with fashion models and entertainment images every day and every night of our lives.

In her work of 1987–1990, from the fashion photographs through the fairy-tale illustrations and the art history portraits to the disaster pictures, Sherman moves to the image-screen, to its repertoire of representations. (This is a matter of focus only: she addresses the image-screen in the early work too, and the subject-as-picture hardly disappears in this middle work.) The fashion and art history series take up two files from the image-screen that have affected our self-fashionings profoundly. Here Sherman parodies vanguard design with a long runway of fashion victims, and pillories art history with a long gallery of butt-ugly aristocrats (in ersatz Renaissance, baroque, rococo, and neoclassical types). But the play turns perverse when, in some fashion photographs, the gap between imagined and actual body-images becomes psychotic (one or two sitters seem to have no ego awareness at all) and when, in some art history photographs, deidealization is pushed to the point of desublimation: with scarred sacks for breasts and funky carbuncles for noses, these bodies break down the upright lines of proper representation, indeed of proper subjecthood.[10]

This turn to the grotesque is marked in her fairy-tale and disaster images, some of which show horrific accidents of birth and freaks of nature (a young woman with a pig snout, a doll with the head of a dirty old man). Here, as often in horror movies and bedtime stories alike, horror means, first and foremost, horror of maternity, of the maternal body made strange, even repulsive, in repression. This body is the primary site of the *abject* as well, a category of (non)being defined by Julia Kristeva as neither subject nor object, but before one is the first (before full separation from the mother) or after one is the second (as a corpse given over to objecthood).[11] Sherman evokes these extreme conditions in some disaster scenes suffused with signifiers of menstrual blood and sexual discharge, vomit and shit, decay and death. Such images tend toward a representation of the body turned inside out, of the subject literally abjected, thrown out. But this is also the condition of the outside turned in, of the invasion of the subject-as-picture by the object-gaze. At this point some images pass beyond the abject, which is often

10. Rosalind Krauss conceives this desublimation as an attack on the sublimated verticality of the traditional art image in *Cindy Sherman* (New York: Rizzoli, 1993). She too discusses the work in relation to the Lacanian diagram of visuality, albeit in a different way, as does Kaja Silverman in *Thresholds of the Visible* (New York: Routledge, 1996).

11. Or, rather, intimations of such conditions. See Julia Kristeva, *Powers of Horror*, trans. Leon S. Roudiez (New York: Columbia University Press, 1982).

Figure 10.1: Kiki Smith, *Blood Pool*, 1992, sculpture. Photo by Ellen Page Wilson. Courtesy of PaceWildenstein.

tied to particular meanings, not only toward the *informe*, a condition described by Bataille where significant form dissolves because the fundamental distinction between figure and ground, self and other, is lost, but also toward the *obscene*, where the object-gaze is presented as if there were no scene to stage it, no frame of representation to contain it, no screen.[12]

This is the domain of her work after 1991 as well, the civil war and sex pictures, which are punctuated by close-ups of simulated damaged and/or dead body-parts and sexual and/or excretory body-parts respectively. Sometimes the screen seems so torn that the object-gaze not only invades the subject-as-picture but overwhelms it. In a few of the disaster and civil war images we glimpse what it might be like to occupy the impossible third position in the Lacanian diagram, to behold the pulsatile gaze, even to touch the obscene object, without a screen for protection. In one image (Untitled #190) Sherman gives this evil eye an horrific visage of its own.

In this scheme of things, the impulse to erode the subject and to tear at the screen has driven Sherman from the early work, where the subject

12. Regarding these differences see "Conversation on the *Informe* and the Abject" and Rosalind Krauss, "The Destiny of the *Informe*," both in *October* 67 (winter 1993).

is caught in the gaze, through the middle work, where it is invaded by the gaze, to the recent work, where it is obliterated by the gaze. But this double attack on subject and screen is not hers alone; it occurs on several fronts in contemporary art, where it is waged, almost openly, in the service of the real.

Obscene does not mean "against the scene," but it does suggest an attack on the scene of representation, on the image-screen. As such it also suggests a way to understand the aggression against the visual so evident in contemporary art and alternative culture—as an imagined rupture of the image-screen, an impossible opening onto the real.[13] For the most part, however, this aggression is thought under the label of the abject, which has a different psychoanalytic valence.

According to the canonical definition of Kristeva, the abject is what I must get rid of in order to be an I at all. It is a phantasmatic substance not only alien to the subject but intimate with it—too much so in fact, and this overproximity produces panic in the subject. In this way the abject touches on the fragility of our boundaries, of the spatial distinction between our insides and outsides as well as the temporal passage between the maternal body and the paternal law. Both spatially and temporally, then, abjection is a condition in which subjecthood is troubled, "where meaning collapses";[14] hence its attraction for avant-garde artists and writers who want to disturb these orderings of subject and society.

The notion is rich in ambiguities, on which the cultural-political valence of abject art may depend.[15] Some of the questions that arise from these ambiguities are familiar by now: Can the abject be represented at all? If it is opposed to culture, can it be exposed in culture? If it is unconscious, can it be made conscious and remain abject? In other words, can there be a *conscientious abjection*, or is this all there can be? Indeed, can abject art ever escape an instrumental, indeed moralistic, use of the abject?[16]

13. This is manifest, for example, in the insistence on the factuality of the body as against the fantasy of transcendence in spectacle, virtual reality, cyberspace, and the like—an insistence that, again, is very different from the postmodernist delight in the image world, where it was often assumed that the real had succumbed to the simulacral.

14. Kristeva, *Powers of Horror*, 2.

15. A fundamental ambiguity is the relation of subject and society, the psychological and the anthropological, the inside (as it were) and the outside. With her recourse to the work of Mary Douglas (especially *Purity and Danger*) Kristeva tends to align, indeed to conflate, the two, with the result that a disturbance of the one is automatically, traumatically, a disturbance of the other. This does not contribute much to the political clarity of critiques of the subject nor to the psychological clarity of critiques of the social.

16. This points to a parallel question: Can there be an obscene representation that is not pornographic? Today it is important to insist on the difference, which might be

A crucial ambiguity in Kristeva is the slippage between the operation *to abject* and the condition *to be abject*. For her the former is fundamental to the maintenance of subjectivity and society, while the latter is subversive of both formations. Is the abject, then, disruptive of subjective and social orders or foundational of them, a crisis in these orders or a confirmation of them? If subjectivity and society abject the alien within, is abjection not a regulatory operation? That is, is abjection to regulation what transgression is to taboo—an exceeding that is also a completing?[17] Or can the *condition* of abjection be mimed in a way that calls out, in order to disturb, the *operation* of abjection?

In her account of modernist writing, Kristeva views abjection as conservative, even defensive. "Edged with the sublime," the abject is used to test the limits of sublimation, but the task remains to sublimate the abject, to purify it.[18] Whether or not one agrees with this account, Kristeva does intimate a cultural shift in our own time. "In a world in which the Other has collapsed," she states enigmatically, the task of the artist is no longer to sublimate the abject, to elevate it, but to plumb the abject, to fathom "the bottomless 'primacy' constituted by primal repression."[19] "In a world in which the Other has collapsed": Kristeva implies that the paternal law that underwrites our social order is in crisis.[20] In terms of the visuality outlined here, this implies a crisis in the image-screen as well; and some artists do attack this screen, while others, assuming it is torn, probe behind it for the obscene object-gaze of the real. Meanwhile, in terms of the abject, still other artists explore the repressing of the maternal body said to underlie the symbolic order, so as to exploit the disruptive effects of its material and metaphorical rem(a)inders.

Obviously the condition of image-screen and symbolic order alike is all-important; locally the valence of abject art also depends on it. If it is deemed intact, then the attack on the image-screen retains a trans-

thought along these lines: The obscene is a paradoxical representation without a scene to stage the object, so it appears too close to the viewer. The pornographic, on the other hand, is a conventional representation that distances the object, so the viewer is safeguarded as a voyeur.

17. "Transgression does not deny the taboo," runs the famous formulation of Bataille, "but transcends and completes it." *Erotism: Death and Sensuality* (1957), trans. Mary Dalwood (San Francisco: City Lights Books, 1986), 63. There is a third option: that the abject is double and its transgressive value a function of this ambiguity. (Bataille, no less than Freud, was drawn to such double, adialectical terms.)

18. Kristeva, *Powers of Horror*, 11.

19. Ibid., 18.

20. But then when is it not? The notion of hegemony suggests that it is always under threat, if not in crisis. In this regard the notion of the symbolic order may project more solidity than the social possesses.

gressive value. However, if it is deemed torn, then such transgression is beside the point and this old vocation of the avant-garde is at an end. But there is a third option as well, and that is to reformulate this vocation, to rethink transgression not as a rupture produced by a heroic avant-garde posited outside the symbolic order but as a fracture traced by a strategic avant-garde that is an ambivalent part of this order.[21] In this view the goal of the avant-garde is not to break with the symbolic order absolutely (this old dream is dispelled), but to expose it in crisis, to register its points not only of breakdown but of breakthrough, the new possibilities that such a crisis opens up.

For the most part, however, abject art has tended in two other directions. The first is to identify with the abject, to approach it somehow— to probe the wound of trauma, to touch the obscene object-gaze of the real. The second is to represent the condition of abjection in order to provoke its operation—to catch abjection in the act, to make it reflexive, even repellent in its own right. The danger, of course, is that this mimesis may confirm a given abjection. Just as the old transgressive surrealist once called out for the priestly police, so an abject artist (like Andres Serrano) may call out for an evangelical senator (like Jesse Helms), who then completes the work, as it were, negatively. Moreover, as left and right may agree on the social representatives of the abject, they may shore each other up in a public exchange of disgust, and this spectacle may inadvertently support the normativity of image-screen and symbolic order alike.[22]

These strategies of abject art are thus problematic, as they were in surrealism over sixty years ago. Surrealism also used the abject to test sublimation; indeed, it claimed the point where desublimatory impulses confront sublimatory imperatives as its own.[23] Yet it was at this point

21. Radical art and theory often celebrate failed figures, especially deviant masculinities, as transgressive of the symbolic order, but this avant-gardist logic of an inside and an outside assumes (affirms?) a stable order against which these figures are posed. In *My Own Private Germany: Daniel Paul Schreber's Secret History of Modernity* (Princeton: Princeton University Press, 1996), Eric Santner offers a brilliant rethinking of this logic: he relocates transgression within the symbolic order, at a point of crisis, which he defines as "symbolic authority in a state of emergency."

22. The obscene may have this effect too. Many contemporary images render the obscene thematic and so safe, in the service of the screen, not against it—which is what most abject art does, against its own wishes. Indeed, the obscene may be the ultimate apotropaic shield *against* the real—partaking of it in order to protect against it.

23. "Everything tends to make us believe," Breton wrote in the *Second Manifesto of Surrealism* (1930), "that there exists a certain point of the mind at which life and death, the real and the imagined, past and future, the communicable and the incommunicable, high and low, cease to be perceived as contradictions. Now, search as one may one will never find any other motivating force in the activities of the surrealists than the hope of

Figure 10.2: Andres Serrano, *The Morgue (Burnt to Death)*, 1992, cibachrome. Courtesy of Paula Cooper Gallery, New York.

too that surrealism broke down, that it split into the two principal factions headed by André Breton and Georges Bataille. According to Breton, Bataille was an "excrement-philosopher" who refused to rise above big toes, mere matter, sheer shit, to raise the low to the high.[24] For Bataille, Breton was a "juvenile victim" involved in an Oedipal game, an "Icarian pose" assumed less to undo the law than to provoke its punishment: despite his celebration of desire Breton was as committed to sublimation as the next aesthete.[25] Elsewhere Bataille termed this aesthetic *le jeu des transpositions*, the game of substitutions, and he dismissed it as

finding and fixing this point" (in Breton, *Manifestoes of Surrealism*, trans. Richard Seaver and Helen R. Lane [Ann Arbor: University of Michigan Press, 1972], 123–24). Signal works of modernism emerge at this point between sublimation and desublimation (there are examples in Picasso, Jackson Pollock, Cy Twombly, Eva Hesse, and many others). Perhaps they are so privileged because we need the tension between the two or, more precisely, because we need this tension to be treated, both incited and soothed, *managed*.

24. See Breton, *Manifestoes of Surrealism*, 180–87. At one point Breton charges Bataille with "psychasthenia" (more on which below).

25. See Georges Bataille, *Visions of Excess*, trans. Allan Stoekl (Minneapolis: University of Minnesota Press, 1985), 39–40. For more on this opposition, see Foster, *Compulsive Beauty*, 110–14.

no match for the power of perversions: "I defy any amateur of painting to love a picture as much as a fetishist loves a shoe."[26]

I recall this old opposition for the perspective that it offers on abject art today. In a sense Breton and Bataille were both right, at least about each other. Often Breton and company did act like juvenile victims who provoked the paternal law as if to ensure that it was still there—at best in a neurotic plea for punishment, at worst in a paranoid demand for order. And this Icarian pose is again assumed by contemporary artists who are almost too eager to talk dirty in the museum, almost too ready to be tweaked by Hilton Kramer or spanked by Jesse Helms. On the other hand, the Bataillean ideal—to opt for the smelly shoe over the beautiful picture, to be fixed in perversion or stuck in abjection—is also adopted by contemporary artists discontent not only with the refinements of sublimation but with the displacements of desire. Is this, then, the option that abject art offers us—Oedipal naughtiness or infantile perversion? To act dirty with the secret wish to be spanked, or to wallow in shit with the secret faith that the most defiled might reverse into the most sacred, the most perverse into the most potent?

This mimesis of regression is pronounced in contemporary art. But, again, it can also be a strategy of perversion—that is, of *père-version*, of a turning from the father that is a twisting of his law. In the early 1990s this defiance was manifested in a general flaunting of shit-substitute (the real thing was rarely found). In Freud, the order essential to civilization is opposed to anal eroticism, and in *Civilization and Its Discontents* (1930) he presents the famous origin myth meant to show us why. The story turns on the erection of man from all fours to two feet, for with this change in posture, according to Freud, came a revolution in sense: smell was degraded and sight privileged, the anal was repressed and the genital pronounced. The rest is history: with his genitals exposed, man was retuned to a sexual frequency that was continuous, not periodic, and he learned shame; and this coming together of sex and shame impelled him to seek a wife, to form a family, to found a civilization, to boldly go where no man had gone before. Wildly heterosexist as this zany tale

26. Georges Bataille, "L'Esprit moderne et le jeu des transpositions," *Documents*, no. 8. (1930). The best discussion of Bataille on this score remains Denis Hollier, *Against Architecture* (Cambridge, Mass.: MIT Press, 1989), esp. 98–115. Elsewhere Hollier has specified the fixed aspect of the abject according to Bataille: "It is the *subject* that is abject. That is where his attack on metaphoricity comes in. If you die, you die; you can't have a substitute. What can't be substituted is what binds subject and abject together. It can't simply be a substance. It has to be a substance that addresses a subject, that puts it at risk, in a position from which it cannot move away" ("Conversation on the *Informe* and the Abject").

is, it does reveal a normative conception of civilization—not only as a general sublimation of instincts but as a specific reaction against anal eroticism that is also a specific abjection of (male) homosexuality.[27]

In this light the shit movement in contemporary art may intend a symbolic reversal of this first step into civilization, of the repression of the anal and the olfactory. As such it may also intend a symbolic reversal of the phallic visuality of the erect body as the primary model of traditional painting and sculpture—the human figure as both subject and frame of representation in Western art. This double defiance of visual sublimation and vertical form is a strong subcurrent in twentieth-century art (which might be subtitled "Visuality and Its Discontents"),[28] and it is often expressed in a flaunting of anal eroticism. "Anal eroticism finds a narcissistic application in the production of defiance," Freud wrote in his 1917 essay on the subject; in avant-gardist defiance too, one might add, from the chocolate grinders of Duchamp through the cans of *merde* of Piero Manzoni, to the shitty sculptures of John Miller and the shitty performances of Mike Kelley.[29] In contemporary art, anal-erotic defiance is often self-conscious, even self-parodic: it may test the anally repressive authority of traditional culture, but it also mocks the anally erotic narcissism of the vanguard rebel-artist. "Let's Talk about Disobeying" reads one banner by Kelley, emblazoned with a cookie jar. "Pants-Shitter and Proud of It" reads another, deriding the self-congratulation of the institutionally incontinent.[30]

However pathetic, this defiance can also be perverse, a twisting of the paternal law of difference—sexual and generational, ethnic and social.

27. Abjected and/or repressed, these terms are rendered critical, able to disclose the heterosexist aspects of these operations. Yet this logic may accept a reduction of male homosexuality to anal eroticism, and, as with the infantilist parody of the paternal law or the infantilist exploration of the maternal body, it may accept the dominance of the very terms that it opposes.

28. For an incisive reading of this discontented modernism see Rosalind Krauss, *The Optical Unconscious* (Cambridge, Mass.: MIT Press, 1992), and for a comprehensive history of this antiocular tradition see Martin Jay, *Downcast Eyes: The Denigration of Vision in Twentieth-Century French Thought* (Berkeley: University of California Press, 1993).

29. Sigmund Freud, "On Transformations of Instinct as Exemplified in Anal Erotism," in *On Sexuality*, ed. Angela Richards (London: Penguin, 1977), 301. On the primitivism of this avant-gardist defiance, see my " 'Primitive' Scenes," *Critical Inquiry* (winter 1993). Mediations of anal eroticism, as in the "black paintings" of Robert Rauschenberg or the early graffiti paintings of Cy Twombly, tend to be more subversive than declarations of anal defiance.

30. Here and elsewhere Kelley pushes infantilist defiance toward adolescent dysfunction: "An adolescent is a dysfunctional adult, and art is a dysfunctional reality, as far as I am concerned" (quoted in Elisabeth Sussman, ed., *Catholic Tastes* [New York: Whitney Museum of American Art, 1994], 51).

Again, this perversion is often performed through a mimetic regression to "the anal universe where all differences are abolished."[31] Such is the fictive space that artists like Miller and Kelley set up for critical play. "We interconnect everything, set up a field," Kelley has the bunny say to the teddy in his installation *Theory, Garbage, Stuffed Animals, Christ* (1991), "so there is no longer any differentiation."[32] Like Miller, Kelley explores this space where symbols are not yet stable, where "the concepts *faeces* (money, gift), *baby* and *penis* are ill-distinguished from one another and are easily interchangeable."[33] Both artists push this symbolic interchange toward aformal indistinction—push the baby and the penis, as it were, toward the lump of shit. This is done, however, not to celebrate mere indistinction but to trouble symbolic difference. *Lumpen*, the German word for "rag" that gives us *Lumpensammler* (the ragpicker that so interested Walter Benjamin) and *Lumpenproletariat* ("the scum, the leavings, the refuse of all classes" that so interested Marx),[34] is a crucial word in the Kelley lexicon, which he develops as a third term between the *informe* (of Bataille) and the abject (of Kristeva). In a sense he does what Bataille urges: he bases materialism "on psychological or social facts."[35] The result is an art of lumpen things, subjects, and personae that resist shaping, let alone sublimation or redemption. Unlike the *Lumpen* of Napoleon III, Hitler, or Mussolini, the *Lumpen* of Kelley refuses molding, much less mobilizing.

Is there a cultural politics here? Often in the general culture of abjection (I mean the culture of slackers and losers, grunge, and generation X) this posture of indifference expresses only a fatigue with the politics of difference. Yet sometimes too this posture seems to intimate a more fundamental fatigue: a strange drive to indistinction, a paradoxical desire to be desireless, a call of regression that goes beyond the infantile to the inorganic.[36] In a 1937 text crucial to the Lacanian discussion of

31. Janine Chasseguet-Smirgel, *Creativity and Perversion* (New York: W. W. Norton, 1984), 3. Differences are not abolished in this universe (this formulation tends to the homophobic) so much as transformed. The exemplar of this transformation in contemporary fiction is Dennis Cooper.

32. Mike Kelley, *Theory, Garbage, Stuffed Animals, Christ*, quoted in Sussman, *Catholic Tastes*, 86.

33. Freud, "On Transformations of Instinct," 298. Kelley plays on both psychoanalytic and anthropological intuitions about the interconnection of all these terms—faeces, money, gifts, babies, penises.

34. Karl Marx, "The Eighteenth Brumaire of Louis Bonaparte," in David Fernbach, ed., *Surveys from Exile* (New York: Vintage Books, 1974), 197.

35. Bataille, *Visions of Excess*, 15.

36. What was the music of Nirvana about if not the Nirvana principle, a lullaby droned to the dreamy beat of the death drive? See my "Cult of Despair," *New York Times*, 30 December 1994.

the gaze, Roger Caillois, another associate of the Bataillean surrealists, considered this drive to indistinction in terms of visuality—specifically that of insects assimilated into space through mimicry.[37] This assimilation, Caillois argued, allows for no agency, let alone subjecthood (these organisms are "dispossessed of [this] privilege"), which he likened to the condition of extreme schizophrenics:

> To these dispossessed souls, space seems to be a devouring force. Space pursues them, encircles them, digests them in a gigantic phagocytosis. It ends by replacing them. Then the body separates itself from thought, the individual breaks the boundary of his skin and occupies the other side of his senses. He tries to look at himself from any point whatever in space. He feels himself becoming space, *dark space where things cannot be put*. He is similar, not similar to something, but just *similar*. And he invents spaces of which he is "the convulsive possession."[38]

The breaching of the body, the gaze devouring the subject, the subject becoming the space, the state of mere similarity: these are conditions evoked in much art today. But to understand this convulsive possession in its contemporary guise, it must be split into its two constituent parts: on the one hand, an ecstasy in the imagined breakdown of the image-screen and/or the symbolic order; on the other hand, a horror, followed by a despair, at this breakdown. Early definitions of postmodernism evoked this first, *ecstatic* structure of feeling, sometimes in analogy with schizophrenia. Indeed, for Fredric Jameson the primary symptom of postmodernism was a schizophrenic breakdown in language and time that provoked a compensatory investment in image and space.[39] And in the 1980s many artists did indulge in simulacral intensities and ahistorical pastiches. In recent intimations of postmodernism, however, the second, *melancholic* structure of feeling has dominated, and sometimes, as in Kristeva, it too is associated with a symbolic order in crisis. Here artists are drawn not to the highs of the simulacral image but to the lows of the depressive thing. If some high modernists sought to transcend the referential object and some early postmodernists to de-

37. Roger Caillois, "Mimicry and Legendary Psychasthenia," *October* 31 (winter 1984). Denis Hollier glosses "psychasthenia" as follows: "a drop in the level of psychic energy, a kind of subjective detumescence, a loss of ego substance, a depressive exhaustion close to what a monk called *acedia*" ("Mimesis and Castration in 1937" [*October* 31], 11).

38. Caillois, "Mimicry," 30.

39. This was first broached in "Postmodernism and Consumer Society," in Hal Foster, ed., *The Anti-Aesthetic: Essays on Postmodern Culture* (Seattle: Bay Press, 1983). This ecstatic version cannot be dissociated from the apparent boom of the early 1980s, nor the melancholic version (noted below) from the actual bust of the late 1980s and early 1990s.

light in the sheer image, some later postmodernists want to possess the real thing.

Today this bipolar postmodernism seems pushed toward a qualitative change: some artists appear driven by an ambition, on the one hand, to inhabit a place of total affect and, on the other, to be drained of affect altogether; on the one hand, to possess the obscene vitality of the wound and, on the other, to occupy the radical nihility of the corpse. This oscillation suggests the dynamic of psychic shock parried by protective shield that Freud developed in his discussion of the death drive and Benjamin elaborated in his discussion of Baudelairean modernism—but now placed well beyond the pleasure principle.[40] Pure affect, no affect: *It hurts, I can't feel anything.*

Why this fascination with trauma, this envy of abjection, today? To be sure, motives exist within art, writing, and theory alike. As I suggested at the outset, there is a dissatisfaction with the textual model of reality—as if the real, repressed in poststructuralist postmodernism, had returned as traumatic. Then too there is a disillusionment with the celebration of desire as an open passport of a mobile subject—as if the real, dismissed by a performative postmodernism, were marshaled against a world of fantasy now felt to be compromised by consumerism. But obviously there are other forces at work as well: a despair about the persistent AIDS crisis, invasive disease and death, systemic poverty and crime, a destroyed welfare state, indeed a broken social contract (as the rich opt out in revolution from the top, and the poor are dropped out in immiseration from the bottom). How one articulates these different forces is a difficult question—perhaps a definitive question for cultural criticism. In any case, together these forces have driven the contemporary concern with trauma and abjection.

And one result is this: a special truth seems to reside in traumatic or abject states, in diseased or damaged bodies. To be sure, the violated body is often the evidentiary basis of important witnessings to truth, of necessary testimonials against power. But there are dangers with this siting of truth as well, such as the restriction of our political imagination to two camps, the abjector and the abjected, and the assumption that in order not to be counted as sexist and racist one must become the phobic object of such subjects. If there is a subject of history at all for

40. See Sigmund Freud, *Beyond the Pleasure Principle*, trans. James Strachey (1920; New York: W. W. Norton, 1961), and Walter Benjamin, "On Some Motifs in Baudelaire" (1939), in *Illuminations*, trans. Harry Zohn (New York: Schocken Books, 1977). This bipolarity of the ecstatic and the abject provides one affinity, sometimes remarked in cultural criticism, between the baroque and the postmodern. Both are drawn towards an ecstatic shattering that is also a traumatic breaking; both fix on the stigma and the stain.

the culture of abjection, it is not the Worker, the Woman, or the Person of Color, but the Corpse. This is a politics of difference pushed beyond indifference, a politics of alterity pushed to nihility.[41] "Everything goes dead," says the Kelley teddy. "Like us," responds the bunny.[42] But is this point of nihility a critical epitome of impoverishment where power cannot penetrate, or is it a place from which power emanates in a strange new form? Is abjection a refusal of power or its reinvention in a strange new guise, or is it somehow both these events at once?[43] Finally, is abjection a space-time beyond redemption, or is it the fastest route to grace for contemporary rogue-saints?

Today there is a general tendency to redefine experience, individual and historical, in terms of trauma: a *lingua trauma* is spoken in popular culture, academic discourse, and art and literary worlds. Many contemporary novelists (e.g., Paul Auster, Dennis Cooper, Steve Erickson, Denis Johnson, Ian McEwan, Tim O'Brien) and filmmakers (e.g., Atom Egoyan in *Exotica*, Terry Gilliam in *12 Monkeys*, his 1995 version of *La jetée*) conceive experience in this paradoxical modality: experience that is *not* experienced, at least not punctually, that comes too early or too late, that must be acted out compulsively or reconstructed after the fact, almost analytically. Often in these novels and films narrative runs in reverse or moves very erratically, and the *peripeteia* is an event that happened long ago or not at all (according to the logic of trauma this is often ambiguous).

On the one hand, especially in art, writing, and theory, this trauma discourse continues the poststructuralist critique of the subject by other means, for, strictly in a *psychoanalytic* register, there is no subject of trauma—the position is evacuated—and in this sense the critique of the subject is most radical here. On the other hand, especially in therapy culture, talk shows, and memoir-mongering, trauma is treated as an event that guarantees the subject, and in this *psychologistic* register the subject, however disturbed, rushes back as survivor, witness, testifier. Here a traumatic subject does indeed exist, and has absolute authority, for one cannot challenge the trauma of another: one can only believe it, even identify with it, or not. In trauma discourse, then, the subject

41. To question this posture of indifference, however, is not to dismiss the possibility of a noncommunitarian politics, a subject of much provocative work in both cultural criticism (e.g., Leo Bersani) and political theory (e.g., Jean-Luc Nancy).

42. Kelley, quoted in Sussman, *Catholic Tastes*, 86.

43. "Self-divestiture in these artists," Leo Bersani and Ulysse Dutoit write of Samuel Beckett, Mark Rothko, and Alain Resnais in *Arts of Impoverishment* (Cambridge, Mass.: Harvard University Press, 1993), "is also a renunciation of cultural authority." Yet then they ask: "Might there, however, be a 'power' in such impotence?" (8–9). If so, it is a power they seem to advocate rather than to question.

is evacuated and elevated at once. And in this way, it serves as a magical resolution of contradictory imperatives in contemporary culture: the imperative of deconstructive analyses on the one hand, and the imperative of multicultural histories on the other; the imperative to acknowledge the disrupted subjectivity that comes of a broken society on the one hand, and the imperative to affirm identity at all costs on the other. Today, thirty years after the death of the author, we are witness to a strange rebirth of the author as zombie, to a paradoxical condition of absentee authority.

INDEX